Dearest Katie

Thanks for your wishes

warm regards

Monica & David
8th July 07

INDIA

INDIA
SPLENDOUR AND COLOUR

Photographs
SUZANNE HELD

Text and Captions
LOUIS FRÉDÉRIC

Executive Editor
JYOTI SABHARWAL

CONTENTS

FOREWORD

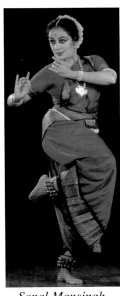

Sonal Mansingh

India is really blessed by nature. But whenever this country is talked about there are clichés. Because so much has been said right from the world travellers, to even those who attacked India, the country was lauded and admired or lampooned. For, India is a country nobody can be indifferent to. It has a very strong identity, a very strong personality and this is where its splendour and colour come from. It exudes an aura, which is intangible, but substantial. India is like that.

Geographically, the Himalayas are the most splendorous mountains in the world. It has the most splendorous rivers, the Ganga, the Yamuna, the Brahmaputra, the Narmada, the Kaveri, the Godavari. Then the deserts, large sea shores in the south and verdant valleys of the northeast, the wonderful plateau which many people don't even know about is the Gondwana Plateau. And this piece of land between the North and the Deccan goes back to the oldest formation of earth and when the countenance separated, this plateau was the chief architect of Asia. So, the ancient complemented with the diametrically different in contour and shape are these features of India — forests of sandalwood, forests of sesame, ebony and mahogany, flora and fauna that form some of the richest biodiversity in India, not only of the tropical variety, but as much the sub-tropical and the alpine. These are the traits that give birth to the colours we are talking about — the colours of the sea, the colours of the deserts, the colours of the mountains, the colours of the virgin forests, the lushness of the starkness.

Another aspect of this splendour is related to the amazing diversity in manners and customs of the people and different ways of living. The seafaring people of sea shores, the desert people from Rajasthan, seven sisters of the northeast, especially Assam, Meghalaya, Manipur. Their dresses, mannerisms, customs are so different and yet imbued with Indianness. And there are countries, which, unlike India, haven't had the privilege of such different tints of the skin, of the eyes, of the hair — right from fair to wheatish, to swarthy to coffee and dark. The Indian body structure, the structure of beautiful, rounded breasts that sit atop a narrow waist, which in turn, tapers into flared hips and those long-flowing limbs, can be so visibly seen in the dances of India, so full of splendour and colour. They reflect the sharpness of the sight, vision and sound. Wherever you go in India, you'll find these colours are the colours of life, of energy, of existence.

It is the splendour of inner richness. There is no poverty of spirit; of imagination, of sentiment and emotion, of relationship and affection, of sharing. The splendour of India lies in that *sutra*, the thread that binds people together, that binds hearts together, that binds landscapes together. It is the oneness and unity of all life, that we term as the Divinity of existence. And the word 'divine' comes from the Sanskrit word, *divya*, which means light, incandescence — therefore divinity, divine, *divas*, *divya*, they all come from the same root. This is the splendour of India, that innate thought of India, which like a laser beam has pierced layers and levels of thinking, imagination, meditation, and transcends to day to day living, where the beauty of life is manifest in every single moment.

**Sonal Mansingh, a renowned Odissi dancer,
is the Chairperson, Sangeet Natak Akademi.**

5

PUBLISHER'S NOTE

Is it really possible to discover and fathom India in its mind-boggling multiplicity, its cultural complexities, its multiracial, multilingual marquee and above it all, the very core of India — its spirituality, the enlightenment and wisdom of its seers and sages that have shaped this 5000-year-old civilization?

No answer, perhaps, could be categoric enough to say, 'yes'. That might explain why for a visitor, who's in India on a short sabbatical, this country remains an enigma, an image, a stereotype. Understandably so, for fleeting impressions can only tap surfaces and not delve deep into what lies behind those surface images. Given the paucity of time, it's all touch and go in an era of surfing satellite channels with barely much retention of attention to pause, reflect and set your mind soaring.

This is where these elaborate, richly illustrated big books that make a serious attempt to capture this colourful country in all its splendorous shades and hues serve both literary and historical purpose — to encapsulate the essence of India with a panoramic feel of its multiplicity. And it, indeed, is a publisher's delight that these series of books on India are put together by adventurous photographers and writers, who brave the vagaries of nature, and follow the hazardous routes after all that relentless research. Still it just doesn't seem enough. For, each title explores a new dimension and you never cease to wonder. Having traversed continents, having mingled with the fraternity of book lovers, one has gathered that India continues to baffle, amaze and beckon those who wish to embark on this voyage of discovery — of its grand, exotic past, the spirit of the orient and the inimitable land that has not only synthesized such tremendous influences over the centuries but also struck an incredibly harmonious note among its people. That's India!

That is the India the authors have attempted to depict in these resplendent pages, brimming with stunning images that would simply leave you speechless. This is a journey that commences afresh every time but would never seem to culminate. For, you never reach a point of knowing it all — you have to keep beating a retreat. And therein lies the real mystique of this country whose layers go on unfolding and unravelling the hitherto unexplored facets of this fascinating country. This is one destination that would continue to haunt any traveller.

Ajay Mago

THE REGAL INDIA

Though I live in a palace encircled by walls
embellished with pearls and rubies,
emanating fragrance of musk and saffron, moss and sandalwood;
Oh Lord, let not my dazzled eyes
ever allow me to forget to chant Your Name!

Gurû Nânak (1469-1539), Shrî Râga

In this myriad land of landscapes, the centre of India, the Gangetic Valley, the 'middle country' that of Madhya Pradesh, or Rajasthan, the regal domain of Maharajas — each region is starkly different from the other. Ranging from vast plains interspersed with patches of hills covered with thick bushy vegetation, to the contrasting arid deserts, this terrain is as bewitching as the monumental treasures it has stored in its heartland. These are the treasures that India owes to quite an extent to the clan of Rajputs, those 'inheritors of kings', who waged battles to triumph over this part of India to establish royal dynasties. They fought relentlessly, as much for the pride and pleasure of its martial race, as its insatiable urge to rule over people to flaunt its might. And the running refrain among these proud Rajputs was their endless rivalries. This is what led them to build walled cities on their territories, besides large and small forts to defend their cities more efficaciously. They continued to fill in their coffers by protecting and taking in caravans, and also levying a tax on all merchandise that moved on the roads under their aegis. Given the unbridled menace of bandits, who raided these caravans, the merchants were gratefully relieved to receive ready assistance from the Rajputs, seeking a safe haven in these fortified cities.

As this clan amassed enormous wealth that facilitated the construction of such majestic palaces, splendid cenotaphs and terrific temples, they also bestowed titles on themselves, varying from Raja, Maharaja, Rawal, Maharawal, to Rana or Maharana, given their particular clan and importance in the hierarchy. As they went on to become generous patrons of arts, they received and honoured musicians, dancers, poets (*bhat*) and writers, and also felicitated those artists, sculptors, painters and engravers, whose works adorned their palaces.

At the other end, the lesser mortals, the economically deprived lower segment of Rajasthan thrived on self-esteem, taking tremendous pride in its traditions, donning moustaches and turbans that became symbolic of those proud and easily offended Rajputs.

There is admirable evidence of this State's splendour. And one of its most outstanding cities is Jaisalmer, better known as the 'Capital of the Thar Desert', the desert of death (*Marusthali*). Its history is traced back to 1156, when Rajput Jaisal built this city of Jaisalmer on a hill overlooking the infinite sand dunes that seem to stretch into no man's land. It raises its five kilometre of ochre sandstone walls as an awesome security guard, keeping a watch over the vast, encircled stretches of emptiness. The reasons were obvious, as rich caravans coming from the northeast and China, on their way to the ports on the Gujarat coast, had to cross this desert, one of the most hostile regions on planet earth. So, after being plundered

by invaders from the north in the thirteenth century, the city was rebuilt around its central fortress, and its defences were doubly reinforced. Subsequently, numerous merchants of the Baniya cast, came in from an area near Marwar, and settled down in the city, conducting business with the passing caravans, dealing in wool, carpets and locally-made silver jewellery. And the most prosperous among these merchants, especially in the eighteenth century, built sprawling havelis, luxurious homes, both in Jaisalmer, and in Shekhavati, near Jodhpur. These havelis were resplendent with murals painted on its walls, charming though primitive, capturing both religious and mundane aspects of everyday life. And keeping pace with the changing times, one of these recently renovated havelis shows automobiles and even an airplane in flight. Ostentatious to every possible extent, they also added perforated marble screens to their decked up balcony windows and even covered them with ceramic and enamel mosaics. As for the ruler of the city, the Maharawal of Jaisalmer sought the construction of numerous temples dedicated to deities, like Shiva, Lakshmi, Ganesha and Tirthankara Jain. One of these temples, the Sambhava Natha, houses a tremendous library, the *Jnana Bhandar*, 'Treasure of Knowledge'.

As you come to the old city of Jodhpur, founded in the fifteenth century, it is surrounded by a wall almost ten-kilometre long with seven gates, dominating nearly a hundred metre of the modern city from its lofty red sandstone citadel. It is a beautiful juxtaposition of the old and new, with a maze of narrow streets. At the end of one of these streets, one may suddenly stumble upon a house with a sculpted or painted facade. Other times, one may take a brief halt in a Hindu temple, which somehow seems out of place in the midst of a bustling marketplace.

In this city too, palaces have been converted into museums, obviously dedicated to that glorious era of the Rajputs. And Umaid Bhawan, the palace of the city's last Maharaja, who passed away in 1947, now runs as a palatial, heritage hotel in all its opulence. The city of Jodhpur is also known to have made an eternal fashion statement. As the English officers imitated the flamboyant nobility, they got the local tailors to design trousers for them in the wake of its royal clientele. So much so that this appellation of 'Jodhpurs' has become the mainstay in the wardrobe of riders and lovers of horsemanship the world over.

Beyond the city, in the town of Mandore, the grand ruins of the Maharajas' cenotaphs and splendour of several Hindu temples is buried under the town's shady woods. All these preceded the other prominent structures of Brahmanic and Jain temples located further away — built between the eighth and twelfth century.

Further to the north, Amber, the former Capital of Rajasthan, lies on the edge of the desert, atop a stupendous mass of rock. Retaining its traditional gateway, the rather steep access ramp ensures that one enters the city riding an elephant. Even today, to capture the grandeur of the now-deserted magnificent palaces of this royal city poses a challenge to a tourist guide. The well-shaded courtyards that lead from *Suraj Pol*, Gate of the Sun, and those of Ganesha elicit immediate attention. The palace for common audience, *Diwan-i-Am*, numerous stately rooms, and even the mammoth, imposing building that houses the gynaeceum, for the most part, date back to the eighteenth century. It's quite a breathtaking view from atop the notched walls, looking down upon the winding ravine that blends with the borders of the routes crossed by the caravans coming from Delhi to Rajasthan. This panoramic vista includes the royal cenotaphs and a small lake whose waters reflect an old fort and a huge palace. Interestingly, the Rajput royals took a benevolent view of the great Mughal Emperor Akbar and offered their services to the extent of seeking matrimonial alliance. One of the daughters of Bhagwan Das married the Emperor in 1562, thus sealing both familial and political union between the

Raja of Amber and the Mughal court, thus securing their prosperity.

Apparently, the city seemed too cluttered to one of its successors, Jai Singh II (1699-1743) who, in 1727, abandoned it and moved some eight kilometre away to an entirely newly built Capital in the open country. Named after the ruler, Jaipur, the 'City of Jai Singh', this erudite Maharaja was also a great mathematician. He sought to resurrect the long-forgotten tradition of urbanization that had come into being with the Indus Valley, at Mohenjodaro, some four thousand years ago. And chose to design his city in checkerboard fashion as the Royal Palace made up the centre, while the houses bordering the streets wore a rough coat of salmon pink plaster. So were the walls surrounding the city painted pink, with this colour at times taking on the hues of an ochre tint. Naturally, the new Capital thus later began to be addressed as the 'pink city'. Although the successor Jai Singh II had planned a large city, he could not have possibly foreseen the phenomenal growth in population that was brought about by the Maharaja's abundance. So, yet another city, this one in the English style, was developed outside the walls, but not sufficient enough to accommodate the million inhabitants who are residing there today. And the crowds double up each time there is a grand ceremony, like the traditional festival of *Gangaur* at the onset of spring, *Teej*, in July, the major celebrations among the many civil and religious events that attract monumental crowds.

Here also the Maharajas don't hold the sway any longer. In 1949, in post-Independence India they gave over their land and wealth to a nation that was turning republic. But the memory and spirit of Jai Singh II remains indelible in the buildings of the old city. Among the most significant reminder is the captivating facade of *Hawa Mahal*, the 'Palace of the Winds' and the historic *Jantar Mantar*, where he used immense instruments for astronomical calculations. As for the palaces, there seems to be a uniform pattern in some of these stupendous structures being converted into museums, some abandoned, and others turned into heritage hotels.

There's so much more to discover in the neighbouring desert, like this large lake engulfed by patches of greenery. In the ancient scripture, *Padma Purana*, the legend has it that this lake is the handiwork of Brahma, who let several lotus petals fall on this very spot, the petals with which he had conquered a demon. Termed as Lake Pushkar (Pushkar, being a synonym for blue lotus), this spot has remained a place of devotion from time immemorial. The renowned Chinese pilgrim Fahian is said to have visited it in the year 400 AD. To facilitate the offerings of the faithful, marble ghats (steps) have been erected. During celebrations these enormous steps can barely be seen as countless pilgrims flock here from all parts of India to purify themselves in the holy waters of the lake. Given the sanctity of this sacred lake, it is completely forbidden to kill any animals and the Rajput princes erected temples all around this area. Although these temples are not particularly, architecturally great creations, but the devotees throng them with unfailing faith. Earlier temples had been demolished during Aurangzeb's regime, given the fanatic zeal of the last of the great Mughals. As per the version of another ancient scripture, the *Vishnu Purana*, worshipping at Pushkar brings in many a blessing and one single bath in the lake purges the soul of all sins. And during the period of *Kartika-Purnima*, that is, in November-December, the divine feats of Brahma are celebrated with great elan, notwithstanding the chill of winters which begins to penetrate in these months. Brahma is the supreme divine among the Hindu trinity, rarely invoked elsewhere. On this very occasion, a tremendous camel and goat fair is also held and the amazing ceaseless movements of these animals raise such thick dust that it even obscures the rays of the sun, which in turn, seem to impart a golden tinge to everything and anything they shine upon. And by the evening, when the dust

has settled down and the sky renders the rouge hues, it is the hour for 12 sacred plays and concerts of Indian music which elicit applause from connoisseurs. And all this while, traders continue to beckon, striking deals and thaumaturgists and magicians of all dimensions display their tricks or forecast the future. The curtains are drawn at the festival with a massive camel race, and the deafening cheers of the zestful spectators add to these colourful crowds of varied ethnic groups. And most prominently visible are the red turbans worn by the Rajputs. These red heads punctuate the crowds lending the perfect bright touch.

Though Rajasthan flourished with fortified cities that had an enviable repute of being impregnable, ironically they failed to resist Mughal artillery, or for that matter the impeccable strategies of the British, who so ingeniously divided the Rajput clan, setting one against another and made use of these factional rivalries to magnify their domination further on. But there was an exception to the rule, who refused to cave in, remained unconquered and above all, managed to escape his rivals seeking refuge in the jungles of the southern region, pursued in vain by the Mughal troops. This was none other than the chivalrous Udai Singh (1537-1572), the Prince of Mewar from the Shishodia clan, which made a proud claim to have descended from the sun. He established his Capital in a region, a centre for the powerful Guhila clan, since the seventh century. The Guhila clan ably resisted the assaults of its neighbours, the Sultans of Gujarat, as that of the Arabs settled in Sind. The new city, Udaipur, 'The City of the Dawn', created by Udai Singh also became his crowning glory as he built a dam on the Berach River, thus creating an enormous artificial lake, Pichola, scattered with islands. Because of the irregular terrain, the lake got divided into several sections. Taking on the title of Maharaja, which he subsequently transmitted to his descendants, once he was completely assured that he no longer had to fear the ominous Mughal armies, he

set upon building a huge palace on the banks of the lake. Interestingly, this vast marble structure was constantly being enlarged by each of his successors. And at present, it presents a labyrinthine of suites in various palaces, inner courtyards, lawns and gardens and staircases that can make you tizzy with its enormity and maze, with a surprise discovery at each turn of the long-winding passages and aisles. The rooms are embellished with mosaic or multicoloured floors, awesome hallways decorated with Mughal-style paintings, and sparkling white marble pavilions with stunning overview of the lake in the midst of hills. Almost each of the smaller islands has a smaller palace on it among which the 'Isle of Jag Niwas', seems to float on the waves. This site of a magnificent palace is the delectable choice for a hotel for those who dream of 'A Thousand and One Nights'. And certainly not to miss the massive, round ochre sandstone tower, more so for its historic significance, for this is where Jehangir's rebellious son, Prince Khurram, the future emperor Shah Jahan, had sought refuge here to escape from his father's wrath. At the other end of the lake, still partly surrounded by its walls, lies the old city with its bustling streets, and many an artisan exhibiting their crafts. As the temples dot the city and further beyond, a contrasting view is provided by the modern high-rise buildings.

The dry, arid lands are not really blessed by the monsoons, as this region is believed to be blessed by the gods. What is remarkable is that the sky is invariably clear, and the scorching heat of the summer gets tempered by the waters of the lakes complemented by a moderate altitude (about 570 metre). It seems paradisiacal that the entire surrounding region is laced with ponds that nestle among the rocks, woods, antique temples, and fortresses. And Chittorgarh is perhaps the most famous fortress, known primarily for its numerous sieges against other Rajput clans, more so for its resistance against Akbar in 1568. At the end of this most memorable siege, the Rajput noblemen, on seeing that all was lost,

attired in yellow robes, went out of the city chanting, to meet their deaths, while inside the city, the women and young girls committed *jauhar*, sacrificing themselves in a tremendous bonfire. And this heart-rending event has been narrated in the verses of many bards and poets.

On the contrary, the city of Ujjain, in the extreme south of Madhya Pradesh, was lesser prone to these conflicts. And this famous Capital of yesteryears is considered to be one of the seven sacred cities of India, with its monuments situated on the banks of the Shipra River, where legend has it that Shiva conquered demons. Equally renowned for its foundations in antiquity, as archaeologists have unearthed vestiges of a ten-metre high city wall dating from the time of Lord Buddha. The city is also the religious and spiritual site of one of the largest of 'pilgrimages of purifying baths', the *Kumbha Mela*. In a cycle of every twelve years, hundreds of thousands of devotees congregate to offer holy prayers at the temple of Mahakaleshvar. This Capital of the famous king, Vikramaditya, Ujjain is also said to be the ancient domain of the Greeks. As history reveals, though the period remains uncertain, perhaps towards the end of the fourth century, Vikramaditya, given his sagacity brought the most esteemed wise men and writers together at his court. Thereafter, the Rajputs of the Paramara clan succeeded another Hindu dynasty in the ninth century, but the Muslims from Delhi took possession in 1235. They had to flee after the Maratha clans, the Scindia and the Holkar, conquered the city in 1972. Notably, the city still remains typically Hindu. As the city was well acknowledged for its phenomenal mathematicians and astronomers, Maharaja Jai Singh II of Jaipur got an observatory installed here. Since this city is ideally located on the first meridian of Indian geographers, an important meteorological station is now in operation here. But the old city has unfortunately almost entirely disappeared, having been destroyed by default by the Maratha General Tukoji Rao Holkar during his reconquest. Though the city's temples were rebuilt soon after, they were more primitive than elegant in style. But this touch of modernity did not deter the worshippers of Shiva. Their ardent devotion remains undiluted as right through the year, they come to Mahakaleshvar to wave *Jyotir-linga*, the Linga of Light, one of a dozen of the sacred lingams in India. The sanctity of Ujjain as a divine destination for Hindus can be gauged from the fact that the ancient poets of renown, like the inimitable Kalidasa in the fourth-fifth century thus described the city at great length in his *Meghadoot* (The Messenger Cloud). So did the poet Banbhatta, around 606 to 647, end his epical poem, *Kadambari*, in this vein: "What more can be said? God Himself lives in this city under the name of Mahakala. For this domain, He abandoned his mountain Kailasa…."

Coming to the other end of Udaipur, at the extreme point of the Aravalli Hills, where well-known white marble quarries are located, this 'Olympus' of India is found on a small mountain. Since the eleventh century, the Jains have been gathering here to pray, erecting numerous marble temples encircled by windowless walls, the *basti*. And on Mount Abu, a cluster termed as Dilwara, includes five sanctuaries dedicated to the memory of the Tirthankara, all admirably decorated with stupendous sculptures. Among the lot, the Vimala Vasahi, built in 1031, is most notable for its main dome supported by eight delicately carved pillars. The Luna Vasahi contains an interior dome, sculpted like a crystal chandelier. This structure is also addressed as 'Tejapala and Vastupala', named after two brothers, ministers of a King of the Solanki dynasty, who sought its construction in 1230. The serenity and pristine environs of these Jain sanctuaries stand in stark contrast to the general commotion often found in other Hindu temples.

India of Palaces, however, is not merely confined to Rajasthan, with its expansive deserts, bewildering fortresses and its dazzling temples, but these palatial structures also extend far to the east beyond the lonely wilds of the Aravalli

Hills, reaching the Gangetic Valley. This vast valley encompasses the cities of Mathura, Agra, and Delhi, that replaced Calcutta as the Capital of India since 1911. On the road leading to the north, the city of Gwalior rises majestically, so beautifully perched on a rocky headland. Believed to have belonged to a Rajput clan, dating back to the fourth century, but hardcore facts prove that the city was founded in the sixth century. In the course of history's fast-moving events, this city was captured first by the Rajput Pratihara and the Kacchapagatha, before finally being conquered by the Chandela. The Sultans of Delhi too laid siege in 1232 but lost out to the Rajput clan of Tomara in 1375. The most renowned Raja of this clan, Man Singh (1486-1516), is acclaimed for adorning the city with a fortified palace, whose walls were so intricately trimmed with blue ceramics.

And the holy city of Mathura, situated on the right bank of River Yamuna, it is considered to be one of the seven sacred cities of India. With its legendary inception, it is especially famous as the birthplace of Lord Krishna, an incarnation of Vishnu. Born as a rustic, in the village of Vrindavan, among the cows and the herdsmen, the young Krishna charmed, enchanted and entertained them all with the sonorous strains of His flute. Also having been a centre of Buddhism for long, Mathura was the Indian Capital of the Kushana, a Scythian tribe that arrived from Central Asia about the first century AD. The city boasts of many splendid monuments, greatly admired by all those who sought its complete destruction, either owing to their iconoclastic fervour or sheer sadistic taste for plunder. Ranging from Mahmud of Ghazni in 1017, to Sikandar Lodi around 1500, and Aurangzeb in 1667 and 1670, to finally Abdali, the Afghan, in 1757, barely much remains of this rich, magnificent city except enormous ruins of ancient temples and steps worn out over the aeons by the pious pilgrims, who descended to feed the sacred turtles. Only by the fifteenth century did Mathura become

a significant centre of Vaishnav belief and the cult of Krishna grew so extensively, for the majority of the followers of the philosophy of this doctrine established *matha*, the venues for congregation. Vallabhacharya (1479-1531), a theologian of the Vishnu cult, penned so in one of his poems: "There is only one text and it is the one sung by the son of Devaki, Krishna, in His *Bhagavad Gita*. There is only one god, and it is Krishna. There is only one duty, and it is to worship Krishna." Mathura and the adjacent villages that reverberate with the legend of Krishna are still thronged by devotees, especially during the massive, elaborate celebrations of honouring this deity, that take place in April and May, the months of *Vaishakha*; and in July and August, *Shravana*, the *Vana Vihara* and *Pancha Tirtha Mela* are held. Innumerable tales, lore and legends have been spun about these places, the various abodes of Krishna. These legendary tales are also related to the ancient temples, which were rebuilt no sooner than they were demolished. And as many rituals permeate the religious year, each accompanied by a mandatory dip in the river. But the atmosphere of these holy precincts of Mathura has somewhat been marred by the mushrooming of industrial and commercial establishments and in its wake the old city seems to have lost its charm. Only the rippling blue waters of the Yamuna continue to lend the city its soul.

And you have to go further south, to the very brink of Deccan to find an exemplary museum city of temples, almost intact. It is so perceived that the Hindus themselves visit this sanctum, above all, for the fear of forgetting such a stupendous past that they ought to retain in their conscious memory, which spurs on this curiosity to see what their ancestors achieved and accomplished; and what their contemporaries, perhaps, might be incapable of replicating. And one comes to Khajuraho, set right in the heart of wilderness, dotted with arid hills that shine golden bright in the harsh light of the pre-monsoon skies. This former Capital of the Rajput clan of Chandela is no longer a city, but a mere village

that survives more on the magic number of tourists than on its meagre agricultural preoccupation. Sounds sad considering that in the tenth and eleventh century, it was a city unequalled in aesthetic beauty. The religious piety of its rulers led them to adorn it with 85 temples, each one more majestic than the other. And now there remain only 25 structures in this pious Capital of an era gone by — those, which escaped miraculously (or perhaps by royal diplomacy) the zealous folly of the Muslim invaders. This cluster of temples, only one of which is still open for worship, is the most pure jewel of Indian art, wherein the architecture synthesizes and the symbolic mountains, the divine domain of the gods. And the very stone from which they were cast — ochre or sepia-coloured sandstone, whose shades and hues keep changing as the sunlight plays hide and seek — has obviously been treated as a precious material. The way it has been modelled, carved, polished and entirely dedicated to feminine beauty by a fleet of sculptors, it seems they were completely smitten by the body and spirit of women. In its own way, it has turned into an eternal symbol of a divine act, the very power of creation and creativity and the unparalleled beauty of nature.

Given the eclectic temperament of the Rajas of Chandela, they indeed worshipped all the deities, including those of the Buddhists and the Jains, and thus erected sanctuaries for them, solely adapted to each of their rites. Since they themselves were fairly adept at the Tantric cults, the Rajas got the temples embellished with multiple erotic scenes, again seeking to symbolize the innumerable ways how the human soul could blend with the divine. Understandably, these sanctuaries have sought fame for this erotic depiction rather than its magnificent sculpture and architecture. But they are often misinterpreted by conservative visitors who prefer monuments with less graphic images. Notwithstanding the essential fact that the Divine was venerated under five of its aspects, Shiva, Vishnu, Durga, Surya and Ganesha and they had to be worshipped. And this is the primary reason why several temples subscribe to this mode of *Pancharatna* with five sanctuaries on the same platform — the one in the centre is the principal deity to be venerated. The renowned Moroccan traveller, Ibn Batuta, who visited this site in 1334, went on to write that this place was haunted by numerous ancestors and priests, and that even Muslims came all the way seeking enlightenment. It was Sikandar Shah Lodi's devastating raid on the region that completely destroyed the city of Khajuraho and also demolished quite a number of temples, and step by step the area lost out on its religious importance. No wonder, its abandoned sanctuaries simply disappeared under dense vegetation. Much later in 1840, these sanctuaries were discovered by British soldiers, but were only cleared of their green boundaries. They got restored only between 1906 and 1923. It is well in keeping with this restoration that today their elegant *shikharas* stand in the middle of gardens. The evenings liven up with sacred performances of the dancers, keeping with the tradition of the Chandela, who were avid lovers of theatre productions. As per the ancient texts, notable among these was *Prabodhachandrodaya*, 'Moonlight of the Intellect' scripted by an author of the times, Krishnamishia (1050-1116), known to have written for Raja Kirtivarman.

Once on the banks of this large lake, Ninora Tal, stood these temples along the city with palaces and houses made entirely of wood. And now there are mere remnants of some ruins, surrounded by stone steps leading to the lake. Supposedly, other lakes, now dry, must also have had sanctuaries. It's quite obvious that the region was quite a prosperous oasis, when they were built, as the very name Khajuraho means 'forest of palm trees'. While travelling through India, it is an absolute must on the itinerary — the sheer beauty of Khajuraho's art and sculpture is unparalleled except perhaps for Mount Abu and Konarak.

After various invasions, Muslims got integrated in Hindu India and the country

witnessed numerous mosques being constructed right next to its temples and sometimes even replacing the temples. While certain Sultans incorporated the Persian religious style, others banked upon the talents of Indian artists and artisans to produce their electric masterpieces. The most striking example, however, which has never failed to astonish the visitors over the centuries, is the city created entirely by the great Mughal Akbar, who, having grown tired of court life in Agra, set up a new Capital right in the middle of the jungle, to the south of this fabulous fortress-city at Fatehpur Sikri. Overlooking a lake, this city is built on a rocky plateau in a primitive region. Akbar had a low six-kilometre wall built around the city. But his dream of the city he had planned never saw the light of day, for the members of the court preferred to stay on in Agra. The only structures that got completed on the plateau were the palaces and the enormous mosque with its 'Door of the Monumental Victory' erected in 1575. No sooner were the buildings completed that they were abandoned, perhaps also because of the lack of water supply. They turned into ghost palaces, wearing a desolate look, overlooking a bushy, vacuous surroundings, bereft of any inhabitants, except for some wild animals roaming there. These palaces of red sandstone are aligned along a main avenue and their grandeur and style are a perfect, eclectic blend of both the Indian genius and the talents of Muslim architects who designed them. Till date, they remain the most sterling, historic example of the imperial spirit of tolerance, which Akbar propagated right through his empire. Not a single soul resides here any longer, except the guardian of this open-air museum, where only the interiors of the palaces offer some respite from the scorching sun. In a magnificent white marble mausoleum in the courtyard of a massive mosque, lies the inaugurator of this imperial city, also a Muslim Sufi saint, Sheikh Salim Chishti, who predicted that the Emperor would have three male descendants. Above the large

'Door of the Victory' that celebrates the triumph of the Emperor over the Sultan of Gujarat, is inscribed an astonishing thought, that sums up the eclectic vision of this great ruler, who immortalised himself in the pages of history: "Jesus, son of Mary (Peace be with Him) said: 'The world is a bridge; cross it but do not build a house upon it. He, who hopes for an hour, hopes for eternity. The world lasts only an hour: spend it in prayer, for the rest is the unknown....' "

The real pride of Agra, which remained the preferred Capital of the great Mughals before being occupied by the Scindia of Gwalior in 1764, was a fort built of reddish sandstone. It held numerous palaces, most of which were rebuilt by Shah Jahan who reigned there from 1628 to 1658, before being dethroned and kept prisoner until his death in 1666 by his own son Aurangzeb. The city remains famous for its other monuments, such as the delightful tomb of the Itimad-ud Daula, built between 1622 and 1628 by his daughter Nur Jahan, wife of Jehangir, the son of Akbar. With its delicate decoration of coloured stones imbedded in white marble, this tomb foreshadows the unrivalled splendour of the Taj Mahal, the gigantic tomb erected on the banks of the Yamuna with its nuances of colour changing with the colour of the sky. Dazzling white in full sunshine, the Taj takes on a pearl-coloured hue at dawn or dusk. In the hot haze of certain days, its silhouette seems to float in air above the horizon. A love poem in marble, dedicated by the Emperor to his wife Mumtaz-e-Mahal, this mausoleum, unique in the world, a little static due to its perfect symmetry, seems to come alive only with the ever-changing whims of the weather in this region. The region itself is a repository of several climes, arid in the west, wet in the east and relatively dry in the south, in Deccan. Here the brilliant ochre shades of Rajasthan are muted to a perfect whiteness, untouched by the dust of sultry summer or dampness of the monsoon rains — making it a symbol of an eternity that exists only in the world of Supreme.

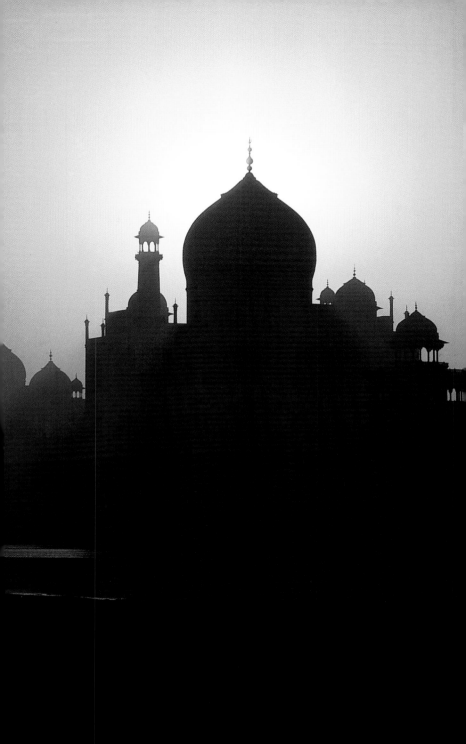

Almost like a dream from nowhere... the silhouette of the enigmatic
Taj Mahal greets the skies at dawn. This epitome of
eternity has become
synonymous with India the world over.

monument is an ode to love – a
poem in marble, dedicated by the
most flamboyant of the Great
Mughals, Shah Jahan, to his
deceased wife Mumtaz-e-Mahal,
'Pearl of the Palace', who died giving
birth to his fourteenth child. Its
profile rising on the horizon from
the morning mist bears calm witness
to the passage of time, space and
people. This mausoleum stands on
the banks of River Yamuna, in such
incredibly perfect symmetry and
unparalleled grandeur.

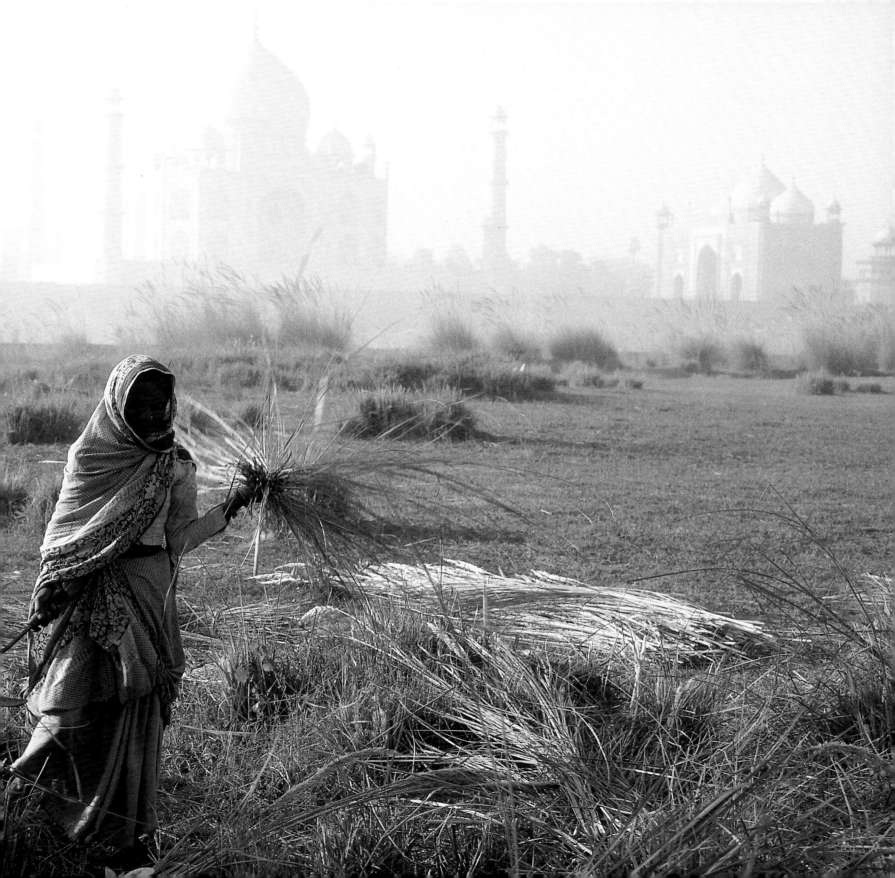

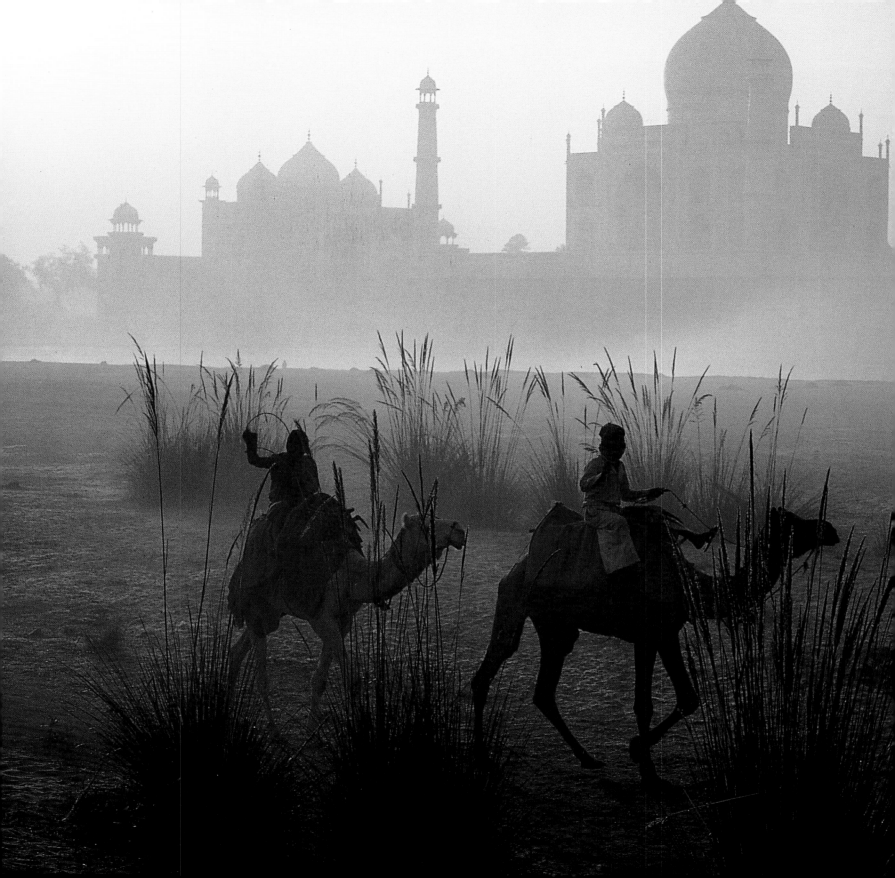

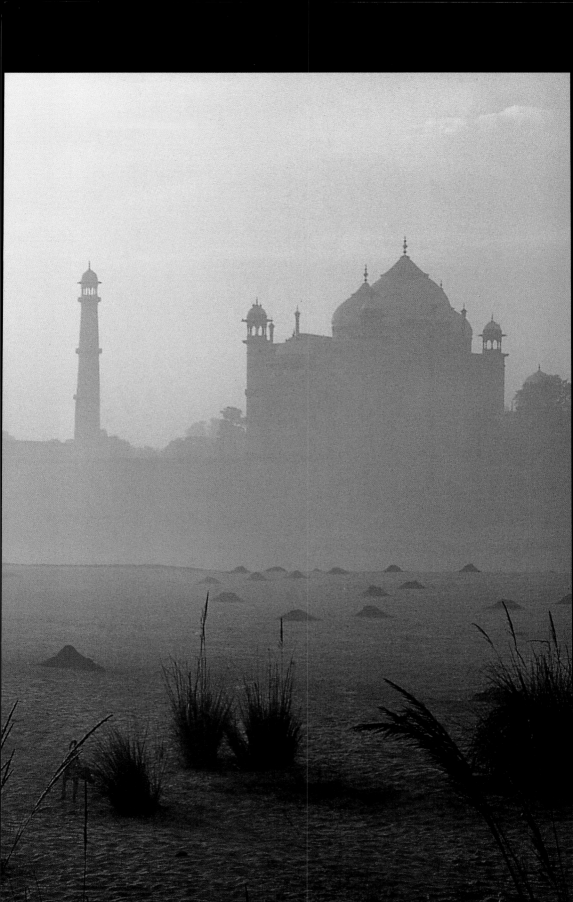

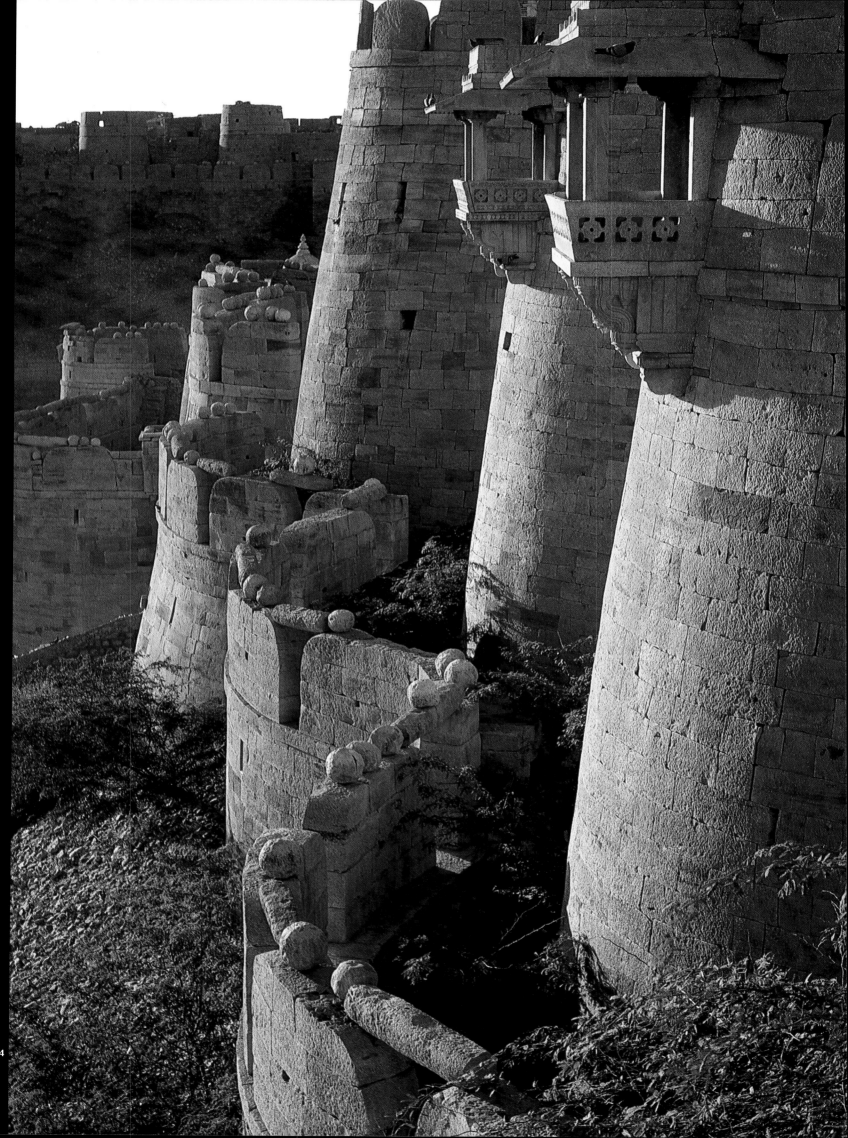

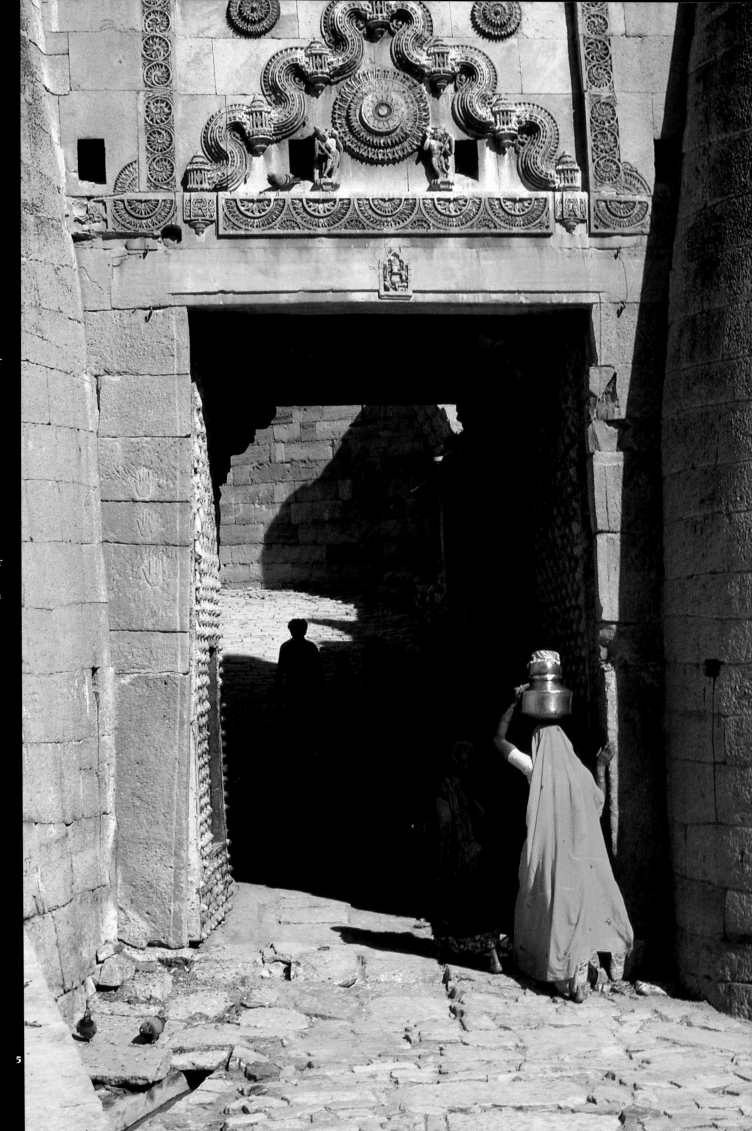

The city fort of Jaisalmer rises majestically from the Thar Desert in Rajasthan. Founded in the twelfth century, it stands on a hill and is still surrounded by five-kilometre long walls, defended by powerful red sandstone towers that were rebuilt in the fourteenth century to protect it against plunder and attacks from its neighbours. The city can only be reached by passing through a richly embellished portal and following a zig-zag pathway.

5

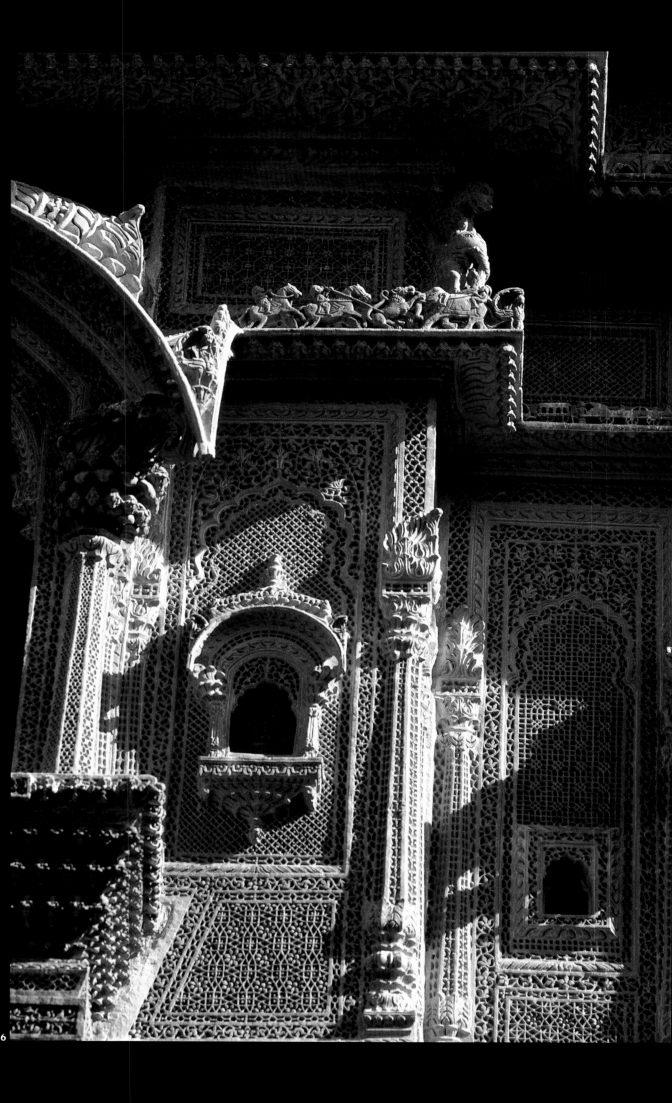

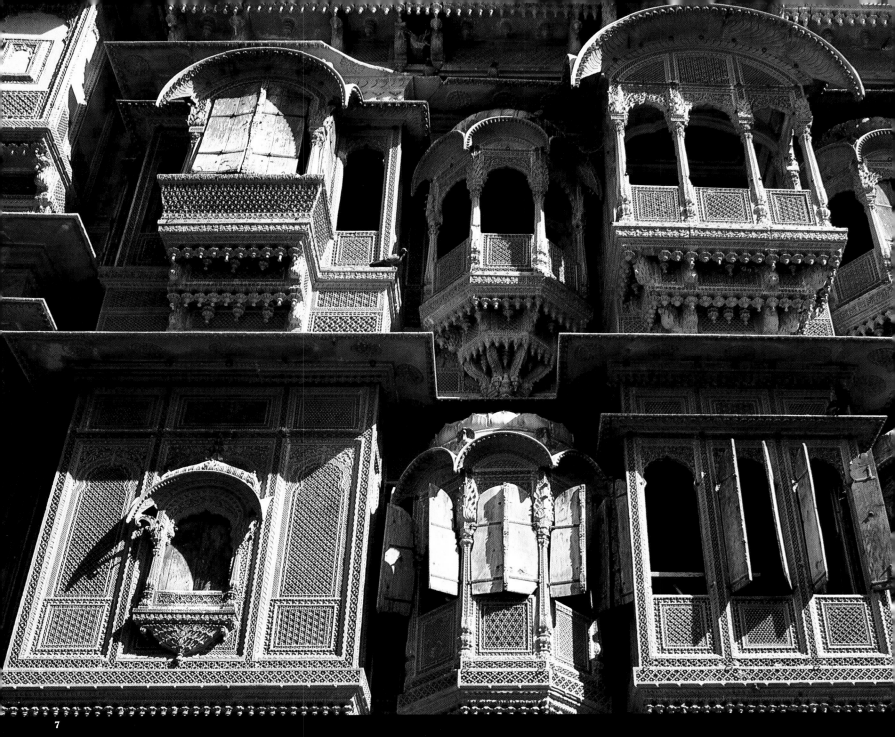

7

Numerous monuments and homes (haveli) of rich merchants can be found
inside the city of Jaisalmer. In the eighteenth and nineteenth century,
when the city was a stopover for caravans, these rich merchants
decked up their homes with magnificent sculpted decorations,
as on the left, the Diwan Nathumal ki Haveli,
and on the right, the Patra Haveli.

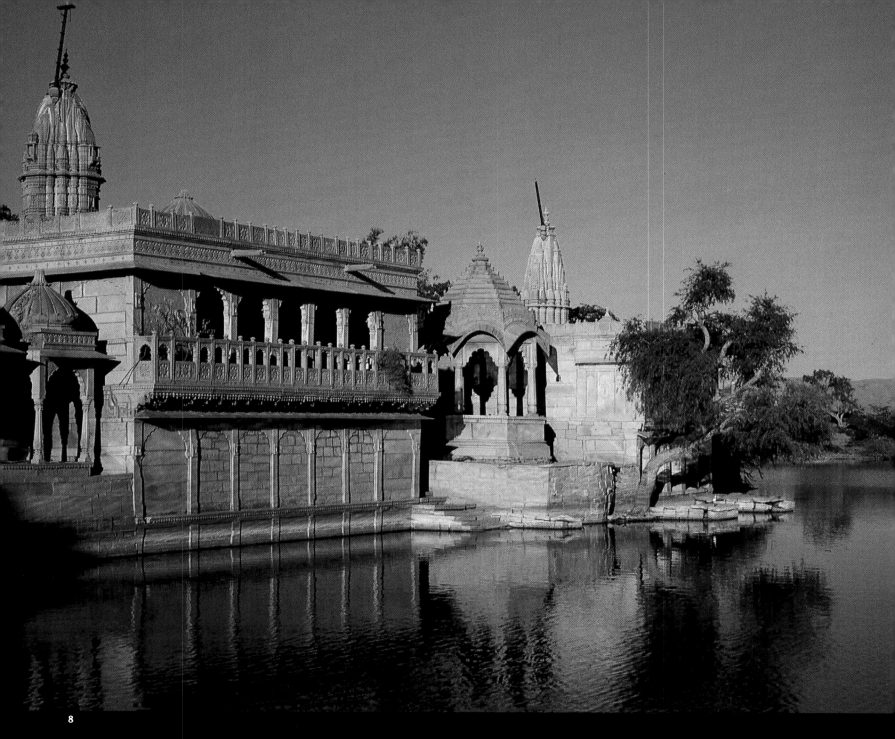

Situated a little outside the fortified city of Amarsar, the Reservoir Lake brings some
relief to the desert heat. In the evening, women from the city come to fetch
water for their households. On the banks of the lake stand
numerous nineteenth century Jain temples. At sunset,
these temples seem to blush, taking
on a hue of delectable rouge.

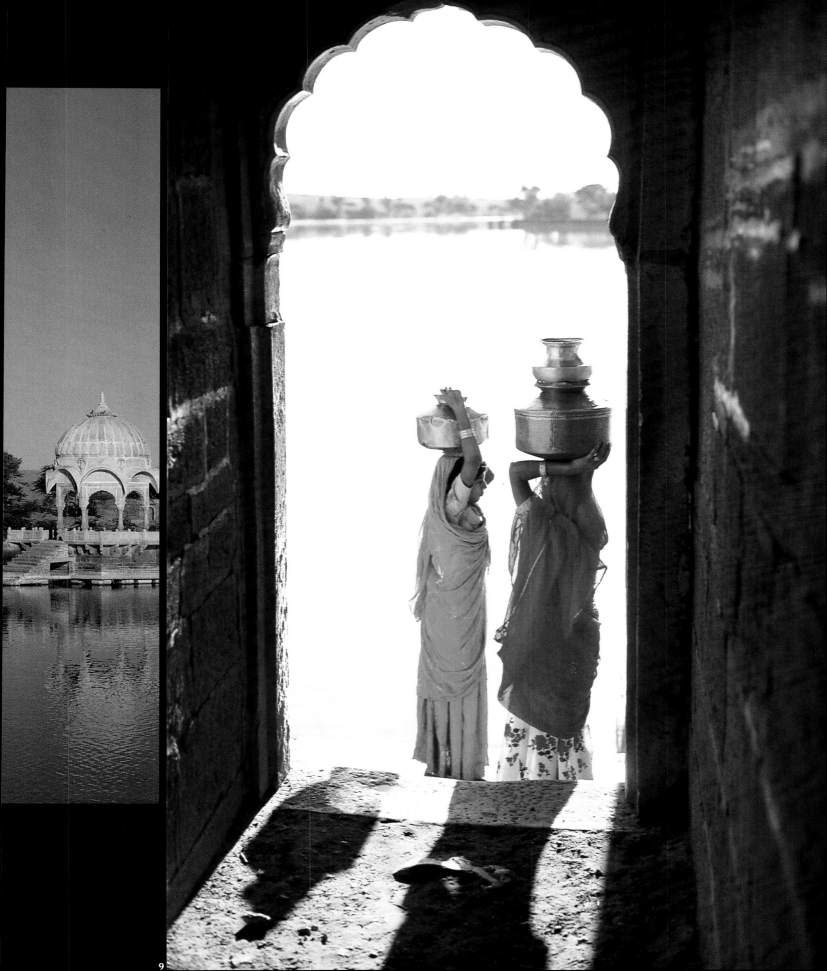

The royal cenotaphs of the
Maharawal (Maharaja) of
Jaisalmer are found at
Bada Bagh, about six
kilometre from the city.
Their pink sandstone
arcades, though lying
in ruins, remain a
perpetual reminder
of the splendour
of this former
desert capital.

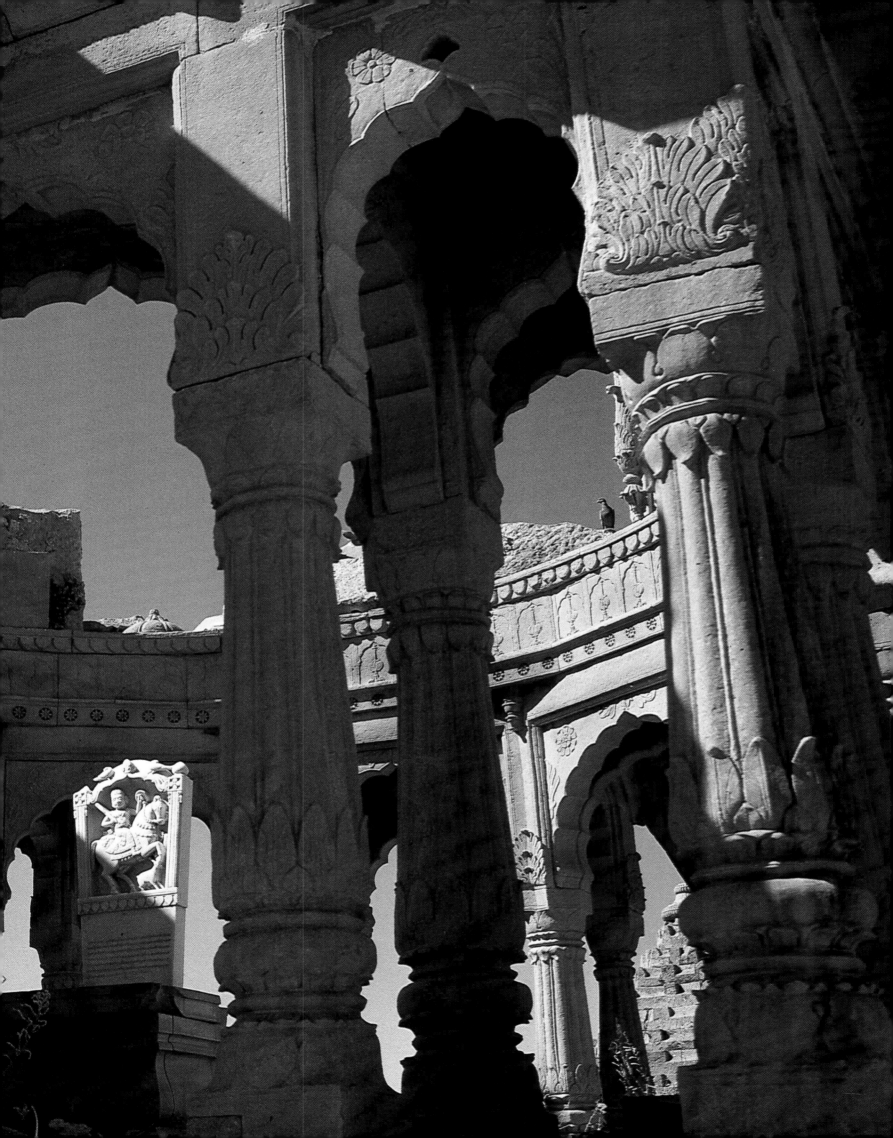

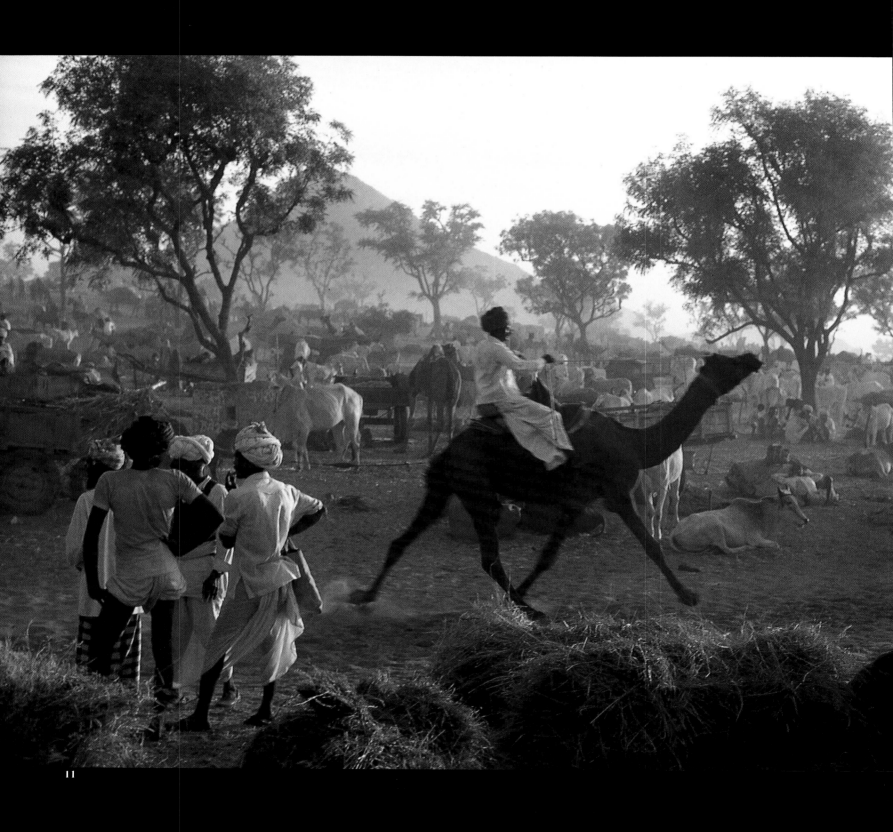

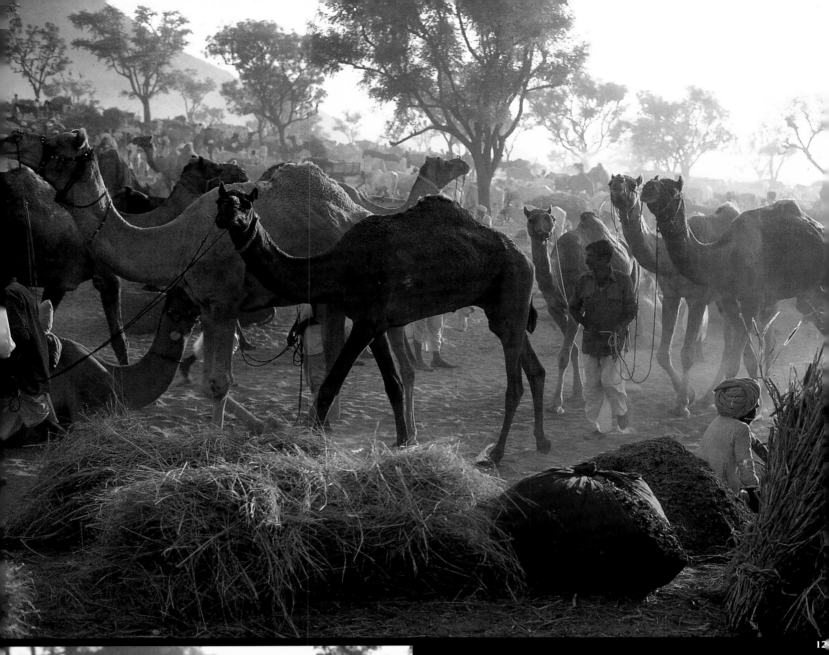

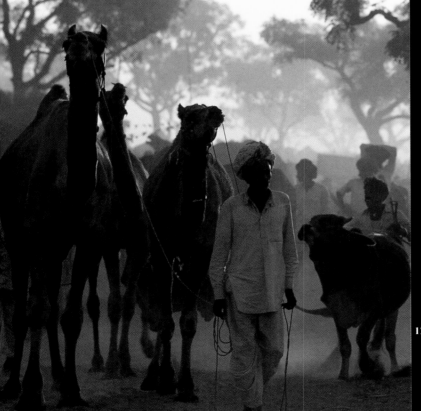

Around the Lake Pushkar, in Rajasthan, a large religious festival dedicated to Brahma takes place each year during the week before the full moon (Purnima) in the month of Kartika (October-November). This is also the occasion for a large animal fair mostly for camels and goats. Also considered to be one of the most sacred places in India, hundreds of thousands of nomads, merchants, curious visitors and the devout congregate for the celebration.

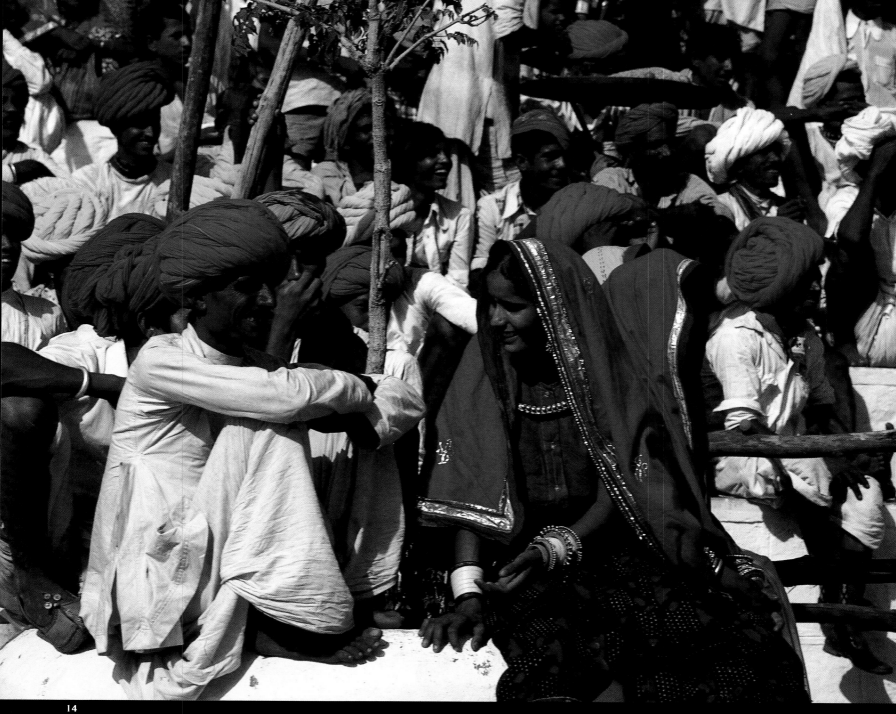

During the festival of Kartika Purnima, the Rajputs, wearing their
finest turbans push and crane their necks to get a

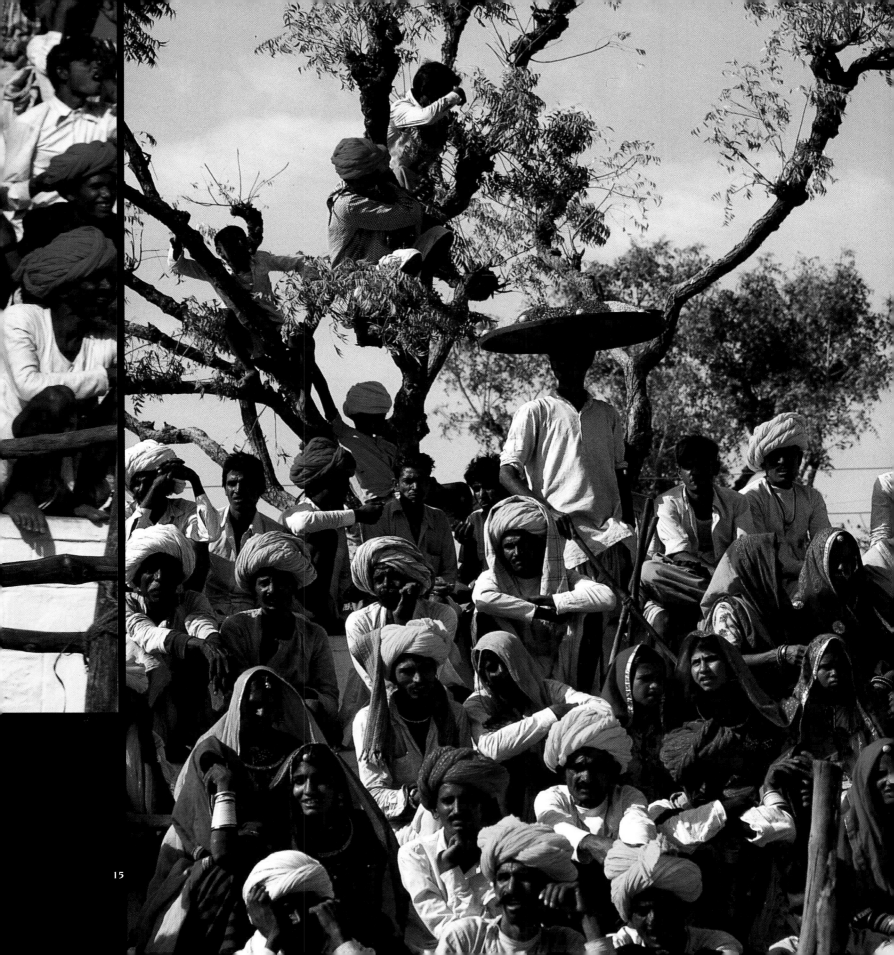

15

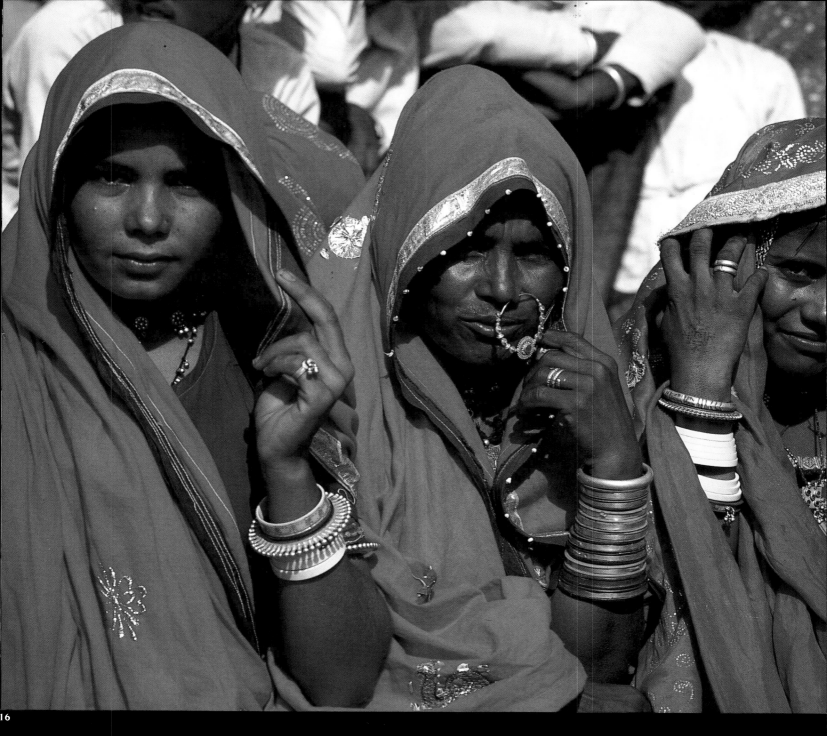

Women of Rajasthan from all the ethnic groups and the tribes,
also make for enthusiastic participants in the festival,

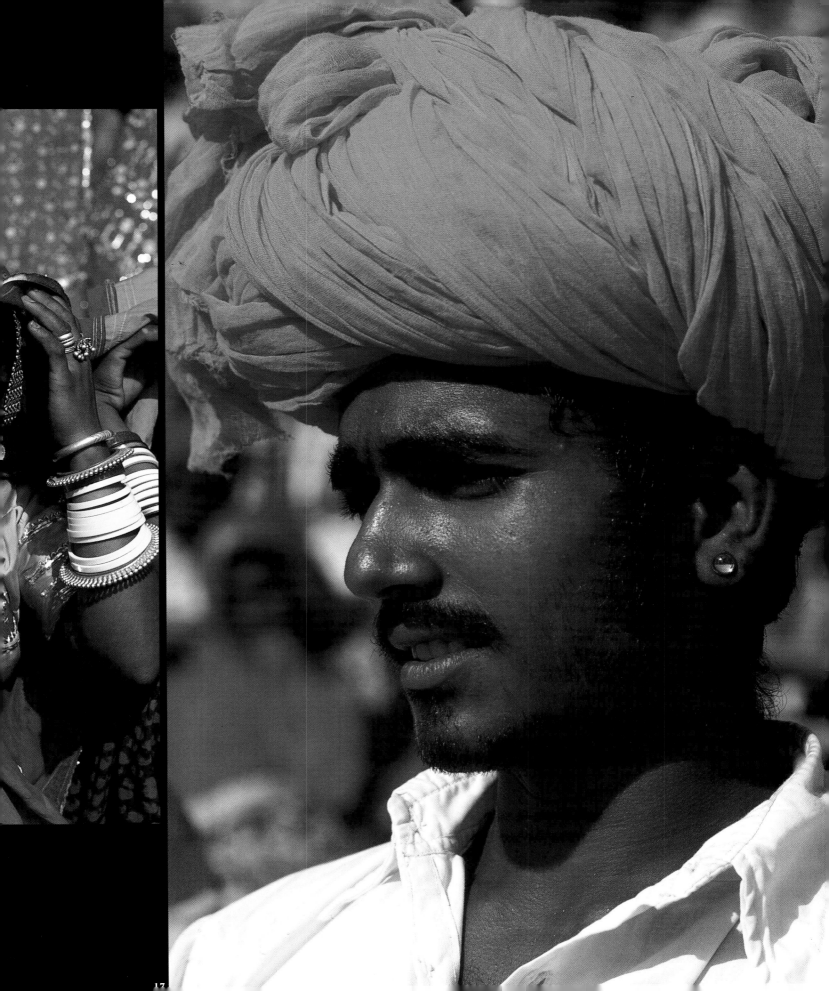

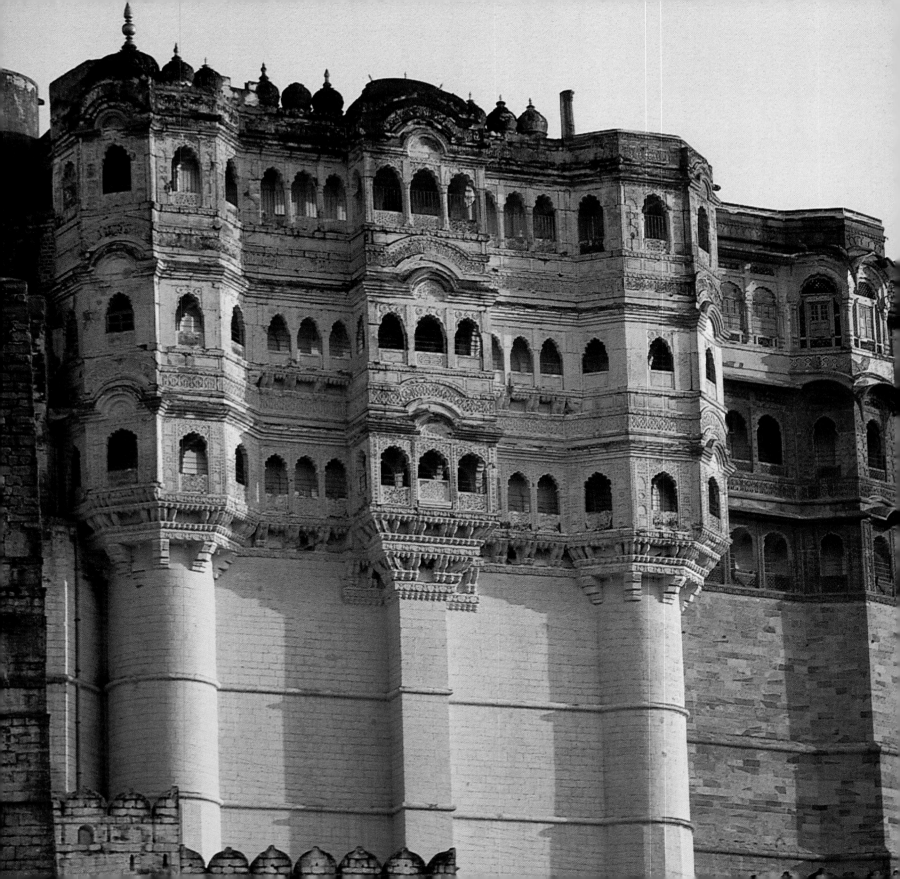

This imposing Meherangarh fortress of Jodhpur was founded in the fifteenth century. Standing on the edge of the desert, it defended the interiors of the city. And walls that are more than seven-kilometre long and six-metre high, with seven gates surround the city itself. Converted to a museum, the fortress is now home to music festivals wherein the shehnai (a kind of oboe) has a primary role to play.

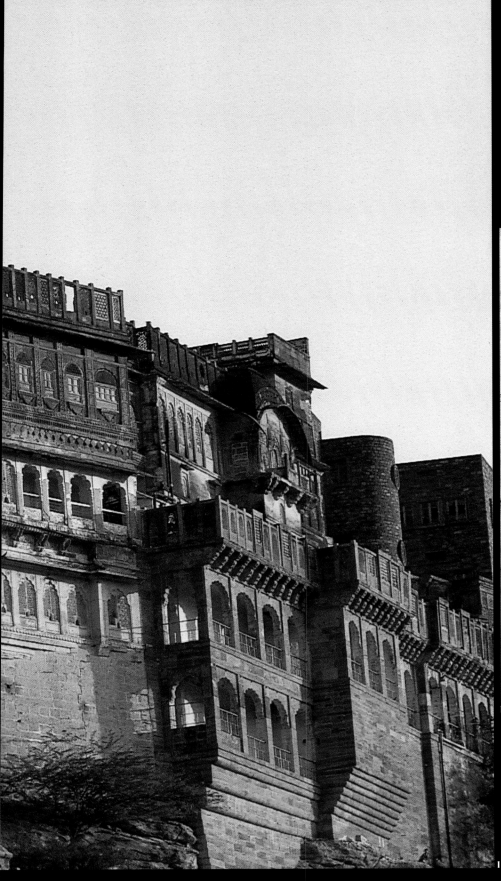

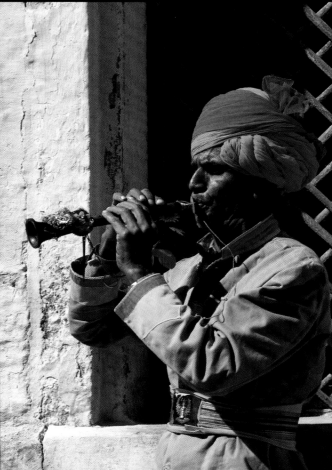

19

18

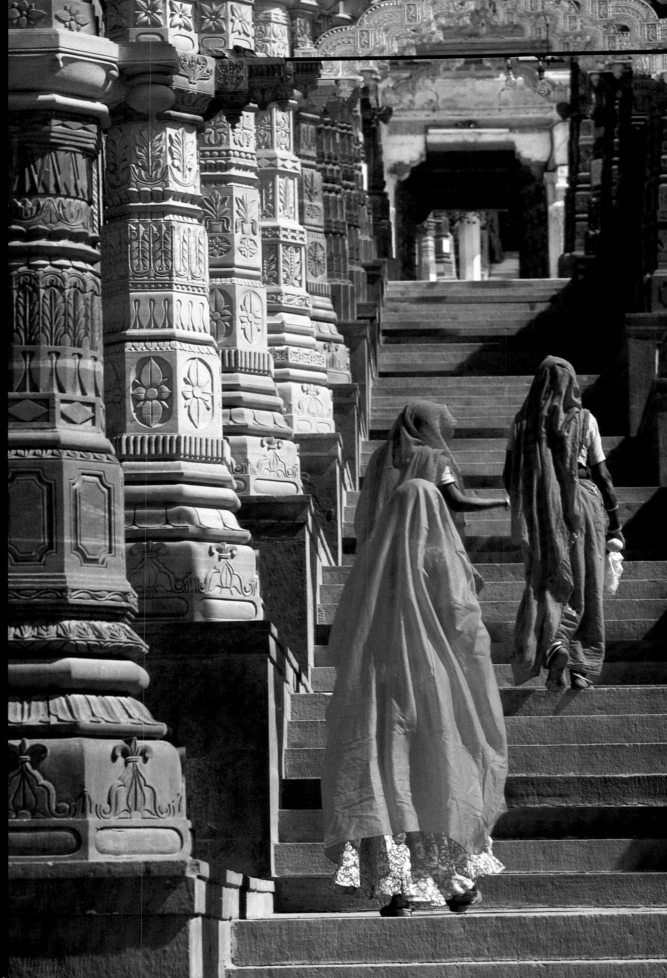

Almost all the cities in Rajasthan have a sprawl of palaces and temples that are truly remarkable for their decor, like this stained glass window from the Bikaner fortress; or this magnificent colonnade decorating a stairway leading to one of the 23 Hindu and Jain temples in the fortress city.

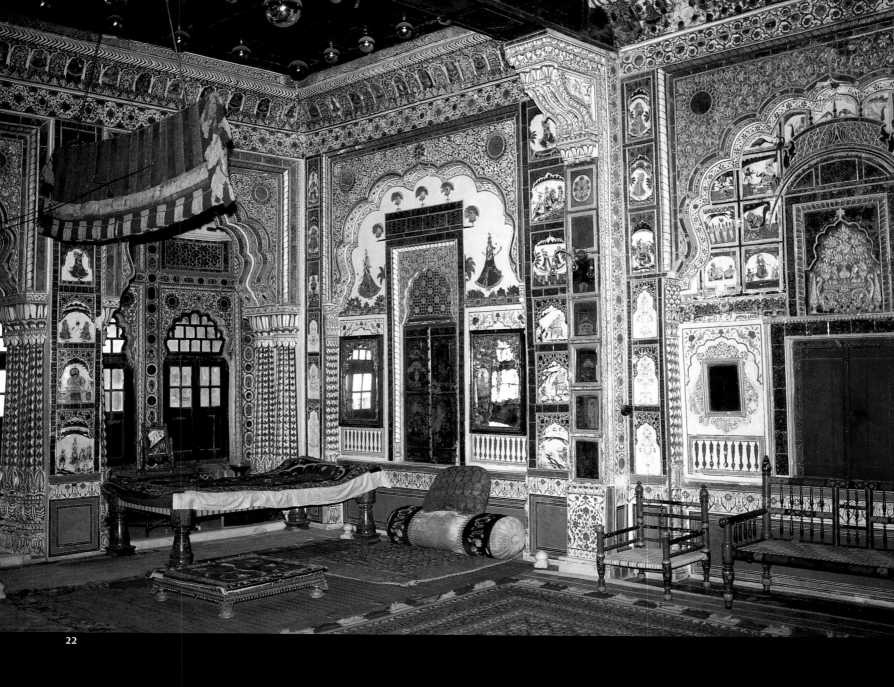

22

Obviously, the palaces of Maharajas
are most ostentatiously done up, as this bedroom
of the ruler of Jodhpur; or this niche holding a statue of Ganesha,
the son of Shiva with an elephant head, found in one of the
walls of the royal palace in Bikaner.

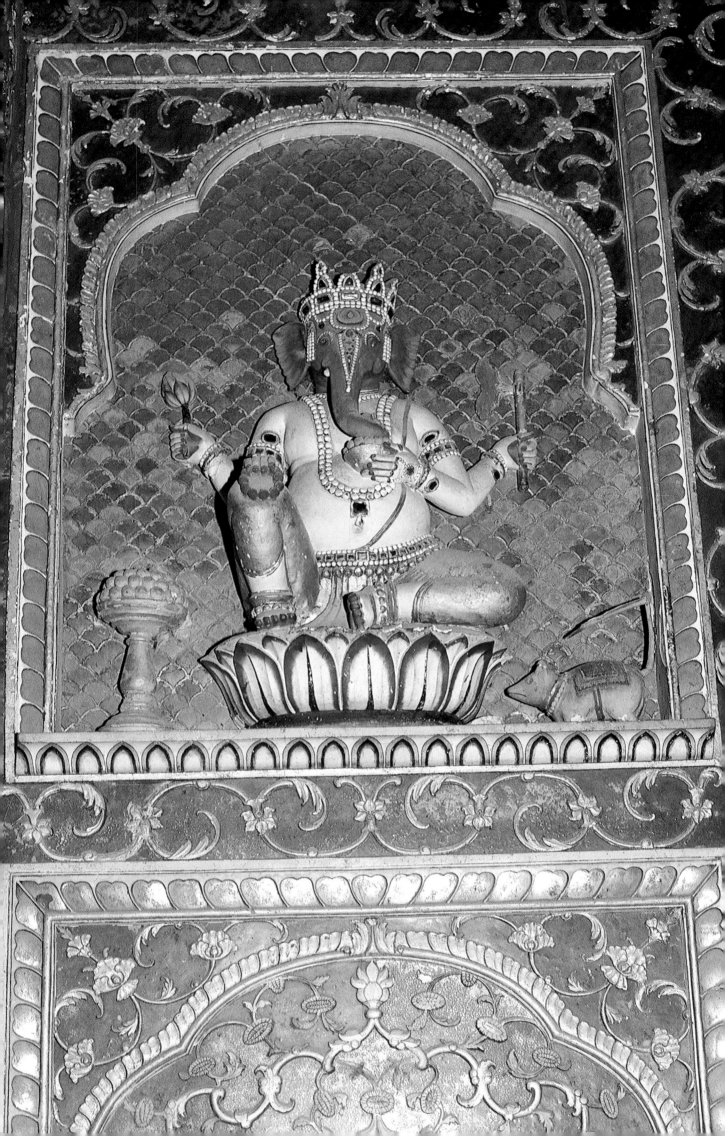

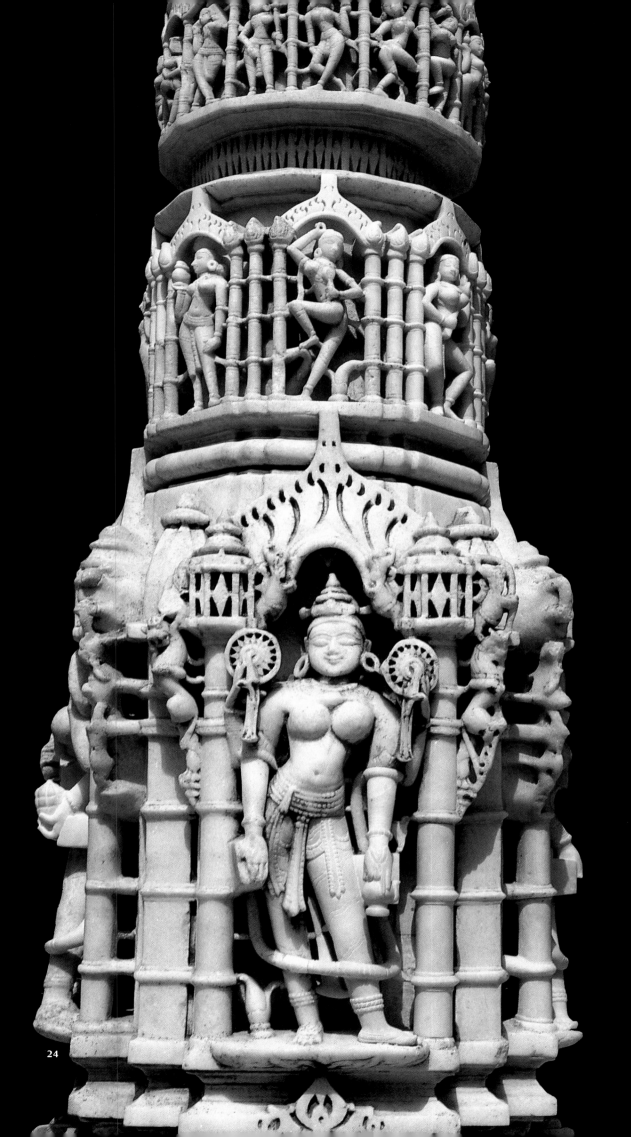

The site of Mount Abu holds several Jain temples (Dilwara) displaying amazing intricacy, like the Vimala Vasahi, built in 1031, by a minister of a local dynasty. It contains 48 white marble pillars, sculpted like lace.

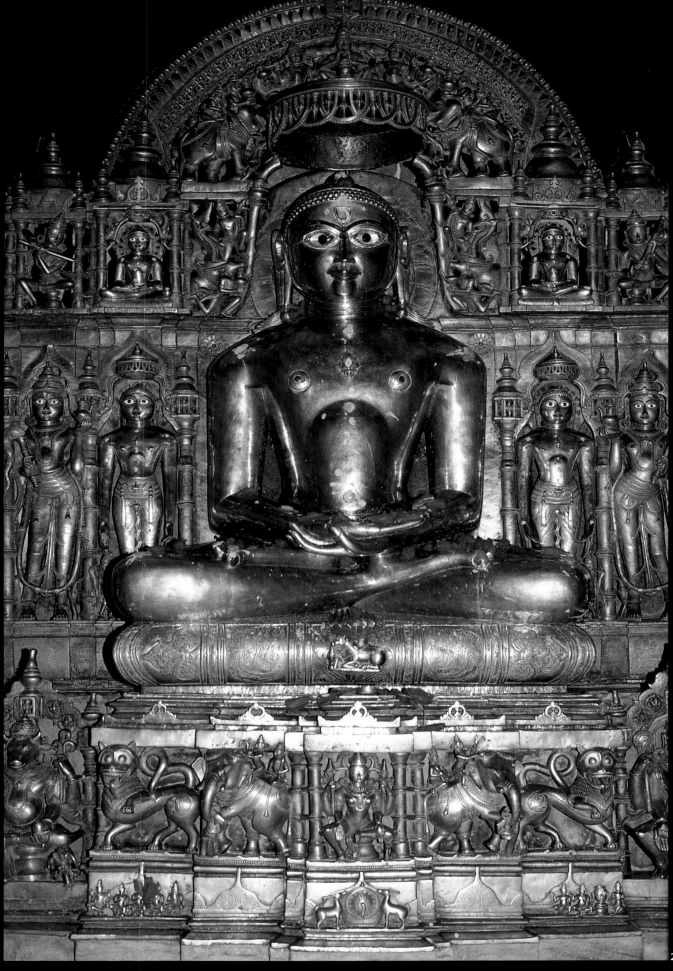

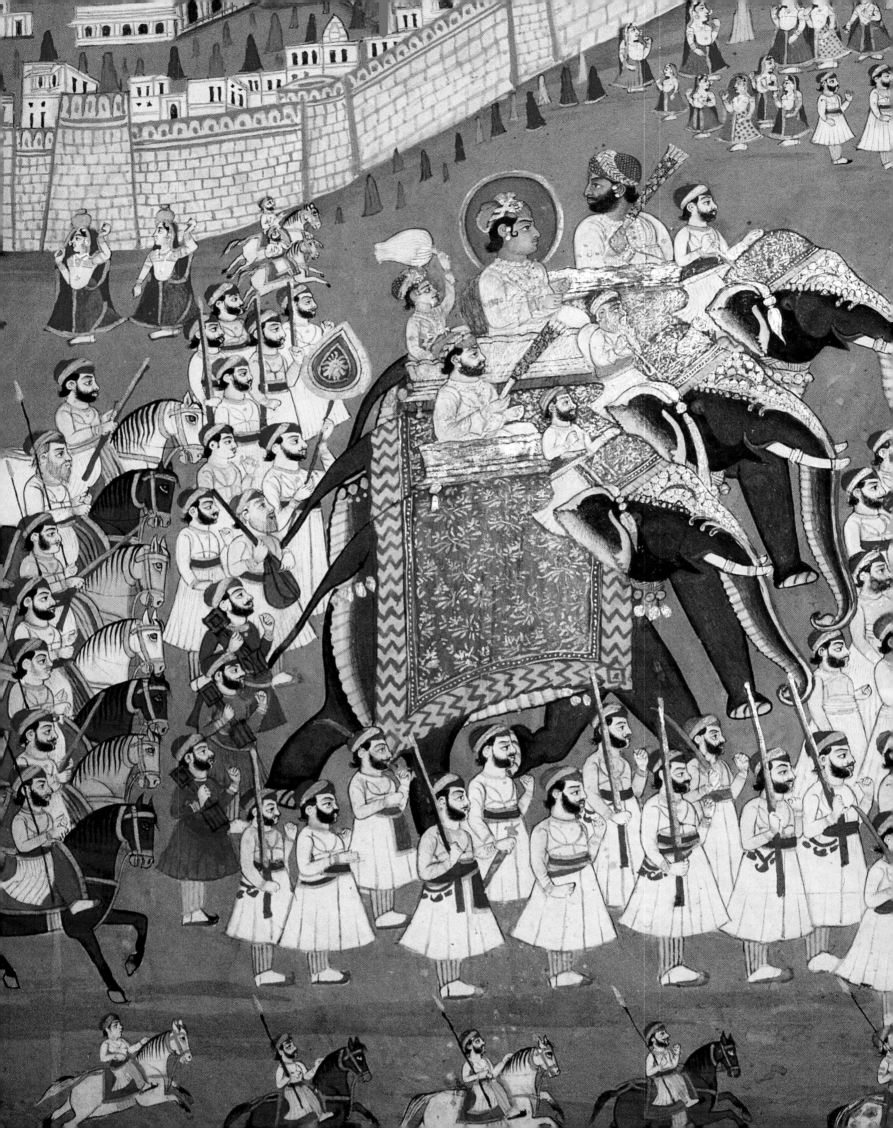

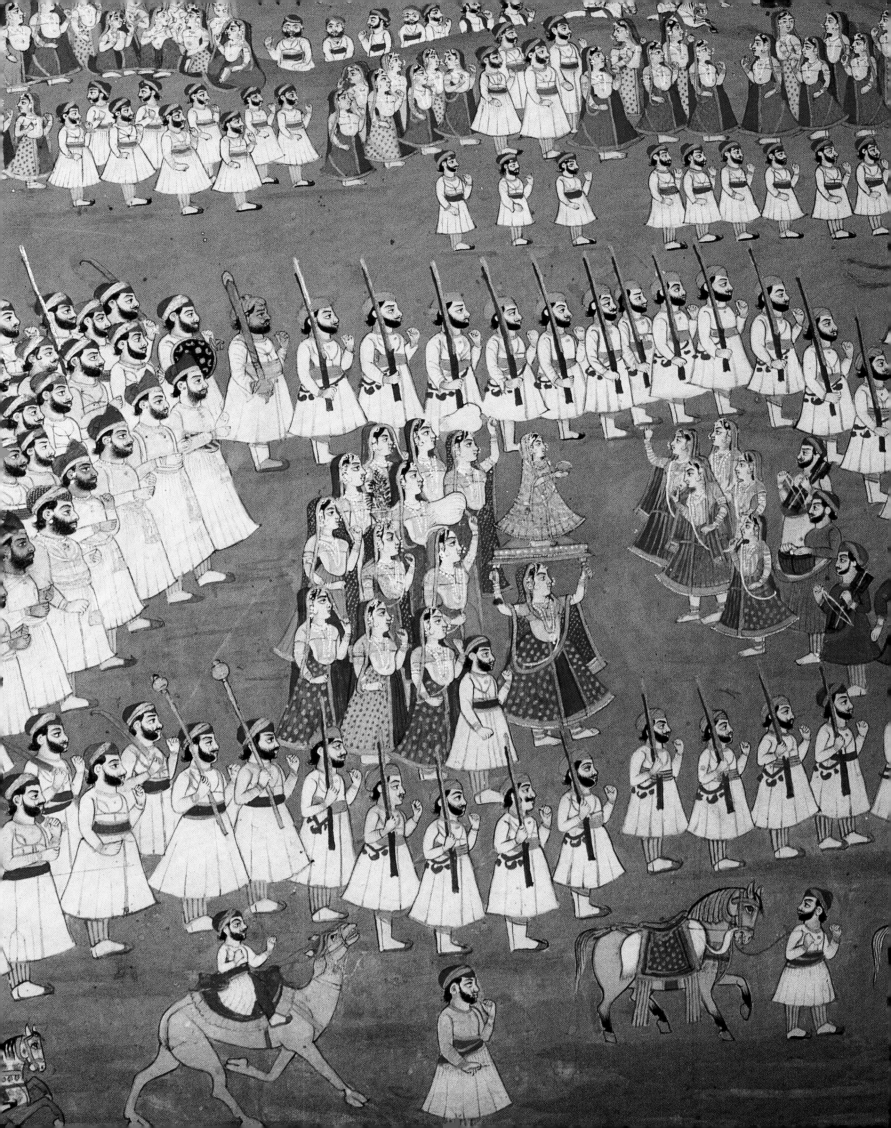

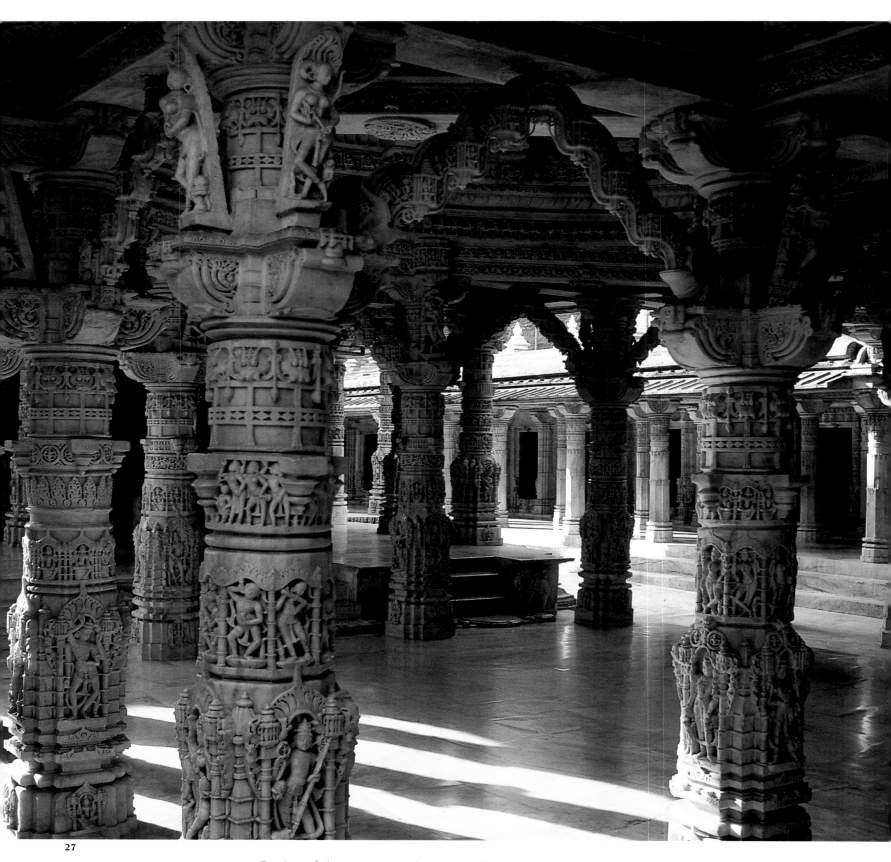

Portico of the entrance to the temple of Vimala Vasahi at Mount Abu,
with its many pillars of sculpted marble (27).

Statue of Jain Tirthankara in the temple of Tejapala and Vastupala
(also called Luna Vasahi) at Mount Abu (28).

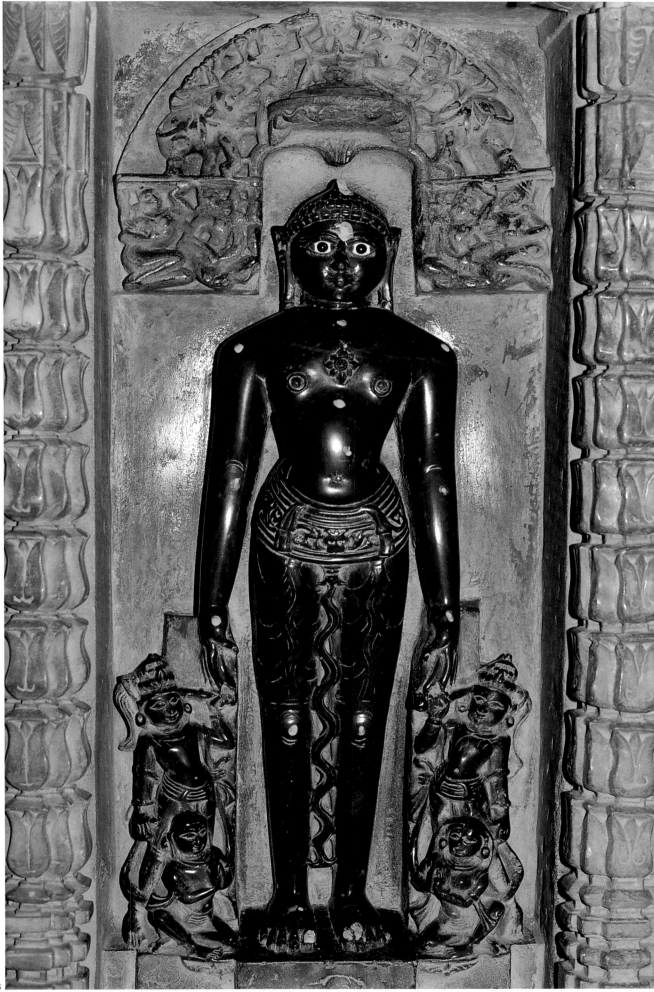

28

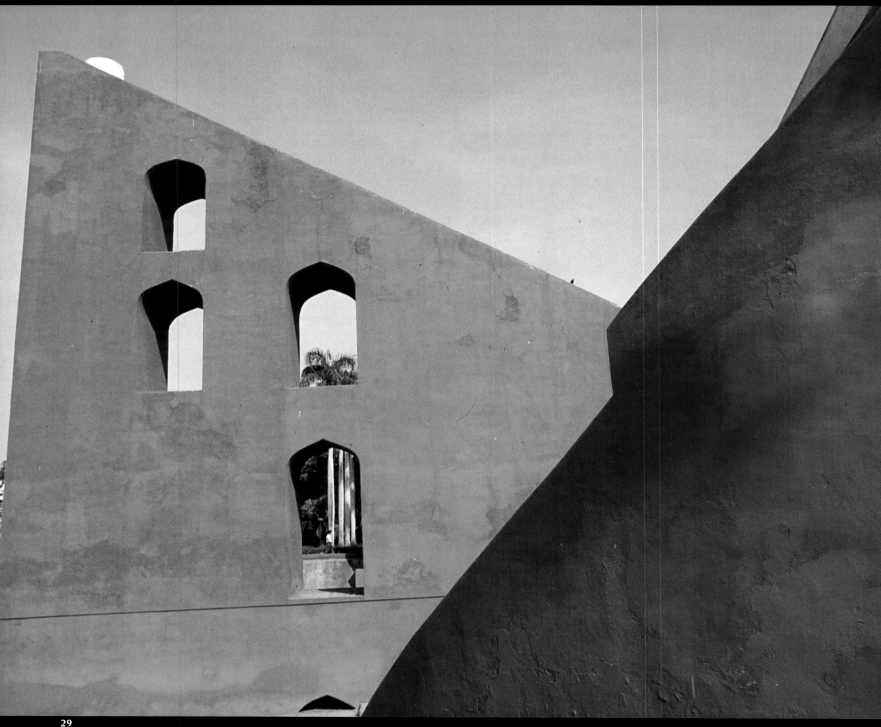

The Maharaja Jai Singh II of Jaipur, who reigned from 1699 to 1743, enjoyed enormous reputation as an astronomer. He invented numerous instruments (yantra) and got them built in cement, bricks and marble in five cities: Delhi, Varanasi, Jaipur, Ujjain and Mathura. Like this historic monument, Jantar Mantar in Delhi (above) and in Jaipur, his Capital (opposite), he used these instruments to study the movement of the stars and establish calendars.

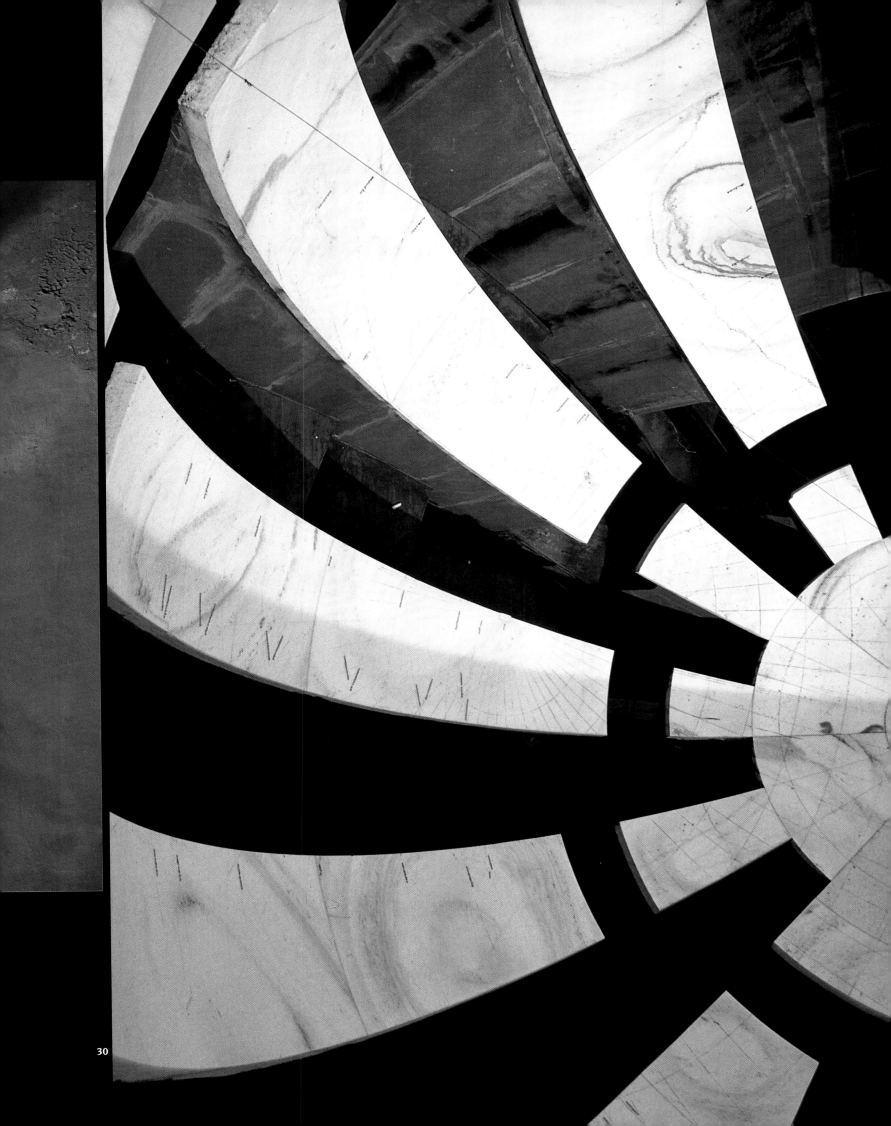

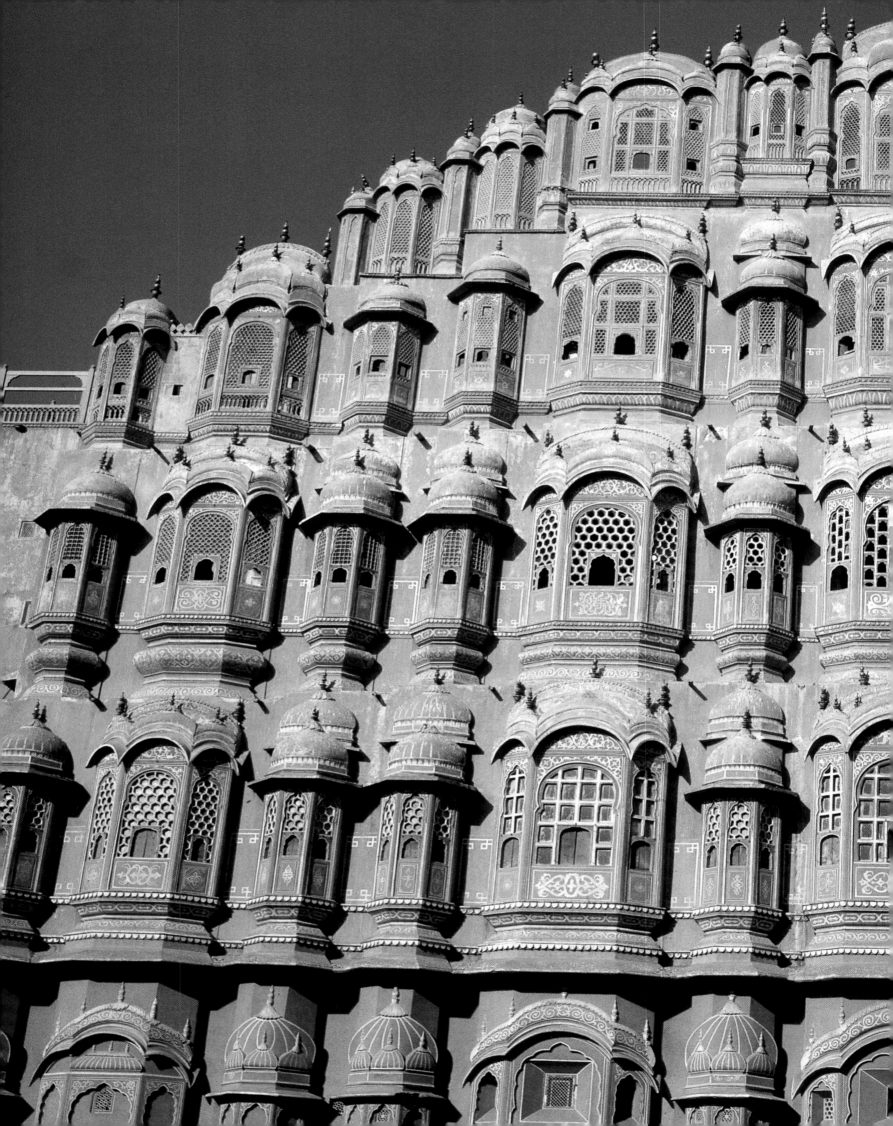

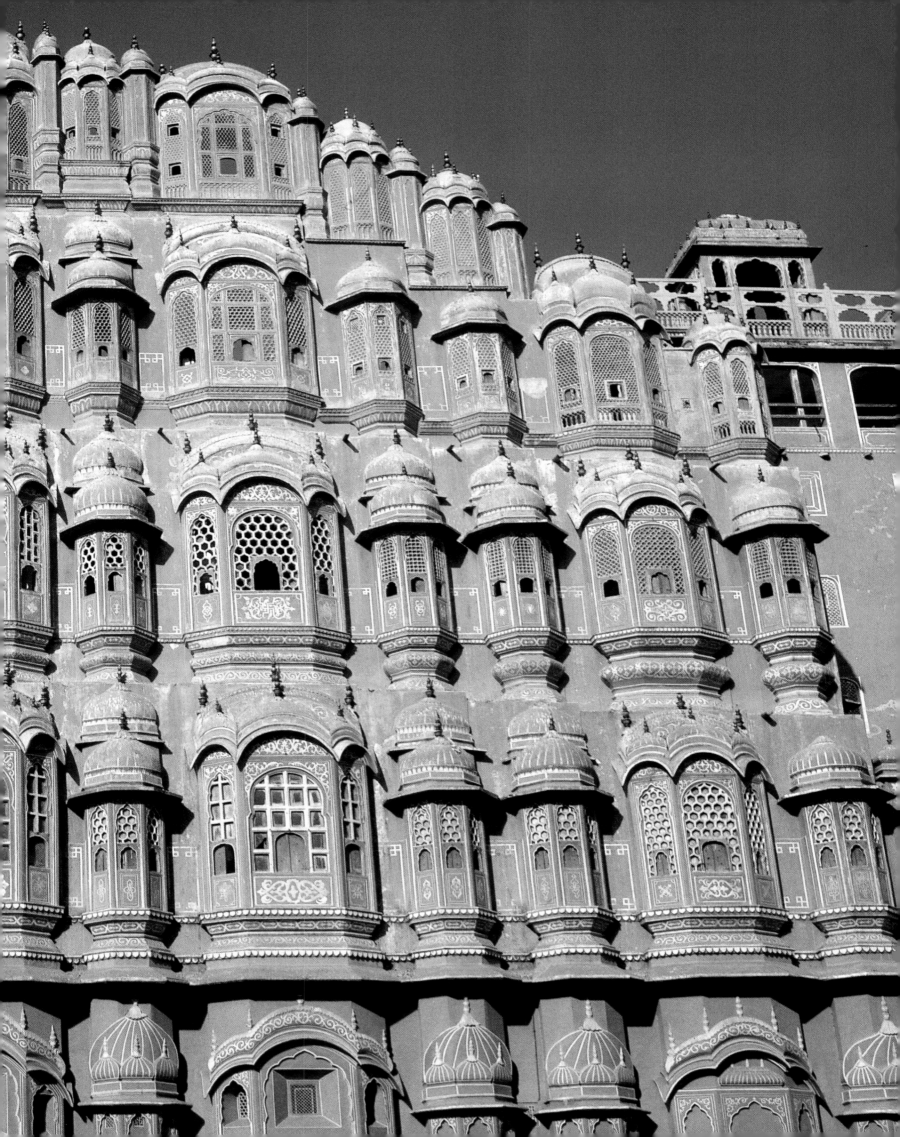

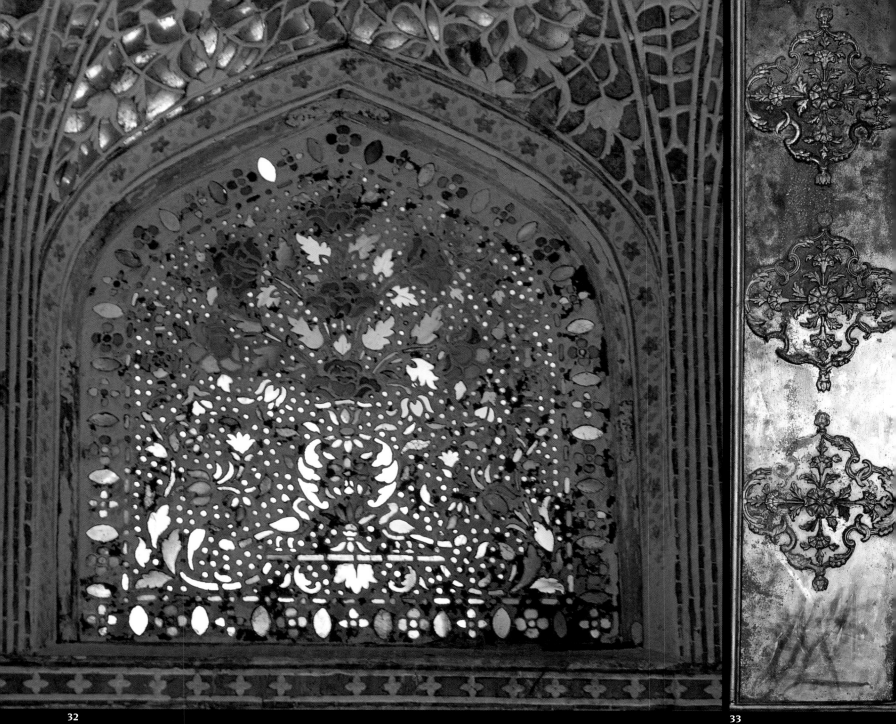

32

33

When the same Maharaja constructed an entirely
new Capital for himself at Jaipur,
the houses and palaces were painted salmon pink,
like this renowned façade of Hawa Mahal, the 'Palace of the Winds' (31)

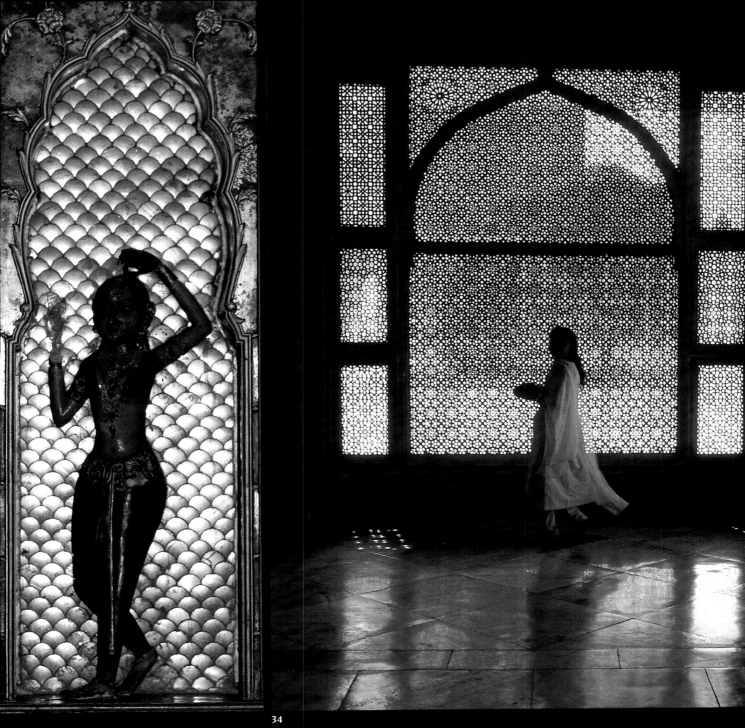

34

One of the walls in Diwan-i-Khas, the private audience room of
the royal palace of Amber, encrusted with coloured glass (32).

A panel of painted mirrors in the royal palace of Bikaner (33).

Made of white marble, this is the interior of the tomb of a holy Sufi,
Sheikh Salim Chishti (1480-1572), located in Fatehpur Sikri (34).

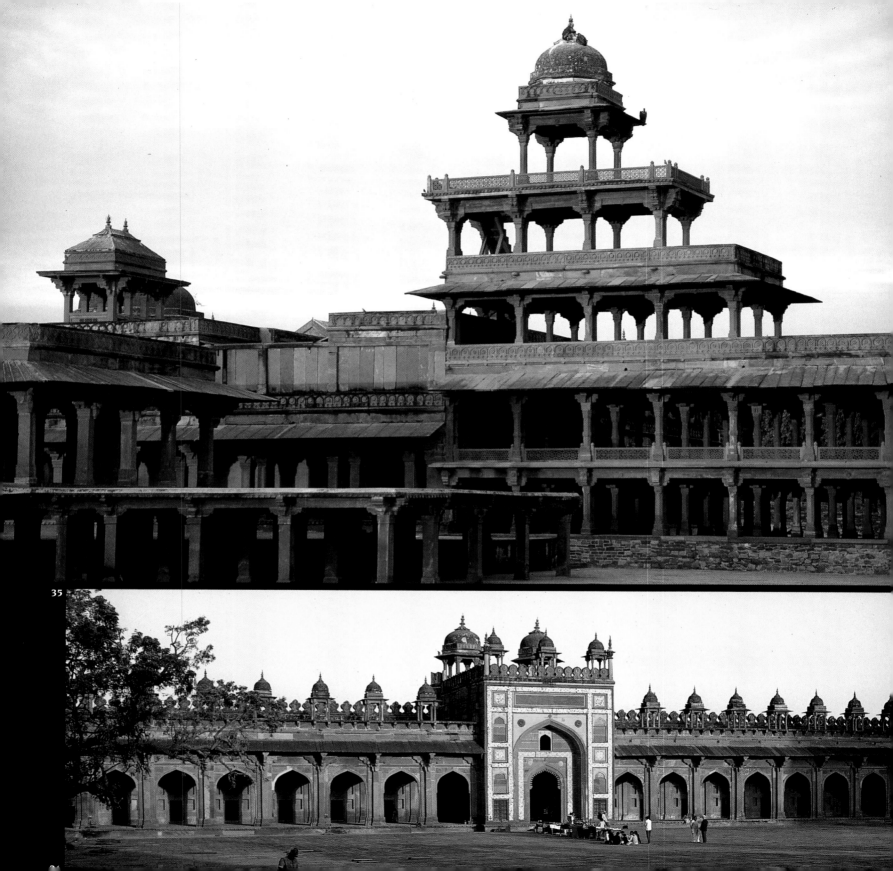

35

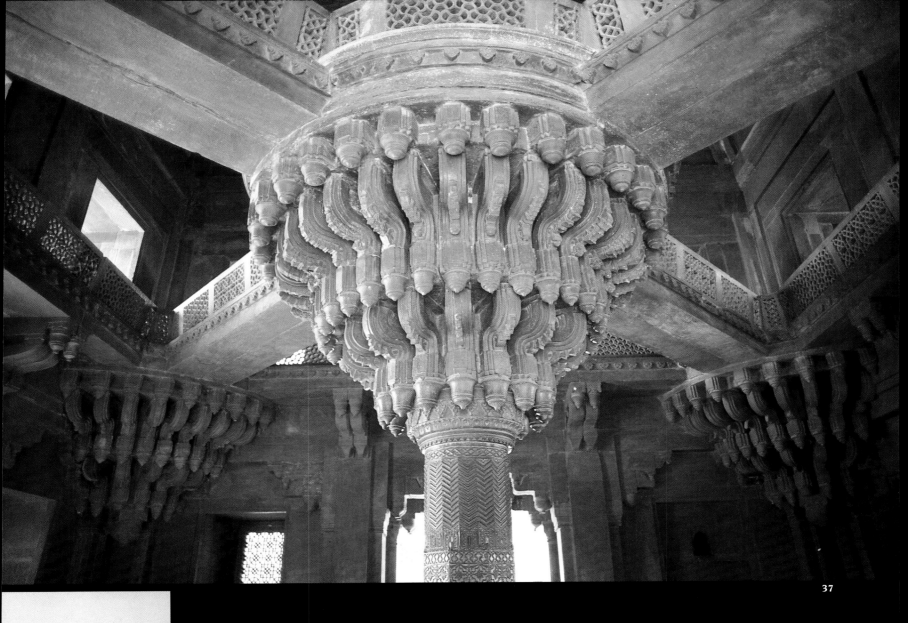

The Panch Mahal, perhaps an observatory, with its
176 sculpted columns (35).

The imperial city of Fatehpur Sikri, built south of
Agra by the Emperor Akbar in 1569, possesses
quite a number of monuments, including the great mosque
(Jama Masjid) built in 1572 (36).

Diwan-i-Khas, whose central pillar was
the Emperor's throne (37).

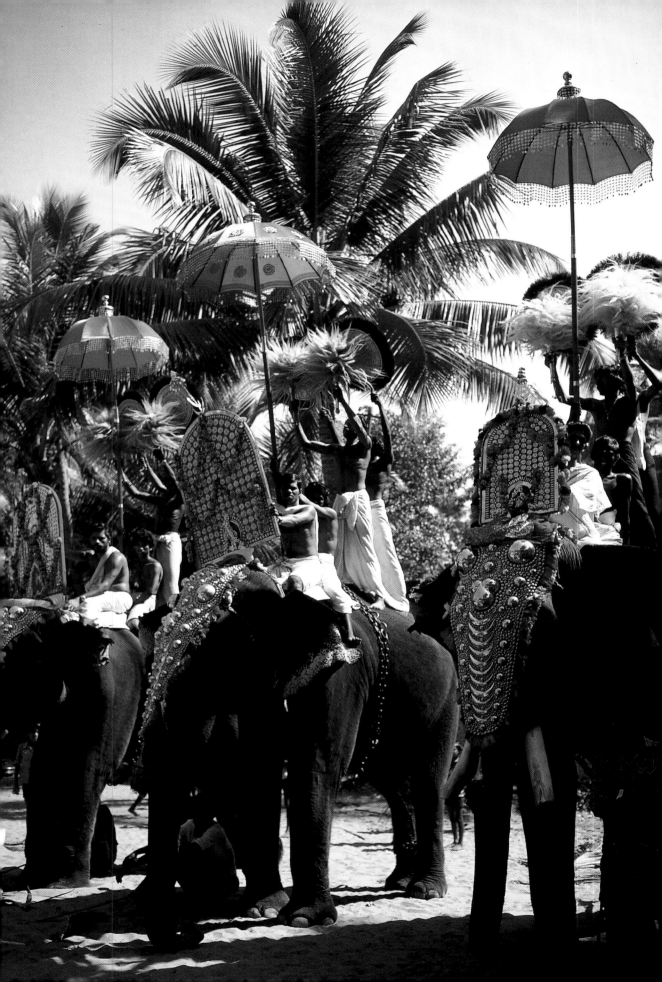

THE LUMINOUS INDIA

*Just as certain parts of the body are purer than others,
so are certain places on earth more sacred than others;
be it given their location or maybe the water is pure;
or perhaps because they were sanctified by the presence of holy men.*

Mahabharata (Anushasana-parva, Chapter 108)

Few countries in the world would be having as many celebrations each year, as the phenomenal number of events in India. Almost all these festivities are religious, even though the modern state of India instituted many a civil celebration, the most spectacular being the Republic Day on January 26. In New Delhi, the Capital, this is the occasion of a grand parade, wherein both the defence personnel and civilians participate alike, and all the ethnic groups of India are avidly represented. The colourful pageants from all the states include cultural performances typical of each region. It ends with a splendid display in the skies by the air force and all the significant buildings in the city are illuminated. A day later, live bands of all the three forces orchestrate a musical evening, 'Beating Retreat' and draw the curtains. But as it happens in today's modern world, in general, these festivities draw crowds more because of fun and curiosity and spend a holiday than nationalist fervour. They would much rather focus on their own traditional celebrations, those that they have nurtured and sustained over generations and celebrated for centuries. And these draw mammoth crowds of followers of one deity or the other.

Though these Indian celebrations are countless, all the same, the authorities officially recognize the number to over four hundred. Among these, Hindu celebrations score above all else, followed by Muslim holidays, Jain celebrations, Parsi festivals and those of the Sikhs and the Christians. So do the tribal celebrations take place right through the year. But in real terms, it seems unknown as to how many there are in all, without, of course, taking the family and local celebrations into consideration. Not a single day passes in this vast subcontinent, when some festival in one region or another is not taking place. Resounding music, bright neon lights, and banquets, which although not always too elaborate, always delight the hearts and palates of participants. The chaotic noise is all-pervading, amplified by loudspeakers perched, like screeching birds in trees, on rooftops and telegraph poles with a deafening volume. And the rest is complemented by clashing cymbals, shrill strains from oboes, rolling drums, exploding fire-crackers. Even the slightest of an event becomes a pretext for a celebration and everyday could be a holiday in the Indian streets.

It becomes a perfect occasion for men to have a shave and put on a sparkling new dhoti, a new lungi, or a new pair of trousers. And the women cull out their most radiant saris from the closets and the young women don jewels and heavy make-up to attract the attention of their men. This is true at least for Hindu celebrations, because Muslim women rarely take part in ceremonies, as these are almost always

exclusively the preserve of men. Hindu, Jain, Buddhist, Parsi and Christian celebrations always take place on dates fixed by the calendars of each of these religions. Only Muslim celebrations vary in their dates from year to year, since they are believed to be based on lunar calendar.

It hardly comes as a surprise that an infinite number of religious sects exist in a country with a population of inhabitants that has touched one billion. More than 17 official languages and more than 800 dialects or regional languages are spoken, wherein ethnic groups are counted in hundreds and castes and sub-castes run in thousands. The number of their celebrations is equally infinite. All this gaiety gives the impression that India is perpetually celebrating right through the year. Often several celebrations are in progress at the same time, sometimes in the same city but more often in different locales of the same region.

And one thing is indisputable — consultation of an astrologer before holding any ceremony in the family — be it celebrating a birth, a christening, the coming of age or a wedding. None of these events would take place unless an astrologer has pronounced the best hour and day for these events. Especially, before any matrimonial ties, a pundit is always consulted to assure the families that the celestial stars that determine the destiny of the future couple would not create a conflict. In the Indian context, the cosmos of stars, the planets, or the gods, is a permanent fixture in the lives of individuals just as it is in their communities. Thus seeking an astrological protection, an Indian, as per his caste and social status, fears nothing, being assured of the best possible life both in the material and spiritual world.

In March and April (*Phalguna* and *Chaitra*), the religious year commences with great fervour celebrating the joys of spring. As it symbolizes renewal of life; the time when the sap rises and the trees put forth their buds, naturally both human beings and animals alike feel a growing desire in their veins to procreate. During the initial days of the solar New Year, without any discrimination or distinction, every one revels in collective song and dance and making merry. In Rajasthan especially, the goddess Gauri is commemorated, the consort of Lord Shiva, who's revered as the deity of abundance. Wooden icons of Shiva and Gauri are carried in processions and bathed in the waters of lakes.

In the month of *Phalguna*, during the full moon in spring equinox, people are ecstatic and their extreme joy reaches a crescendo and literally explodes, especially in the north of India, during that festival of colour — Holi. The festivities even prolong for a week, and more so in Mathura, as in all other places attributed to Krishna, men and women laughingly douse each other with giant syringes and even buckets full that shower red, green or orange-coloured water and sprinkle gold-coloured powder. All the folks are seen everywhere in white attire, worn especially for this occasion, to ensure that multi-coloured spots become all visible. Perhaps, only foreign tourists, who may not have been warned well in advance, fail to appreciate the custom on finding themselves showered with coloured water. However, if feeling threatened by a red or green shower, they can avoid being made to look like parrots by gifting something to these children who, delirious about their windfall, would quickly abscond looking for another 'victim'. Factually speaking, this ritual is not really religious in the strict Hindu sense, but probably a relic from tribal customs; or perhaps it emanates from a cult devoted to fertility with the red colour most likely symbolizing both the renewal of blood in the veins, and the harbinger of spring, the season of love. Also, at this time of the year in the south of India, the Ashoka trees are in full bloom. The red flowers of this tree are believed to evoke Kama, the god of carnal love; and the rice fields reverberate with ardent songs of the peasants,

who seem to make coarse jokes during this season. At the end of this long-stretched phase of Holi, wheat flour cakes, *poli*, are burned in hope that the next crop, fertilized by this sacrifice, would be as bountiful.

And on the ninth day of the month of *Chaitra*, the most anticipated celebration in India takes place, at least for the followers of Vishnu and Rama. This is the time they celebrate the birthday of legendary Lord Rama, the King of Ayodhya, whose exploits, known to everyone, are recounted in the great epic, *Ramayana*. These verses are attributed to poet Valmiki of the first century AD. Rama is believed to be the ninth incarnation of Vishnu. After many a travails, following his forced exile, Rama went through the sheer agony of his wife Sita beguiled and kidnapped by a ten-headed Demon-King Ravana. Nevertheless, he managed to discover Ravana's lair with able assistance of his brother Lakshmana, and later with the amazing feats of a tribe of monkeys, whose army was led by Hanuman. Situated on a coastal island in the walled city of Lanka, Rama beleaguered this ogre's island, by building a pathway aided by these agile animals. As the conflict resolved, but only after a fantastic battle wherein some celestial weapons won the day and Rama killed Ravana, and miraculously rescued his wife, saving her from being burned at the stake, and brought her in a flying chariot to Ayodhya. Back in his kingdom, another of his brothers, Bharata, was eagerly waiting to return him the symbols of power — Rama's own wooden slippers.

The epic *Ramayana* contains 48,000 verses, each comprising sixteen lines, This is a fabulous love story that also recounts a quest that was bound to lead to the union of *jiva*, the individual soul represented by Sita, and the universal soul, symbolized by Rama-Vishnu. And some social historians also perceive it as symbolizing the conquest of southern India by the Indo-Iranian tribal leaders around the seventh century.

While in Varanasi, holy Benares, celebrations of such tremendous magnitude venerate Vishnu, even though the city is essentially dedicated to Shiva. And from his palace in Ramnagara, located on the opposite bank of the Ganges, the Maharaja himself makes a regal appearance atop an elephant that is ostentatiously draped in parade trappings. His Royal Highness flags off the festivities, watches the shows, and, finally, partakes in a ritual celebrated by the Brahmins, in particular, in the middle of the day. They solemnly break open a coconut to symbolize the birth of the hero. The streets of Varanasi and Ramnagara are milling with huge crowds as the processions of actor-heroes of *Ramayana* find it hard making their way through the sea of people, as does the Maharaja and his procession of royal elephants. The devotees rush, push and shove in a bid to touch the actors' clothes or have a *darshan*, a glimpse of the icon of that Almighty, who they believe, might bring them some piety, solace, happiness or wealth. On the day of the full moon during this sacred month, the followers of Vishnu also commemorate the birth of Hanuman, the monkey-hero of *Ramayana*. During Hanuman Jayanti, they cover the deity's statues with gold powder and red paint and decorate them with neon lights in such strikingly bright colours, and offer flowers and fruits. All these rituals are performed in the midst of deafening din, which is believed to drive away the demons and evil spirits and draw the deity's attentions to its devotees.

In the south of India, in the land of the Tamils, it is the great 'marriage' of Shiva and his consort Meenakshi 'with eyes like fish', that is solemnized in the great temple-city of Madurai, built between 1560 and 1680, dedicated to yet another form of Shiva, Sundareshwara, the 'Lord of Beauty'. In this ten-day festival, day after day, the processions of the deities add to the fervour of the devotees. The

statue of Shiva-Sundareshwara is piously carried from its own sanctuary to that of Meenakshi, and then finally brought back to its original sanctum.

As the resonant sounds of music fill up the air, the followers display enormous faith escorting these sacred pictures and statues; and they keep offering balls of ghee even while moving on. Ghee is a kind of vegetable butter when added to a burning lamp renders a rather dark tint to the statues and that is supposed to bring good fortune to the faithful. And when the procession is over, music and dance performances are presented in many a pavilion of this massive religious complex, which glows in the light of thousands of oil lamps. This ardour for celebrations seems to calm down in the months of June and July, given the oppressive heat. But the next round of festivities hardly takes long to take off again. It's an encore, this time in Puri, in Orissa, with the annual ritual of *Rathayatra*, 'Procession of Floats'. This celebration is a tribute to Lord Jagannatha (another incarnation of Lord Vishnu), His elder brother Balram and His sister Subhadra. The festival follows the full moon in the month of *Jyeshtha* (June), to celebrate this *Snana Yatra*, 'Procession of the Bath' of the deities.

Rathayatra is such an elaborate ceremony carried over days, drawing unbelievable, phenomenal crowds, perhaps unthinkable in any other country except India. During the second day of the new moon in the month of *Ashadha* (July), Brahmins bring three statues of the deities out of their sanctuaries, that are placed on huge, carved wooden floats (the centrepiece measuring 15-metre in height, weighing several dozen tons and mounted on 16 wooden wheels, that precisely measure two-and-a-half-metre in diameter). While priests and musicians are atop this float, the pilgrims harness themselves to long ropes attached to these floats and amidst loud chants and cheers pull them along the main street of the city. This

journey brings the deities to Gundicha Mandir, the 'summer temple', dedicated to Lakshmi, the consort of Vishnu. The statues are put up for a week in this temple, located about a kilometre-and-a-half away and thereafter brought back to the main temple, Shri Mandir, in a similar procession the way they were taken away. This 'divine trip' is conducted to commemorate Lord Krishna's trip from his native village of Gokula all the way to the city of Mathura. And once these floats have served their purpose, they are taken apart and cut into little pieces, which are then distributed among the pilgrims, who give a small sum in exchange as an offering. But once again, these floats would be rebuilt and sculpted for the great expectation of next year's festive augmentation. And these countless devotees of teeming thousands, who pulled the floats, are rewarded with the produce grown on land belonging to the temple — this blessing is eagerly awaited.

At the end of it all, nothing can recreate the fantastic atmosphere that prevails during the passage of these floats — it's nothing short of being ethereal. Even the sunrays are unable to penetrate the dust being raised by countless feet treading the path. With the music blaring at such a decibel level and the crowds chanting "*Om! Namaskara Bhagavan Vasudeva!*" (Hail Lord Vishnu!), it creates an ear-splitting cacophony. But the devotees in absolute frenzy jostle and press in to help those pulling such monumental floats. Drums roll and fifes and oboes wail, all the while amplified by loudspeakers. In this melee of never-ending pushing and shoving, as the air becomes saturated with dust and sweat, it gets a bit hard to breathe. It is but natural that the ropes cut into the shoulders of those pulling these massive floats and blood, sweat and dust make for a peculiar mix on the streets. At times, one of those pulling the float, even stumbles with exhaustion, and could be crushed by those large wheels of the float. So, he's immediately replaced by another to carry on

uninterruptedly. It is said that in the past, many a devotee volunteered to seek death by letting themselves be killed in this way, with a belief that it would build a passage to paradise. With changing times, such incidents are rare indeed and the followers simply go and wash their wounds in the nearby sea. But before pulling the floats, it's mandatory that they take ritual baths in the five sacred places surrounding the city, and then pray to Lord Vishnu.

Once the celebrations are over, some of the pilgrims tread through the sandy beaches and pay a visit to admire the wondrous temple of Konarak. But this is more owing to the appreciation of sculpted, architectural beauty than devotion. Way back in 1241, a nobleman had dedicated this temple to the sun in the hope of being cured of leprosy. The tower that once stood 70-metre high, now lies crumbled. As it is stated in the *Brahma Purana*: "Over the pleasant and sacred sands of this lovely country lives the Sun God, of a thousand rays, known by the name of Konaditya. He who gives out joy and liberation."

Almost around the same period, the fifth day of the month of *Shravana* (August), snakes are worshipped during *Naga Panchami*. These snakes represent the powers of the Chthonians, the Naga, related to cobras. Observed primarily in Rajasthan and in the south of India, this celebration essentially comprises offering milk and honey to the sacred snakes of the temples, or to those snakes that the peasants in the west of India keep in their homes to protect them from rodents. On this day, those who till the soil do not work, out of sheer reverence not to disturb the Naga, for soil is their abode and exclusive realm.

Just three days later, especially in Mathura and surrounding villages, followers of Lord Krishna commemorate His Birth with a festival, *Janmashtami*. All over again, massive crowds visit the temples and ensure that they attend the ritual bathing of the deity's statues. Once

more it's time for adolescents and adults alike to sing, dance and perform theatre. These plays are fascinating, enacting episodes and anecdotes to illustrate the lovable though innocently wicked exploits of baby Krishna.

On the other hand, Rajasthan becomes privy to the great celebration of *Teej*, the harvest. Women celebrate by attaching swings to the trees. As they swing back and forth amidst laughter and squeals of joy, they also express a sense of freedom to live it up. And they make a bid to imitate the course of the sun in the sky creating paths made by these rustic swings (*andolaka*), their ropes adorned with flowers, thus paying obeisance to this star that ripens the grain. In Jaipur, Parvati, the mountain-dwelling consort of Shiva, is venerated on this occasion. The women devotees of the goddess are draped in a red sari, while men can be seen in their enormous red turbans.

On the day of the full moon (*Narali Purnima*), in the month of *Shravana*, Indians of all castes and communities celebrate the end of the monsoons, which at times may go well beyond this calendar. On this occasion, especially the followers of Shiva, throw coconuts into the sea paying homage to Varuna, the god of the waters. As a result, the beaches of the entire peninsula are crowded with entire families in tow, and the waves are covered with thousands of floating coconuts, which would soon begin to slowly rot on the sands. This is also the time to celebrate *Rakshabandhan* and sisters tie red silken threads and amulets (*rakhi*) around their brothers' wrists, a symbol of gratitude as women seek the protection and benevolence of their brothers. At the same time, the *Dvija*, 'twice born', that is, members of the three upper castes, exchange their old sacred threads (*upanayna*) for new ones in cotton, especially spun for the occasion.

Thereafter follows the month of *Bhadra* (September), and that too is brimming with a plethora of celebrations. And one of the most

significant festivals is that of *Ganesha Chaturthi*, which takes place especially in the state of Maharashtra, in Mumbai (Bombay) in particular, and also in the state of Tamil Nadu, in Chennai (Madras) in particular, where the devotees worship the son of Lord Shiva, Ganesha, who has the head of an elephant. Clay statues of Ganesha, painted and embellished by the local artisans, as well as statues of other deities in the Hindu pantheon, are avidly bought up by individuals to hail good fortune. These icons are carried home in palanquin and offered lights, flowers and fruits for a week. And on the fourth day of the month, the statues are again carried in palanquin, this time to the seaside or a riverbank, where they are placed on the ground and offered lights and flowers one last time. All the while, drums are rolling and fifes are playing. As the sun begins to slide in these waters, so do the priests gather all the statues and submerge them into the rippling waves, and they disappear in no time. Only the wreaths of flowers that garlanded the statues are left floating on the waters. Following a certain belief, on this night, not a single devotee would dare look at the moon, as it might bring in bad luck.

In the following month of *Ashwin* (October), *Durga Puja*, the 'Veneration of Durga', takes place all over India. This celebration culminates on the tenth day, *Dussehra*, at the end of a nine-night period, *Navaratri*, marking the end of the monsoons. Durga, 'The Inaccessible' goddess, is also another incarnation of Parvati, Shiva's consort, as she is venerated as the wife of Shiva and Vishnu at the same time. She marks *Shakti*, the symbol of noble power, astride a tiger fighting the terrible buffalo-demon Mahishasura. In West Bengal, she is associated with Kali, the more demanding 'Black Goddess'. But her most spectacular festival takes place in Mysore, in Karnataka, where the Maharaja's palace is flooded with lights from thousands of electric bulbs. Each night, during the *Navaratri*,

devotees of the select of *Shakta* (those who worship *Shakti* or divine consort) venerate a young girl 'in good health, gracious and beautiful', who incarnates one of the nine forms of the goddess.

This is also the time to commence the celebration of *Rama Lila*, playing the saga of Rama's lifespan that reaches its climax at the mid-hour on the ninth day. Various groups of youngsters, all made-up, donning period costumes enact characters from *Ramayana*, and dance while singing passages of the great poem before a large set of excited audience. Then on the tenth day, it's the finale amidst a mind-blowing crowd of spectators, as huge wooden and paper statues of the heroes of *Ramayana* are set ablaze, and fire-crackers, thundering drums and joyous screams make for a unique cacophony. This bonfire, consuming images of the great epic poem's heroes, signify a kind of revenge over the Indo-Iranians; for the epoch of *Ramayana* was for many of the Dravidians reminiscent of the conquest of southern India by invaders from the north. Also, by way of this fire, the Dravidians get to express their differences, laying due emphasis on other deities, mainly Shiva, which they venerate, since Vishnu-Rama is given far lesser importance in their beliefs.

In the era gone by, it was meant to be an auspicious day that the noblemen chose to go to war against their neighbours and conducted a ceremony to bless the weapons (*ayudha puja*) of their soldiers. In the modern times, as the Maharaja no longer performs the role of a warlord, he is merely content to lead the procession, perched atop an elaborately painted elephant, ornated with richly embroidered drapes. Accompanied by the drums of his guard, the erstwhile ruler goes outside the city and takes his place under an acacia tree, splits a gourd with his sword, thus symbolizing Durga's victory over the demon Mahishasura — the triumph of virtue over evil. And then his retreat to the palace

is hailed with fireworks. Every house which comes in the purview of the passage of this procession is so brightly illuminated. As the curtains are drawn on this final night of lights, dry popping fire-crackers, thundering music, and all sorts of delirious shouts and screams, last well up to the wee hours. This celebration, which is both royal and religious in its very component, is really unique by itself. Thousands of spectators from all the southern regions of India breathlessly await the most spectacular bonfire.

Of all the celebrations spread through the Indian calendar, perhaps the most universal of them all is *Deepawali*, more popularly known as *Diwali* — the festival of lights. It takes place from the twenty-seventh day of the month of *Ashwin* to the second of the month of *Kartika*, the end of October to the beginning of November. The week of festivities that marks *Diwali* is so very elaborate and ostentatious. All Hindus, irrespective of their caste or social status scrupulously observe this period. And those following the Vikrama calendar (beginning in 57 BC), it marks the beginning of the year. This is the most auspicious occasion, when Vishnu, Krishna and Lakshmi are worshipped alike, in private homes, shops, workshops, offices, and factories. Each and every building is lighted with neon tubes, wreaths of electric lights and even simple, earthen oil lamps. Affluent merchants in the west of India flaunt their riches with most striking light decorations and even donate alms to the less privileged. Whether it's the artisans, workers, or even intellectuals, they all venerate their work tools and offer them light, often that of a candle or an earthen oil lamp. These flames are the very symbol of enlightenment and renewal of life. In West Bengal, numerous statues of goddess Kali are made by skilled artisans. The devotees buy these statues of the goddess, who is avidly worshipped. Thereafter, the staunch believers parade these statues in processions, and finally submerge them in the waters of the Ganges.

The month of *Pausha* (December-January) too is dotted with ceremonies, especially in the south of India. Two such occasions, *Pongal* in Tamil Nadu and *Sankranti* in Karnataka are celebrated by the families who observe the ritual of eating the new rice and thanking the cows for giving milk. They embellish the horns and hooves of the cows, place flowers on them and walk them through the streets of villages and towns to the sound of bands and drums. Sometimes, ox-cart races or cockfights are organized in villages, much to the pleasure of everyone. In Madurai, the anniversary of the birth of Tirumala Nayaka is celebrated, who, as an independent prince had reigned over this city from 1623 to 1659, known to have built the great temple of Meenakshi-Sundareshwara. Statues of the deities are taken out of the temple, draped in splendid garments, jewels and flowers and this procession culminates at the large lake of Mariamman Teppakulam, about five kilometre away. Placed on a brilliantly illuminated light raft, they are taken all around the lake before ending their voyage on the small central island. The island is also lighted with hundreds of lamps and it resounds with the music of drums and fifes. The entire city of Madurai is resplendent with light, especially the magnificent palace that Tirumala Nayaka had erected for himself. The streets come alive as dance shows are organized, and people are regaled with orchestra and theatre plays.

The months of January-February (*Magha*) are equally filled with festivities. On the fifth day, the intellectuals in particular, venerate Saraswati, the goddess of knowledge, music and fine arts. During *Vasanta Panchami*, books, pens, pencils, typewriters and computer screens are dedicated to the goddess. In West Bengal, statues are also made in honour of this goddess, and after having been duly venerated and adorned with flowers, the same ritual is followed — submerging those statues in the waters of the Ganges. On the thirteenth day, following this occasion, is the

celebration of *Shivaratri*, when the devotees of Shiva, both the creator and destroyer of this world, pray through the night and offer flowers and fruits in temples that are illuminated as a mark of happiness. This is when traditional, massive fairs are held, generally on the banks of rivers and the sunset is heralded with colourful neon lights and resounding music. And year after year, the ceaseless cycle of these celebrations begins anew every time, always on time, keeping the spirit of centuries alive and lending that beautiful rhythm to the life of Indians. But there are other festivities too, not always linked to religious events. So, any occasion can be pretext enough to have a festival — a puppet show, a visiting theatre group, a birth or wedding.

Say, for instance in Kerala, no precise date is fixed for the Kathakali presentations that can be performed on any given occasion. Once the dancers arrive, a makeshift stage is erected, a curtain is hung as a backdrop and, by the light of torches, the show begins right at the fall of dusk and lasts until dawn. Since, the audience has well memorised the episodes of the *Ramayana* or *Mahabharata* that are enacted, they come in droves solely to savour the magic of theatre, to watch and admire the costumes, elaborate make-up and histrionic skills of actors-dancers. This extraordinary make-up is very special and consists of pieces of paper and thick layers of coloured rice paste. The striking colours of their stunning costumes shimmer in the torchlights.

In the temples of the south, mainly in Tamil Nadu, every significant religious celebration is matched with sacred dances, like the Bharatanatyam. In the years of yore, it was the temple dancers (*devadasi*) who pursued this art form but now young girls and women undergo rigorous training for a number of years, right from the age of five, to excel in this classical rendition. They perform ritual dances, where each gesture of the arm or hand plays an important role. But these performances are more often than not, on theatre stages rather than in temples. Many of these dance forms, as those dedicated to Lord Krishna (Manipuri, among others) or palace dances (Kathak), which have somewhat lost their purely religious character, are most often performed as cultural shows during these massive celebrations.

Besides, there is local entertainment and other celebrations, like those of the Parsis, Zoroastrians, who emigrated from Persia in the eighth century. They are found in a large number in the region of Mumbai. There are also the Jain celebrations, which are held on a far more discreet note. And the Muslim festivals are held to commemorate the sacrifice of Abraham and later on celebrate the end of the Ramadan fast. Christians celebrate Easter and Christmas. There are countless village festivals, those of the peasants, the fishermen, with every ethnic group or tribe, being more colourful than the other.

Most of these festivals have certain traits in common, especially music and light, both indispensable ingredients for any celebration. Indian celebrations sometimes seem so out of proportion, yet they reflect the country where everything seems so elaborate, whether it is the enormity of the deserts, the height and scale of the mountains, the devastating torrential monsoons, the sometimes unbearable scorching heat, that unusual brilliance of the skies, the sheer, overwhelming magic of colour, the incredible number of worshipping places that elicits the unstoppable movement of milling crowds, on a never-ending pilgrimage.

The whole of India, indeed, seems perpetually permeated with the sun, lights, prayers, and such spontaneous exuberance, all of which bear witness to an intensely vibrant, culturally rich and incredibly diversified life being lived.

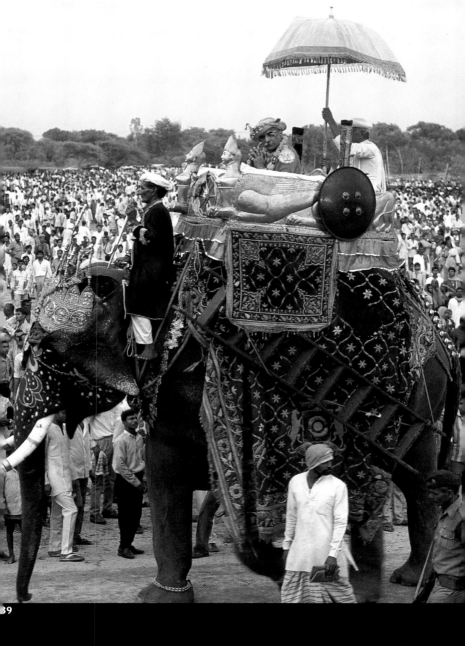

In Varanasi, holy Benares, the Maharaja parades
on an ornately draped elephant
during the annual festival,
Rama Lila, in homage to Lord Rama

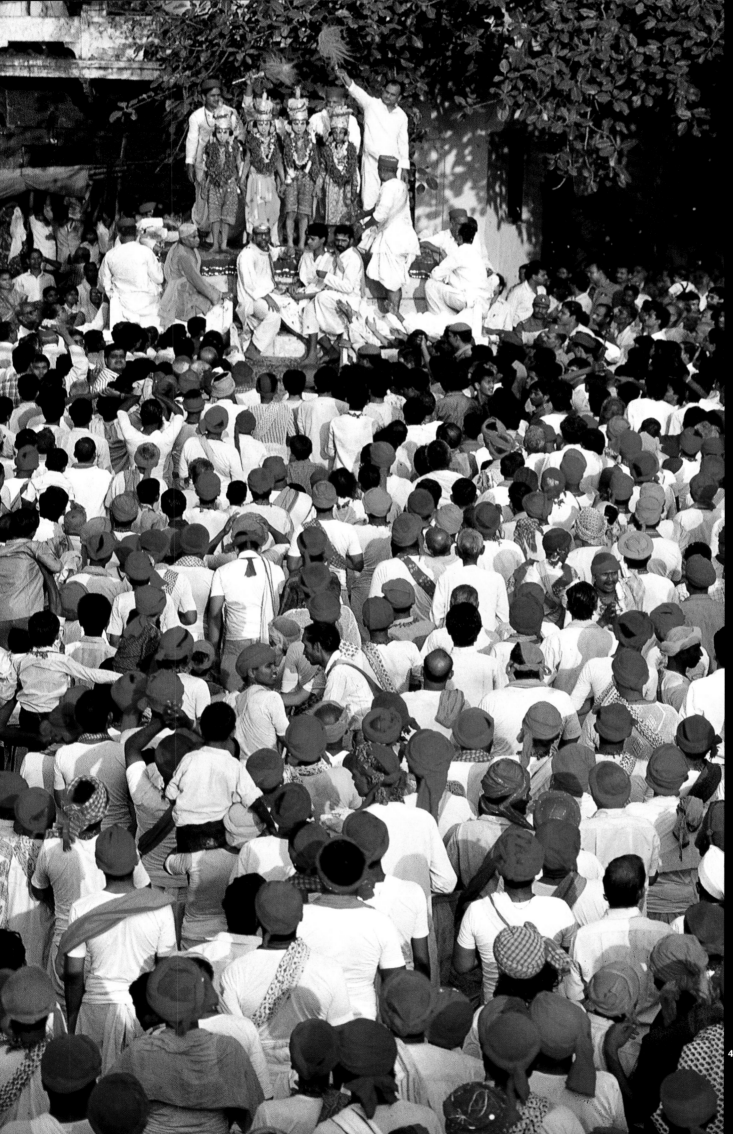

During the elaborate ceremonies of Rama Lila pantomimes enact the legend of Lord Rama. Here, on the last day, Rama finally reunites with His brothers, Bharata, Shatrughana, and Lakshmana.

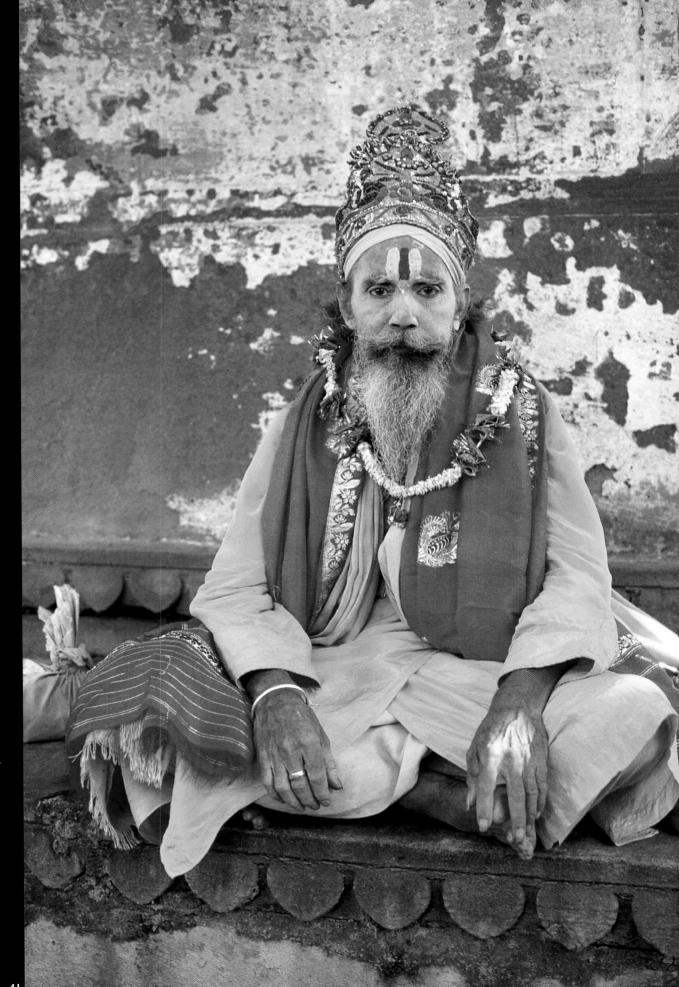

Holy men abound at this festive celebration, like this devotee of Vishnu, who, for the occasion, has donned a costume playing King Dasharatha, Rama's father.

During the great festival of Rama Lila, the Maharaja of Varanasi, followed by his son, rides on an elephant to the banks of the Ganges, where he would preside over ceremonies. He slowly wades through the stream of thronging crowds that push and strain to have a darshan, blessed look, of the rulers (42).

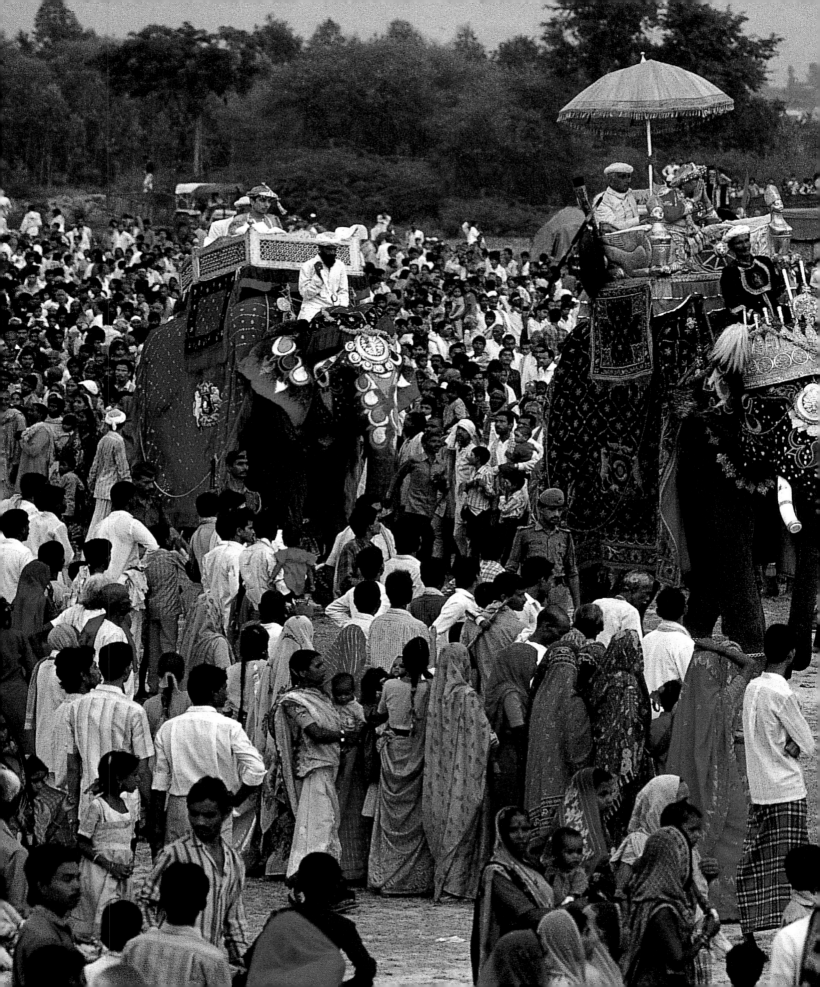

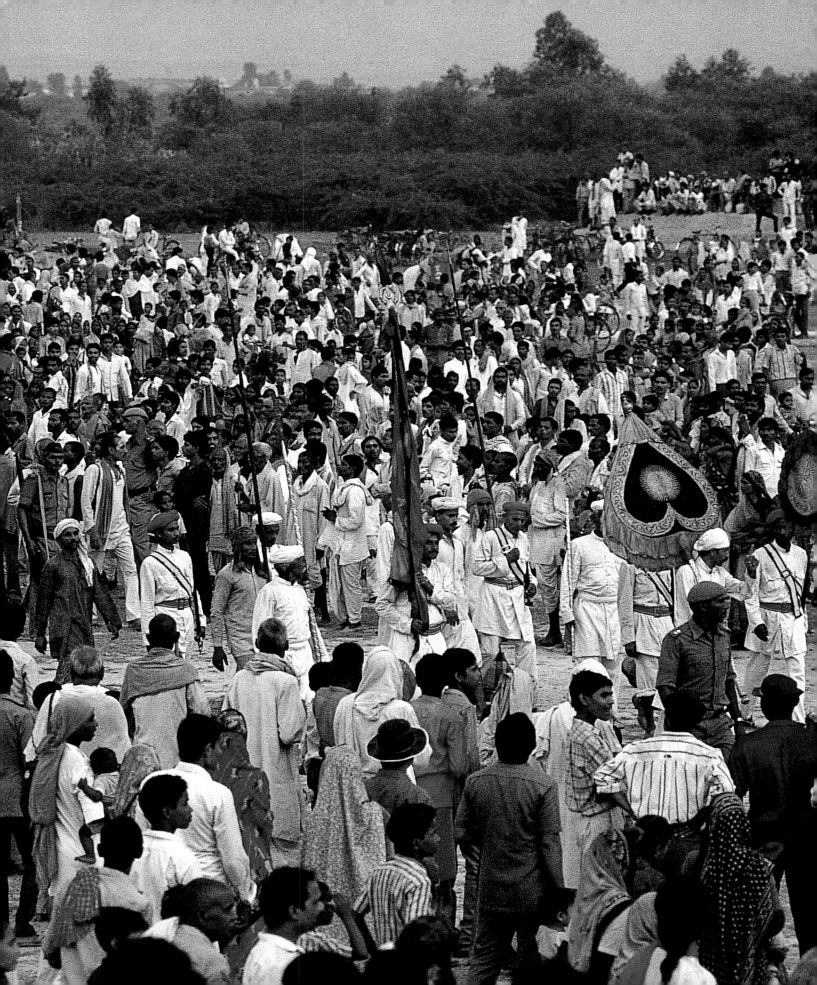

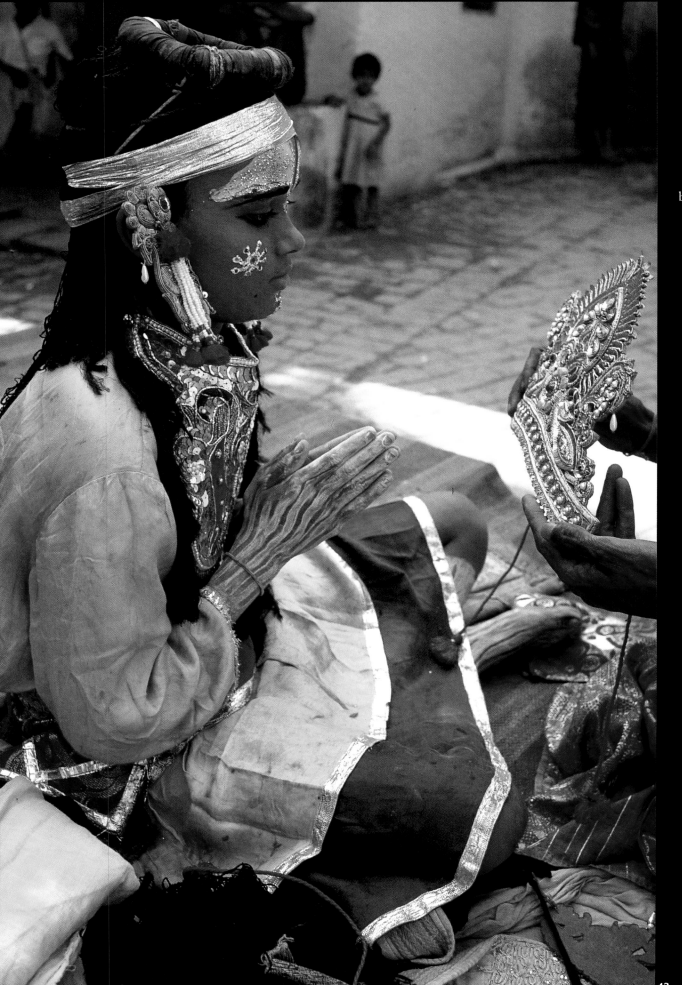

During the Rama Lila, a young boy playing the role of Lakshmana, Rama's eternally faithful brother, meditates and prays, with folded hands, before the royal crown being offered to him.

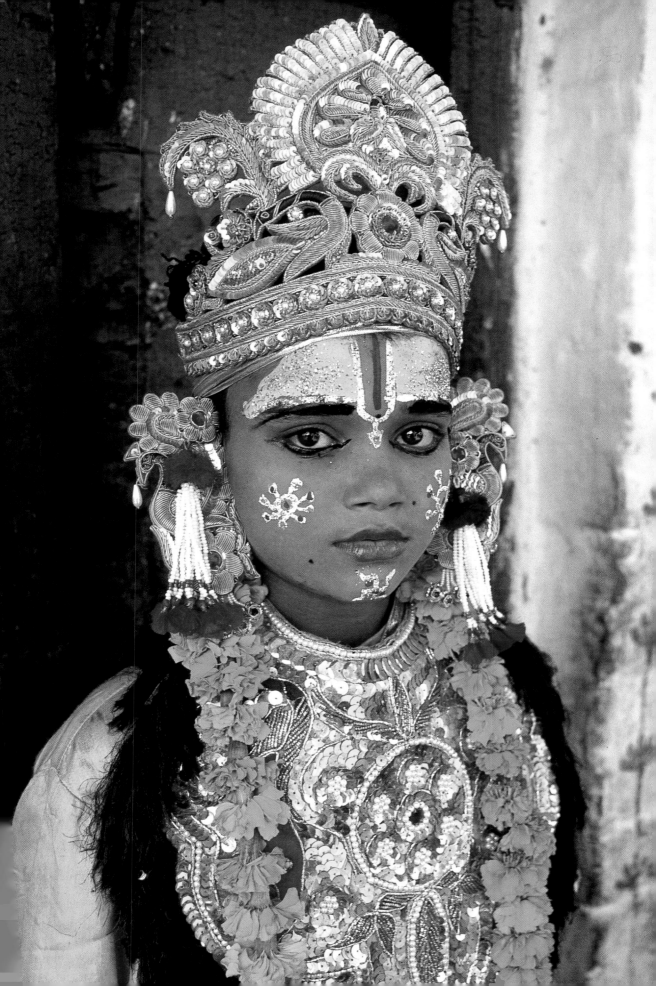

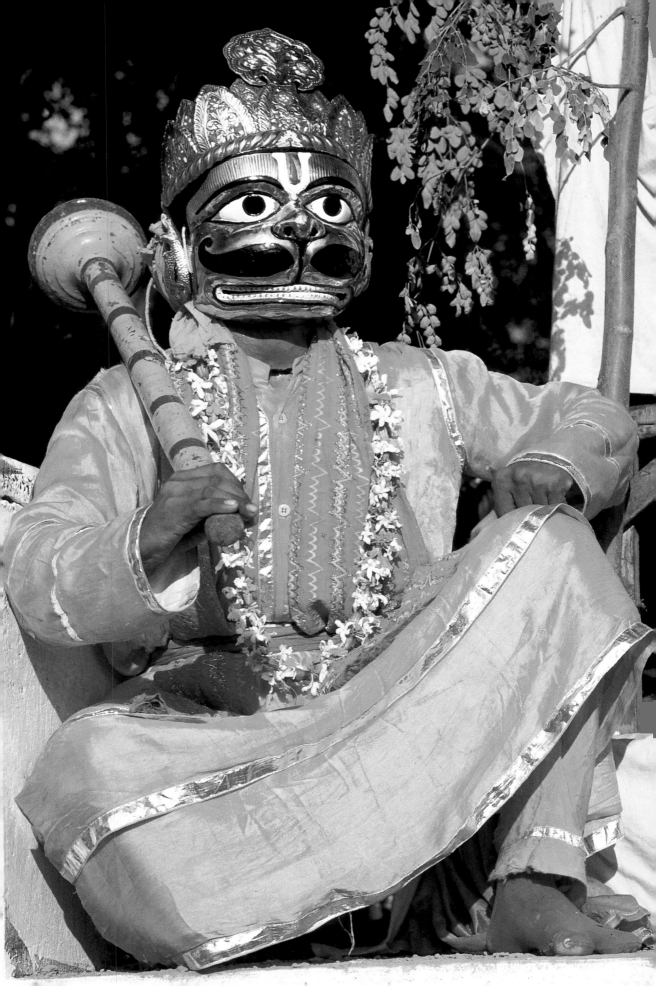

A participant in the
festival of Rama Lila
proudly carries a symbol,
in the form of a giant
feather, perhaps to
represent the 'aerial'
nature of flying
Hanuman.

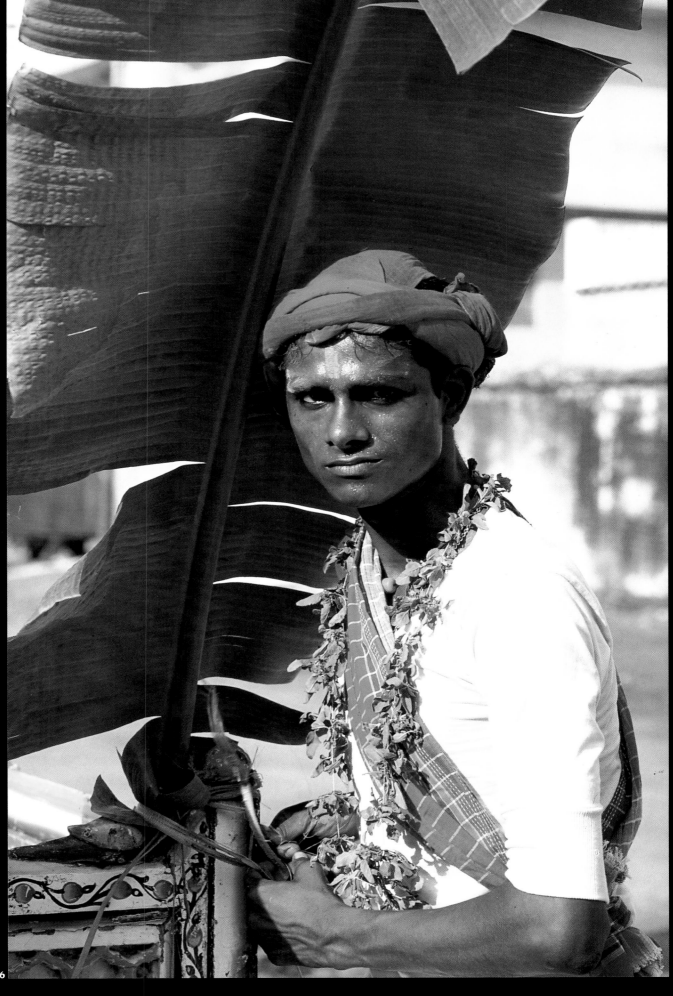

46

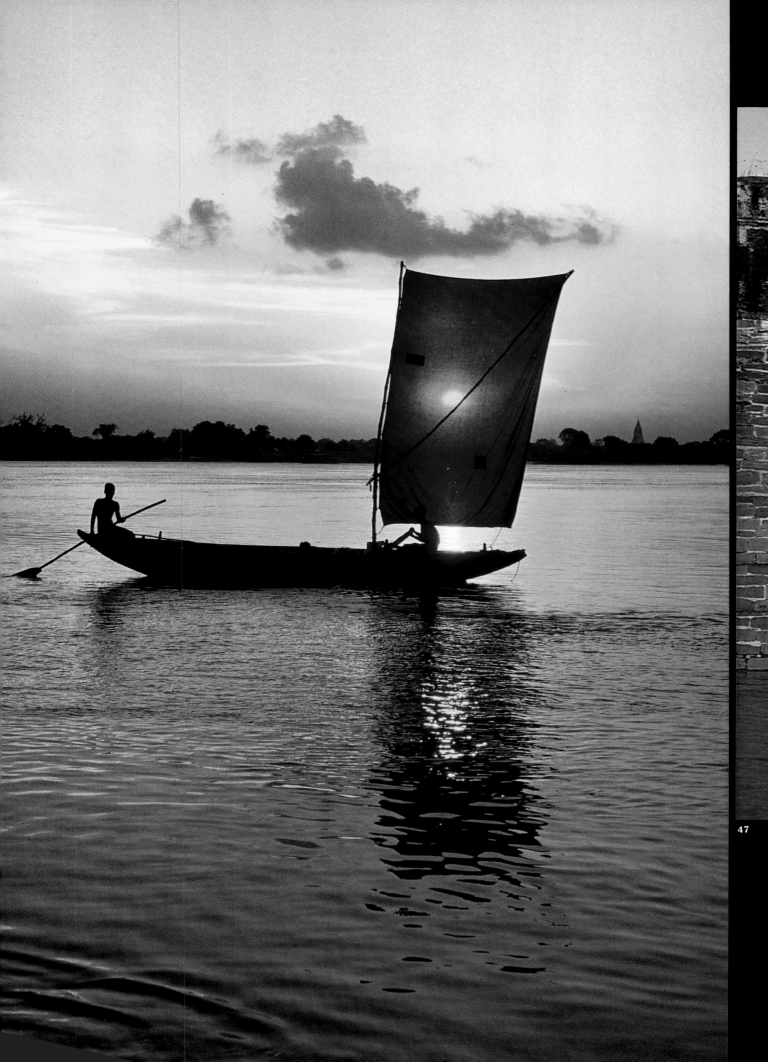

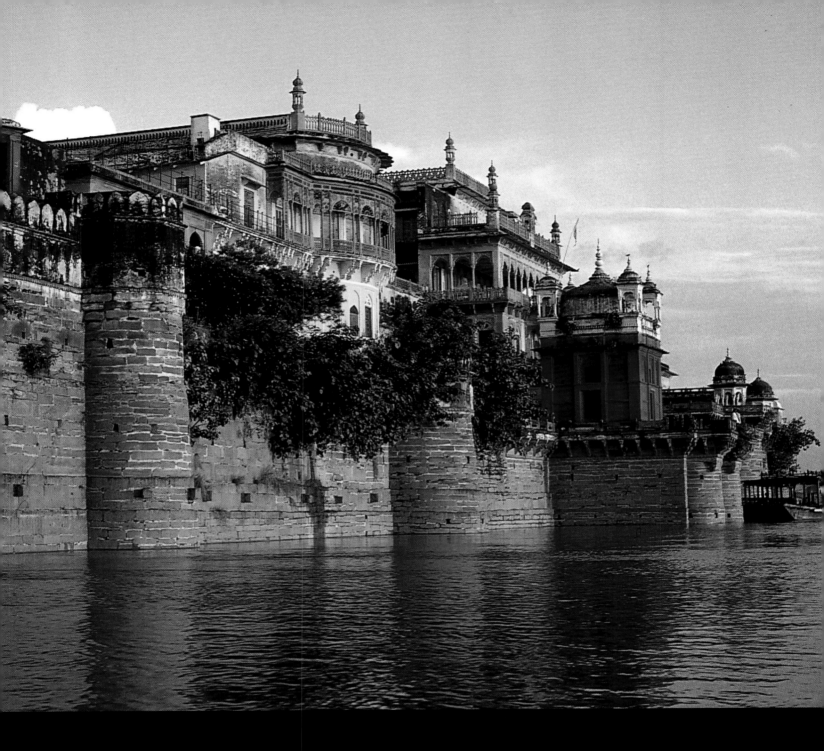

Facing the holy city of Varanasi, in Ramanagar, the Maharaja's massive palace rises
impressively above the waters of the Ganges. The palace walls plunge deep into the water.
Although the Maharajas, who once represented the grandeur of India, may have lost all their official
power, they continue to be staunch guardians of ancestral traditions.

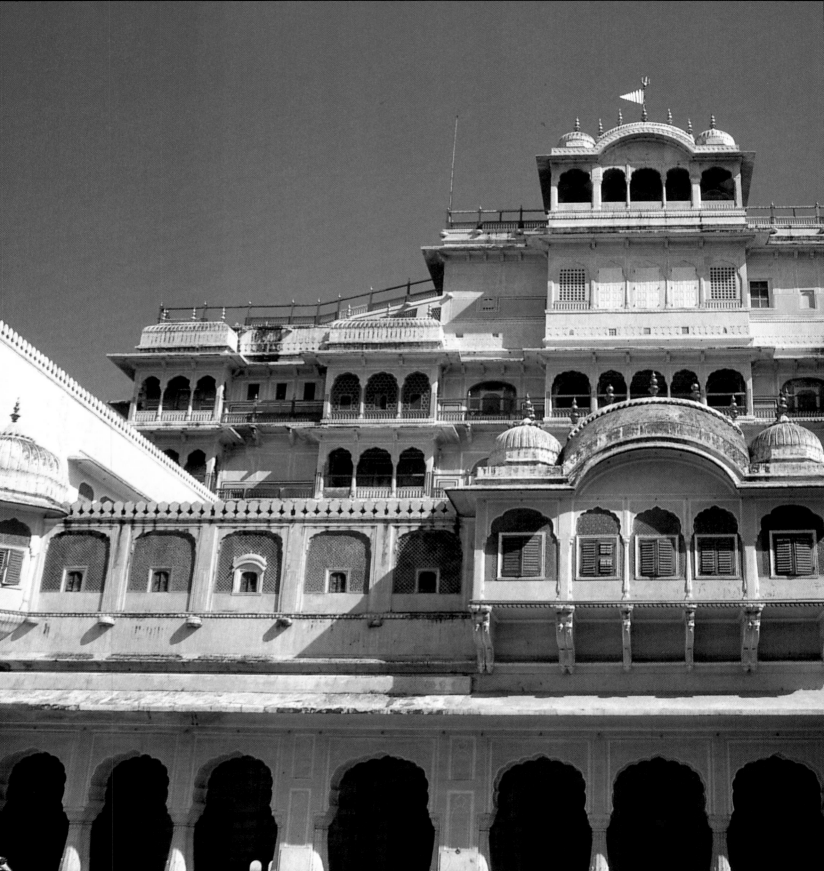

In Jaipur, the Chandra
'Palace of the Moon
gorgeous part of the im
palace of the Maharajas
of white marble, its s
storeyed premises in
galleries, balconies,
verandahs.

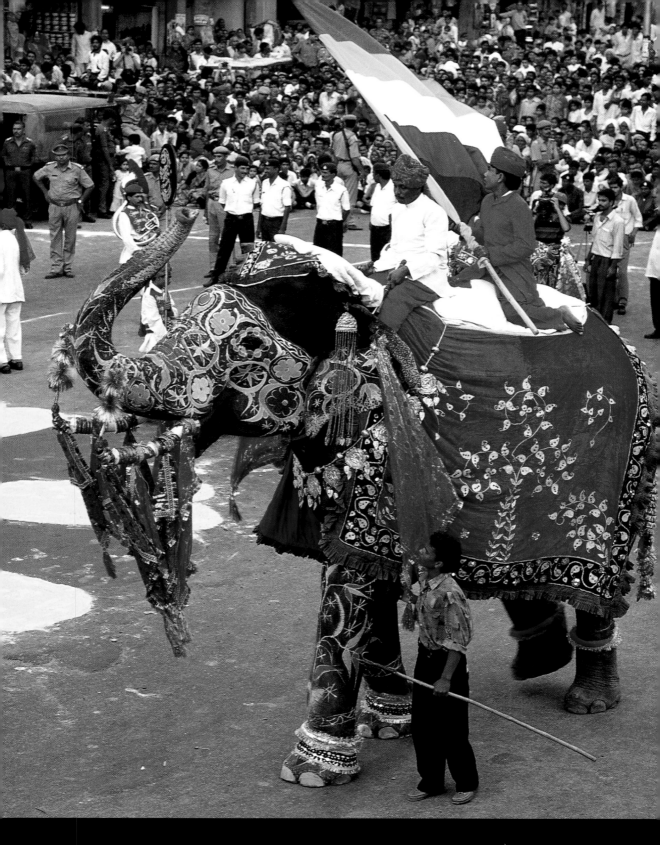

A state elephant, richly painted and elegantly draped,
carries the state flag at the opening of a spectacular parade during the festival of Teej.
The phenomenal crowd, gathered to witness the festivities, is so dense that

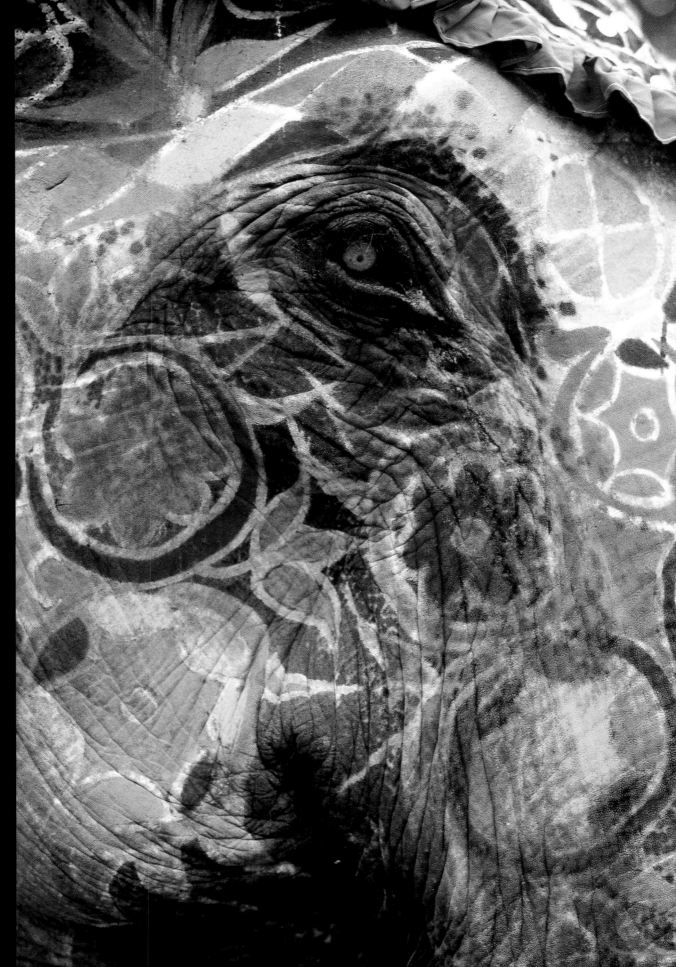

The elephant almost enjoys the status of a sacred animal. And for this occasion, it is adorned like a god, with its body covered with bright designs traced in coloured powder by a Brahmin.

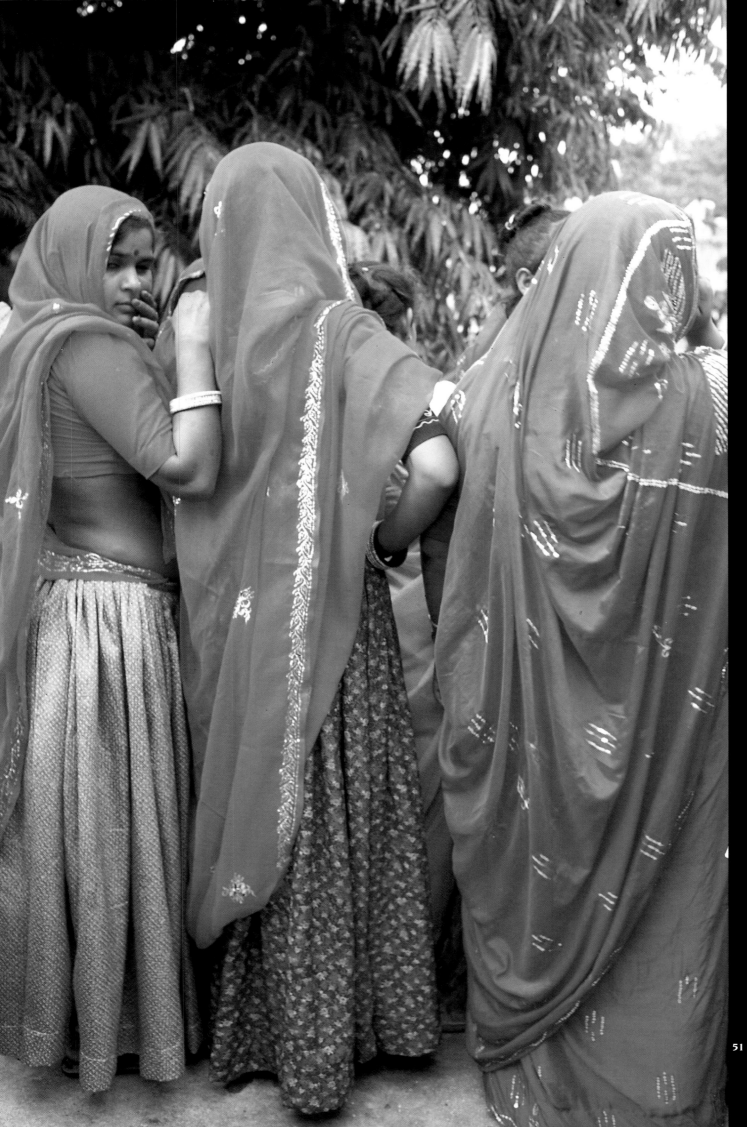

The women of Jaipur bring out their most beautiful saris from the closets. They too assemble in hordes to relish this parade of elephants and musicians.

51

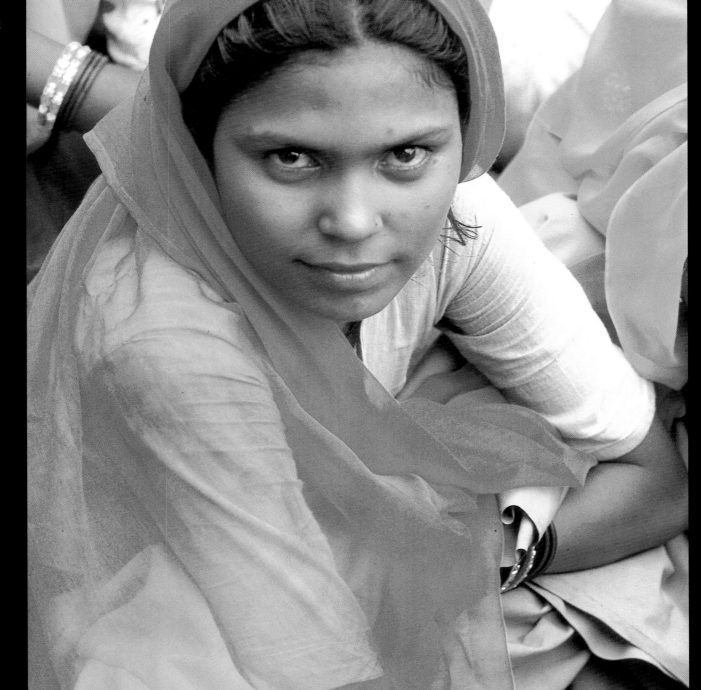

One of them seems to have found a place up front and, sitting on the ground, patiently awaits the procession.

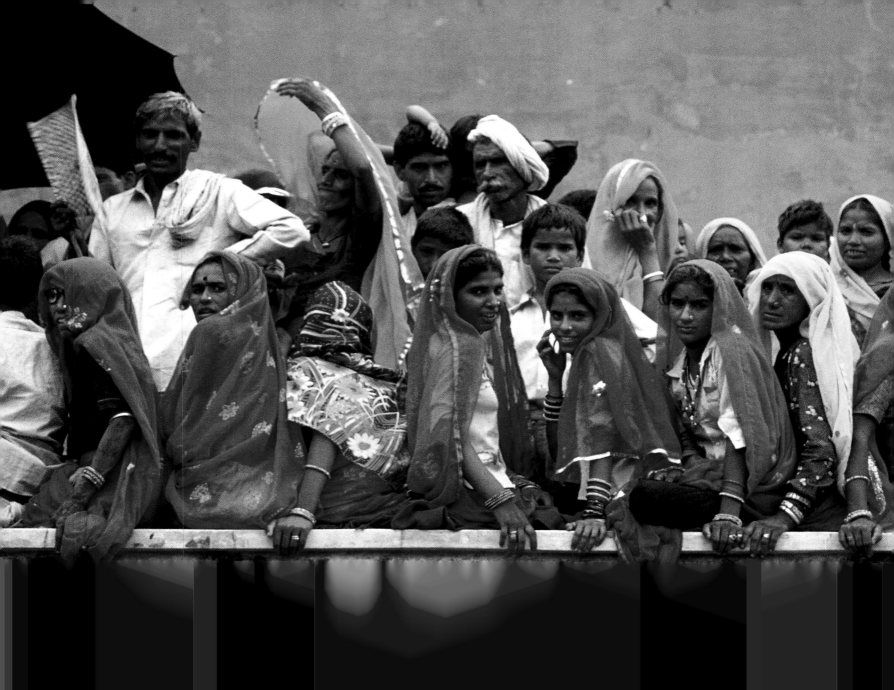

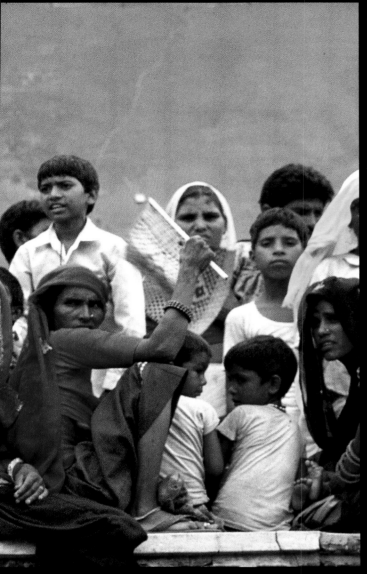

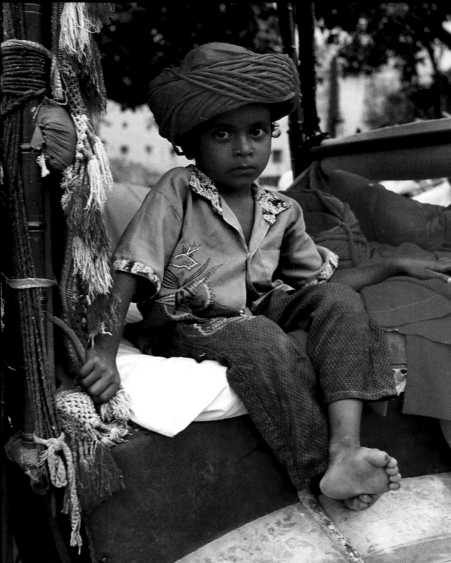

54

A little boy, wearing a turban like an adult,
has also managed to find a place
in a horse-drawn carriage.

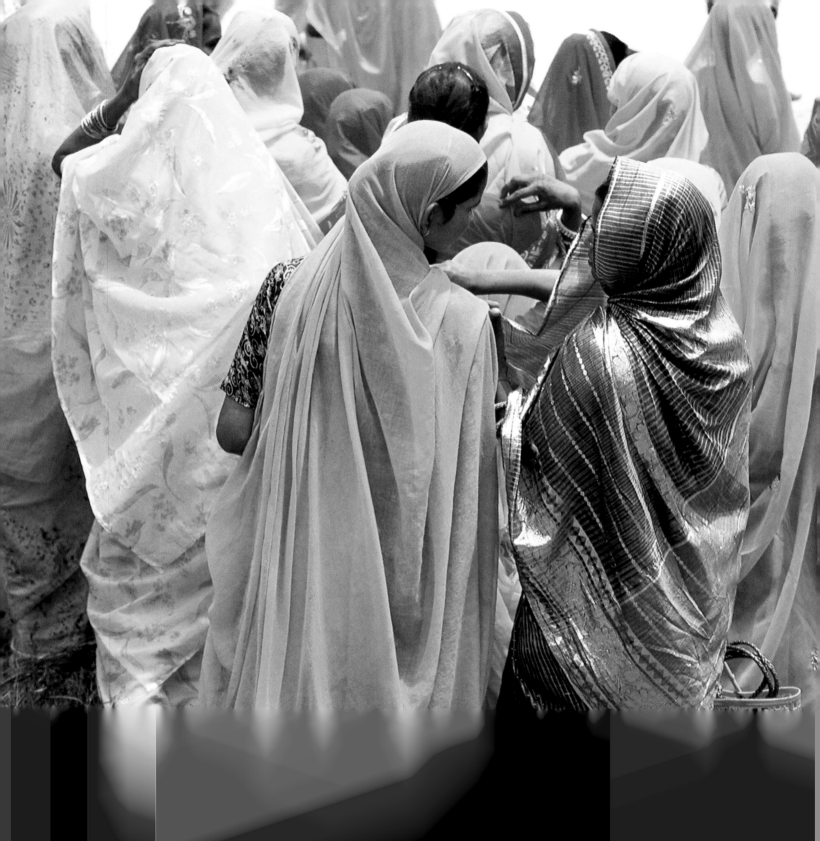

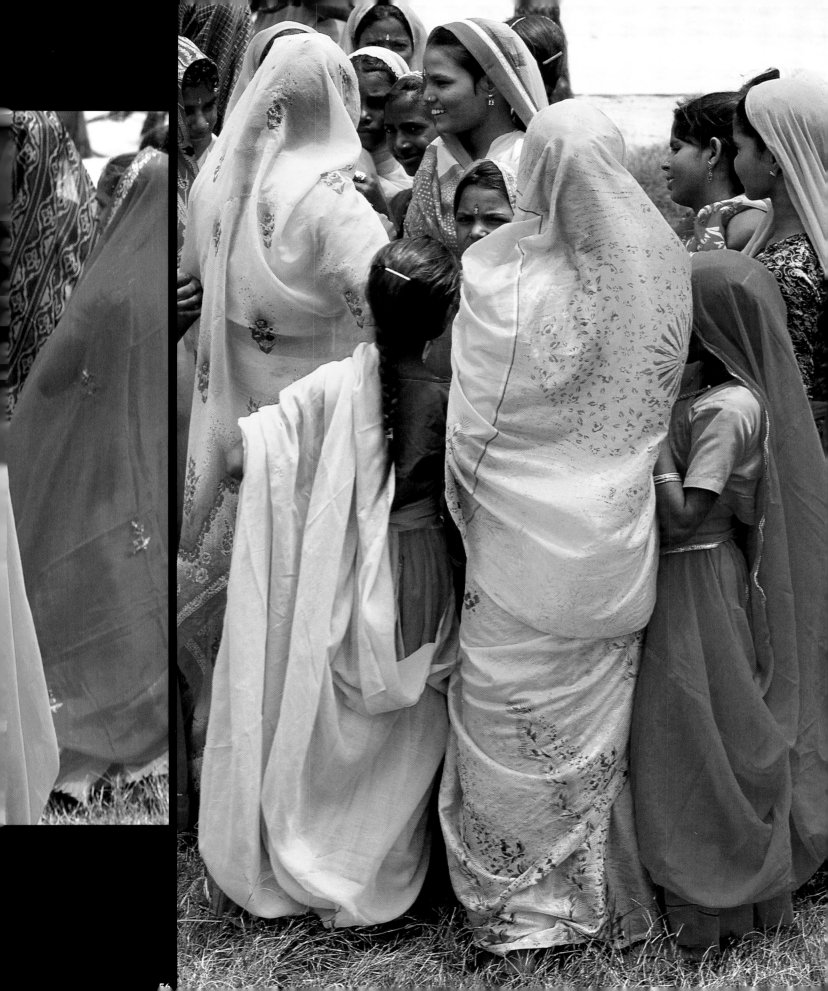

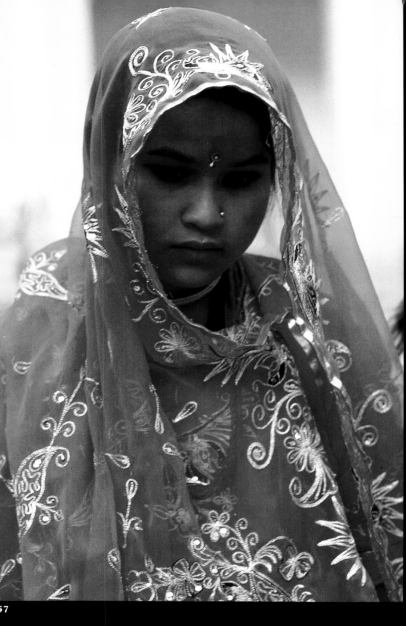

For a wedding, the bride is most ornately dressed.
She remains, however, pensive because,
most of the time, she doesn't know
her husband-to-be until the
ceremony actually
takes place. In a bid to cheer her and add to
her confidence, women from the
family and the village, here in Rajasthan,
dance as they accompany her.

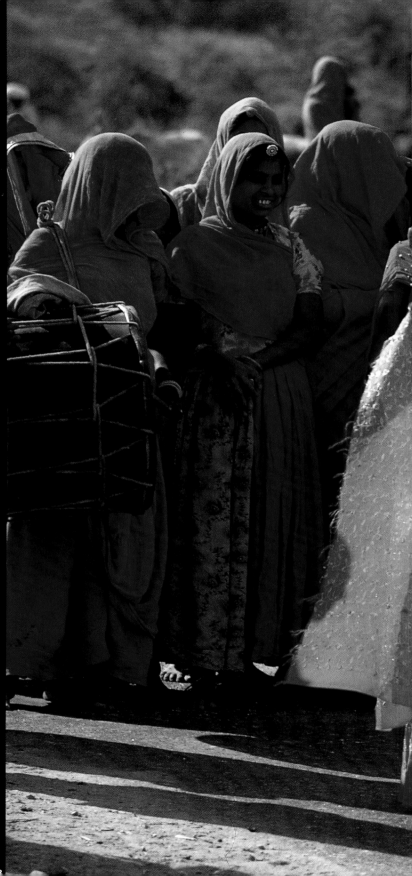

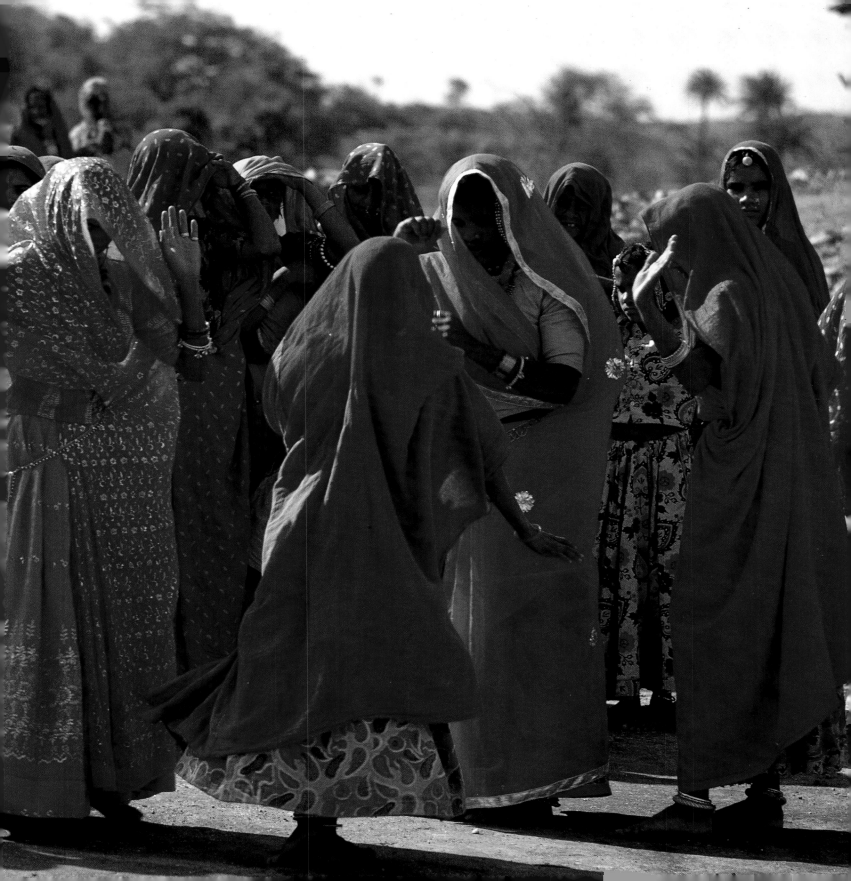

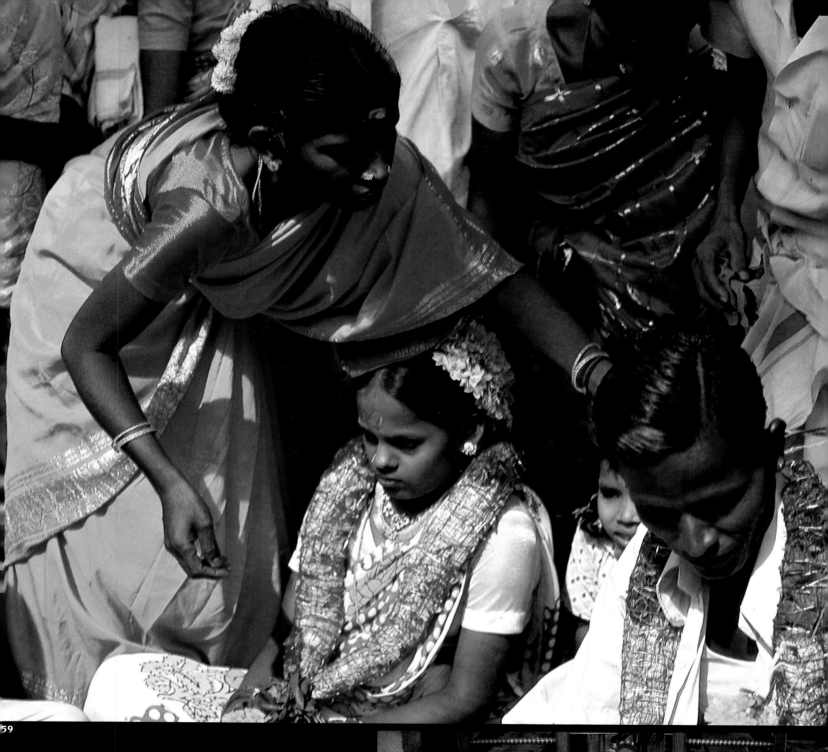

In the south of India,
marriage is usually solemnised
in the local temples, as here in the temple of Kapaleshwara
in Chennai. Offerings of sweets, drinks,
and flowers pile up at the foot of the altar.

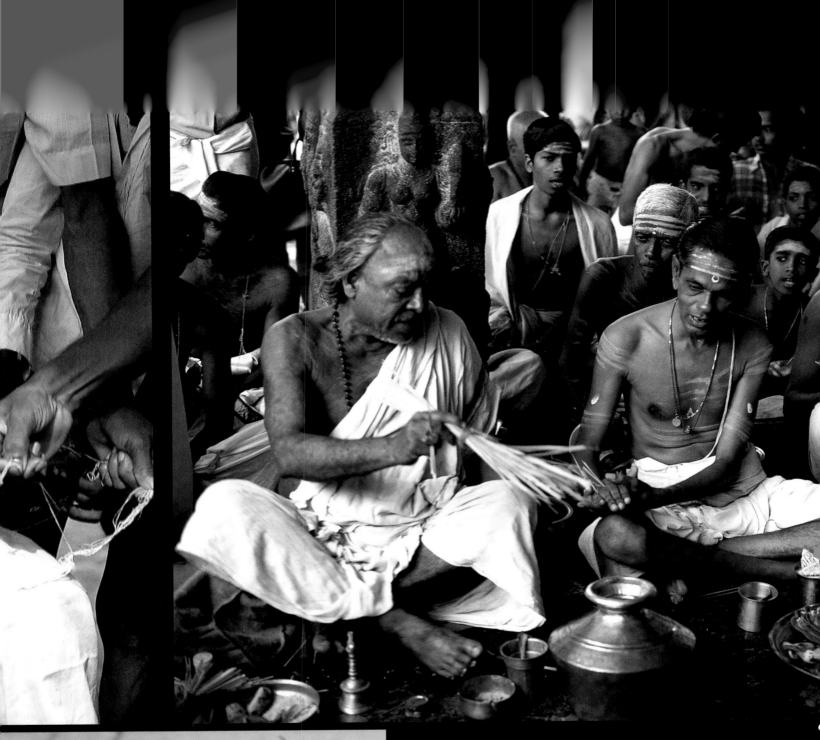

In Chennai, in the temple
of Kapaleshwara, dedicated to Lord Shiva,
Brahmins perform several rituals
of the puja. The offerings of flowers,
fruits and betel leaves often
accompany these prayers.

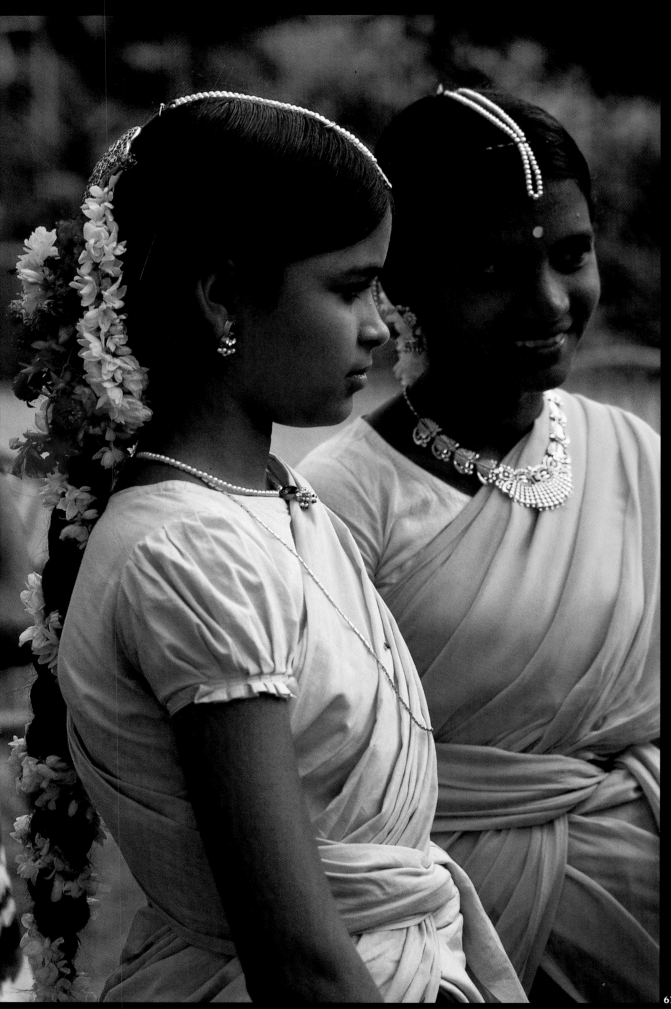

In the south of India, as here in Tiruchirapalli, the inhabitants are Dravidians, and have darker skin than Indians of the north. But the young girls know how to accentuate their dusky beauty by wearing strings of pearls and jasmine flowers in their hair.

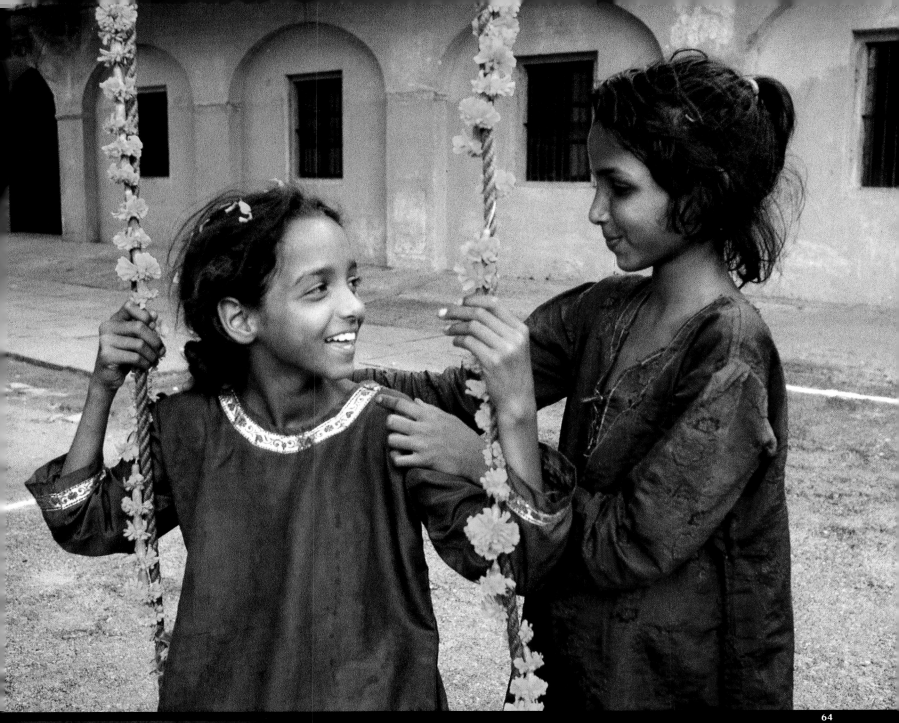

A popular pastime of young girls is swinging.
The arc of the swing, andolaka,
in the springtime, is symbolic of the path of
the sun and the renewal of desire.
In Rajasthan, during the festival of Teej,
young girls decorate their swings that are
hung from tree branches, with flowers.
They also prepare sweets to
serve as offerings.

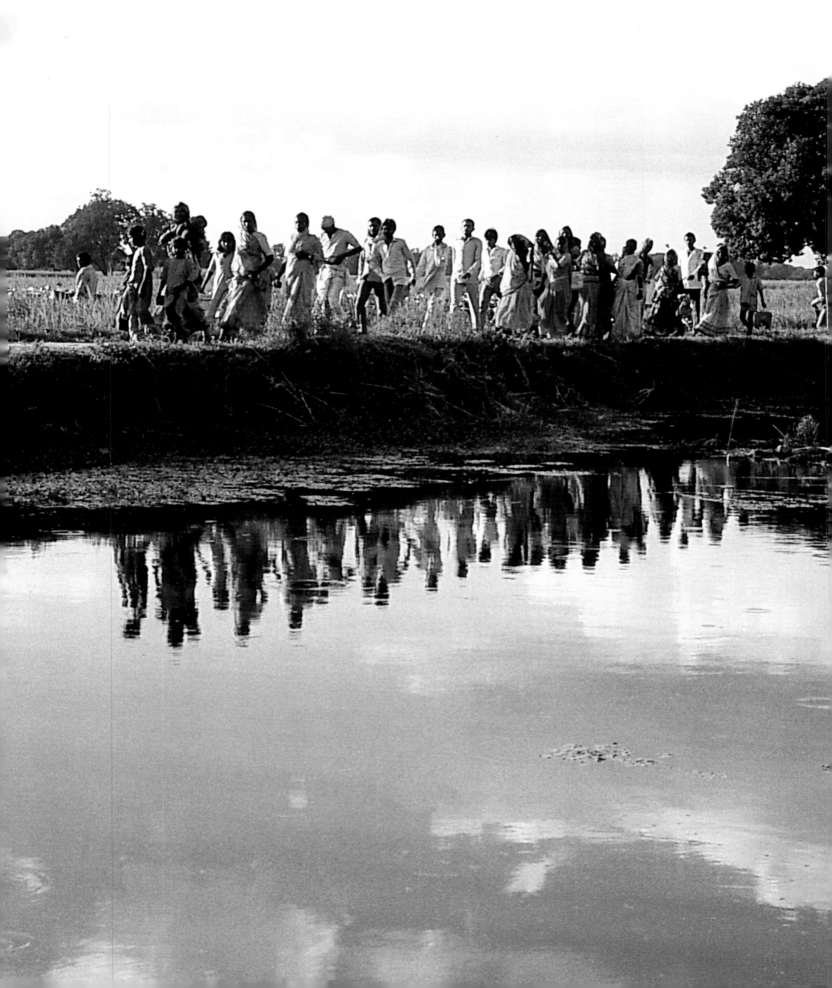

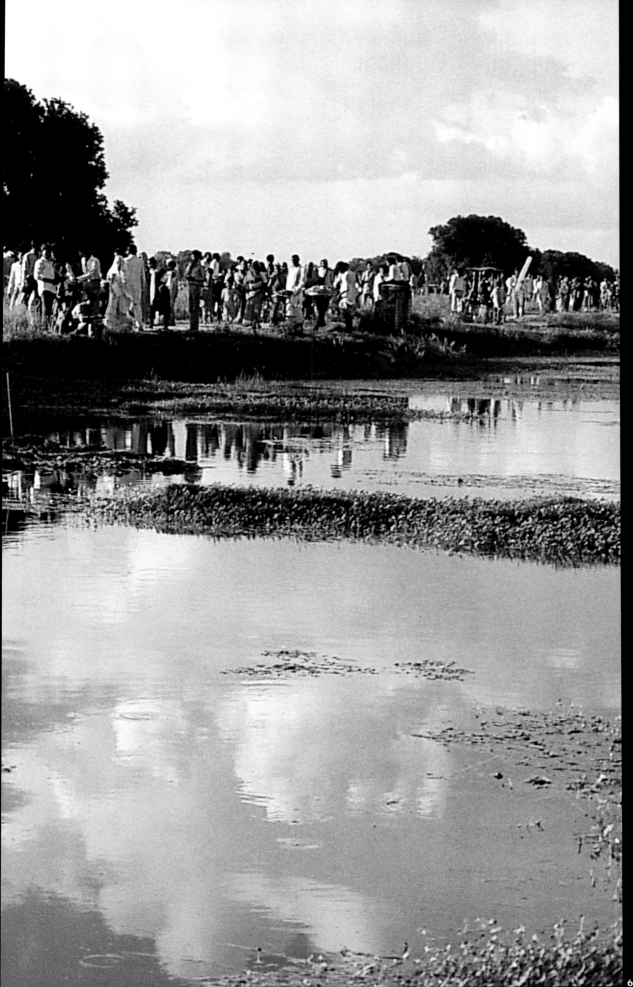

Peasants like to unwind, and they
often walk long distances
to a neighbouring
village to take part
in a ceremony,
be it a wedding, or a religious
celebration. They form
these groups given similar interests
and, walking slowly, enjoy
the walk when the weather is fine,
leaving behind the thoughts of
hardship and daily cares.

Adults or children, they enjoy puppet shows alike. As these puppets vary from region to region, from string puppets, to being mounted on sticks, and others played as hand puppets, in Rajasthan, large wooden string puppets are most popular. And the themes of these shows are often the same episodes from the Ramayana or enacting tales of valour depicting gallant deeds of the Rajput warriors.

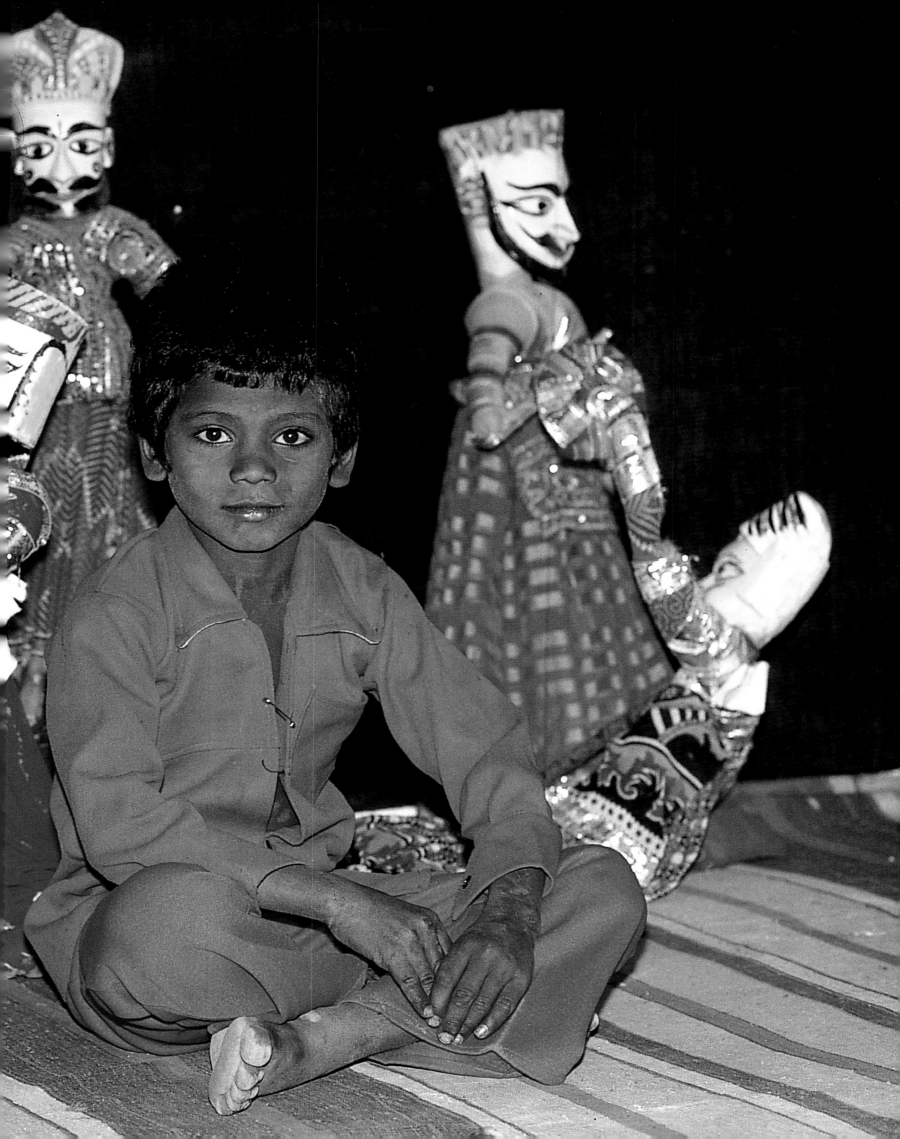

During large festivals, travelling carnivals set up carnival rides that are simply delightful. There are swings or, as here in Varanasi, a kind of Ferris wheel with brightly decorated seats. And when they groan and sway dangerously under the weight of these riders, their families look on with a certain air of apprehension.

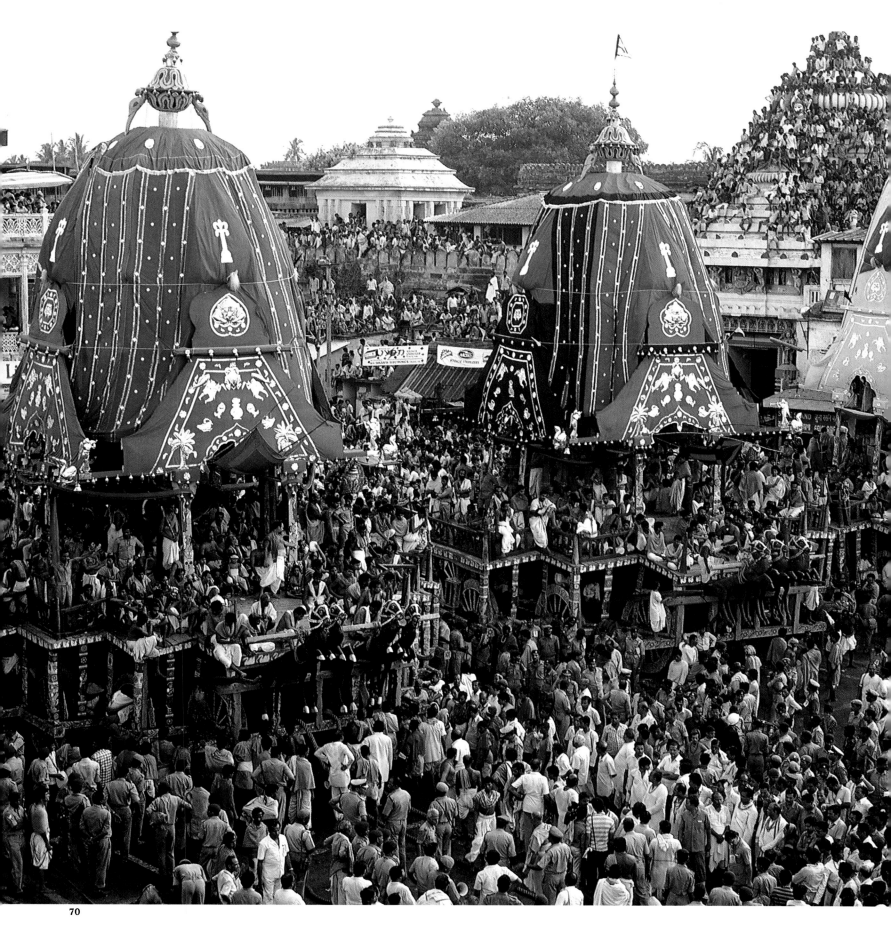

In Orissa, the Rathayatra, 'Festival of Floats', is annually held in Puri.
Held to commemorate another incarnation of Lord Vishnu, called Jagannatha, His brother, and His sister,
the devotees harness themselves to these sculpted wooden floats to pull them in the procession.
Those who wish to make their task more rewarding, climb aboard the floats and mingle with the musicians and dancers.
Immense silk canopies cover the statues of the deities.

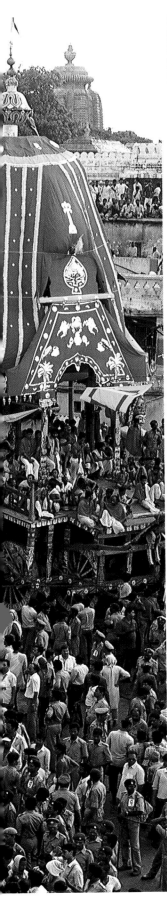
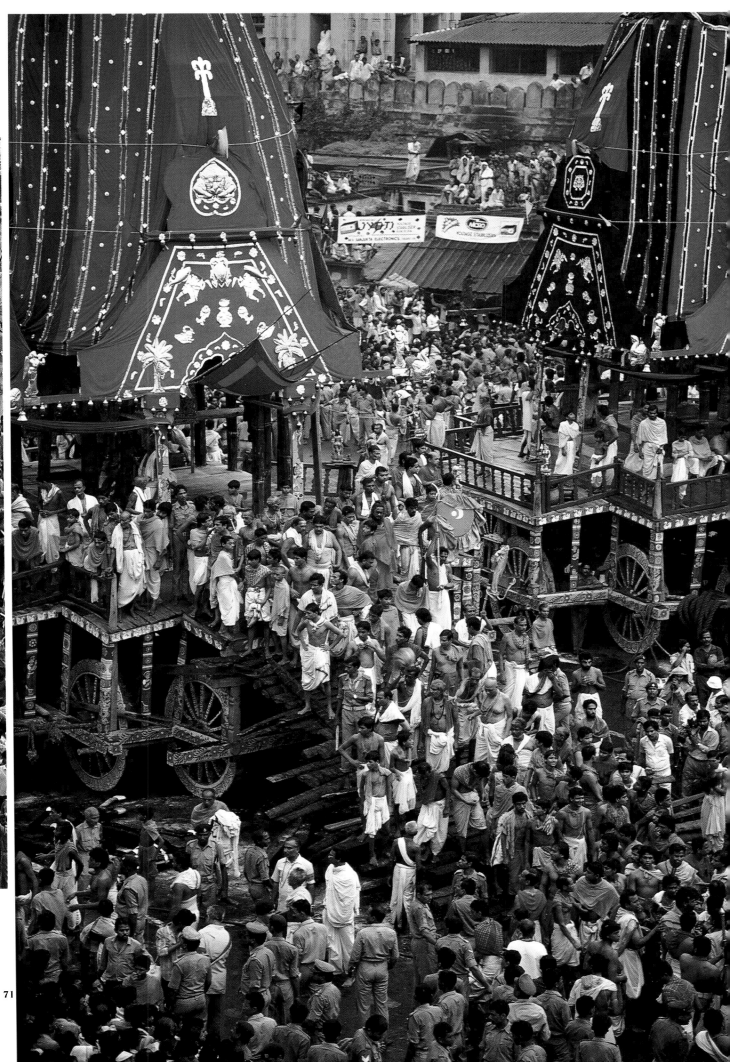

71

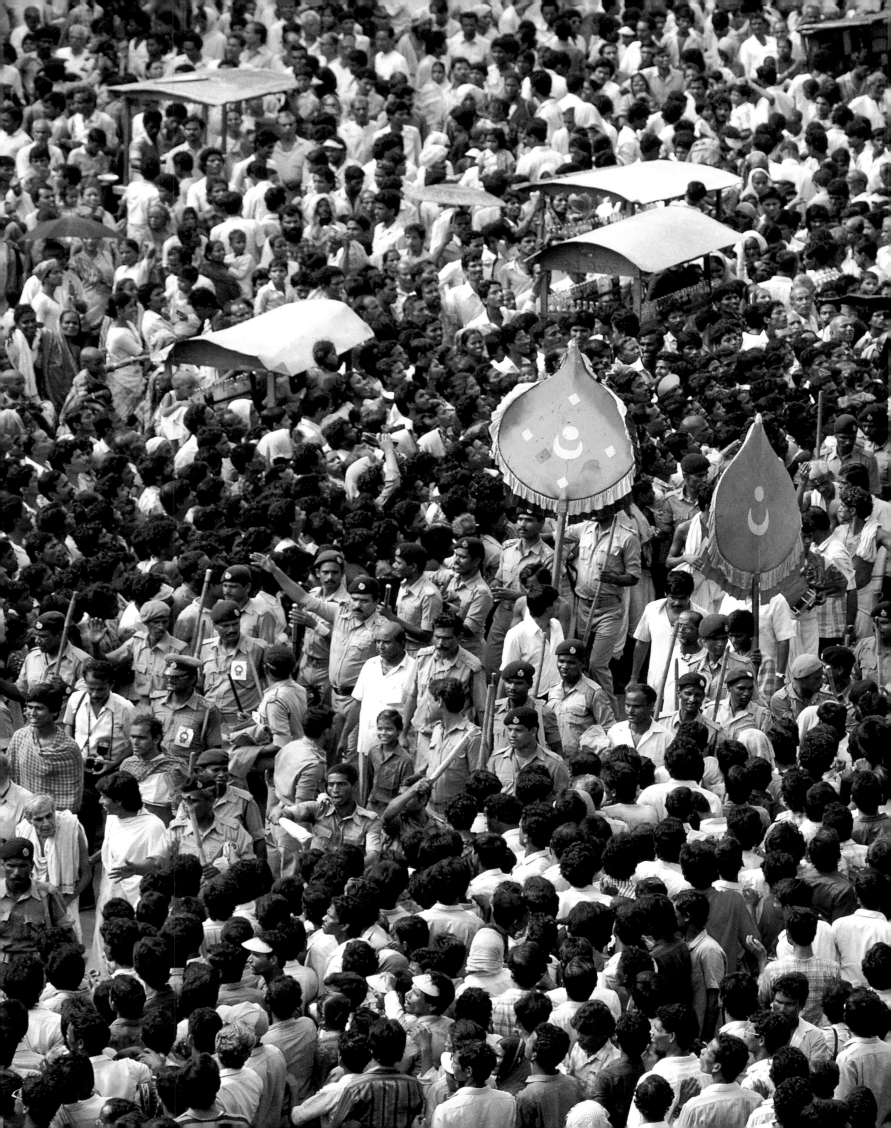

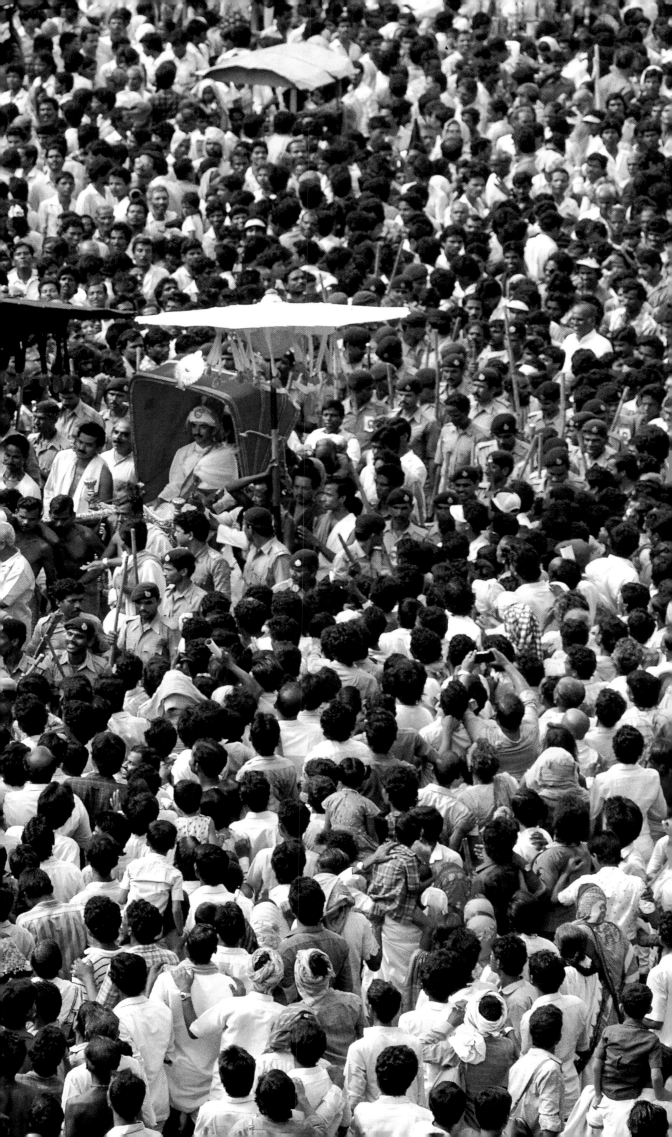

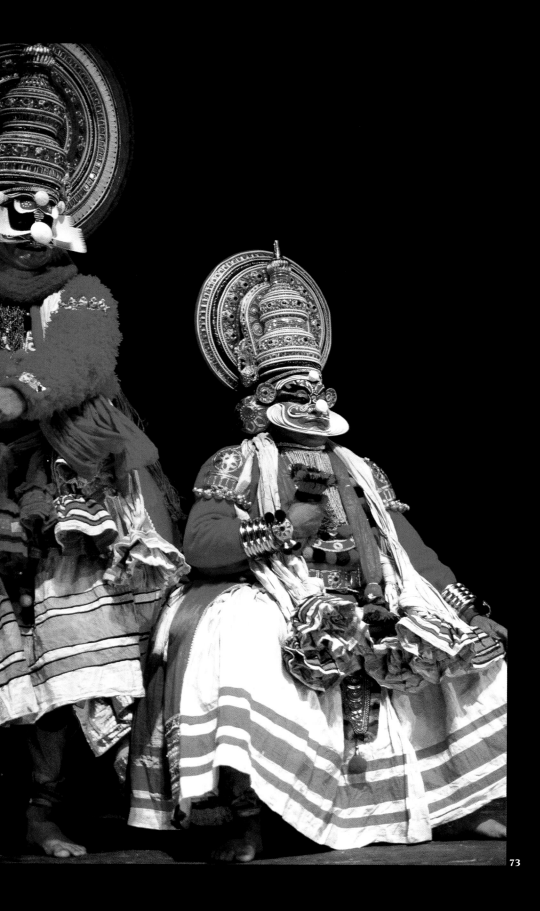

In Kerala, no celebration can
possibly be culminated without a performance of Kathakali,
a drama in dance and mime, presented at night in the open air
by the light of torches or oil lamps.

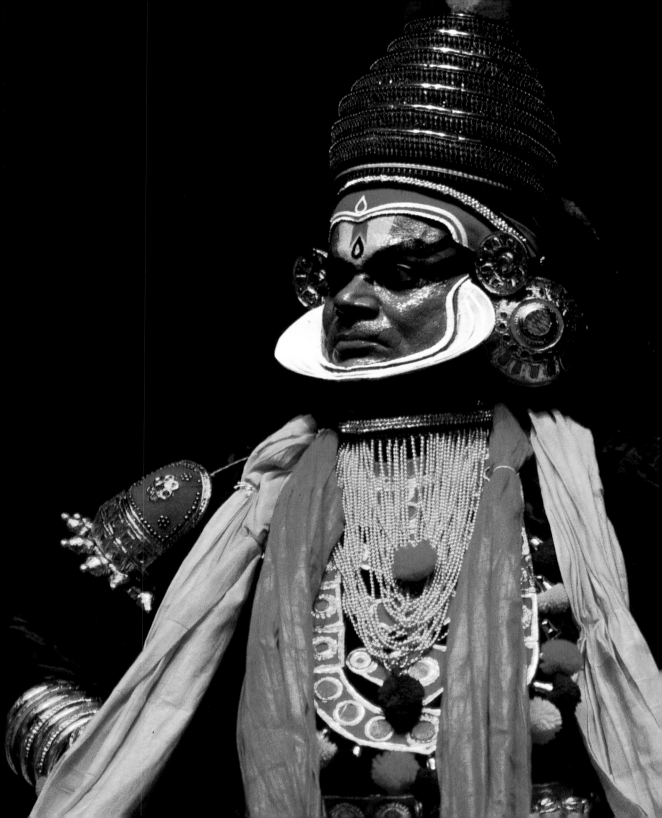

THE HOLY INDIA

The Lord resides neither in wood nor in stone.
He is present only when the devotees are devoted.
The Lord resides neither on top of the mountains nor in a temple.
Because He is the incarnation of Consciousness and Contentment.
He lives only in the hearts of the devout. Aum tat sat!

Bhagavad Gita

India has most aptly been defined as the country of the gods. Deities are omnipresent here; their abode is not only in temples or sanctuaries or mountains, but in village and city streets, in public squares, at the foot of trees — in other words, just about everywhere. Their images and icons adorn everything that can possibly be decorated. The Hindu pantheon abounds with countless deities, and the religious scriptures, like the great epics, *Ramayana* and *Mahabharata*, project an infinite number of characters of divine demeanour.

But, as the saying goes, appearances can be quite misleading, given that inevitable divide between image and reality. Beneath this apparent diversity of names and forms lies latent a fundamental belief that there is one and only supreme power — the oneness of Divinity. The innumerable forms, names, and qualities attributed to multiple aspects of the Divine are only human reflections of the infinite possibilities of that Almighty, the single Divinity. It may be referred to by any name, have any peculiar quality — good or evil — and take on possibly any imaginable form, from that of a mountain to that of an atom. It is the holistic totality of the universe, which at the same time carries each of its components. Say, what can be found in a single twig is, like everything else that exists in the universe! It really needs to be understood, as to how the Indian veneration of the slightest

thing, which may, however, seem so trivial, is understood to be a veneration of that eternal mystique, an unknown and unnamed cosmic entity, which contains the very essence of everything that exists, living or otherwise.

The very creation of the universe is considered as divine, as much in its entirety as in all its components. With an intrinsic belief that every human act, even breathing or eating, is essentially divine, and consequently everything that exists is worthy of honour, thus an Indian right from birth finds himself steeped in this religious universe of veneration, worship or simple consideration, given his social status or the level of education. He literally savours the Divine, with his mother's milk. All the same, the perception of the concept of the divine has often altered with the passage of time; and since human beings are very different from each other, they got to consider the Divine only through its appearance. Hence, the incredibly countless images and philosophies, to which they are bound. If most Indians are not much aware of philosophy or perhaps even lesser about theology, other than this vague notion of a universal Divinity, they, nevertheless, repose tremendous faith in the words of their holymen, as much as they did in the past. Above all, they sincerely believe in the power of prayer, *puja*, and the rituals consecrated to the same. This, in all probability, accounts for the devotion Indians show for anything that

represents the Divine, be it veneration of statues and pictures of the gods, ceremonies commemorating these gods, or pilgrimages and other devotional acts.

The unique Indian belief in reincarnation, that asserts the possibility of a soul or spirit, whether human or animal, to reintegrate itself into a body in another life after death, is deeply entrenched in the Indian psyche. And this reintegration is conditioned by the composite thoughts and karmic deeds in one's former and present life. Though this belief seems absent in the writings of the Vedas, the oldest sacred texts in India, this doctrine of reincarnation was depicted very early by the philosophers and wise men of the Upanishads. While the Vedas dealt with the basic personification of nature's elements; the texts of Upanishads and the Brahmins, or priests who preached from the Vedas, adopted the notion of justice found in the concept of reincarnation, and propagated the same among the people. This was a simple task for them because the basics of this theory certainly existed in the mindsets of the people of India, well before the Indo-Iranians arrived in the Gangetic Valley. And the Brahmin sages only refined and redefined the notion giving it a philosophic shade. This is precisely why morality is both religious and civil at the same time in the Hindu mind, as these two aspects are inextricable, given the enormity of Divinity. And Hindus had the propensity to attribute every diverse virtue and 'moral aspect' to their deities, thus giving them corresponding names and forms.

Interestingly, in Brahmanism, the great deities are generally male and passive and they cannot act without their female counterparts, i.e. *Shakti*, which is always active. Though there are exceptions or certain instances, where male and female deities are somehow blended. At the same time, these *Shakti* are often worshipped separately from their male counterparts and, like these, take on very different forms. That is how,

Lakshmi, the *Shakti* of Vishnu, the deity who presides over fortune, beauty, and elegance, takes on as many forms and names as her husband. She may be Shri, Devi, Kamala, Padma, Sita, Rukmini, Indira, etc. Parvati, *Shakti* of Shiva and Vishnu's sister, is even called Durga, Kali, Maya, Gauri, Annapurna, Uma, Devi — all these appellations are accorded in consonance with the qualities attributed to her on various occasions. Saraswati, the goddess of music and the arts, consort of Brahma, is often shown with signs solely attributed to Him. So it's obvious that these female deities generally carry the same symbols as their divine husbands, whether it is the lotus flower, conch shell or sundial for Vishnu, or the trident flame and crescent moon for Shiva. Saraswati, however, often carries the veena, a traditional musical instrument. Each deity has a mascot (*vahana*) to ride, which becomes synonymous with its identity: Nandi, the white bull, for Shiva; Garuda, the vulture, for Vishnu; Hamsa, the swan, for Brahma; Airavata, the three-headed elephant, for Indra; a tiger for Durga; a ram for Agni; a turtle for Varuna, etc. The pictures of these animals become symbolic of these gods and their consorts, and are recipient of the same veneration of the devotees, who, given these mascots, can easily relate to them.

But the allegiance of the devout towards their great deities is not merely confined to worshipping them in their various forms or those of their *Shakti*. Some of the gods have 'sons', the most popular being Ganesha, the son of Shiva, with the head of an elephant. He is considered to be the god of trade and travellers, and his mascot is a rat. There is also Kartikeya (often called Skanda), another of Shiva's sons, known to be god of war and is almost always shown seated on a peacock. Among this pantheon, Vishnu is perhaps the most venerated of the gods because he's believed to protect life and makes it evolve. As the protector of entire humanity, at least ten major 'incarnations' (*avatar*)

have been attributed to him. His sole mission was to save the world from imminent disaster, caused by the evil deeds of a sovereign or of demons. Among these incarnations, the most venerated are Rama, the King of Ayodhya and the real hero of *Ramayana*, and Krishna, whose adventures are so elaborately recounted in the *Mahabharata*. And since both the drawbacks and virtues of Krishna are so very close to human traits, He became the deity most loved by the followers of Vishnu. But there are also Matsya, deluge's fish; Kurma, the turtle who supports the world; Varaha, the wild boar, who brought the world out of the water; Narasimha, the lion-man who killed an evil king; Vamana, the dwarf who conquered the world against an ambitious king; Parashurama, who killed the pride of the Kshatriya and the Vaishnav; and finally Kalki, the white horse that is supposed to come in the future to save humanity one more time. But in real practice, only Vishnu's *avatars*, Rama and Krishna, are venerated as the 'real' Deities. Besides these 'real' deities, Indians also worship numerous animals, among which cows are considered to be most sacred. This, perhaps goes back to the memory of initial days of Vedic culture, when owning of the cows was essential for the survival of the tribes. The cows furnished the tribes with meat, milk, leather and dung, and facilitated the cultivation of the fields with primitive wooden ploughs. But owing to beliefs in various regions, animals are more or less sacred. Monkeys are associated with Hanuman, the General of the army of these intelligent beings who helped Rama rescue his wife Sita. Tigers are symbolic of Durga, while turtles evoke the river goddesses, and snakes too are worshipped because they protect the crops from rodents, etc. But what is human about these gods are the existing rivalries among them. Many a stories abound, offering explanations to the devotees as to why a god in particular, Shiva or Vishnu, is more superior or supreme to the other. At the end of the day, these versions of the stories vary as per the author's subjective preference for one god or the other.

At the other end, philosophers have used various legends and ancient texts to corroborate their ideas and elaborate theories, aimed at facilitating liberation from the cycle of birth and rebirth. And the most renowned among these, Shankaracharya, for instance, who lived in the eighth-ninth century, preached absolute monism (*advaita*). And others, like Nimbarka (who died in 1162), believed in a sort of blending both the facets — monism juxtaposed by dualism. Still others extolled *Bhakti*, a piety-oriented philosophy that calls for unconditional love of the devout for his deity, in whom he reposes innate faith. This was well in keeping with the spirit and sermons of the *Bhagavad Gita*, 'Song of the Lord', a Vaishnav inspiration, found in the sixth book of the *Mahabharata*. And the most fascinating part is that the number of philosophers abounds in India as much in the present times as it did in the centuries gone by — and interestingly that number is as vast as the gods of the pantheon. But this unquestioned devotion of the devotee at times reaches such a level that just about any fortune-teller, however ignorant, easily passes off as a 'holy man' or 'living god'. And as this vocation of forecasting fortunes got somewhat crowded in India, a good number of these soothsayers moved on to Europe or America and established learning centres in respective countries. Since the curiosity of human beings vis-à-vis what their fate would unfold remains undiluted, whether in east or west, these fortune-tellers attract the naive masses and acquire a following, in turn amassing a considerable fortune and filling their own coffers. Having struck fame and riches in foreign lands, some of them got back home in India and erected luxurious temples, thus leading to further increase in their following and fortune with these real estates.

In the Indian context, this profusion of philosophies that varies from absolute atheism, as does Buddhism, to complete materialism

on one hand and total renunciation and most ethereal of concepts on the other — it paved the way as much for infinite cosmological and mathematical speculations, as it served a basis for the intrinsic Indian beliefs. All these beliefs refer to at least two concepts — that of reincarnation and the fundamental oneness of Divinity, no matter how it is presented, how it acts, or whatever name may be attributed to it. But one aspect is more than amply clear that Divinity is in the heart of every being and that every form of worship, no matter how primitive or grossly superstitious, is legitimate from a certain religious point of view. For, religion seems to permit everything without any distinction, since diversity is the way of life and man is responsible only towards himself.

Hence, Indian devotion is a very curious blend, as fairly evident in the course of pilgrimages and grand celebrations. It is authentic devotion of the devout with as much an element of curiosity to know, as the desire to escape from the confines of the universe that entail toil and domestic worries, to visit other places and interact with other people. That might explain why every great celebration attracts thousands and thousands of participants to religious centres. And these pilgrims often travel for weeks or months to arrive at their destination. For instance, during the mammoth *Kumbha Mela* that takes place every 12 years in one of the great locations consecrated by legend and tradition alike, as in venues, like Haridwar, Sravanabelagola, Kumbhakonam, Puri or Prayaga near Allahabad, the teeming millions comprising men, women, children, sadhus and sages, young and old alike mingle, though such uncontrollable numbers amassed together, can often lead to catastrophic stampedes. Elderly persons or children are trampled to death, or sometimes people are drowned, when an overloaded boat might get capsized. But with this undying belief that death is part of life and without death there would be no life, those who meet their end during a pilgrimage

are reassured of being reborn into a better life or perhaps achieve *moksha*, salvation.

It is a known fact that in the past many a devotee committed suicide by jumping from a sacred mountain, or those who volunteered to get crushed by the enormous wheels of the floats of Jagannatha in Puri during the massive celebration of *Rathayatra*. In the modern era, such mystic feats have somewhat diminished given the pressures and changing beliefs of a fast-paced material life; but still in the Indian mind, the fundamental belief persists that life is a small price to pay in return for the rewards of this sacrifice. For, it is the life after death that is far more important, and the real step that takes you closer to eternity; and this mundane life is nothing more than a simple passage to the world beyond. If you were to breathe your last in the holy precincts of Varanasi (Benares), the city of Shiva, it would be a sheer blessing for the worshippers of this god. The ghat, steps along the banks of River Ganges, are always crowded with pilgrims who come to bathe, purge their sins and regenerate themselves in the waters of this sacred river. Even those who are seemingly near their end, are brought here, so that they may breathe their last breath and their last rites be performed in this holy city. These beliefs are even more accentuated by the Buddhist doctrines that are equally emphatic about the impermanence of all things on planet earth. The idea of seeking that divine purity was and still is shared by numerous Hindus and Jains. The Hindus refuse to sacrifice any living being (*ahimsa*), even microbes, the Jains choose to wash away their sins in the waters of a sacred river, or the pool of a temple, before going to say their prayers. Earlier, sacrifices by fire were common with the Rajputs but today it is not only rare but a thing of the past. As these sacrifices by fire were perceived as a form of purification, even today the fire is symbolized by offering a light to a deity. And this light, in a way, represents giving of oneself. For, it is believed that

water and fire, being basic elements, can never, in any way, be tainted.

Even more curiously, there's a political angle to it as politicians often attempt to take advantage of these underlying beliefs, the ever-present religious devotion in the Indian spirit, and to use it for diabolic purposes. Even today, various political parties try to lure voters to the polls by using an image of a sacred animal, supposed to represent their programmes. Among all the sanctuaries venerating a deity in India, the oldest ones that remain behind belong to the Buddhist faith. Those that existed before were made of wood and other destructible materials and naturally disappeared forever. What they really looked like can only be determined by the structures made later in stone and also the relief sculptures and paintings that decorate them. In many parts of the country, devout Buddhists erected monumental stupas to commemorate Buddha's death and depict his doctrine. The most famous of these is located on a hill in Sanchi, in the centre of India. In the first century AD, some of these stupas had high doorways (*torana*) magnificently embellished with graceful bas-reliefs. This intricate décor, in a way, lends an idea of the architecture of this period and one can visualize the designs of homes and the cities. These amazing stupas are reproductions of one of the destroyed Bharhut that dated from the second century BC, but the admirable bas-reliefs are fortunately preserved in the museum in Calcutta. These are known to predate those that were erected in the southeast of the peninsula, principally at Amaravati. Those too were no less remarkable, covered with marble bas-reliefs of exceptional beauty. Unfortunately, an ignorant local potentate destroyed them in the nineteenth century in order to recuperate the building materials. As a stroke of sheer chance, a few of these splendid works were rescued and now they are the distinct pride of the Madras museum. They bear witness to the fantastic talent of the artists during the first

century AD. Between the second century BC to the seventh century AD, religious Buddhists dug some thirty grottos in the cliff of Ajanta. Most of these grottos are decorated with paintings, which is why they are called the 'Sixtine Chapel of Buddhism'. But there has been a negative fallout of the constant flow of visitors, as it seems to have blackened these frescos and some of them are even indiscernible. It is being seriously considered that there could be a possibility of reproducing them elsewhere, following this pattern. The design of Buddhist grottos that originated in India found in great number right through the country, was exported to Afghanistan and Central Asia. From Longman and Yungant as in Dunhuang in China, they can be seen all along the Silk Route, where they were widely constructed.

Thus, the Hindu and Jain sects followed this example and also excavated numerous grottos in Ellora that is some distance away from Ajanta. In the seventh century, they sculpted from the side of a cliff, an enormous jewel in stone, dedicated to Shiva, the Kailasa. This was modelled after similar temples erected in the south. With more intensive digging, these were found to be scattered almost everywhere, each one more magnificent than the other, most notably at Badami in Karnataka.

Actually, there doesn't seem to be any clear distinction between temples and sanctuaries devoted to Shiva and Vishnu. Given the same style of architecture that seems to have been adapted simply to suit the rituals of each sect, it became customary to describe these religious monuments as belonging to the 'Northern Style', characterized by a high curved tower (*shikhara*) rising above the sanctuary. Considering that the 'Dravidian' style (southern) has a tower of several levels called *vimana*, or the 'hybrid style' (*vesara*), that is seen most often. In real terms, it is quite difficult to determine which style is which, for each one has obviously influenced the other in the course of these

centuries. It would rather be more appropriate to describe these temples and sanctuaries according to the region they were erected in. Some of them seem to belong to no particular style at all, as perhaps they are the outcome of an architect's fantasy, who built them at the behest of the devout.

But as a matter of fact, the devotees barely pay attention to styles and even less so to the skills of the sculptors and painters. They are perhaps more interested in those scenes that depict the deities in these paintings and decorations, rather than in any particular idea of symmetry or architectural genius. It is owing essentially to the aesthetic sense of the rulers and the educated elite of the ancient times that one today gets to admire the masterpieces of India's religious art. As stated earlier, the devotees are barely interested in art, and they venerate Vishnu as much in a statue made by a great sculptor, as they would do a simple piece of wood painted with His image, like that of Jagannatha at Puri. Actually, for the devout, the form is of no significance, for it is merely seen as a support for a superior being. A simple round picture can often replace a statue of Shiva, lovingly designed by a sincere artist, an ammonite fossil (*shalagrama*) replaces an ornate portrait of Vishnu. For that matter, even a simple coconut, since it has three 'eyes' often replaces a statue of Shiva, and a pot of basil (*tulsi*) can become synonymous with a picture of Vishnu.

The innumerable temples, some of which remain unparalleled in architectural splendour, are therefore, not due to the devotion of Indians, but rather the consequence. The great rulers of this country had the temples built as much to glorify the deities, as to affirm, ascertain and assert their own power. And the Brahmins had them built to show their intellectual and moral superiority and attract gifts from the followers. But in spite of the lavish use of marble and elaborate decor, modern temples are not as alluring from an aesthetic point of view,

and display no sense of innovation. It is merely a reflection of the pride and sometimes amazing wealth of the Brahmins, though in no way has this had any noticeable effect on the devotees, who however, crowd them with as much devotion as those venerable structures, where rulers and artists competed to showcase the best of their talent and technique. For the devout, divinity resides just as much in a marble cake covered with gold, as in an architectural jewel, artfully carved in granite or sandstone. They come to worship the deity who has its abode inside the temple, and not to admire the craftsmanship, no matter how sublime it might be. A god cannot reside in something imperfect, worn out by the years, broken or in ruins. A broken statue, even though repaired, does not complement the spirit of a god to live in. As this belief prevails, one cannot worship decently or wholeheartedly. That should explain why the old temples are mainly visited out of curiosity. Only the very eminent sanctuaries, lovingly looked after over the centuries by generous donations from a succession of Brahmins, have really been saved from being desanctified. Such examples can be seen and appreciated as in the case of the Lingaraja in Puri, or the Brihadeshwara in Tanjore, among others. For the most part, old temples are bereft of the devotees, who visit them more as tourists, than drawn by a sense of devotion. However, the reverence remains, as they never fail to offer flowers to statues or divine pictures that are still in good condition. So, one need not be surprised, if while visiting an old temple, where rituals are no longer solemnized in an ambulatory or gallery, one finds a statue of Shiva, Ganesha, or Vishnu or some other deity, adorned with a wreath of fresh flowers. You may even see that some pious hand may have put a little red powder and a candle at the foot of the statue. Or one could sometimes encounter a Brahmin, with folded hands, who might have strayed in here, reciting a prayer before a giant sculpted statue of Nandi or Varaha.

Such instances are found in the temples of Khajuraho, where their pristine look has been miraculously conserved from the ravages of time and human beings alike.

For that matter, India as a whole is a vast museum, exhibiting to the bedazzled eyes of travellers, a stunning diversity of temples and places of worship. These temples are at times hidden in almost inaccessible areas. More often, even hidden in the maze of a large city or lost in poor villages, far from the bustle of hi-tech life. They may be perched on the banks of a river under a grove of coconut trees, or isolated in a desert landscape. All these are obviously in addition to Buddhist monasteries, places of devotion, which the monks constructed well away from densely populated centres, in the quiet solitude to meditate and preserve their concentrated spirituality. Most of these are located on the lonely, frozen slopes of the Himalayas in Ladakh, or at the other end of the mountain chain, on the green summits of Sikkim. One significant aspect of these places of worship is that almost everywhere in India, mosques are scattered among the Hindu temples, and bear witness to the Muslim presence in the country. There are plenty of mosques or tombs of every size, simple, or grand, like those of Humayun (1565) or the Taj Mahal (1632-1652) in Agra. Those of the Bijapur and Golconda dynasties are located in the south. It is rare to see any abandoned mosques, for prayers are still said every day. But on the other hand, quite a few tombs have been abandoned, for no one pays a visit any more to honour those for whom they were built and who are now obviously forgotten. Their sole visitors are art lovers or archaeologists.

Hindu monuments, however, are far more in number and generally older. Few temples were constructed in the north after the Muslims arrived at the end of the twelfth century. In those regions, where Islam barely had much influence, religious structures continued to be built. This was mainly in the west and south of the peninsula and in relatively remote regions too. This was what happened in Orissa, where, in the middle of the thirteenth century, a Hindu ruler was still powerful enough to build the great temple of Konarak. In the west, dominated by the Jains, the rulers were builders and restorers, in Mount Abu, in Palitana, and at Girnar in Saurashtra. Further south, in the twelfth century, the Kings of Hoysala, in Karnataka, ordered the construction of splendid temples. And they seemed to have a distinct, peculiar style with three sanctuaries and were located in Belur, Halebid and Somnathpur, to name a few. Others followed in a similar style in Warangal too, mainly continuing the architectural tradition of the region that flourished in Badami, Pattadakal and Aihole in the seventh century. But these structures reflected an early style that later conquered the north and led to the prestigious clusters in Bhubaneswar, near Puri. These temples were first dedicated to Shiva and then to Vishnu, grouped around a large lake, Bindusagar. The most striking among them is the enormous sanctuary of Lingaraja, rebuilt between 1090 and 1104, and whose *deul*, the sanctuary tower, rises more than 40-metre high.

It was in the face of the Muslim threat that a great Hindu empire, that of Vijayanagara, was created in Karnataka and Andhra in 1336. From its Capital, the renowned though now the deserted site of Hampi, this empire conquered a part of southern India and established fortresses and temples all over. Receptive to interacting with foreigners and fostering trade ties with them, the empire had, in no time, become so very prosperous; and in the fifteenth century, its Capital counted over half a million inhabitants. This city elicited the admiration of the travellers, having been fortified by seven successive walls. Travellers, like Barbosa or Abdur Razzak relate that the city had palaces 'whose roofs and walls were covered with sheets of gold as thick as a sabre's blade and were encrusted with

jewels.' The immense sprawl of temples across the empire reflected renaissance of the Hindu faith, perhaps owing to the religious tolerance of its rulers. But the immense wealth and prosperity of this empire caused its downfall and in 1565, a coalition of Muslim princes defeated the empire's forces at Talikota, and mountain tribes plundered Vijayanagara, over a long period. The last of the rulers were simply unable to protect the city from these attacks and the empire fell apart, as the provincial leaders, the Nayakas, sought their independence. And one of the most important among them, who reigned in Madurai, won acclaim for having built an extraordinary city temple there. And this temple was dedicated to the cult of Meenakshi-Sundareshwara, the forms of Shiva and Parvati. And during the same period, a temple, which surpassed in grandeur was built in Tiruchirapalli, on the island of Srirangam on River Kaveri, totally devoted to the worship of Vishnu. This considerably enlarged an ancient sanctuary, where, from the seventh to the tenth century, it became a centrepoint for the aspiring and inspired poets, the Alvars. In their songs of mythical devotion, some of the most sonorous verses in Tamil literature, they chanted the glories of Vishnu and His *avatar*, Rama and Krishna. Not only are these great temples noted for their numerous surrounding walls, but also the slender towers (*vimana*) of the sanctuary draw awe and wonder, especially, for their very high doors (*gopuram*) rising above the entrances to the walls (the one on the southern side of the temple of Meenakshi in Madurai reaches 60 metre). The various floors are decorated with thousands of statuettes, representing the 33 million gods of the Hindu pantheon. It also has mythological scenes and sculptures, which are, in principle, repainted every 60 years. The number of these *gopurams* may be as many as 21, as in Srirangam, with the height diminishing as one nears the sanctuary.

Inside the walls, an entire city, both religious and secular in character, stretches forth with its shops, markets, temples, and *mandapa* (pillared halls with flat roofs, whose pillars are sometimes in the form of horses or mythical animals), which is perpetually animated, as Brahmins mingle with the merchants and the devotees. Not an hour passes by without some ceremony or other, a *puja* (ritual prayer), or a procession taking place within the innumerable sanctuaries, which can be safely termed as a 'pious factory'. The devotees and the pilgrims pray there, chanting the names of the divine, burning camphor and ghee on the makeshift altars, breaking coconuts to the clashing sound of cymbals in order to make an offering. They even sleep in the courtyards and have family meals. It is a never-ending *mela* of piteousness with perhaps no parallel, though one can easily imagine similar acts taking place in parts of Europe during the Middle Ages, when faith was as intense, like in this part of the world and, so obviously inextricable from even the slightest chores of daily life.

During the reign of the Pallava and the Chalukya in the seventh and eighth century, the south of India rivalled the talent and imagination of Karnataka, in early attempts at architectural construction. In Mahabalipuram, a little to the south of Chennai, figures were carved in rocks scattered along the beach. Symbolic scenes, like 'Descending the Ganges', were sculpted in the stone face of a cliff, while temples were constructed in granite, like those of Kanchipuram, as a tribute to these great gods.

The devotion of the devout Indians cannot possibly be measured by the number or beauty of their temples, for this dedication to the Divine permeates every moment of the life of each individual. Certainly, India is the country of gods, but above all, it is the country of devotion, an incredible devotion to all possible expressions of the divinity. And for Indians, the real life is not the one here on earth but in the divine hereafter, which, far from being a paradise brimming with happiness, is rather owing to complete absence and lack of desire — for, that abstinence eventually warrants the absence of any suffering.

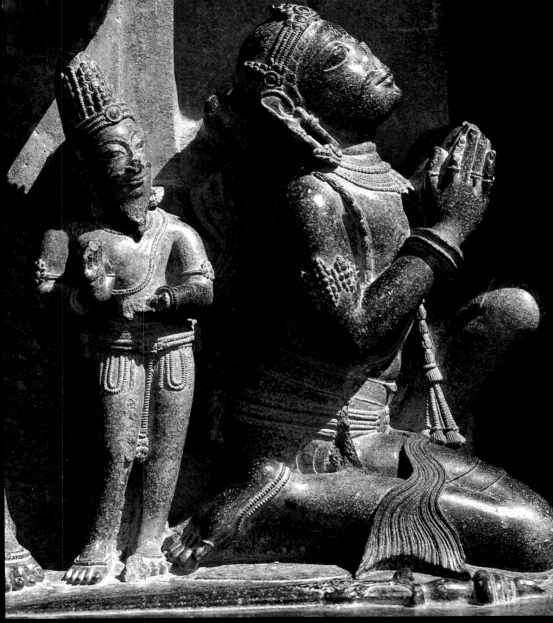

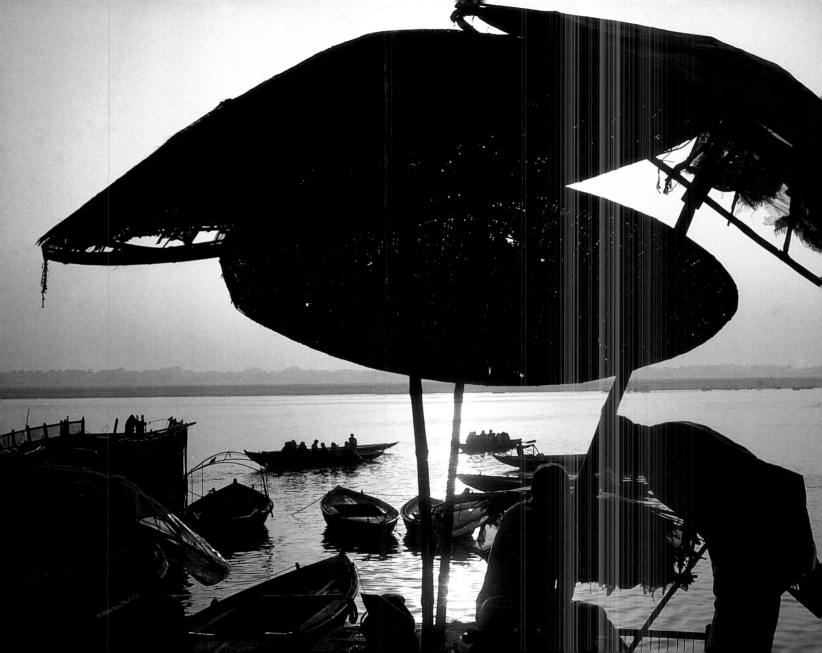

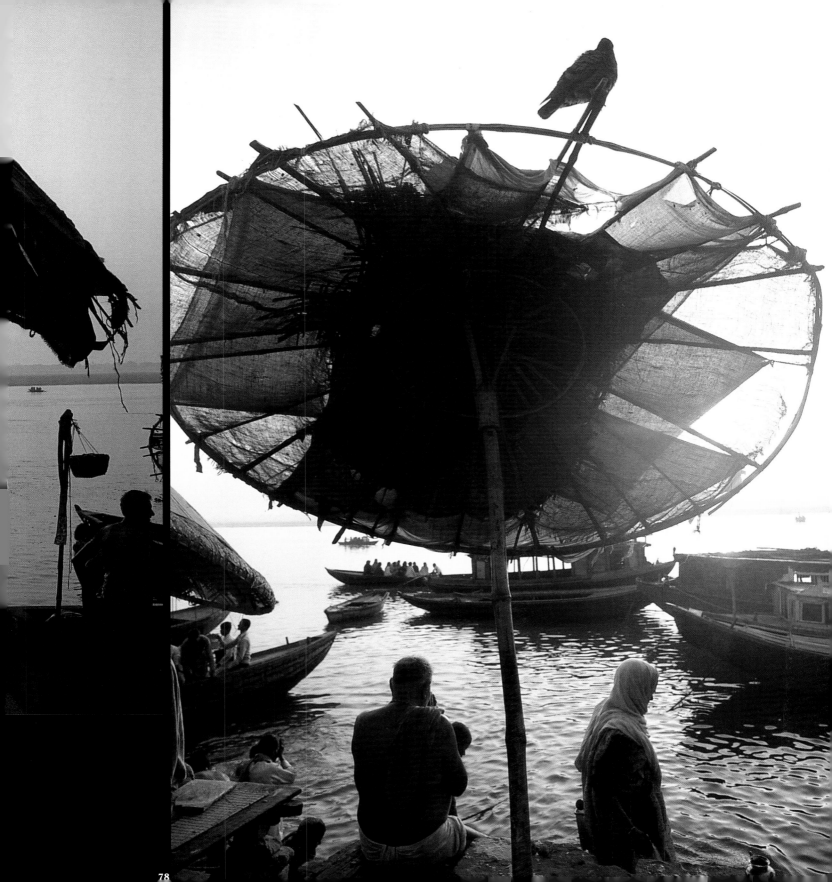

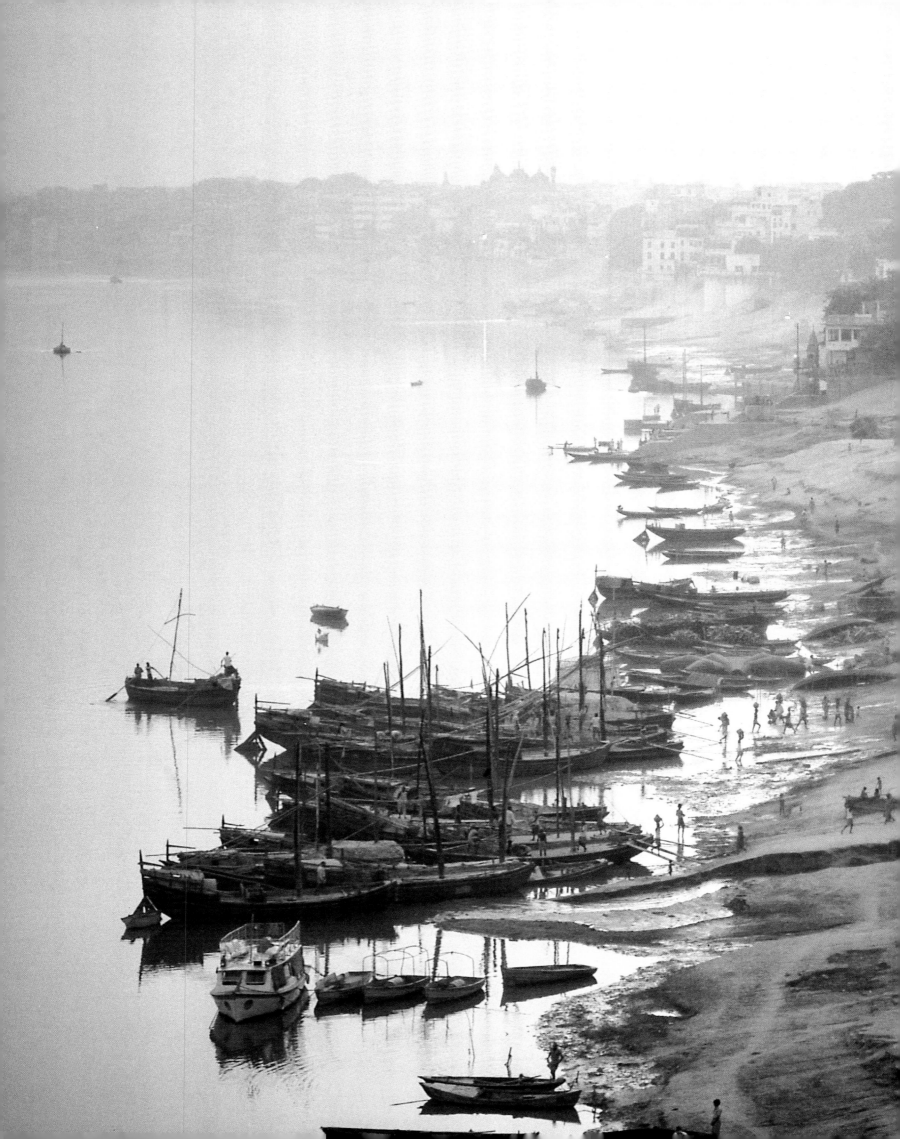

Right through the year, the ghat in Varanasi is overcrowded with the devotees, who come here to bathe in the Ganges. On the occasion of the Grand Puja, during the full moon of November, a sea of pilgrims comes to pray and bathe in the sacred river to purge all their sins.

At sunset, fishermen and freight carriers leave their boats moored on the banks of the Ganges, at the exact spot reserved for them, to the east of the famous marble ghat (79).

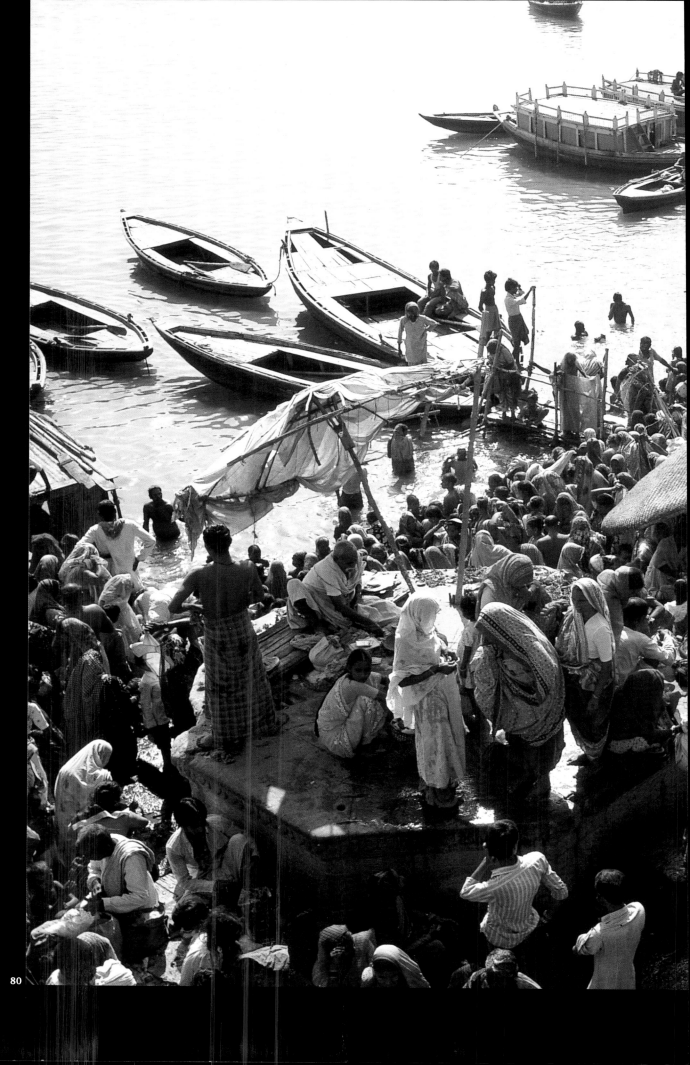

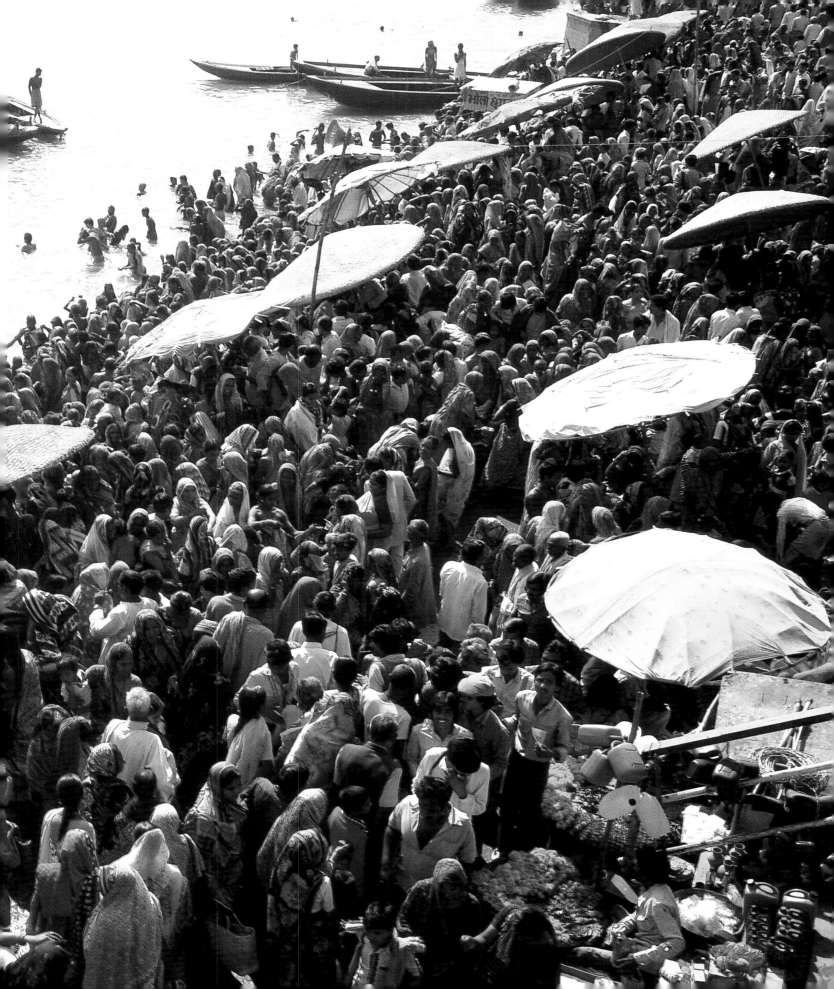

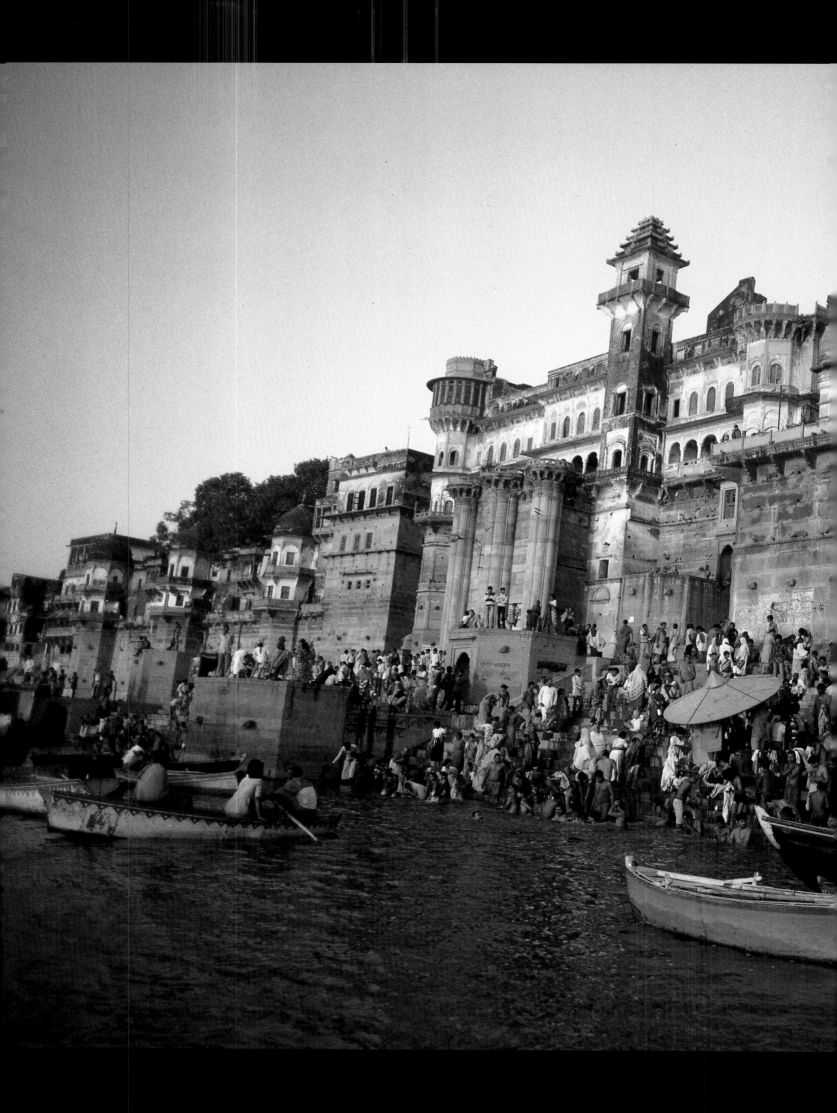

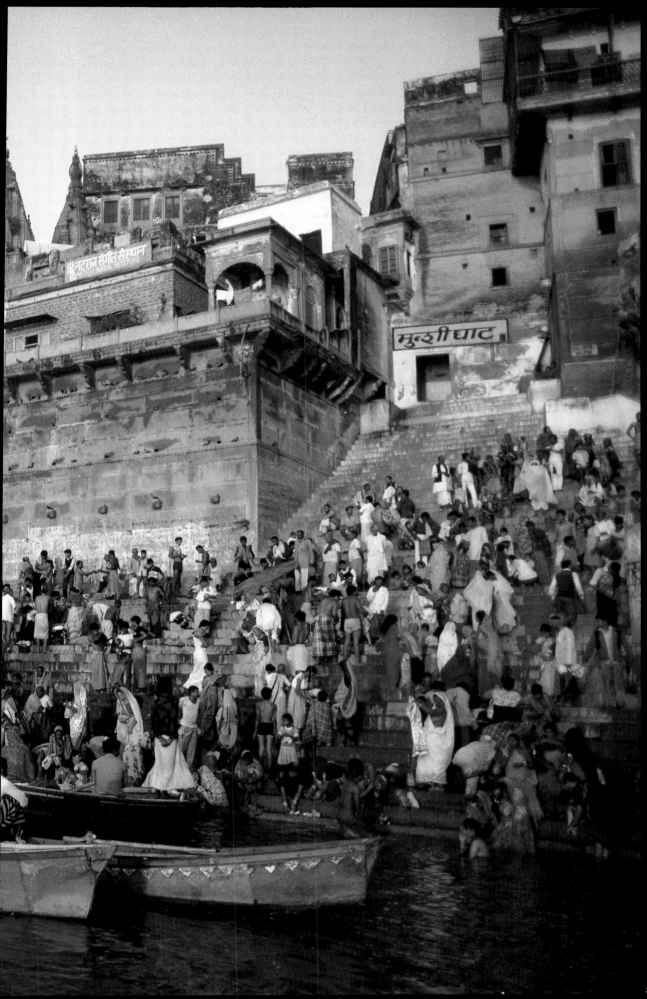

मुन्शी घाट

The city of Varanasi rises above the banks of the Ganges, plunges its ghat into the river, and overhangs its sacred waters with temples and princely residences. The endless crowds surging towards the river, attracted by its purifying and regenerative waters, in their haste, take little notice of the majestic structures, lined along its banks.

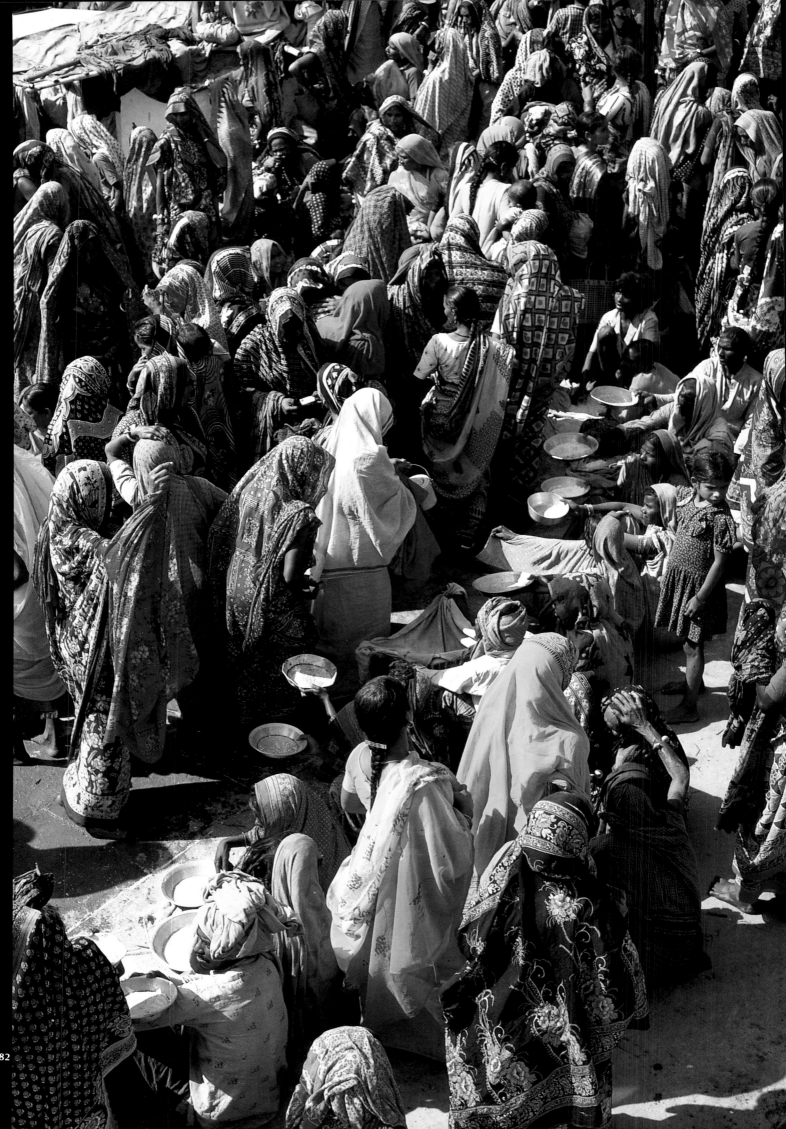

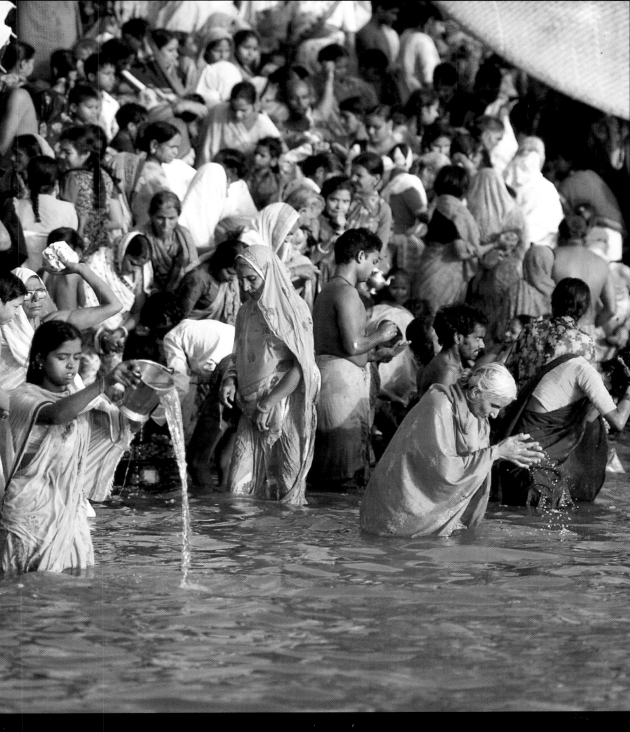

The streets of the sacred city are constantly brimming with the followers.
There are many beggars too seeking alms, with a hope to receive
an obol from those who were fortunate enough to get to
the water and to plunge themselves, fully dressed,
while performing the prescribed
rituals. With such intense homage
paid by teeming millions to
this nurturing river, the Ganges, is
reverentially addressed as the

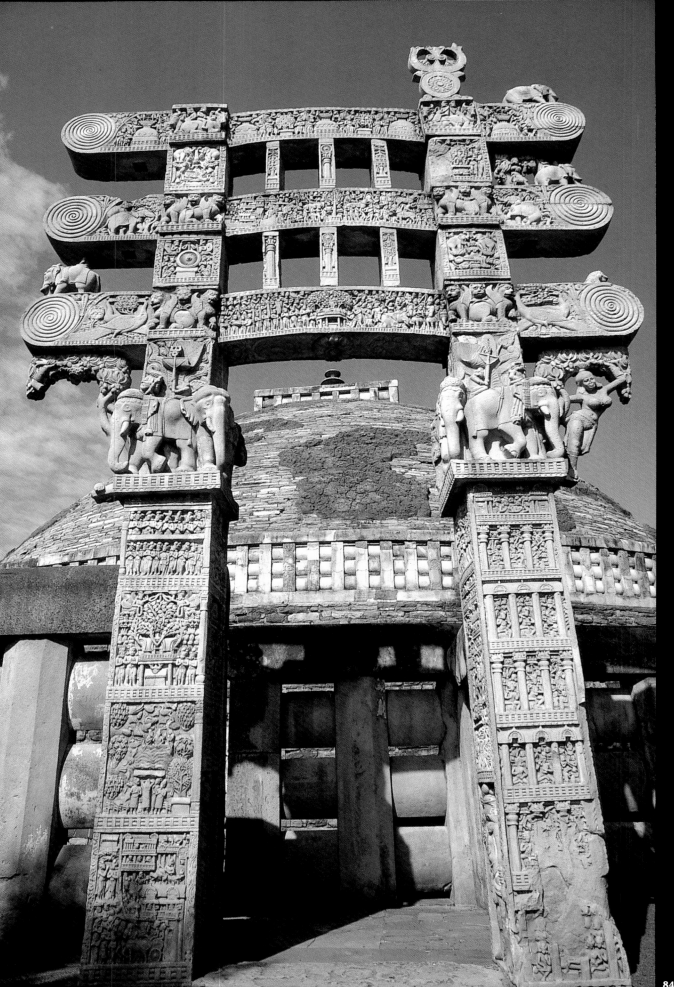

Right in the centre of India, in the Sanchi, lies one of the oldest Buddhist sanctuaries, founded in third century BC, during the reign of King Ashoka. Large stupas, hemispheric structures symbolizing the teachings of Buddha, were built of brick, covered with quarry stone and enlarged in the first century AD. High, decorated porticos, toranas, stand before the entrance to the ambulatory, permitting the followers to perform the ritual of going around them while touching them with the right hand. Splendid pillars in the form of tree genies, support their architrave.

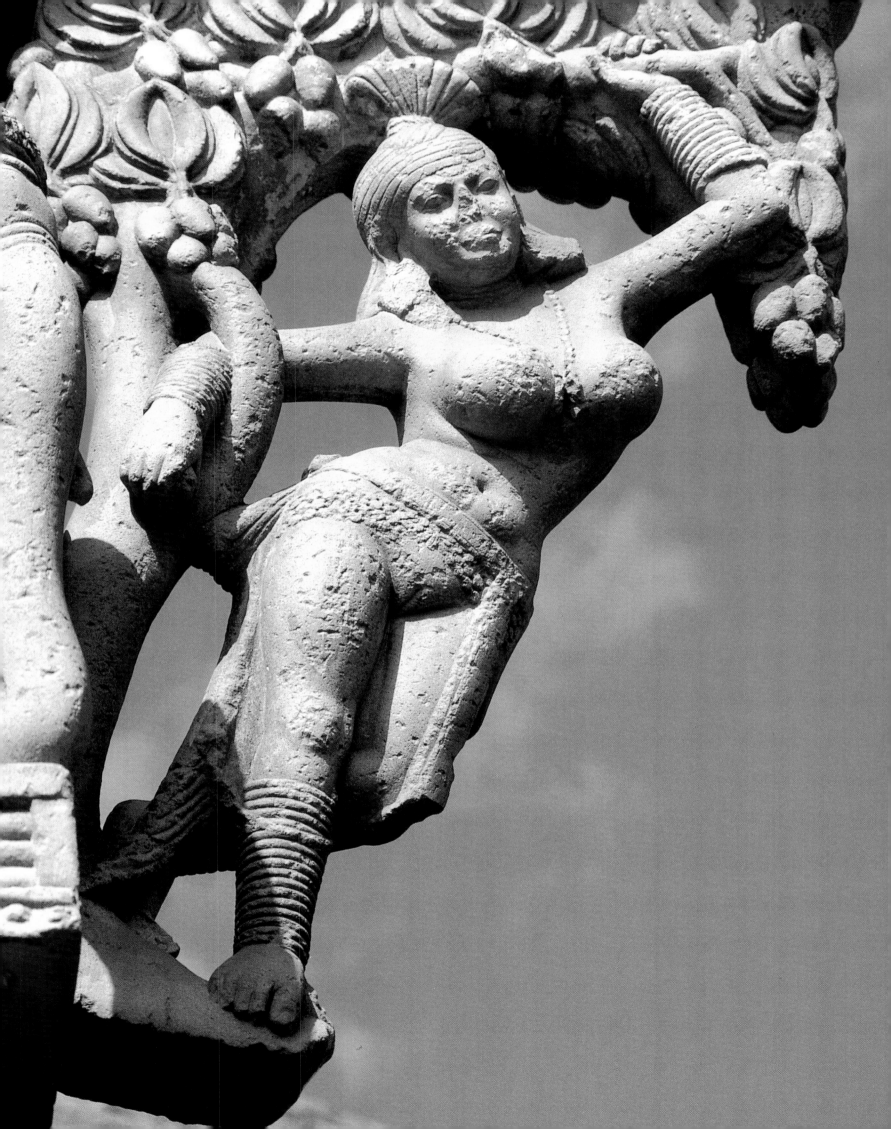

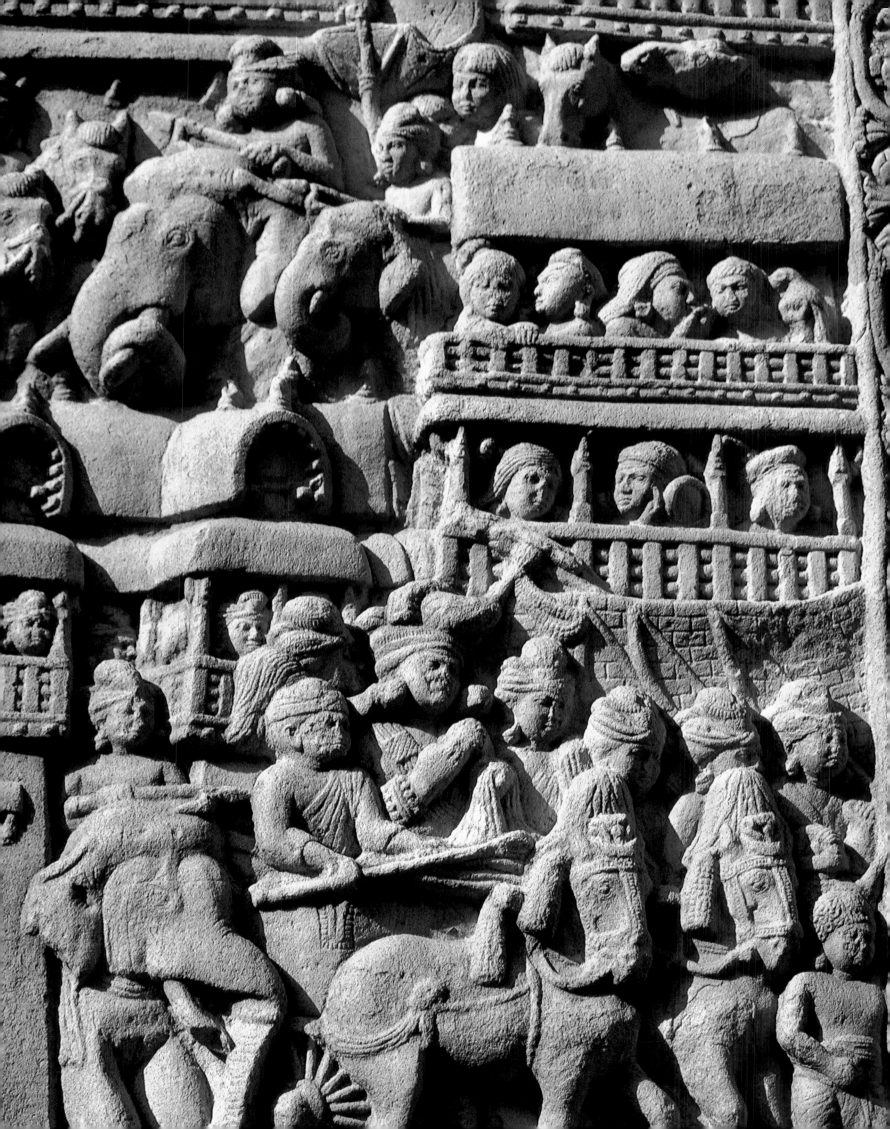

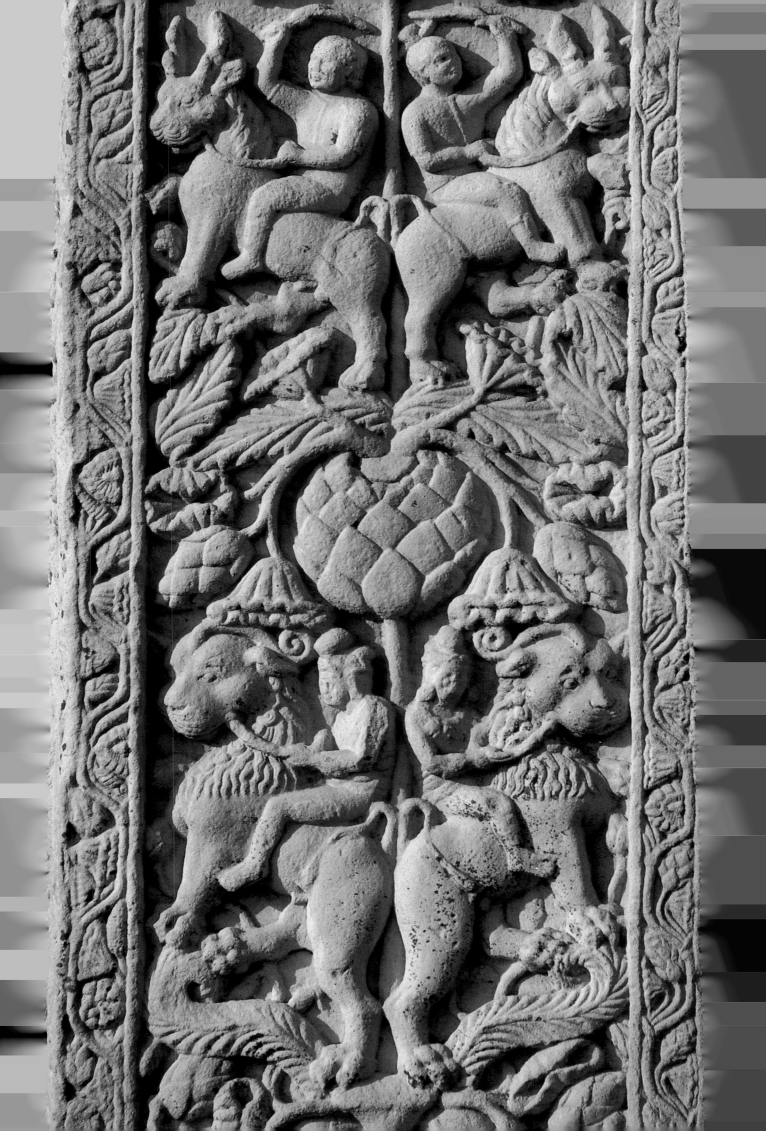

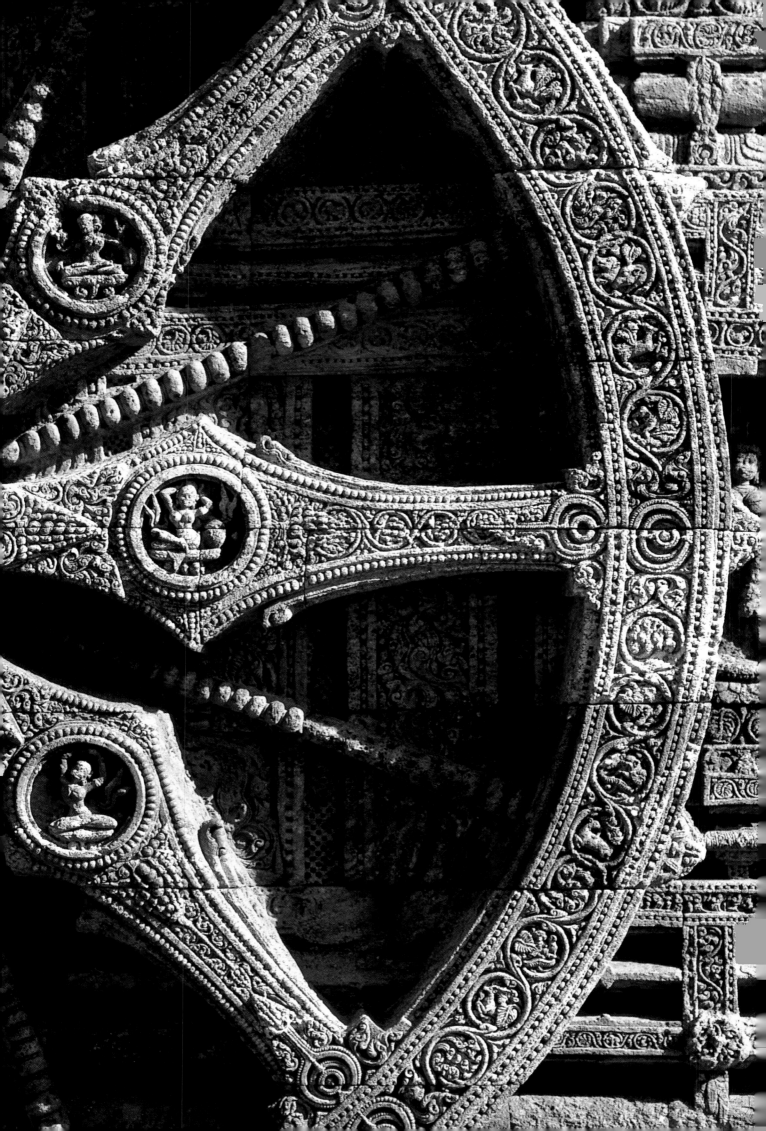

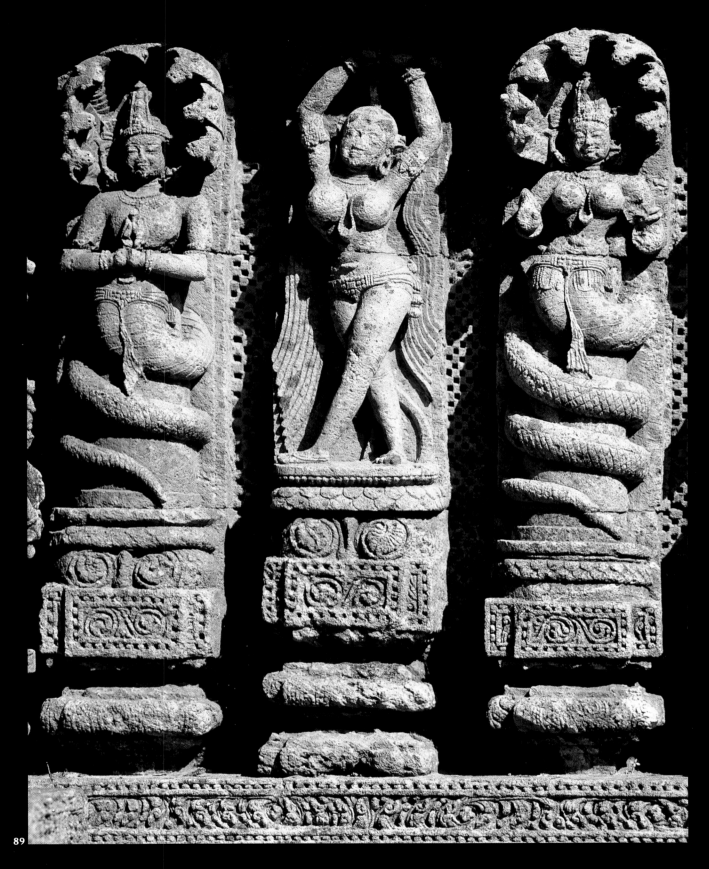

89

The great Temple of the Sun of Konarak, on the coast,
is the eternal symbol of the chariot of the sun, with its enormous wheels,
chiselled and wrapped with foliated scroll and historic medals.
The walls of the 'dancing room' in the temple are decorated
with delicate sculptures of dancers and Chtonian muses,
the Nagas, princes of poetry and fine arts.

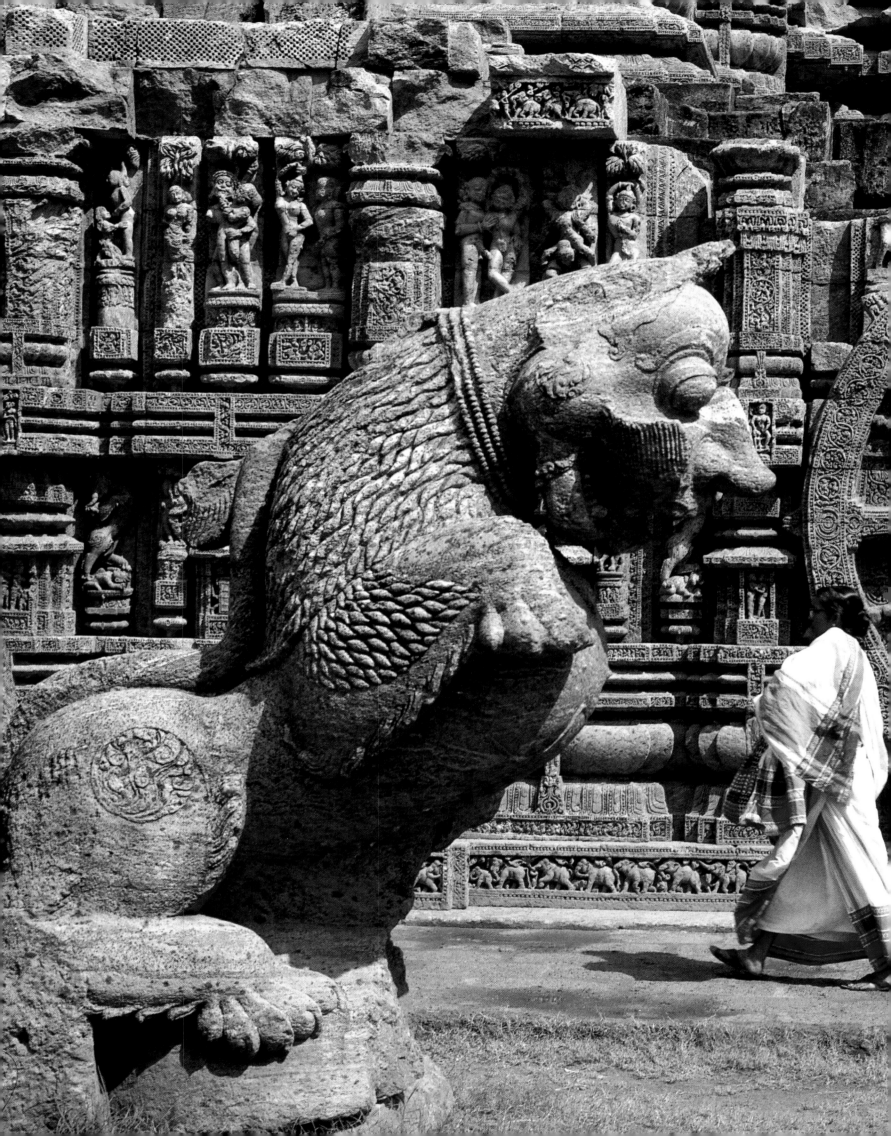

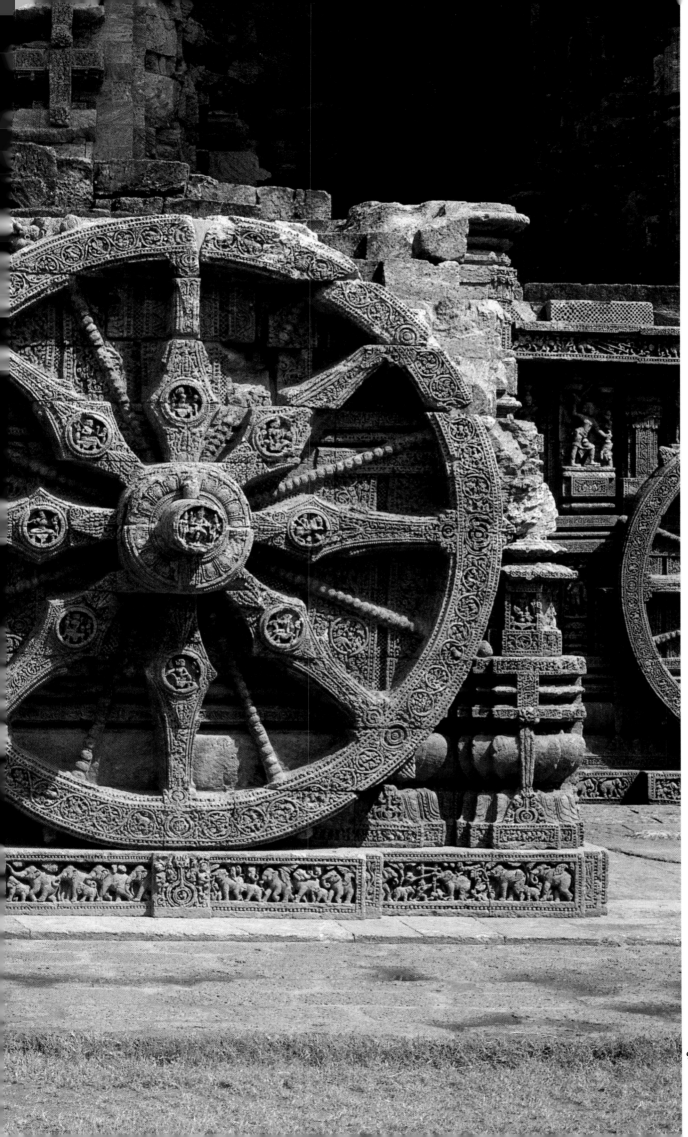

This immense temple, entirely sculpted in pink sandstone, encrusted with flecks of iron, makes for a gigantic solar calendar. Unfortunately, in 1630, an earthquake destroyed the 70-metre high main tower. Only the mandapa, the rooms, were spared. These are mounted on 24 wheels and drawn by eight stone horses. This sculpted decoration more than illustrates the glory of Indian art at its peak.

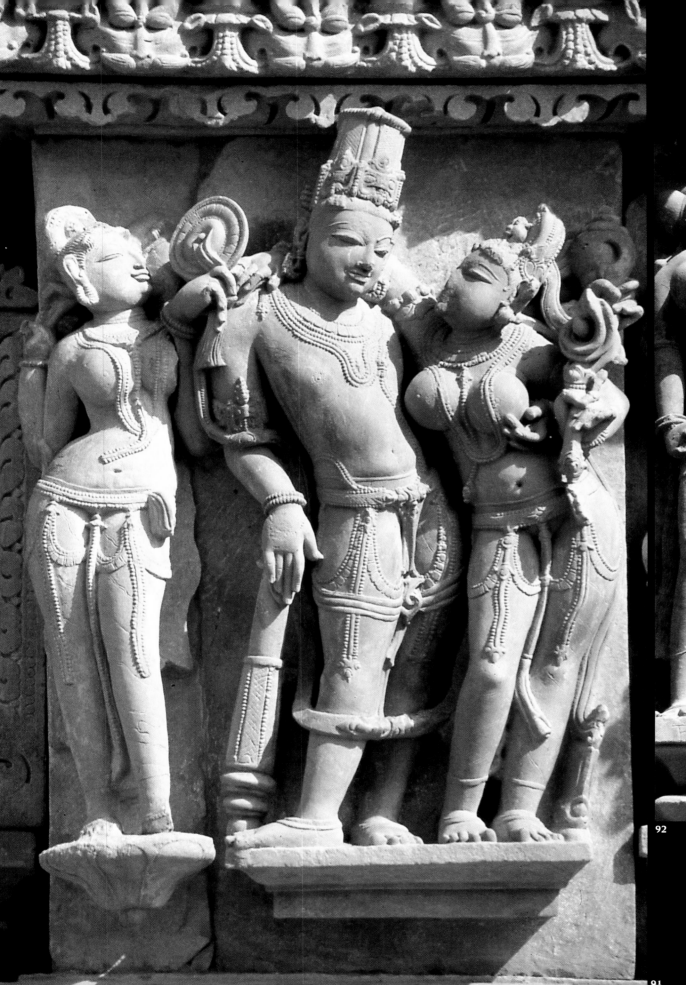

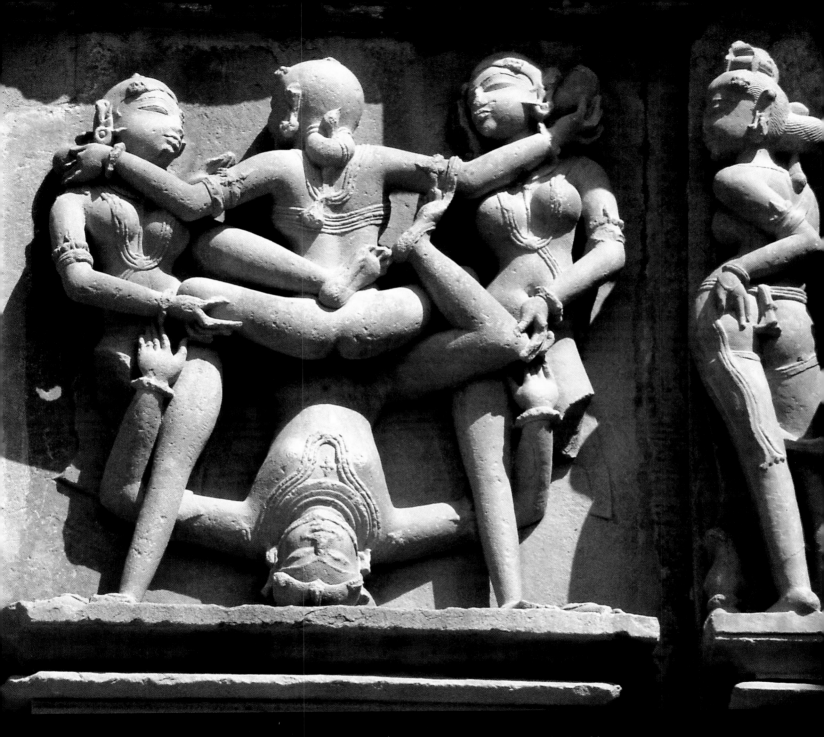

The 25 temples of Khajuraho, in the centre of the peninsula, were built of brown
sandstone in the tenth and eleventh century, dedicated to the great Brahmin deities.
Their rapturous adornment is a hymn to feminine beauty and mystic love,
often projected in these erotic poses, not in the least shocking for the Indian mindset of the times.
The real essence of these scenes evoked the many ways,

In Darasuram, in the south of India,
the great Temple of Airateshwara,
built by King Rajaraja Chola II (1146-1173),
is dedicated to the cult of Shiva.
Here, Shiva is shown coming out of
the sacred lingam after a dispute
with Vishnu. In Chidambaram,
the large sacred city of Tamil Nadu, the deities
are shown in all their forms, as on this copper
plaque that shows Saraswati, goddess
of music and the arts, atop the Hamsa,
the swan, known to be her vahana,
the mascot.

94

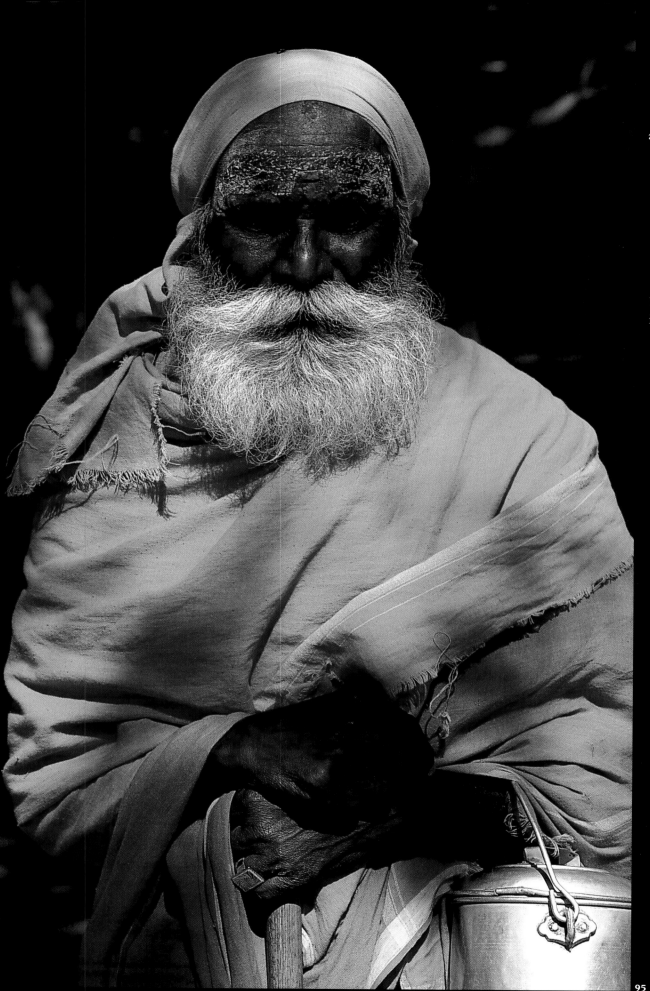

In the south of India, as elsewhere, there is a large number of sadhus, or wandering ascetics, as this follower of Shiva. Before going to the temple, he applies a sandalwood paste to his forehead and places a red dot between his eyebrows, indicative of his saying his prayers.

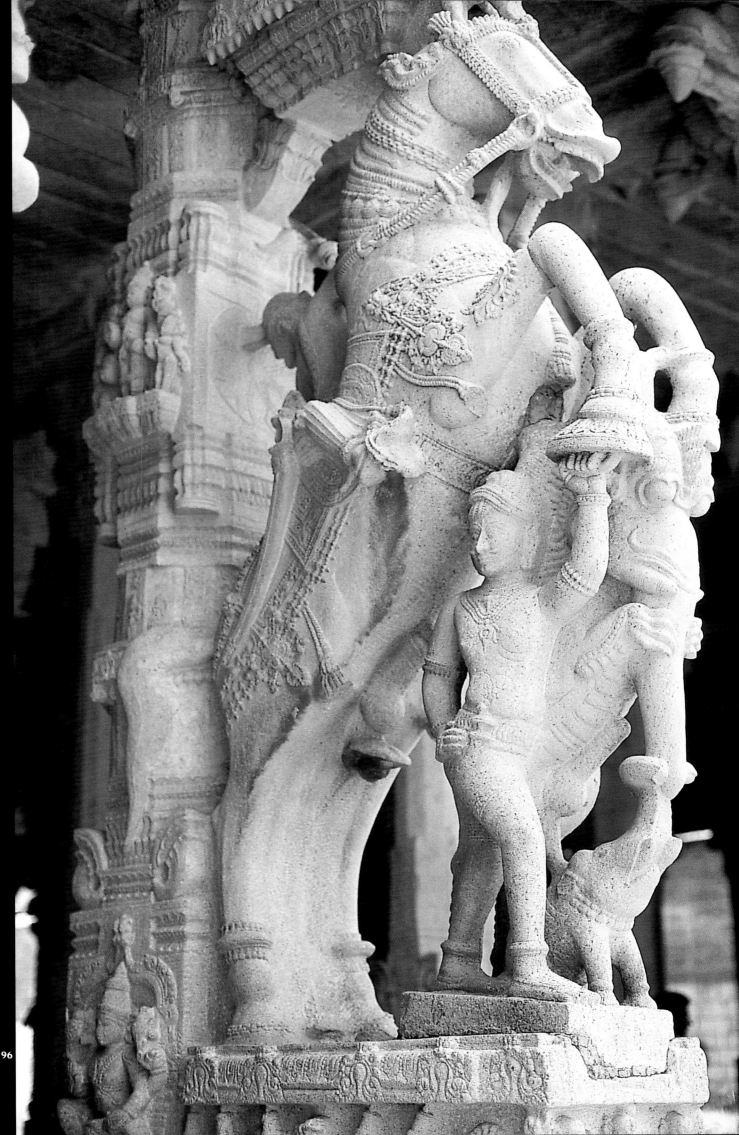

In the vat temple of Vishnu in Srirangam, enormous sculpted pillars symbolize the combat of the faithful (armed horsemen) against figures representing passions that trouble the hearts of human beings.

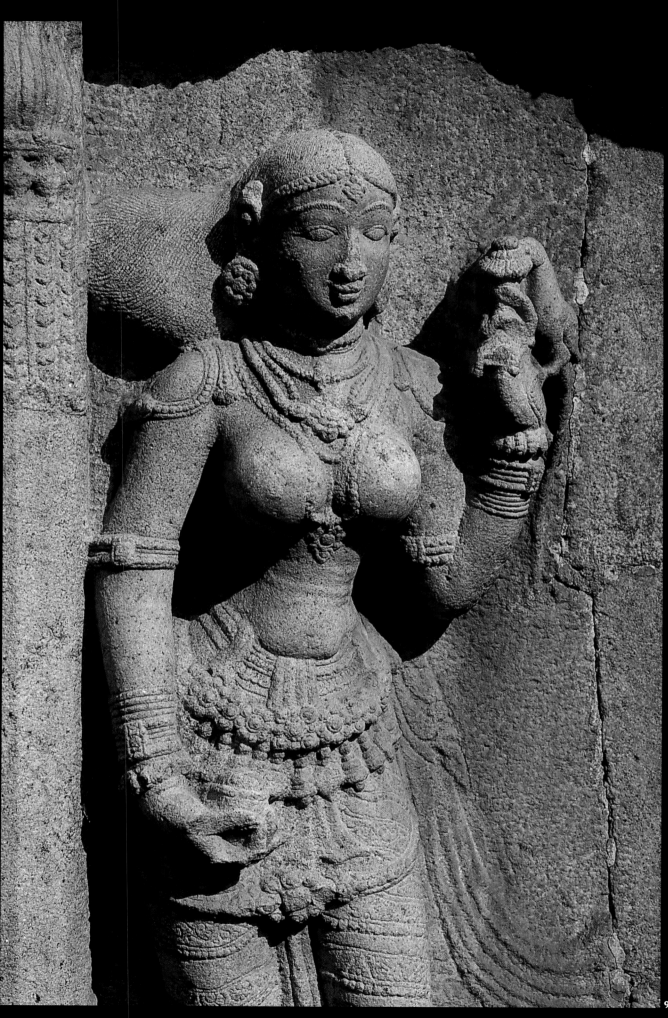

In the same temple, from the Chola period (tenth-thirteenth century), can be found carvings of donors, like these curvaceous princesses, their bodies covered with jewels. Indian sculptors were always particular about enhancing the femininity of their models by exaggerating their breasts and hips, while their legs were often treated as simple pillars.

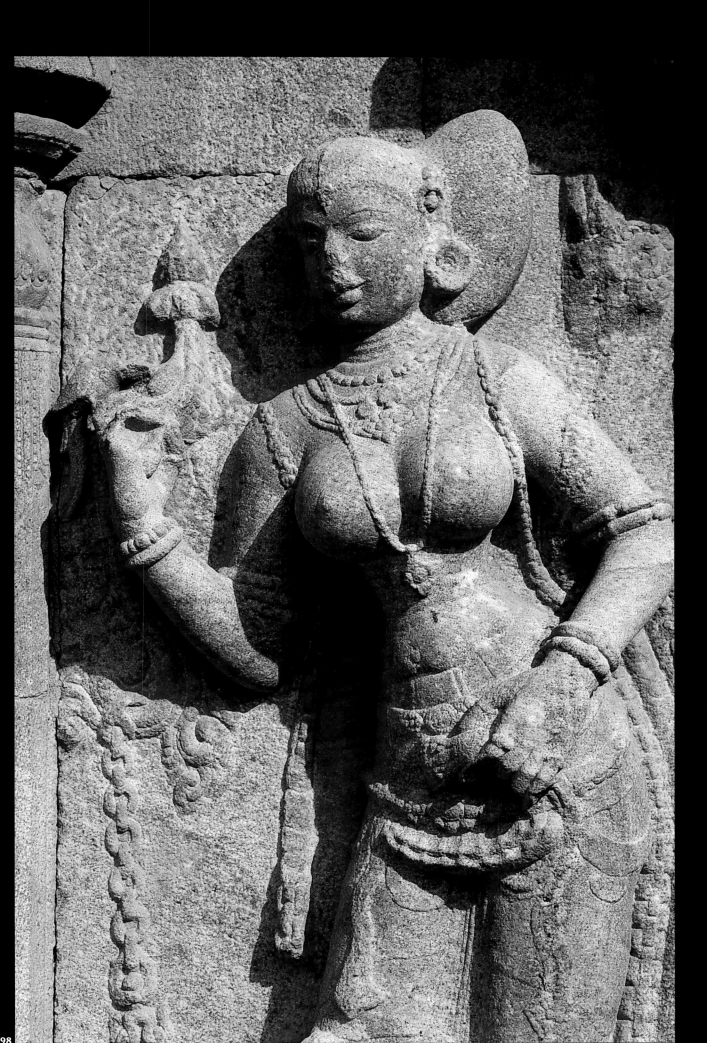

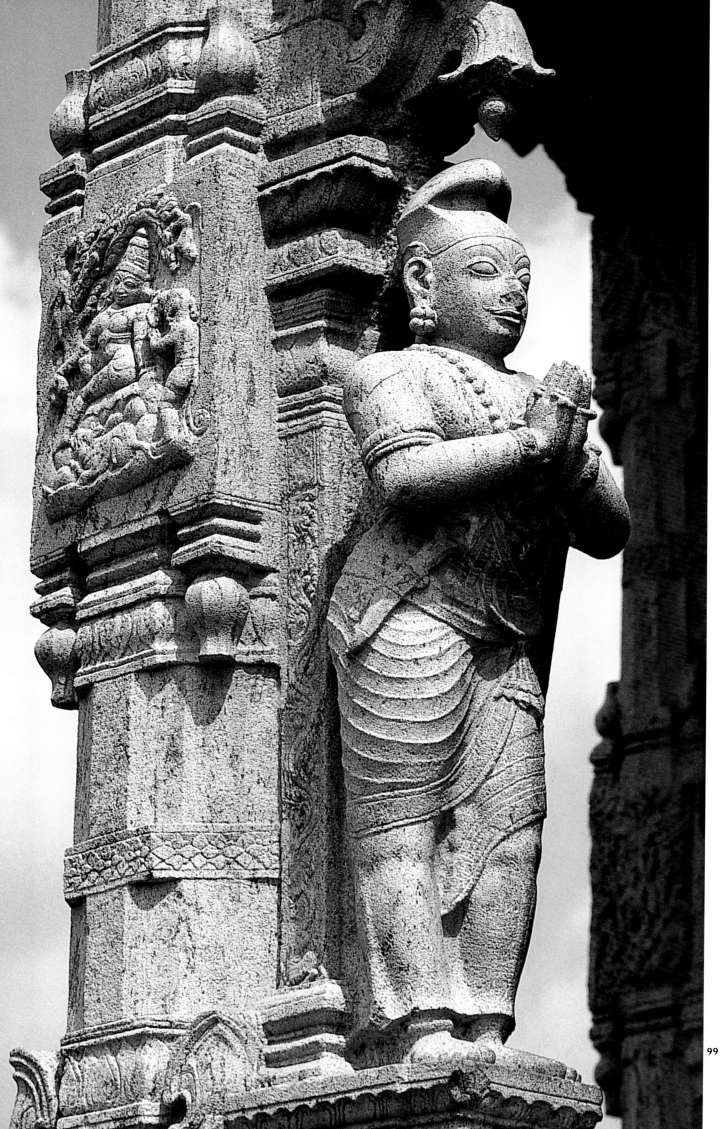

Benefactors are also shown in sculptures, like this one in a praying position, decorating a pillar of the great temple of Brihadeshwara in Tanjore (Tanjavur), built around the year 1000 and dedicated to the cult of Shiva. The temple can be seen here through the pillars of a mandapa. Its tower reaches a height of 66-metre and topped with a sculpted stone weighing 80 ton.

99　　　　100

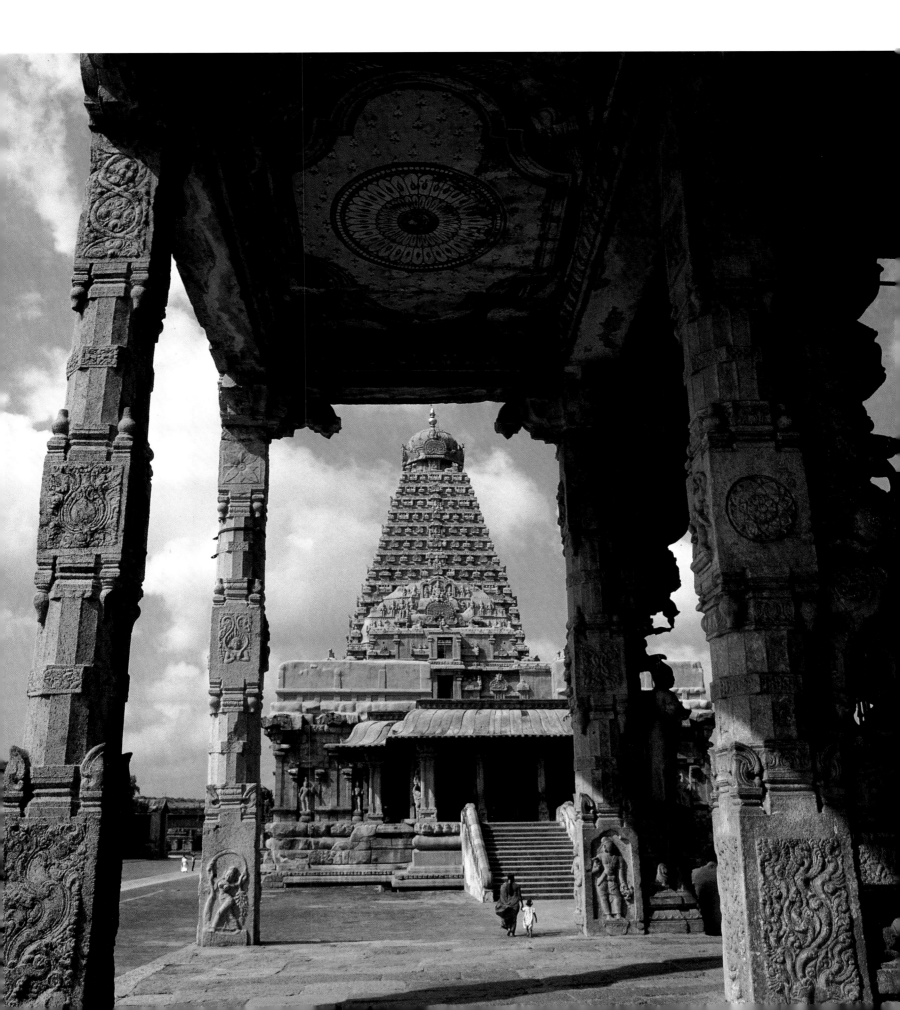

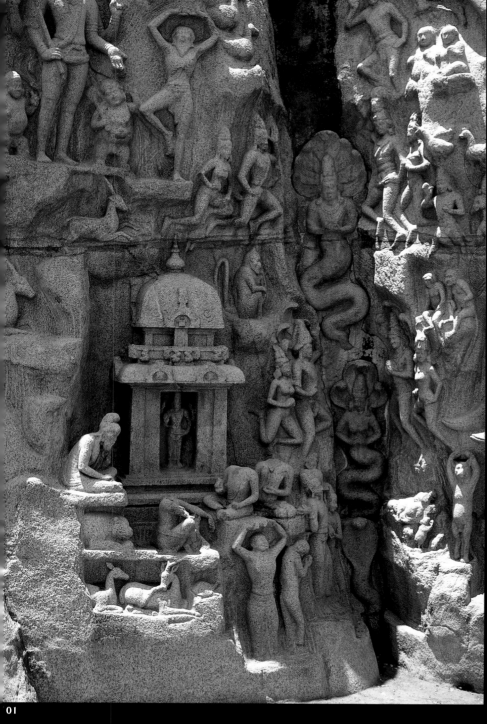

In Tamil Nadu, on the coast, at Mahabalipuram, numerous
sculpted rocks can be found. Carved in the seventh and
eighth century, these rocks represent architectural
structures, or as here, mythological scenes.
But the sculptures on this large rock,
'Descent of the Ganges', have yet to
be clearly deciphered.

01

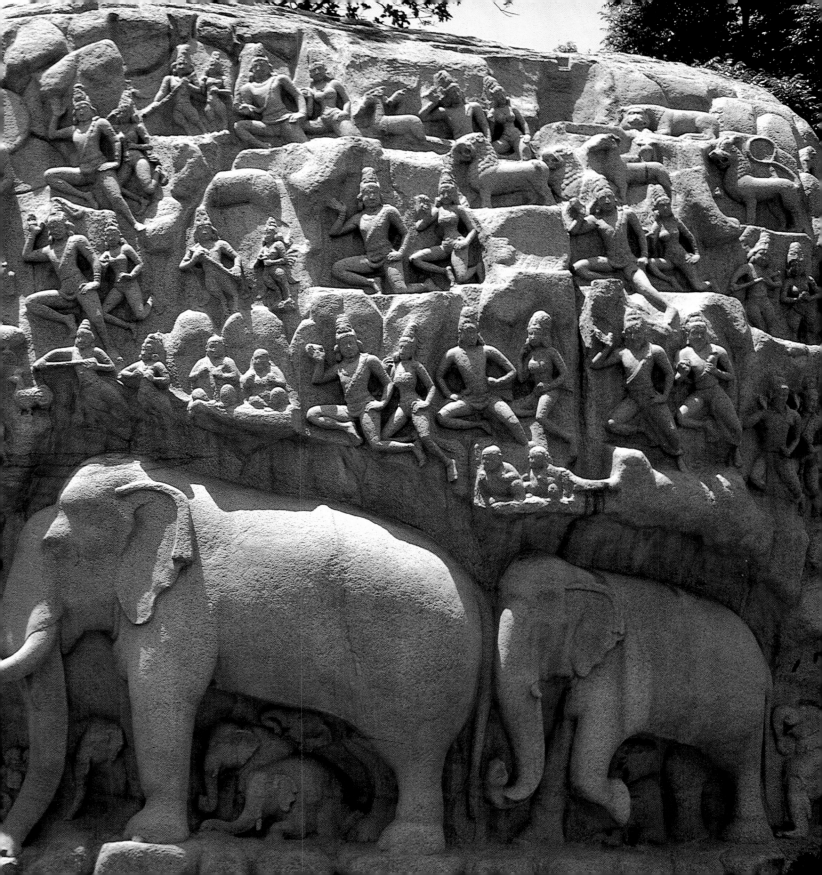

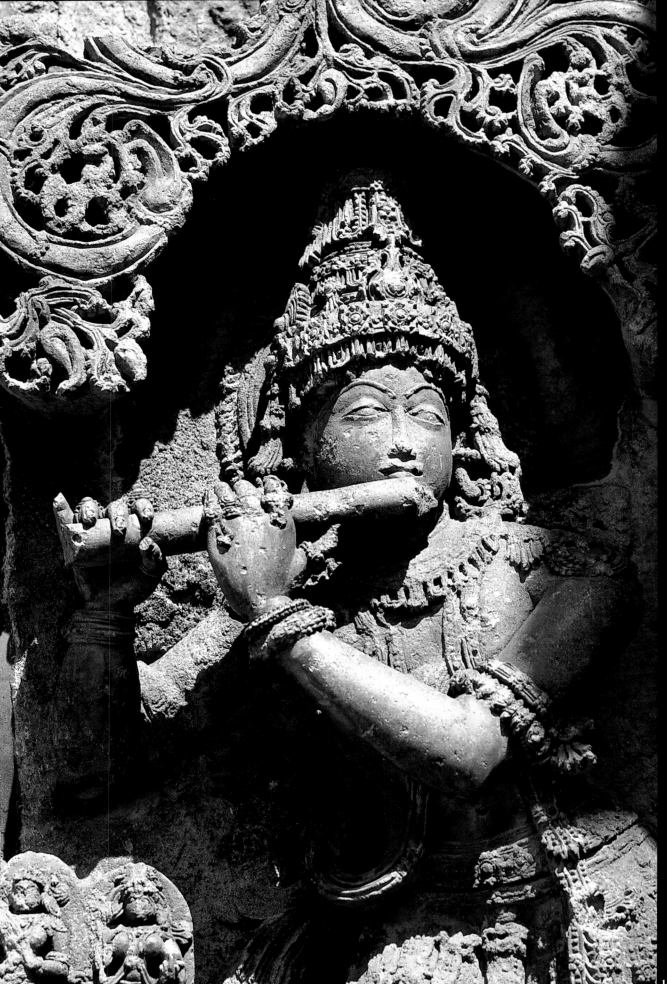

In the twelfth centur[y] the devotion of the rulers of the Hoysal[a] dynasty in Belur and i[n] Halebid, led them to erect magnificent temples dedicated to Vishnu, Shiva, and Surya. The walls of these temples are entirely decorated wit[h] the images of the deiti[es] and their avatar, or incarnations. This one depicts Vishnu-Krishn[a], the divine herdsman, playing the flute to attract and charm soul[s] represented by the gopis, the maidens tending the cows in th[e] gardens of Vrindavan.

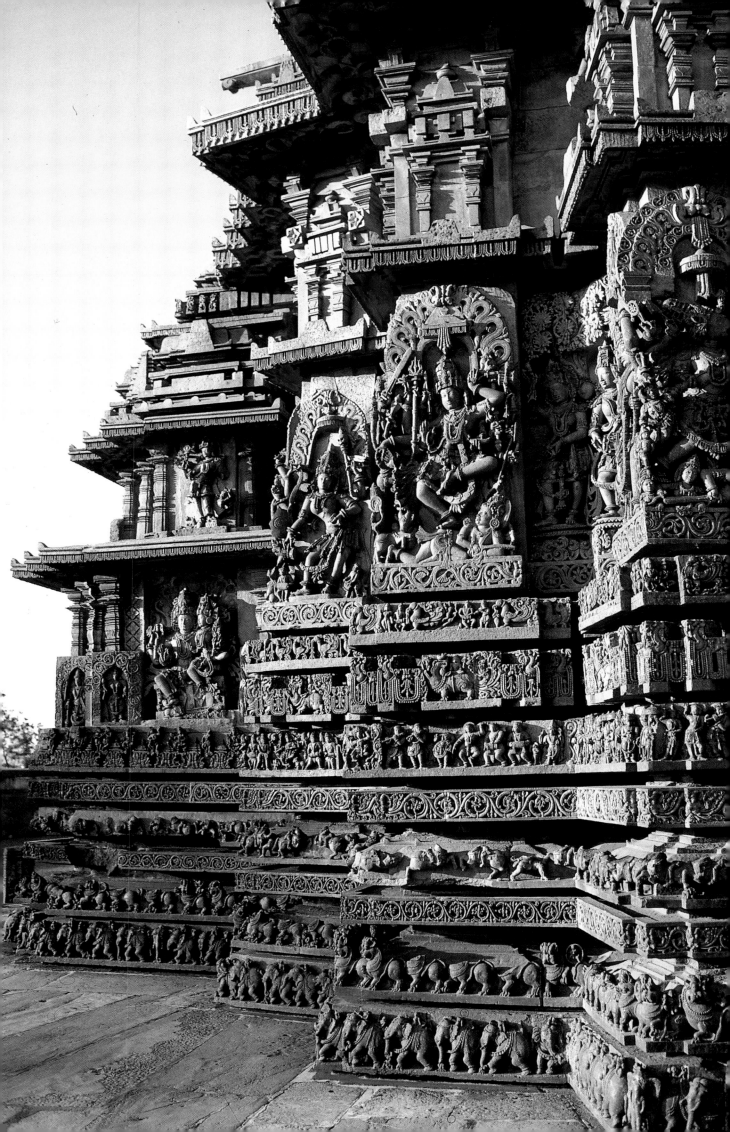

True followers or simple visitors, no one ever fails to make the ritualistic tour around the temple of Hoysaleshwara in Halebid. Thus giving them an opportunity to examine and comment on the innumerable friezes and sculptures that decorate the tiers in the walls of the sanctuary.

105

In the same temple of Hoysaleshwara, the son of Shiva, Ganesha, with his elephant head, is one of the most venerated deities of Hindus. He is the god of travellers, merchants, students and the learned. He is also the god of thieves, as is Hermes for the Greek. Here, in the south of India, he is familiarly addressed as Pillaiyar, 'the Son' (of Shiva).

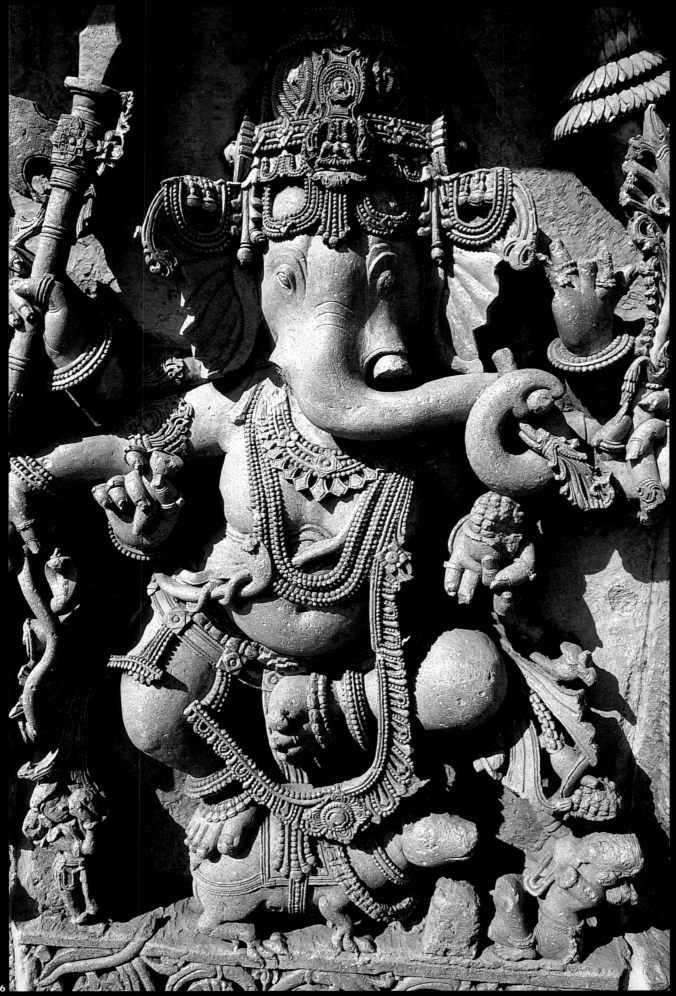

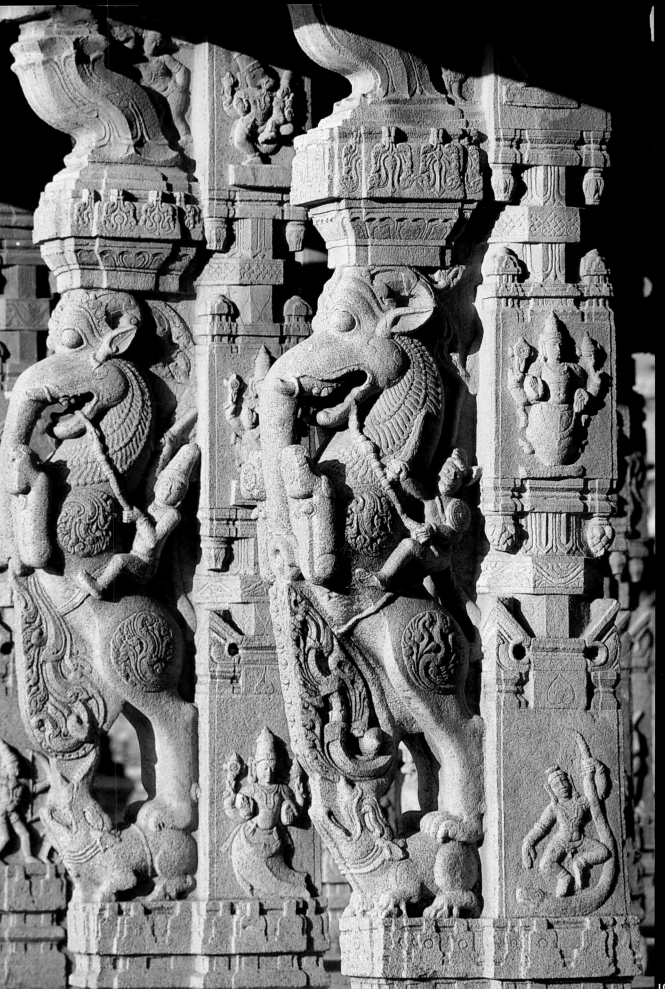

In Hampi, the opulent Capital of the Vijayanagara Empire from the fourteenth to the sixteenth century, only the ruins and several temples remain. One such temple that survived both the invasions and ravages of time, is the Vitthala Swami, dedicated to Vishnu in 1521. The temple's pillars are decorated with magnificent, mythical animals, half-elephant, half-horse, mounted by tiny riders.

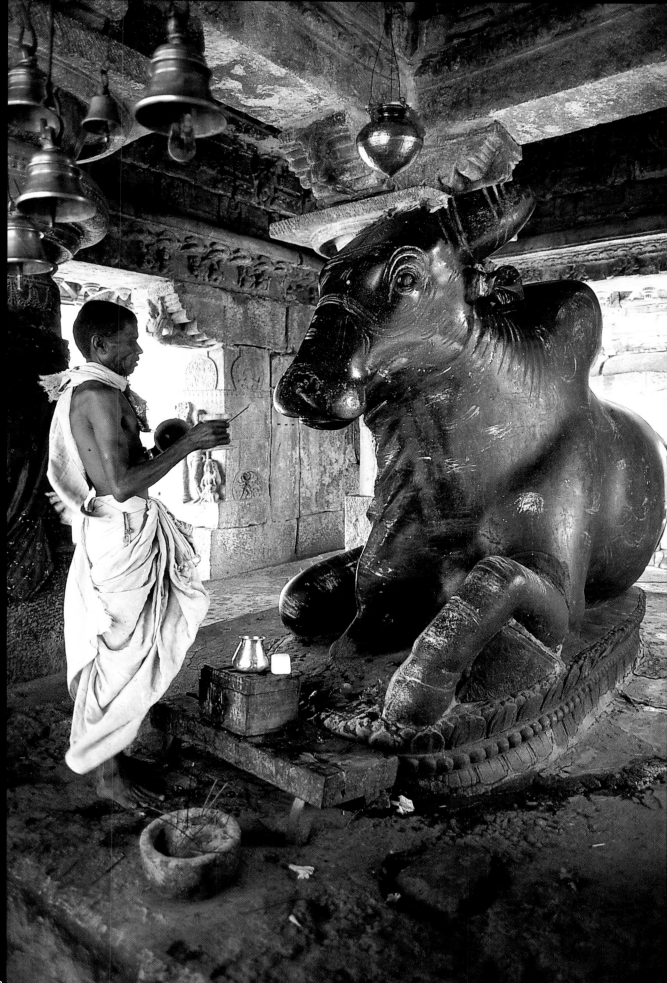

Another highly
venerated animal is
Nandi, Shiva's white
bull (vahana), which
He rides. Statues of
the bull are often
colossal and always
placed at the entrance
to temples dedicated
to this major Brahmin
Deity. Here, in
Pattadakal, in
Karnataka, a Brahmin
pays homage (108).

Not far away, in
Badami, the Capital of
the Chalukya Kings in
the sixth century,
temples are stacked at
the foot of the hill
next to an artificial
lake, Lake Bhutanah
Tank (109).

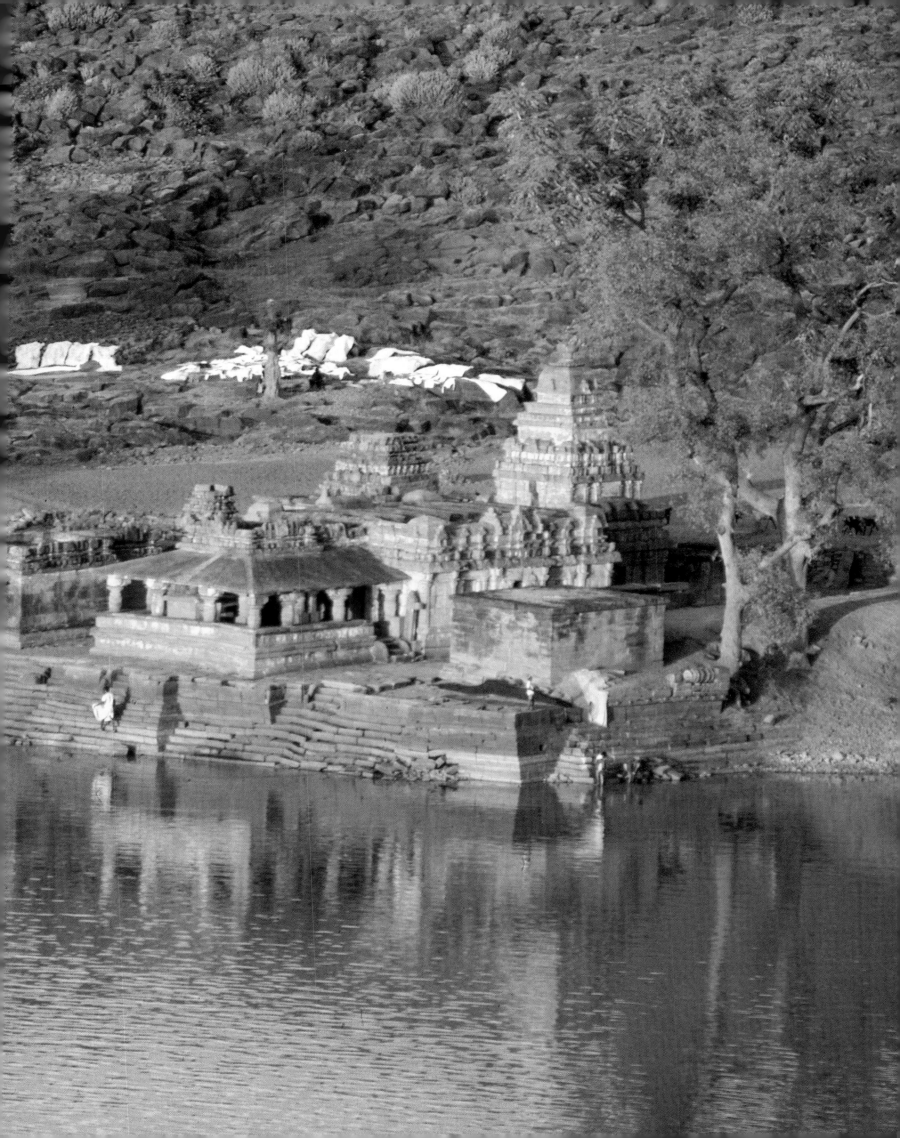

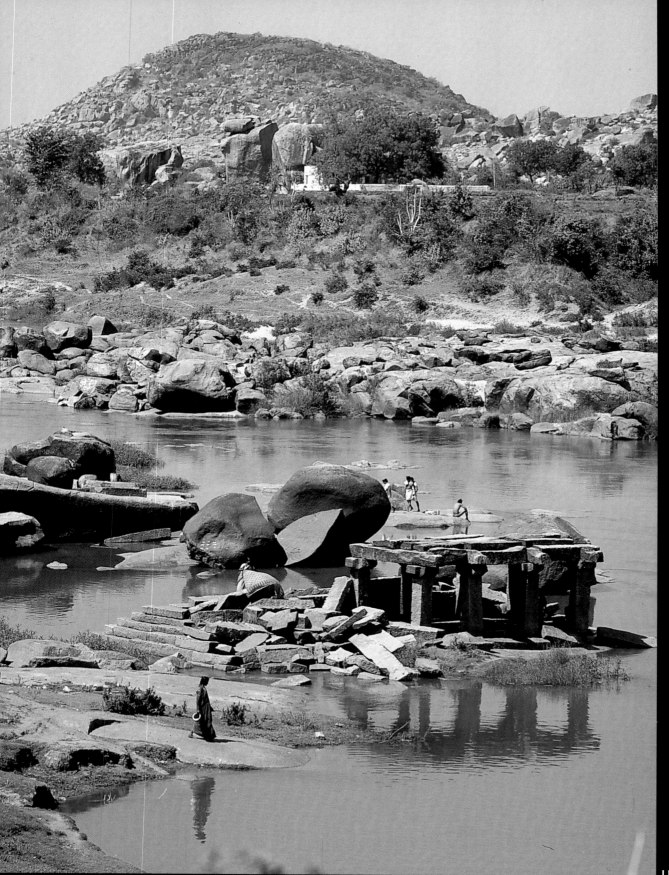

Small temples have been built on some of the enormous rocks in the bed of the Tungabhadra River, in Karnataka. In the third century, this river was dammed up by a gigantic earthen dam near Hospet, thus making it navigable in certain places. A modern dam now backs up water for 370 kilometre, essentially used for irrigation purposes.

THE REFLECTIVE INDIA

I greet thee Ganga, mother of the waters,
foremost in all the universe,
benevolent and immortal, giver of peace.
Thou art the very soul of the Lord Narayana!
Mantra invoking the Ganges

Trodden by a hundred thousand feet, the marble steps, sink a little deeper each day day into the sacred reflections of holy bathers, disturbed by the constant movement of men and women. Above the multitude of heads, the ashes of the dead still smoke on the pyres. And below, stretches a mystic joy unabashedly, where water, steam, and the fire of haven have blended.

This evening, Dasyaputra has come to soak his wretched body into the waters of the Ganges, so that it may be purified. From the heights of this city of a thousand temples, his eyes, shining with light and faith, slowly look around the sacred river, and he sees his brothers standing overjoyed in the waves invaded by the sun. His gaze also wanders over various divine temples of stone, upon the smoking fires and it also pierces with all his soul through this sparkling river, which lures and fascinates him. The pariah, an outcast, his poor body worn and exhausted by the long walk over dry and dusty roads, the untouchable, leaning on a stick, lets his gaze roam, seeing nothing. Only a wrinkled and dirty loincloth covers his hips that he could never dream of replacing, nor would he ever take it off till it became his shroud. Beads of sweat shine on his forehead and hang on his moustache, like jewels, and his feet are calloused and blistered.

All around, he sees fruit sellers with their baskets before them swelling with mangoes and oranges, bananas and watermelon, the most exquisite fruit and the most beautiful flowers. Dasyaputra feels his nostrils flare with the enticing aromas around him. Yet no desire invades his stomach, for being poor, he does not know the meaning of desire. He has never had anything, and he knows he would never possess anything, except his body and his freedom. But he also knows the sun that scorches his body, the earth that nourishes it and the water that soothes and quenches his thirst. He asks for nothing, because he needs nothing. He is only a pariah, an untouchable. His existence as a mere man is enough for him.

There were times, however, when he had hoped. Seated along the side of a road, a bit shady patch away from sun, he had dreamed of an outstretched hand, a friendly smile. . . He had dreamed of something unknown, unimaginable, immense and impossible, and that something was love. And about that time, a passer-by roughly knocked him into the ditch and spat upon his chest, in disgust. The saliva remained there, as if it were a medal.

But today, Dasyaputra is happy. Happy to be free, happy to do nothing, ignorant of the worries of having possessions. . . The sun goes down, setting the temples aglow, stabbing the river, which seems to bleed. The crowd slowly disperses. From time to time, a small coin is tossed at the feet of the pariah, who stoops and quickly puts this treasure away in the folds of his loincloth. The untouchable waits. He knows that he cannot bathe his sweat-covered body in the sacred waters, until those of the upper castes have finished their purification. His skinny body, by its impure contact, must not soil those of the castes. Nor can he be within their purview. He does not complain, for he knows that one day, Shiva would bless him with a place among men, his brothers, later, much, much later, when he is ready.

Below, the fires have got doused and the men have disappeared, driven away by the nightfall. The marble steps leading down to the river are now deserted and the waters lash at them and drown them along with the poles stuck here and there in the water. The poles seem to keep the river riveted to the earth, to this place where it flows ceaselessly, tainted only by the human filth. Dasyaputra gets up and stretches. He feels tall and strong. Suddenly, everything around him seems small. The temples are less gigantic, the river less wide, the sky less high and less sparkling. As he descends the steps, his heart seems to swell with an unknown joy. He hears music that is played for him alone, accompanying him all the way to the river and blending with the play of light. The water gradually rises up over his body, and he laughs aloud, showing his teeth.

With his hands, with his feet, with all his body, the pariah laughs, and now he swims. The music follows each of his movements, the water, sensuously sliding over his body, caresses it and he imagines it to be a kiss from his beloved. Dasyaputra is so happy that nothing can now mitigate his joy. He rolls in delight in this living matter, which moves to make a place for his body that has never before had its place among men. The current of the water divides his thoughts and, as capricious as the reflections, his joys jump from one thought to another, varying each second. He delights in seeing his reflection distorted each moment, he sings when he sees a rouge wave playing on the surface of the water, or he laughs heartily at the swirl of the tide on the old stones with their wavy patterns. This lasts just a fraction of a second. But the moment is eternal. Already the water has become colder and darker. The crocodile slides out of the mud to hunt fish and turtles.

With an unspoken word of remorse and with a wave that bids adieu, Dasyaputra gets out of the water, his eternal companion. For the last time, he slowly goes up the steps and from the marble, still hot, a trail of steam rises, as if to erase his steps and the memory of his visit. Above his eyes, the temples have put on their silver glow. So daunting in their stillness, they seem to want to deprive this impudent pariah of that happiness. Tomorrow, an unrelenting sun would lead him once again, along the roads of India, seeking his pittance, for his survival, and waiting for his death. But this evening, intoxicated with the experience of having known a contact softer than that of the roads and the hard stones of the cities, Dasyaputra sleeps.

A smile of indescribable joy uncovers his teeth. . .

This Indian fable illustrates the relationship the inhabitants of the peninsula share with the water element that conditions their very existence and determines their attitude towards nature. Water is the source of all life, and in India, it is somewhat unequally distributed. Either it is dismally lacking, especially in the west and regions, where the monsoon rains fail to reach, or hardly touch upon the land, or it is found in overabundance as in the extreme south, and the Bengal plains hit full force by the southeast monsoon. While in one place they have to drill immense, deep wells (*baoli*) to find water, on the contrary, in another place, they have to build reservoirs to preserve it. Most legends have their origin in divine exploits, and are associated with this element; whether it is the Ganges coming down to earth, this mammoth celestial river that Shiva had to slow down by letting its waters flow over the top of his head, or whether it is the aquatic power contained in a vase, where the gods had held Him a prisoner. If reasoned in this vein, all water is sacred, including every river, and the Ganges is the epitome that symbolizes them all. As a divine body, it is supposed to be absolutely pure, for water has that unique ability to cleanse both the body and the soul. Furthermore, not a single *tirtha* (holy place) is without at least a pond, where the devout can take a dip. In many of these sacred places, blessed by the gods, ritual demands that the pilgrims visit several of these ponds or lakes before visiting the temple. In places, where no natural lakes are close by, the architects, who designed these religious structures, never failed to provide a pond inside every sacred complex, built with steps leading to the

154

water to enable the devotees to bathe before the prayers. So naturally, the locations are usually chosen where there is a lake nearby, as in Bhubaneswar, Khajuraho or Pushkar.

It is also on these man-made or natural lakes, that on designated dates, deities from the nearby temples are paraded around in boats, as if to regenerate their powers. During certain ceremonies, it is the custom to baptise statues of deities, and sometimes, after having worshipped them with all the rites, the statues are thrown in the river or in the sea, so that, as they sink, they can be reunited in the hereafter. The custom of baptising is universal and follows the same principle in Christian and Sikh baptism, Muslim purification, as well as other rituals of purification found in most religions, are all based on the symbolism of water. Water is intensely believed to be a purifier by its very essence. It is the life force of the earth, the sap of trees, the very principle of life. In India, as elsewhere, to offer water is symbolic of reception, a sign of welcome, as much as of purification. One washes his hands to get rid of a material or a spiritual stain, and feet are washed to keep the outside dirt from defiling a sacred place. In baptising a child or a sacred picture, it is symbolically given a new life and new energy. An Indian who bathes in the waters of the Ganges, or a river or a lake, is doing so not only to cleanse himself. Thus he must particularly offer the water itself a prayer of veneration. By the same token, he who has the privilege of dying and his last rites being performed on the banks of the Ganges, would have his ashes purified. In this way, he believes, he would be able to considerably diminish the number of his reincarnations. On the occasion of the great pilgrimage of the *Kumbha Mela* that takes place every 12 years in Prayaga, where the Ganges, the Yamuna and the mythical Saraswati come together, it has witnessed some accidents. Boats overloaded with pilgrims making their way to the middle of the sacred waters have often been capsized. But the devotees who have drowned on those occasions are sometimes envied by others because they are sure not to be reborn. . . and achieve *moksha*, salvation.

India also offers its own version of the legend of the great flood, wherein it is not considered a divine curse, as in the Judo-Christian world. On the contrary, it is believed to be a regeneration of life that permitted primitive humanity to start out anew, breaking fresh grounds, purified of its lower, bestial nature. As all water is sacred, Indians take great care not to waste or pollute it. River water, in particular, is venerated. Descending from the mountains, the domain of the gods, it flows ceaselessly, to finally merge with the waters of the ocean. So flow the lives of human beings, whose souls, one day or another, would unite with the universal soul, where no distinctions are made in race, age, sex or ideology.

However, there's a catch here — that all rivers do not have the same powers of purification, as *Shrimad Bhagavat Purana* defines: If a single bath in the Ganges washes away all the sins and cleanses all the stains, three successive baths in the Saraswati are necessary to obtain the same result. In the Yamuna, seven days of bathing are mandatory. As for the waters of the Narmada, it is enough just to look upon them to be purified. Nevertheless, the devotees must be cautious enough not to take a sacred bath on certain occasions. Though the rules may vary with the rivers, but generally this holds true for the rainy season. The *Puranas*, 'ancient texts', describe the rules pertaining to bathing in infinite detail, and certain texts affirm that in the *tirtha*, sacred places, 'on the occasion of weddings, trips, battles, sacrifices, revolutions, festivals and great conflicts', there are no stipulated restrictions on touching of the waters. And this is essentially because the waters have saving properties and anyone bathing in them cannot be impure.

But rules related to bathing in sacred waters are innumerable. For instance, one must approach the water bare feet, take off one's headdress and offer *namaskara*, a greeting. Then, touching the water, one must say a prayer first before plunging entirely into the river. Finally, the pilgrim must leave his clothes on, shave his head and after yet another bath, he must offer a sacrifice to commemorate his ancestors. However, in the case of married women, offering a simple lock of hair is quite sufficient. But, in all cases, the bather must face the very direction from which the river flows. Needless to say, rules vary with the *tirtha*, as with the sects, since each one of them has its own text. And one rule, followed irrespective, is that one must never accept a gift during a pious visit to a *tirtha*. For, it would entail a punishment leading to plummeting of one's fortunes. On the contrary, donating alms is highly recommended.

Some rivers in India are considered to be feminine, as the likes of the Narmada, the Godavari, the Tungabhadra, the Yamuna, and the Bhagirathi, to name a few. Other rivers are believed to be masculine, as the likes of Shatadru, the Sone. . . But even though the *Mahabharata* recognizes that 'certain parts of the body are purer than others, certain places are more sacred than others', this does not in the least deter the pilgrims from any station of life from regularly paying a visit to the banks of rivers to say their prayers, without the slightest worry about the river's status in the hierarchy of holiness. And to dilute these differences, it is commonly accepted that all water emanates from the Ganges, including the ones in artificial lakes around the temples. It is enough for a Brahmin, having made the pilgrimage to the banks of the Ganges, to bring back a little water from this great, magnanimous river and pour it in the pond to lend it, *ipso facto*, the same sacred properties.

In a *tirtha*, sources of rivers are venerated in particular, as witnessed in the case of *Gaumukh*,

'the mouth of the cow', in the Himalayas. This is the very source of the Ganges and *Triambaka* in Maharashtra is the source of the Godavari, 'the Ganga of the South'. The temples built around these holy precincts are again constantly visited by innumerable pilgrims. And legends lending numerous explanations of the divine origin of these rivers are certainly not in short supply, associating one or the other fable with certain sages of ancient times. Like Krishna, just by His very presence, sanctified the Yamuna, and Rama, during his exile, simply rested on the banks of the Godavari with his wife Sita and his brother Lakshmana.

In many of the regions, an annual ceremony takes place at the source of rivers. During this veneration, a young girl who symbolizes the river, is honoured and adorned with jewels. The great river artery of the south, the Kaveri, is venerated as a goddess, and, in its honour, the devotees offer coins to the waters of the little lake from where the river commences its journey — its very source. In certain parts of the west of the peninsula, where there is constant paucity of water, numerous big wells are dug, often several tens of metre in circumference. Here too, the interior walls are decorated, and its stairways and niches where sculpture, representing the gods are placed to sanctify the underground water. And when evening falls, strings of women walk up to the well, swinging their empty water pots on their arms. They gather at the curb of the well with other villagers, to chat for a moment in the shade of a large tree, to catch up with the gossip. And, leave thereafter, taking brisk steps, their pots filled with water and balanced on their heads, while clutching another pot tightly to their hips. In the south of Rajasthan and Gujarat, they go down the steps in a single move into the *baoli* to reach the water. They stop on the landings to greet a picture of a deity, and then slowly beat a retreat to the surface, loaded with this precious liquid, such a rare commodity in their

region. In other parts, they go to river banks or to a lake, where, day after day, following the same rigmarole, filling up their earthen or metallic pots and raising them above their heads in one swift movement, placing it gently on a little cushion. All this happens amidst the flurry of long skirts, saris and laughter that might even attract young men looking for a wife. And once these banks are deserted by the women and night falls, the animals take turns to quench their thirst in long gulps. The herdsmen are also present there to wash up the animals amid wild splashing, as they call out to them and scream with joy.

In numerous temples too, the doors that open to inside sanctuaries are decorated with pictures of Ganga (the Ganges) and Yamuna, standing on a Makara, a mythical monster that is part dolphin and part crocodile. The role of these goddesses is to symbolize the ritual bathing that is absolutely essential for purification, before stepping into the precincts of a holy place. In addition, the images of deities must constantly be sprinkled with water, so that they would retain their energy and create synergy. This belief is especially visible in the cult of Shiva, whose symbol, a sculpted phallus, is kept constantly dampened by a thin stream of milky water during the ceremonies and prayers. This blessed water, once collected and piped outside the temple into a stone pool, is considered by the followers to contain powers of purifying those who use it. In many a village, a simple coconut with a pierced hole and placed above the symbol of a god, lets its water fall drop by drop on the sacred stone. While this nonstop, constant refilling of the coconut is considered to be an act of pure devotion, in the great sanctuaries consecrated to Shiva, the holy symbol literally stands in water and is constantly offered flowers and fragrance. This is particularly the case at Triambakeshwara in Triambaka, at Mahakaleshwar in Ujjain or even at Vishveshwara in Varanasi, which is renowned for

housing several of the dozen most sacred lingams in India. These are the *Jyotir-lingams*, the 'lingams of light', during certain grand ceremonies. The Jains also venerate their saints and prophets by sprinkling them with water and at times also with milk. At Shravanabelagola in Karnataka, the monumental 18-metre statue of the sage, Gomateshwara, is venerated with this very act. And hundreds of litres of milk, mixed with honey and flowers, are poured over the statue's head from a scaffolding built for the occasion.

However, water is not exclusively meant for sacred purposes, and India's rivers constitute indispensable commercial arteries too. Throughout the year, the navigable rivers are furrowed by a multitude of boats of every possible sort, loaded with passengers or more often, transportation of building stones, lumber, grain and every imaginable variety of goods. These boats pass by the smaller boats of fishermen who live along the banks of these rivers. The inexhaustible reservoirs of water, these rivers are also used to irrigate the paddy fields, through a system of canals, aqueducts and canalisations. Rivers, whose beds have dug deeply into rock, are least adapted for irrigating their banks. In such cases, the peasants have to bring the water up to the banks, using various systems, such as the noria. This system of bringing water to crops is generally inadequate, and dams have been built in many a region. These dams, in turn, create lakes from which water is far more easily accessible. Two of the oldest dams were constructed in the first century AD across the Kaveri near Tiruchirapalli and across the Tungabhadra, near the city of Hospet. The number of dams and lakes to be used for irrigation has considerably increased in modern times. One among the first was Periyar, named after the river in Kerala, on which it was built in 1895. Ever since its creation, it turned into a centre of phenomenal natural reserve, with elephants, wild buffaloes

(gaur), tigers, bears, deer and especially birds making for a spectacular sanctuary. So have other dams been built in various parts of the country to generate power. Thus the sacred rivers also serve humans, who venerate their very being and express gratitude for the services rendered.

Water is present just about everywhere in the Indian landscape. In desolate regions, there are lakes and wells, in others, there are streams, creeks and rivers. In the paddy fields, the water does not flow but rather mirrors the sun and floods the countryside with such delightful reflections that keep changing with the hues of the skies and passing clouds. In the Ganges, Mahanadi and Kaveri deltas, the water is split up into hundreds of streams and the land is turned into a marsh. Yes, this is where that illusion of the horizon is created and it is really hard to say just where the land ends and the sky begins. As both seem to blend, a mirage is simply inevitable. Thus, the frail silhouettes of the peasants appear gigantic as they walk in a single line along the banks, carrying their bundles on their heads.

The Hindus are not the only ones who venerate water. Haunted by the memory of the arid, dry regions from which they hailed, Muslim rulers in various states lay great emphasis on setting up gardens with cascading streams flowing through them. One such spectacular garden is that of Shalimar, near Srinagar in Kashmir that Jehangir had built for his wife Nur Jahan, in 1619. So were the tombs of Mughal rulers invariably built in the middle of fabulous gardens, laid out with flowerbeds and livened up with splashing fountains. For these men of the desert, the very image of paradise could only be created with the flower gardens, dotted with cypress trees, the constant, sonorous sound of running or splashing water, and pools reflecting the azure skies. In their palaces in Agra, as in Delhi, where summers are torrid, sculpted marble canals cooled the interiors of the rooms. In the evening, torches threw flickering light upon the water that got reflected in countless broken sparks on the mosaic mirrors decorating the walls. No palace could possibly be envisaged without a pool, and also a pavilion nearby for the members of the court to unwind at leisure and enjoy the soothing breeze in the evening. In mosques, in the centre of the great courtyard, where the devout gathered, there was always a pool of water, where the believers may take water for the ritual of their ablutions.

When their palaces or fortresses were far from rivers or lakes, Indian rulers were equally thoughtful and furnished an inside courtyard with a fountain. And for that matter, also created immense reservoirs, sometimes underground, to ensure that never ever would there be paucity of water. In India, as elsewhere in the world, water is as indispensable to material life as it is to the spiritual facets of life. It sustains the very existence and symbolizes the soul that mirrors divinity. But what is baffling is that despite such veneration for water, the sea, which touches a very large part of the subcontinent, is rarely considered as a *tirtha*. The coastline, although often decorated with temples, is not at all considered sacred, except in several well-defined places that are sanctified by cultural monuments. Because of its infinite immensity, ferocity, and unfathomed depths, the ocean, which is the domain of Varuna, portends fear. In ancient times, the Brahmins would never risk going to sea, and being afraid of losing their religious stature, they left maritime travel, which indeed was perilous at that time, to merchants of lower castes or to the religious Buddhists. Even the most daring of these Brahmins would trade along the coast, only when pushed by the needs of his business or to proselytize. It was the Chinese or the Arabs, who really dared to cross the ocean, transporting passengers and merchandise or even taking pilgrims to Mecca and bringing them back. Although Indians from

the north would rarely risk going to the ocean, those in the south, being only superficially Brahmanised, and in more direct contact with the ocean, had established maritime association with the Roman West, as early as the first century AD. And so had the rulers on the Coromandel Coast (from Cholamandalam or the Chola region) very early on established flourishing ports in the Bay of Bengal that traded with countries in Southeast Asia. In the tenth and eleventh century, the Cholas had mastered the art of sailing the eastern seas. Given their impressive fleet of large outriggers, they followed the coasts, going all the way to Malaysia and Java to bring back cargoes of gold, precious wood and spices. They even put up military opposition to the Malay empire of Shrivijaya, which, at that time, controlled trade between India and China. The enormous fortunes of these Chola kings inspired them to erect the magnificent temples of Tanjavur (Tanjore) and Gangaikondacholapuram, and became generous benefactors to other sanctuaries too in the region.

In Kerala, which extends along a coastal region to the southwest of the peninsula, numerous ports were involved in trade with China, Ceylon, and the West. Lagoons and arms of the sea dot the coast and create safe havens for boats of all sizes. This was thus the preferred coast for pirates, who sought refuge here. It was also the historic coast where the first European ships anchored in India. In 1482, the Portuguese Pedro Alvarez Cabral established a centre for the pepper trade at Cochin, now better known as Kochi Bandar. The enormous wealth of the Hindu and Muslim kingdoms near the coast so impressed the Portuguese that they chose to establish a permanent colony in Goa. And their example was soon followed by other European nations, eager to get their share of the pie in the spice trade.

And this is where lies the real truth. The foreigners who came to India were not merely interested in trade, but also tried to colonise the coastal regions and establish ports and fortresses. And since India was divided into numerous kingdoms and seeing the commercial advantages they could get from these colonies, virtually put up no resistance. They calmly watched the sea battles between the Arabs (from Egypt) and the Portuguese, and later those that opposed the English and the French. Indian states started worrying when these foreign powers, based in Pondicherry or Calcutta, began to meddle in their internal affairs. While invaders had traditionally come across desert passes in the northwest and had more or less been assimilated, the new ones, brought by the sea, still remained foreigners. Their Christianity was resolutely as opposed to Brahmanism as it was to Islam. For the majority of Indians, the ocean, apart from its devastating fury, remained an ominous object of terror. Although certain religious ceremonies now and then take place on the beaches, and pictures of deities are submerged into the waters so that they would disappear, the ocean is not really venerated. Sometimes, even more appeasing sacrifices are made to the ocean by offering flowers or coconuts to its waters.

Nevertheless, the sea constitutes a source of life, especially for those who live along the coastal areas and make their living from fishing. The lagoons of Kerala are often ringed with villages of fishermen, who cast immense square nets upon the water. These nets are somewhat like those used by the Chinese. Actually, these ports were in contact with China very early on, especially by way of Ceylon. In the seventeenth century, a Chinese emperor donated ceramic tiles to the Jewish community of Cochin to be used to decorate their synagogue. It is said that during the early centuries AD, a Jewish tribe, fleeing Roman persecution, settled in this region. The apostle Thomas is said to have come to Madras about this time. There is still a district of the city and church,

San Thome that has been erected to perpetuate in his memory.

Though India may seem to vary, nestling between the ocean and the mountains, the latter too generate these innumerable streams of water that flow in every direction. The majority, however, flow towards the east, as the subcontinent is slightly inclined towards the rising sun. Only several coastal steams, coming down from the western ghats, flow into the Arabian Sea, and only one large river, the Narmada, merges therein. But, as we have observed earlier, it is no less sacred because of this merger. The pilgrims, who venerate this river, always carefully follow its flow on one bank and return by the other bank, towards its source. This is how things should be, in Indian thinking — always going in the direction of the rising sun to meet new life that never ceases to renew itself.

The gods themselves, being mortal, came down from their mountains following the course of the rivers, so that they could join and become part of the great oneness of the universe. And if there is this urge to meet the gods, then you are propelled to go where their spirit dwells eternally, on the frozen heights of the Himalayas. Only then one may claim to culminate the vision of India through its regal palaces, its infinite devotion, its kaleidoscopic lights, its reflections in the waters — all that goes into making it a reflective India.

All over India, century-old trees,
venerated by the local residents
often protect sources of water,
who associate them
with genies.

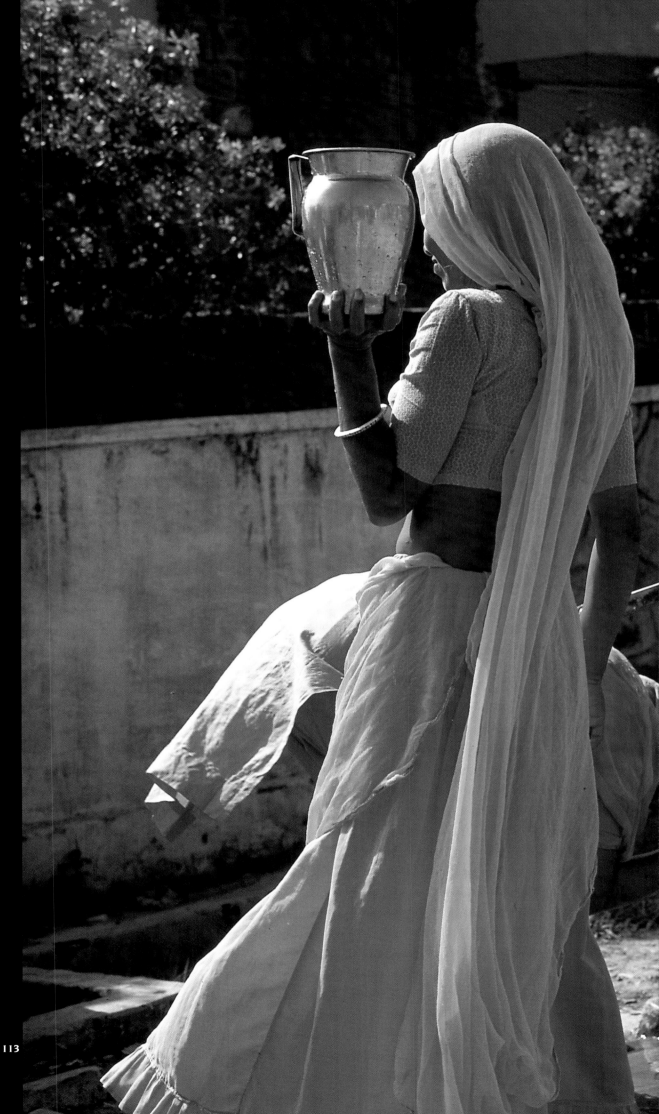

In Rajasthan, mostly an arid land, wells are especially bustling in the evenings, as here in Alwar. Women from nearby villages come over to fetch water in large earthen pots or metal jugs. This is the time for these women to relax and chat laughingly with their neighbours to catch up with the latest gossip.

Water is often used as a symbol in temples or in palaces, and artists
have displayed great imagination in representing
its sinuous path, as shown above in a temple dedicated to Shiva,
in Mandu. Water flows through a labyrinth
(symbolizing a snake)
carved in the floor, before it sprinkles down on the
lingam (phallic symbol) of Shiva, located below.
In Rajasthan, as here in Bundi, wells (baoli) are often immense.
Stairs along the inside walls are used to
descend to water level.

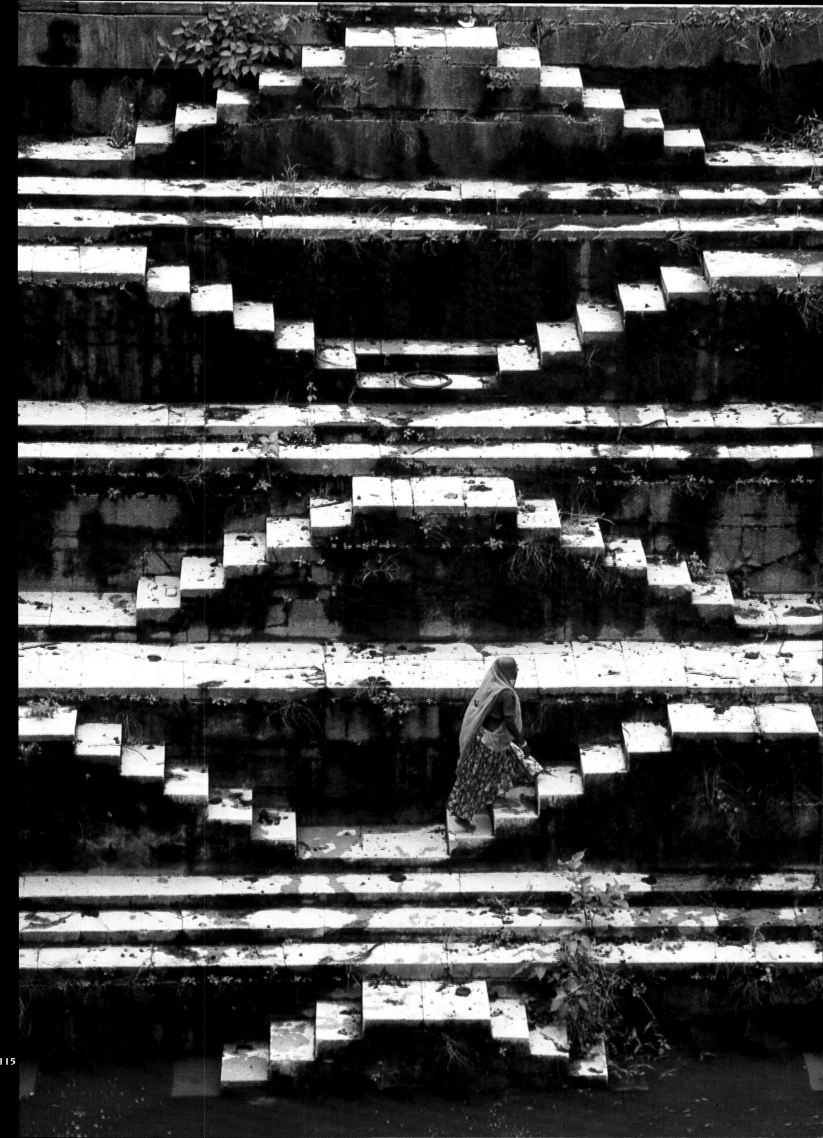

After bathing, fully-clothed, in the Ganges, pilgrims, both men and women, usually let their clothes dry in the soft breeze and the sun, as here on the ghat of Varanasi.

116

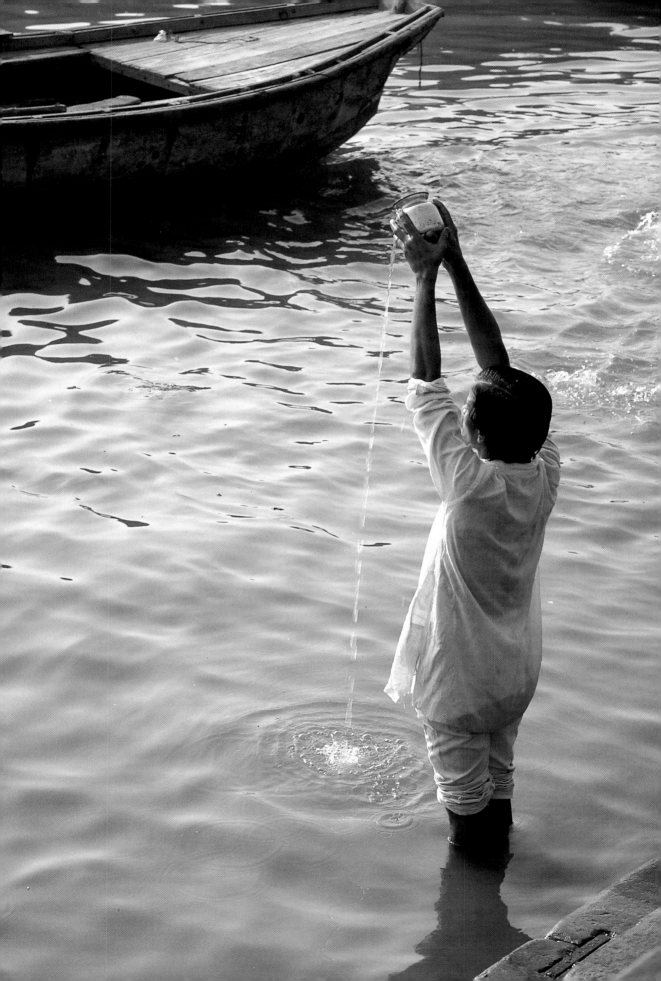

Princes seemed propelled to erect their palaces
near water, as water is symbolic of life that is
eternally flowing.
Small pavilions, as here in Alwar,
in the palace of the Maharaja,
were used by the princes and princesses
to savour the evening coolness
afforded by the waters of the artificial lake.

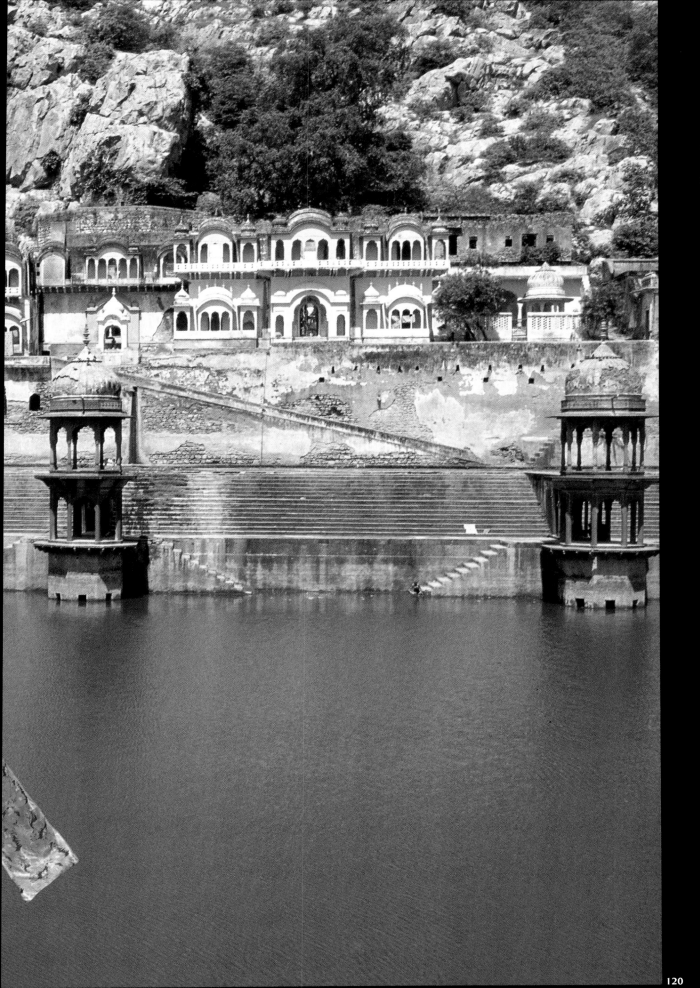

From the balconies in the towers of the former palace of the Maharaja of Alwar, the inhabitants let their multicoloured saris dry in the light breeze, as it ripples the surface of the lake.

On the bank of Lake Pichola, in Udaipur, the imposing white marble and granite palace of the Maharaja rises majestically. Built at the end of the sixteenth century, the palace is made up of innumerable rooms, stairways, towers, gardens and pavilions. Almost 460-metre long, it is the largest structure in Rajasthan (121).

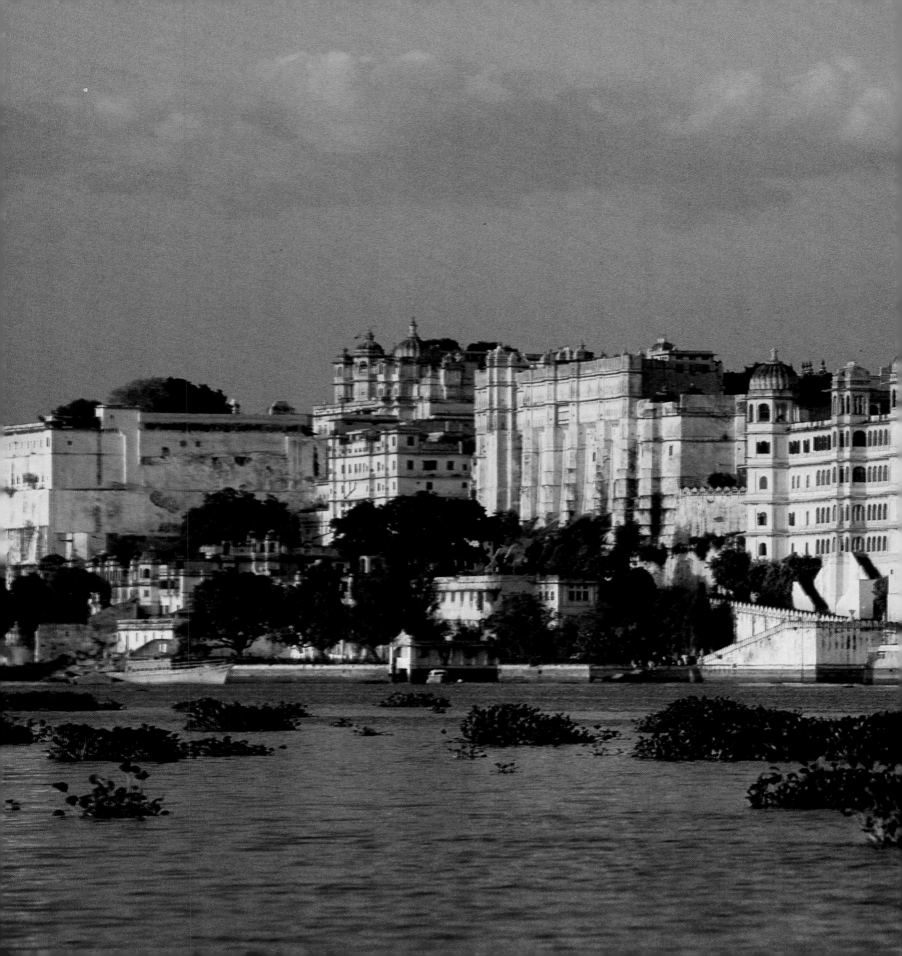

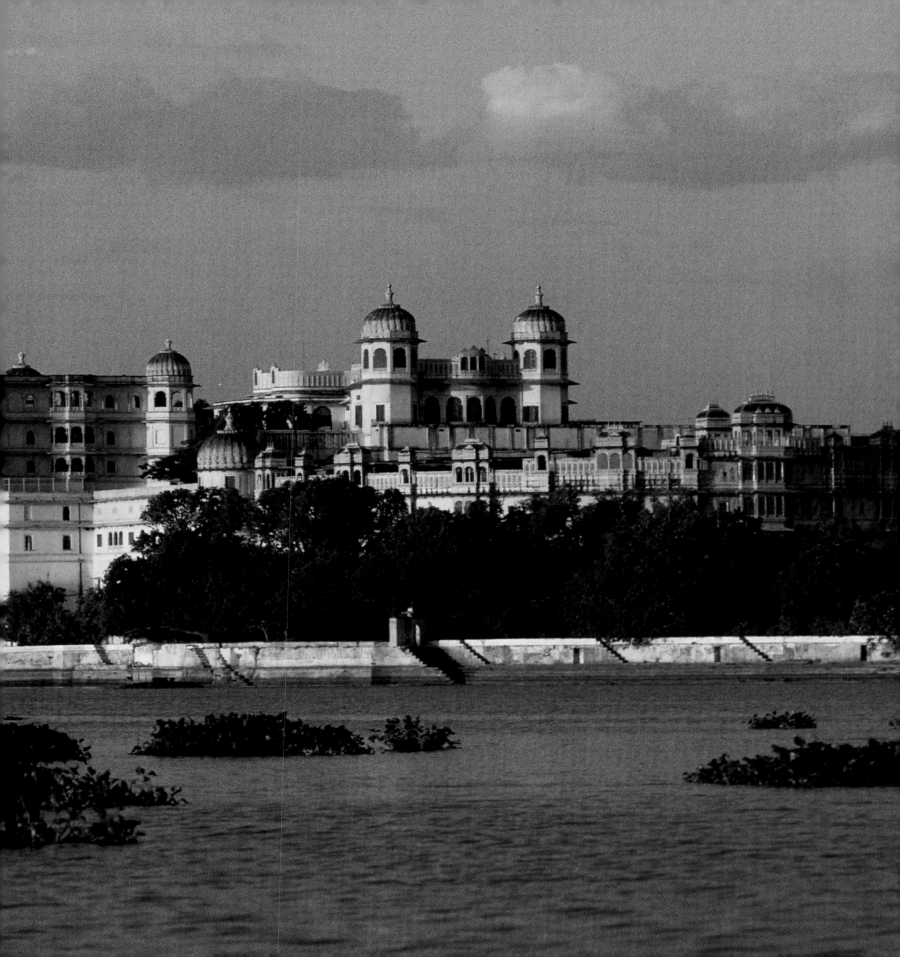

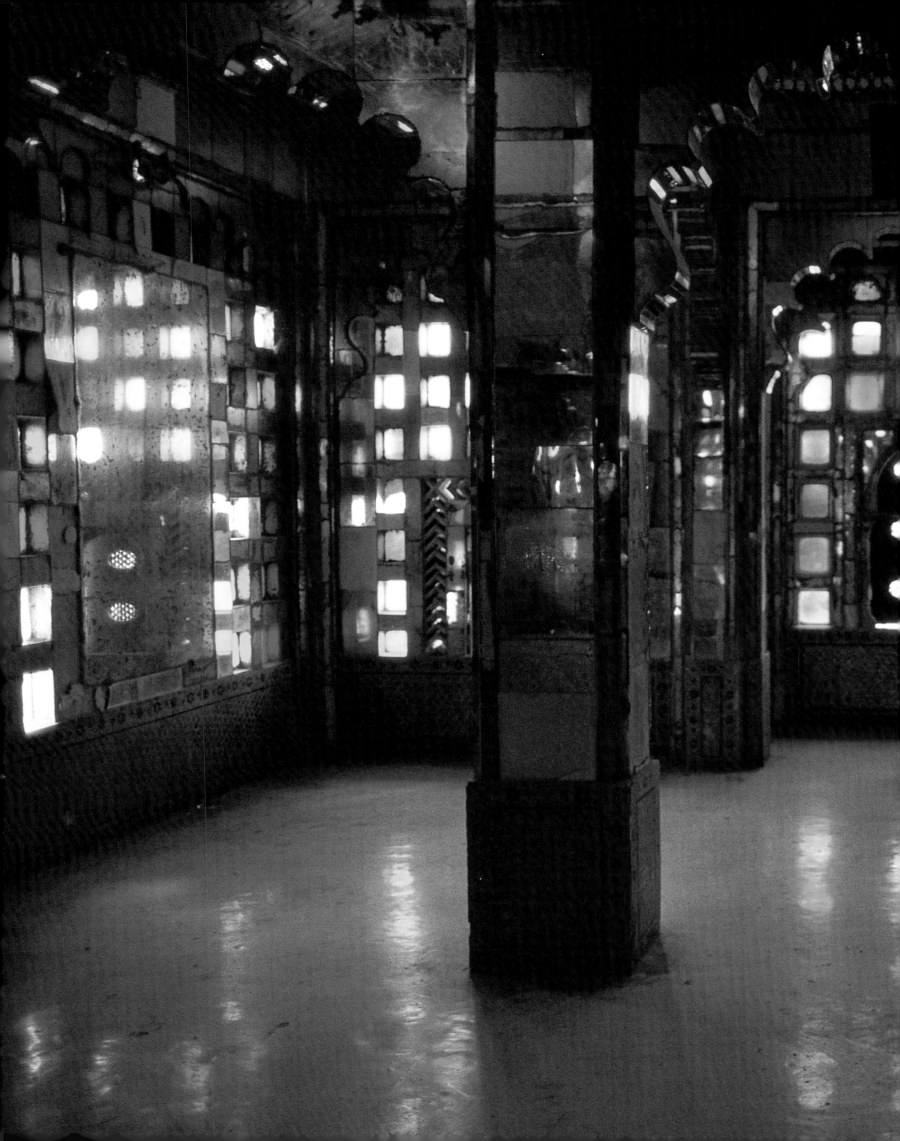

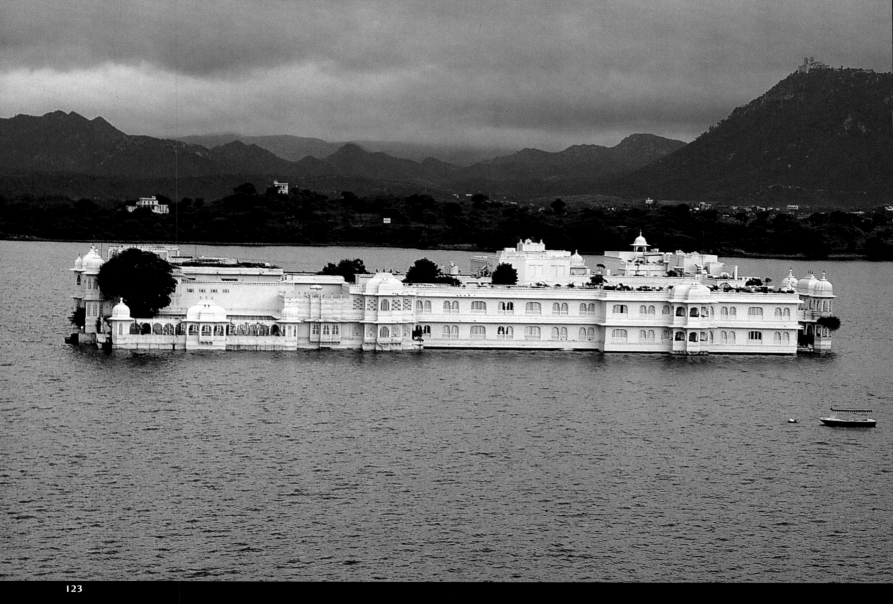

123

Opposite the palace of Udaipur, on an island in Lake Pichola,
rises a white marble palace built in 1746.
Today, this palace, the Jag Niwas,
shown here in the early dawn,
from the main palace, is converted into a hotel.

The palace of the Maharaja of Udaipur,
the Moti Mahal, 'Palace of Pearls',
is illuminated by a riot of coloured glass
encrusted in the marble of its large windows
that overlook Lake Pichola (122).

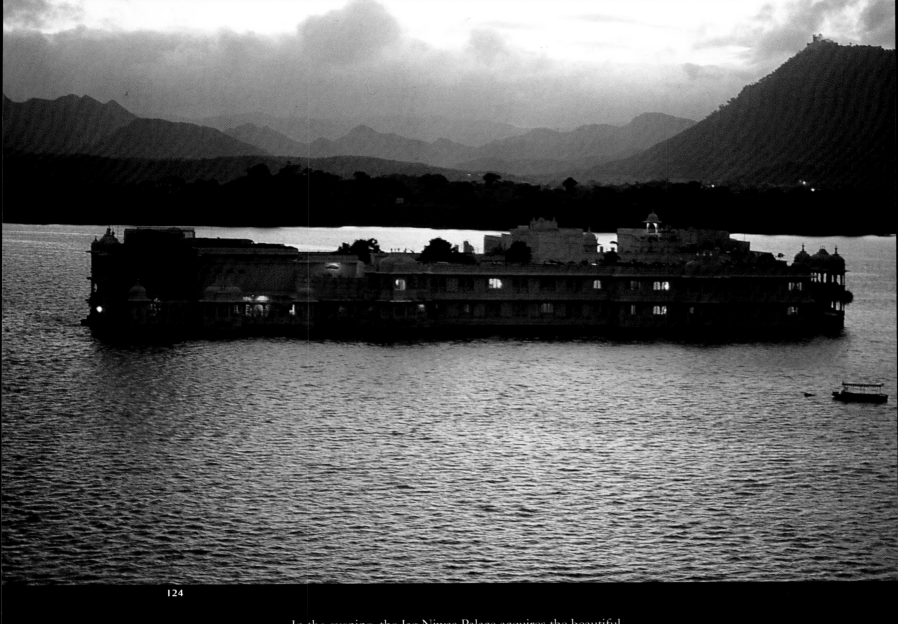

In the evening, the Jag Niwas Palace acquires the beautiful
shades of the setting sun and is lit up like a ship

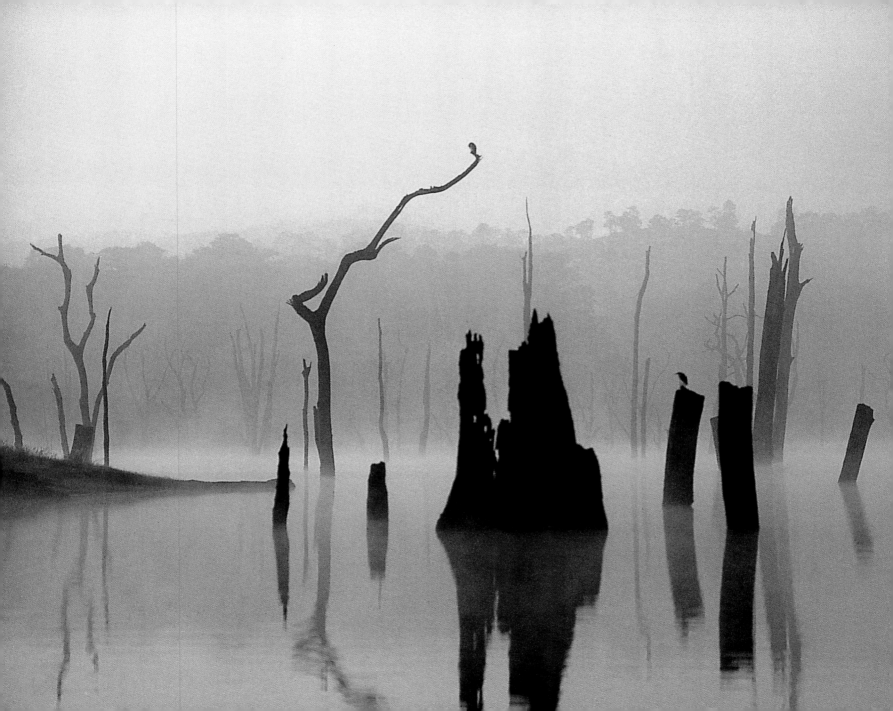

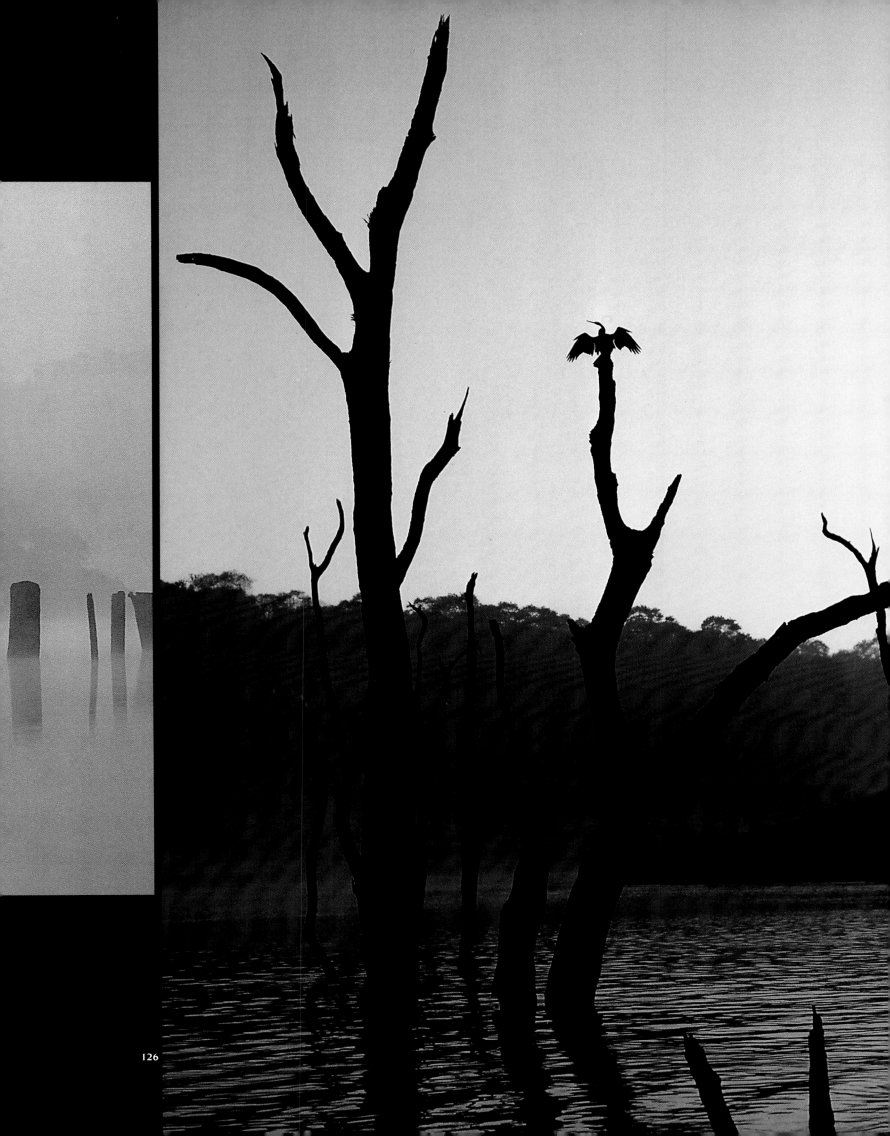

The coast of Kerala is riddled
with arms of the sea,
called 'backwaters'
that have been used by seamen
since the ninth century,
at least by those sailors,
mainly Arab navigators, trading
with China and Europe.
These calm waters are ideal
for fishing, which is practised
here with a kind of net first
used in China.

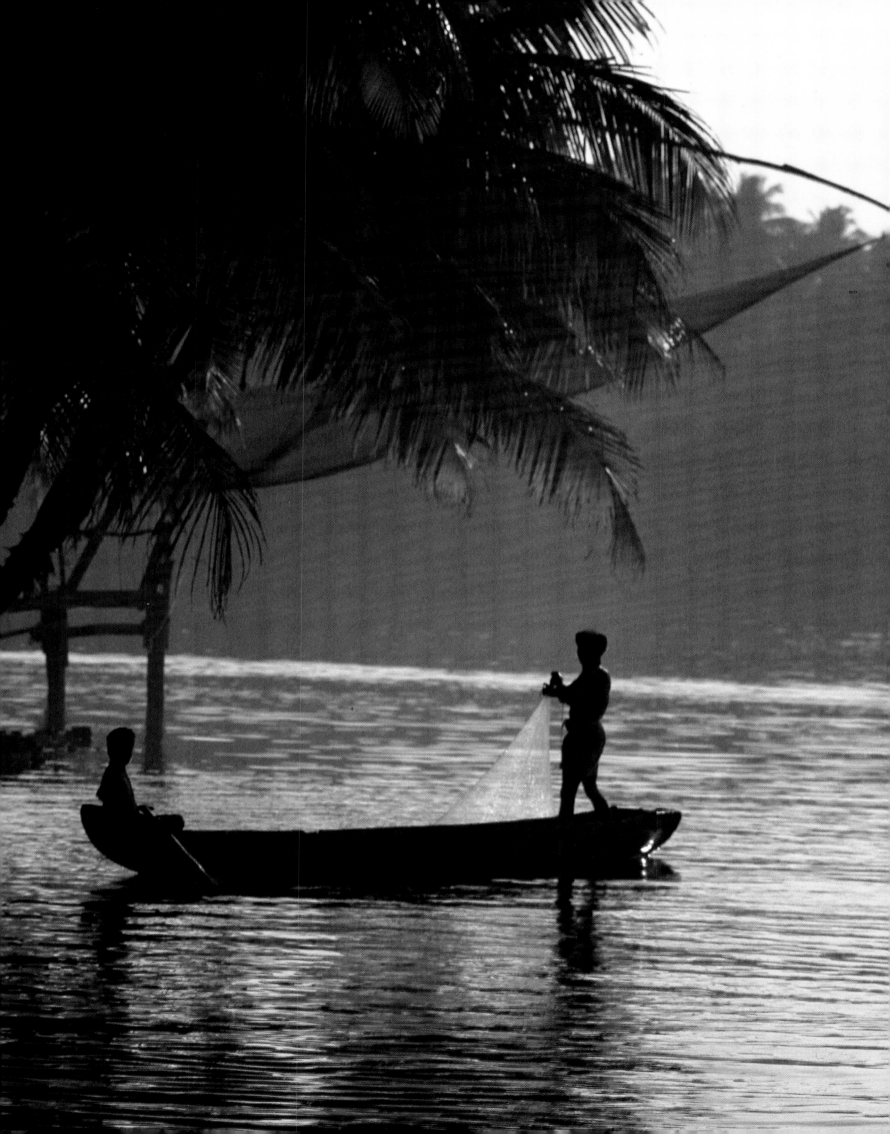

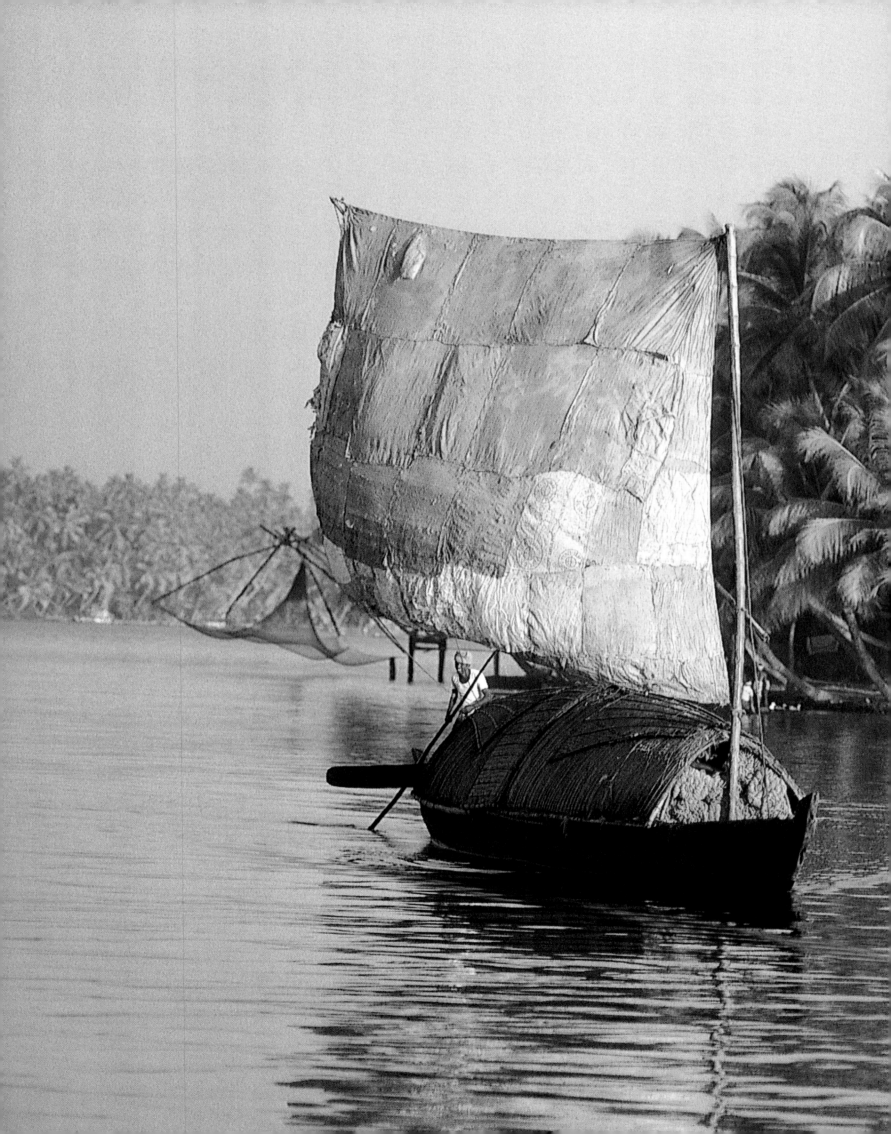

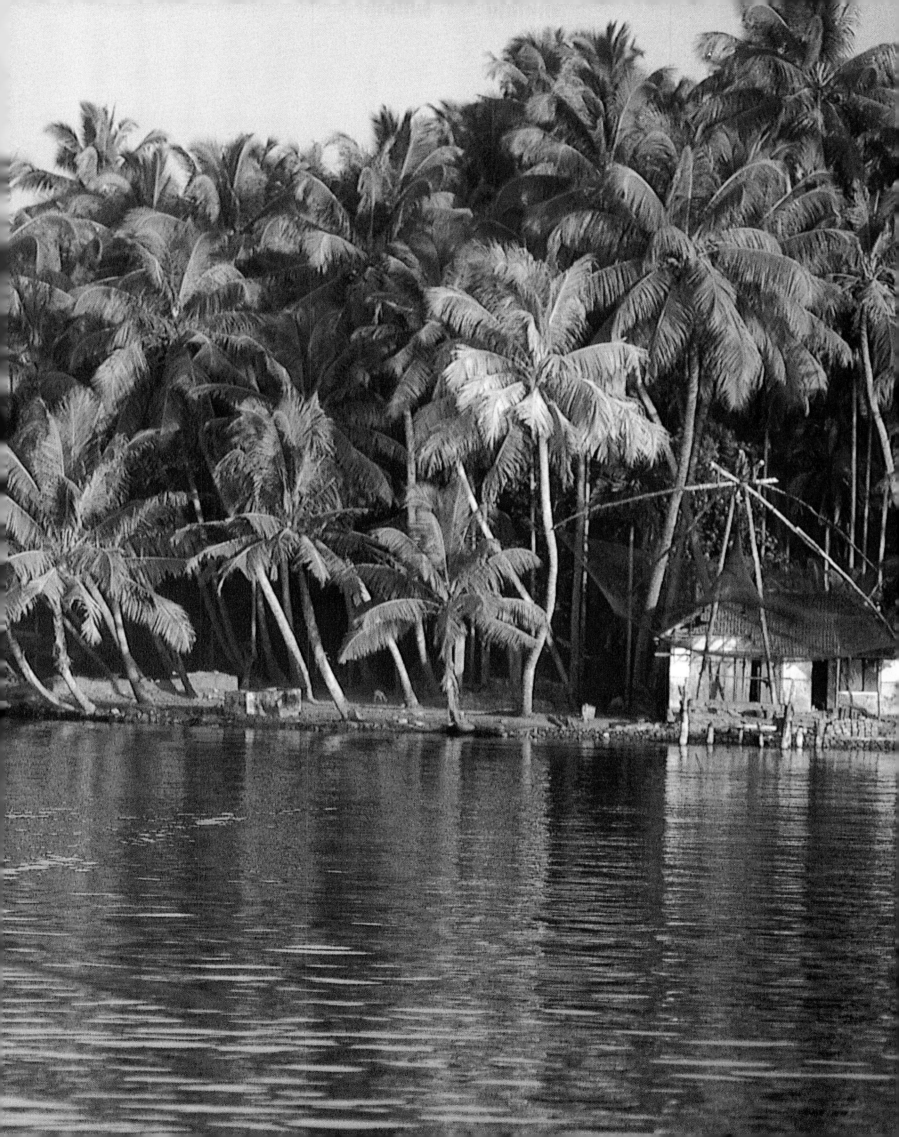

In the extreme north of the
peninsula,
in Srinagar, in Kashmir,
many rivers are crossed by
old wooden bridges.
The banisters of these bridges are
often used by villagers
to dry freshly dyed bolts of cloth.

Small boats with square sails and
covered by woven mats,
go up and down canals lined
with coconut trees,
near the coast of Quilon,
now known as Kollam.
The huts of villages are
scattered around the
banks that are home to
fishermen and peasants, who
harvest and use coconut
fibres to make ropes
or baskets (128).

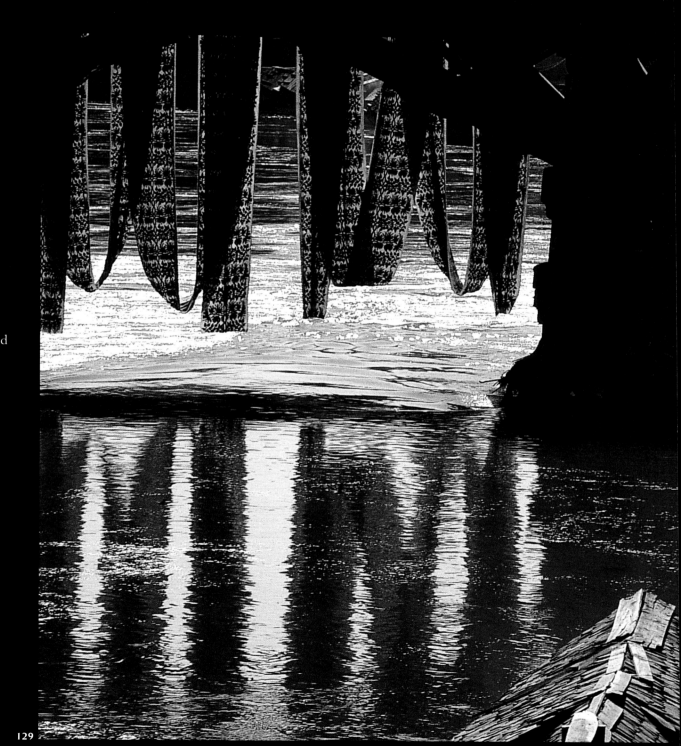

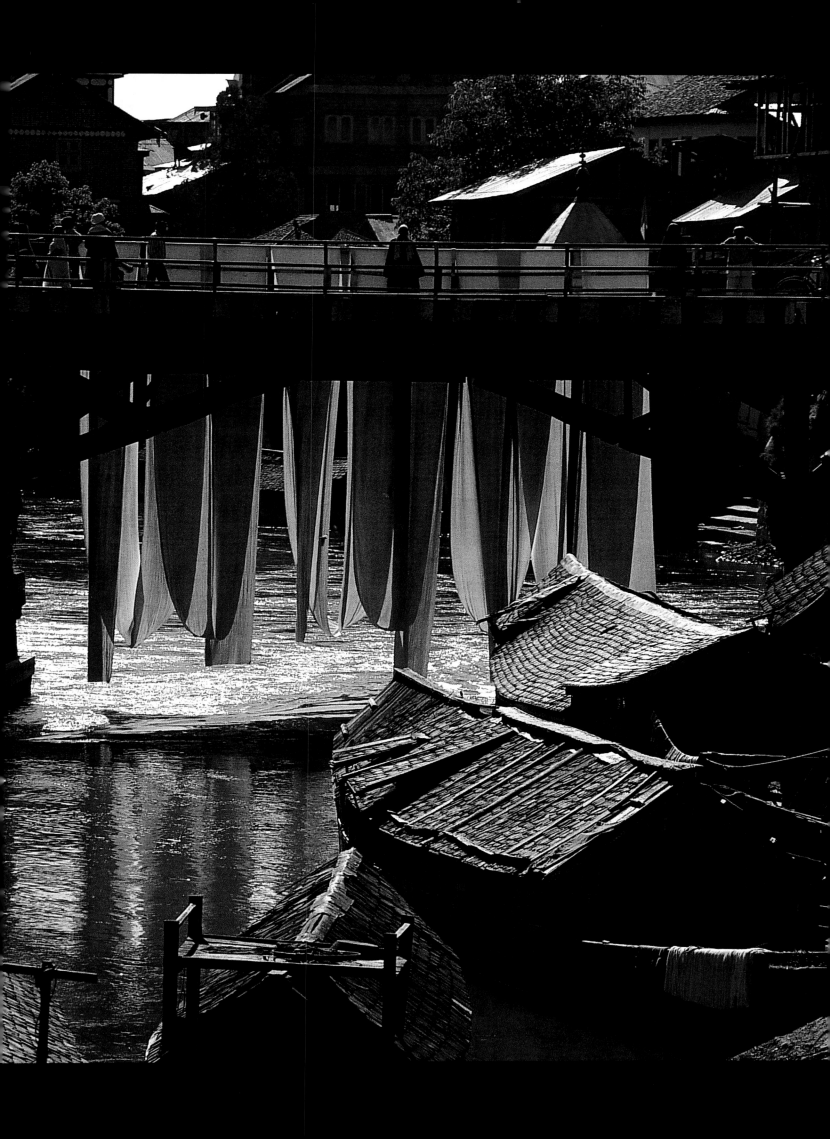

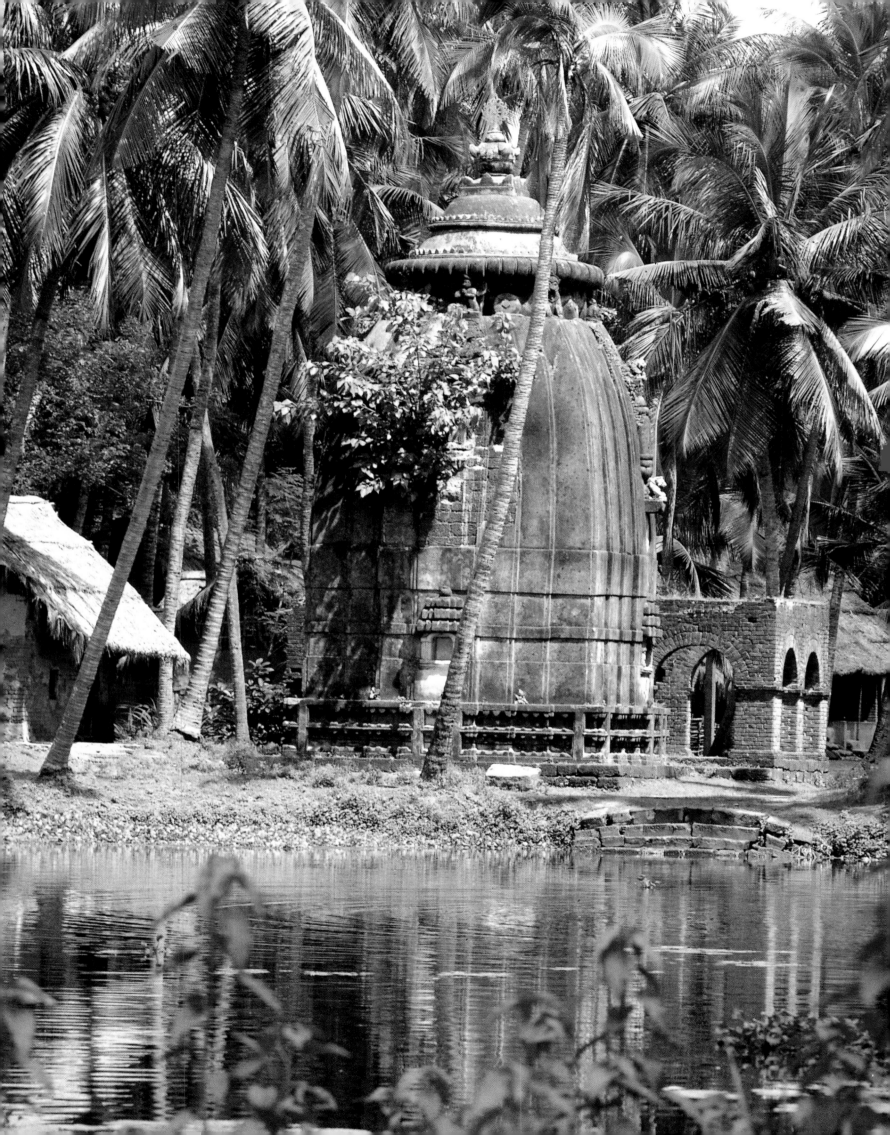

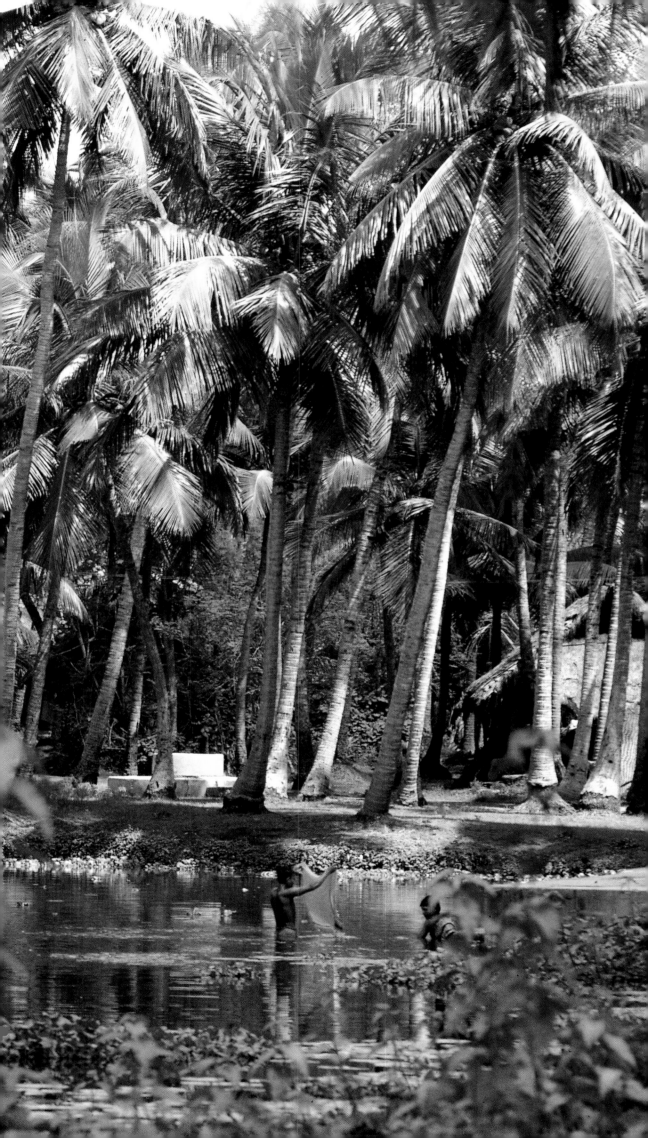

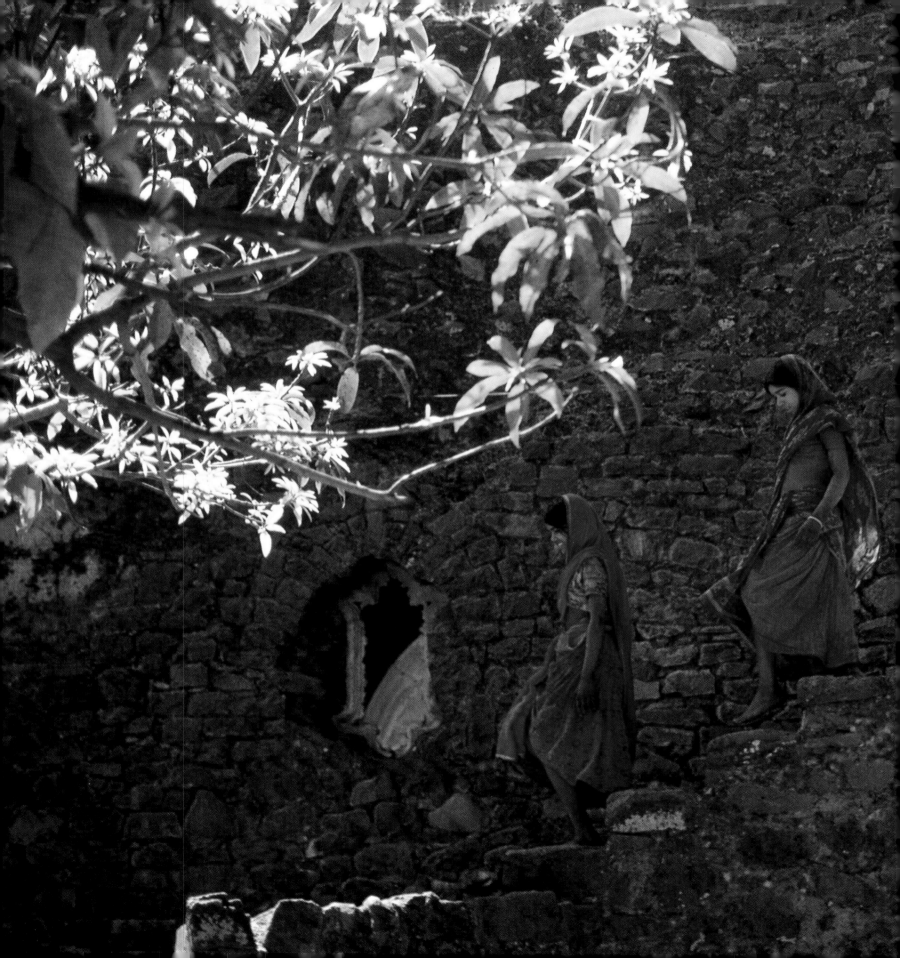

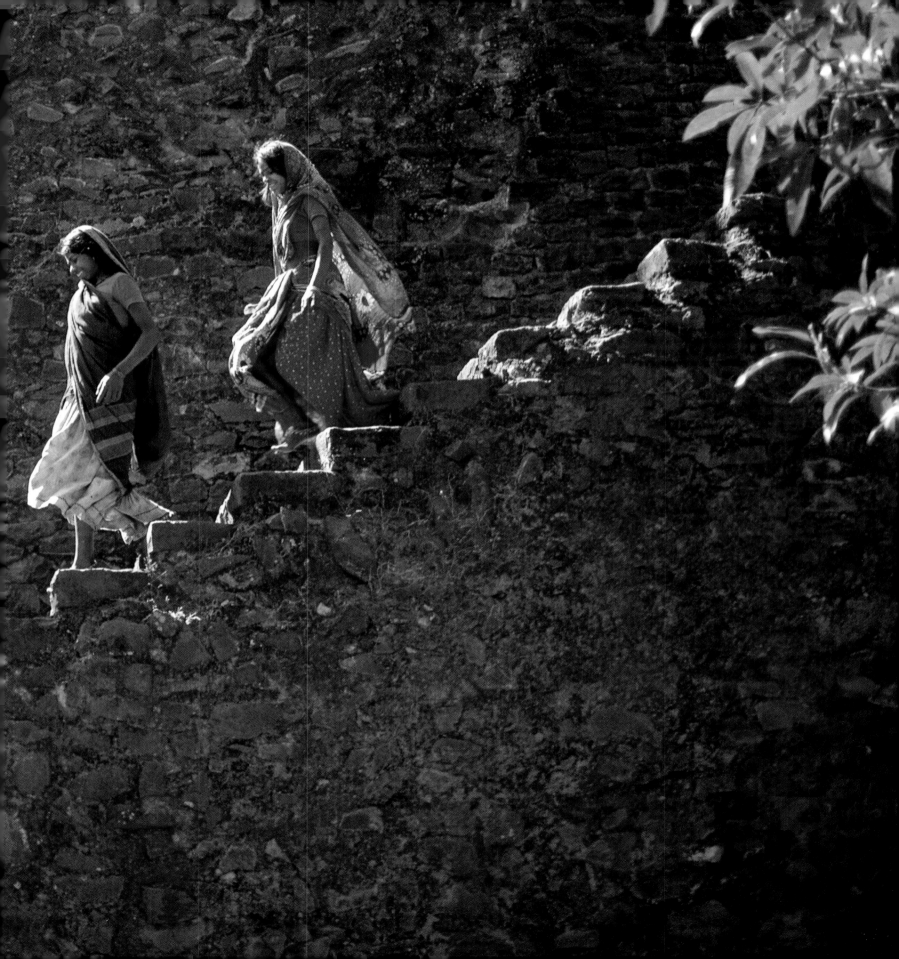

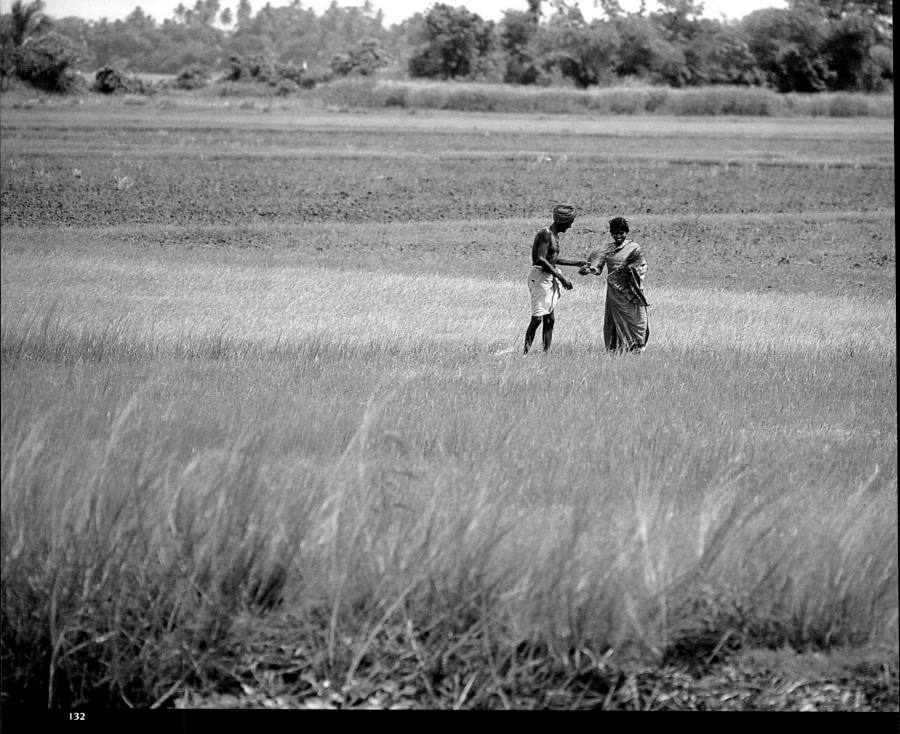

In springtime, the square rice fields of the Indian plains create a
green mosaic pattern, broken up by reflections

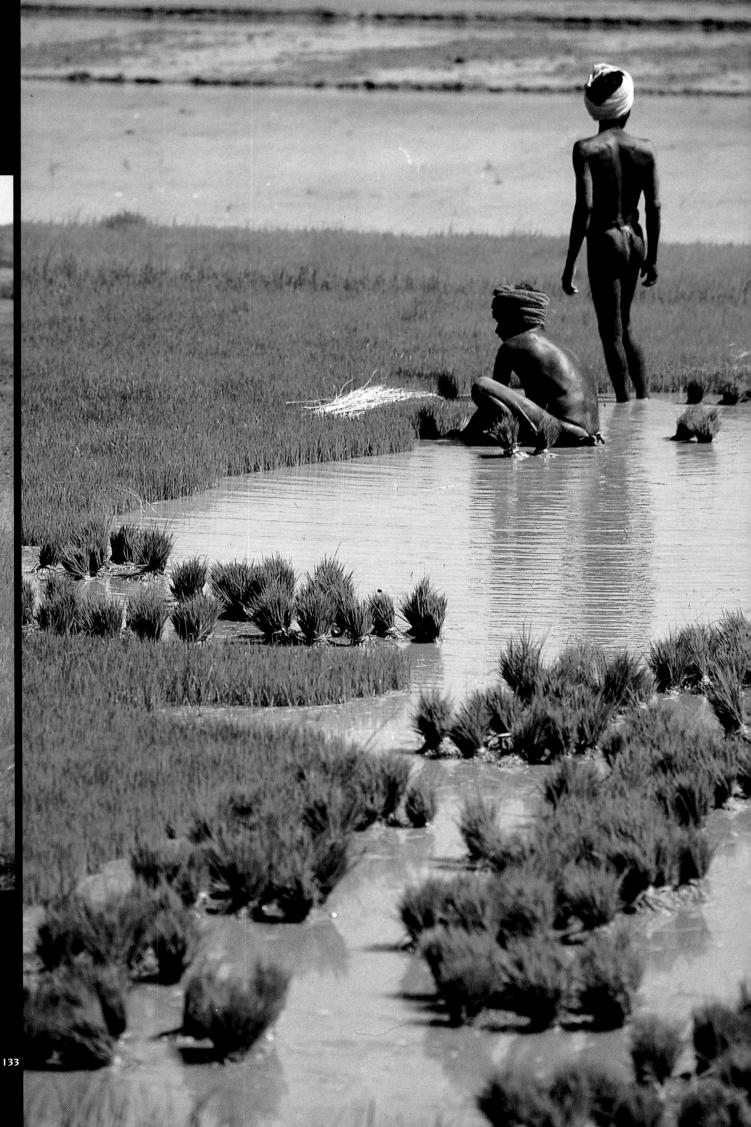

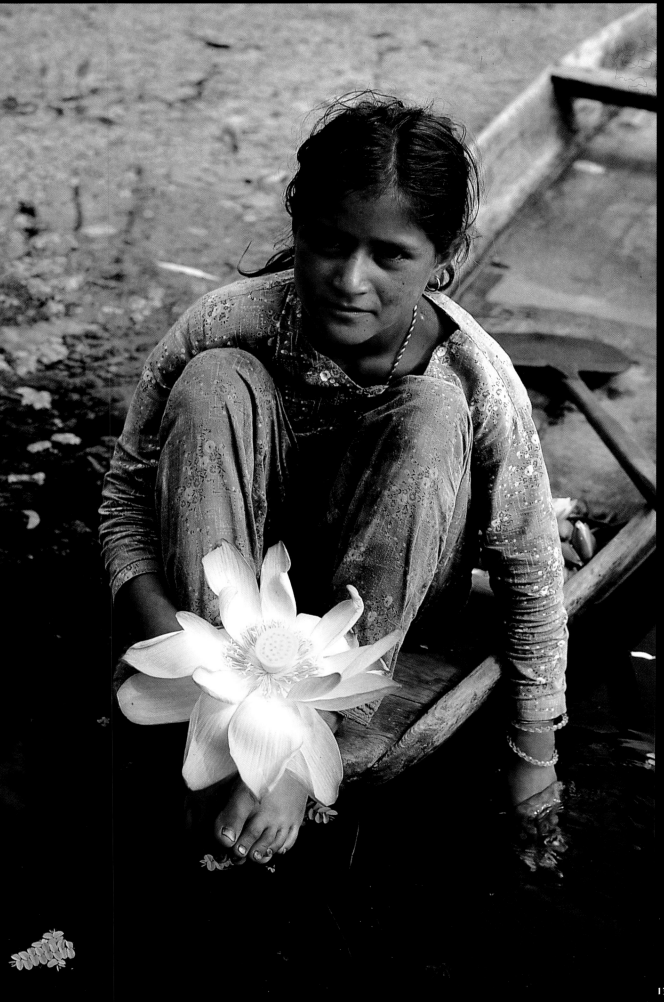

Water is also a source of joy and beauty. All those enormous lotus flowers that grow on the surface of the water are destined to adorn the altars of the deities, as they symbolize divine purity, rising from the mud of human sins.

THE HIMALAYAN INDIA

The true liberating knowledge has come from the Himalayas
as a revelation;
it has dispelled the darkness and enlightened those,
who aspire to the highest degree of Brahman purity,
which neither knows birth nor death.

Bharavi (sixth century), Kiratarjuniya

Here's a very enticing analogy — that the shape of India could be compared to a giant elephant head with its trunk doubled back. The body would be Asia, the ears, Pakistan and Bangladesh. The peak of its head would be the snow-covered summits of the Himalayas. But the twists and turns of history, the hazards of tumultuous politics have left India with sovereignty over only a small part of this immense area of the tertiary period. The Indo-Buddhist states of Nepal and Bhutan, having a Tibetan culture, deny India access to the highest Himalayan summits. In spite of these geographical barriers, present-day India can still extend its hand to Tibet and China by two narrow territories — in the extreme northern part of the peninsula, by way of Kashmir and Ladakh; between Nepal and Bhutan by the high valleys of Sikkim; and in the extreme northeast, India borders Chinese Yunnan by way of Assam. But this is not the real Himalayas, rather the 'everlasting snows' that the enormous Brahmaputra River has to detour around, as it makes its way from the centre of Tibet to join its waters with those of the Ganges, north of Calcutta.

And the real Indian Himalayas are to be found in the north of the province of Uttar Pradesh that literally means 'province of the north', in the province of Himachal Pradesh, 'mountains of the snows', and in Kashmir, a part of India bitterly disputed by Pakistan. And Kashmir is where the highest and most remote valleys of the subcontinent are found. The Indian Himalayas are also found in Ladakh, Zangskar, Spiti and other lesser-known areas squeezed between the Pamirs and the Karakoram peaks, along the course of the Indus River.

Most of the great rivers of India have their sources in the Himalayas, like the Brahmaputra, the Indus, and the Sutlej, besides of course, the innumerable streams flowing to the left of the Ganges. These, for the most part, have their sources in the mountains of Nepal. The Ganges, as if by a miracle, is entirely Indian with its source at Gangotri, several kilometre from the Tibetan border in upper Uttar Pradesh. And it flows across India to its delta in Sundarbans, south of the large city of Calcutta. This powerful river, like its main affluent, the Yamuna, is formed by two streams that tumble down the slopes of Nanda Devi (7800-metre high), Bhagirathi, and Alaknanda. Those two streams come together near a village, Devaprayaga, that is, 'Joining of Two Waters'. And an amazingly high fall finally brings it to its outlet in the plains, at Haridwar's 'Gate of the Waters'. Here its altitude is only 311 metre. As legend would have it, the sacred river had its true source at the foot of Mount Kailasa, the 'abode of Shiva' that is located in Tibet. And this legend relates

that the river commenced its course from a large lake, sacred to the Hindus, Lake Mansarovar (called Ma-'phang by the Tibetans), at an altitude of about 4500 metre. The Sutlej, principal affluent of the Indus, actually does have its source in the neighbouring Lake Ravanahrada. This seems to confirm geography and lend credence to the myth. What could have been more imperative for the Hindus and the Buddhists, since antiquity, than considering the Himalayan summits, the domain of the gods. For sure, the mythical Mount Kailasa is located there and this is where Shiva is believed to have received the tumbling waters of the Ganges on his head, as it fell from the skies after being thus commanded by the fabled sage Bhagiratha. Shiva had the Ganges pouring on His head to ensure that it broke its fall to earth and transformed it into a calm and benevolent river.

Simply undaunted by the rigours of the climate or mountain paths, numerous pilgrims come from all parts of India each year to *Gaumukh*, the 'cow's mouth', where the foamy, milk-coloured waves of the Ganges gush from under a glacier. They also cross perilous paths to visit Badrinath, at an altitude of 4000 metre at the foot of Mount Kamet (7796 metre). This is the site of an ashram where the great sage Shankaracharya lived (around 800) and where the renowned sage Vyasa is said to have dictated the text of *Mahabharata* to Ganesha, the son of Shiva. Other pilgrims visit Kedarnath, a little further and higher up the mountain, where Shankaracharya breathed his last. Sanctuaries are bound to abound in this region which is so sacred in its very demeanour. The region is so loved by the gods that in a small valley at some 3300 metre of altitude, thousands of varieties of wild flowers just burst into bloom each summer, as if to adorn the gods who haunt this abode. Given the altitude, the air is so clear that if there were no clouds or fog, one could see far into the distance, with a view of mysterious mountains on one side and vast plains on the

other. By contrast, the sky is a deep blue, almost black. In this seemingly timeless zone, one would indeed feel beyond time here, in a magical world, where existence itself is nothing short of a miracle.

The mountains seem to dominate just about everything, demolish everything and represent an unimaginable supreme power, almost surreal. And therein lies its sublime beauty. The pilgrims, totally under the spell of these overpowering mountains, feel almost like gods themselves. The pebbles in the paths no longer hurt their feet, the boulders can't hold them back, no longer do they feel any fatigue — for, they are headed towards the goal of their pilgrimage, the holy temples of the ultimate destination. The higher they climb, the closer they feel to the gods, quite oblivious of the surroundings, nor do they notice the groups of long-haired goats, each loaded with a double sack of supplies destined for those who safeguard the sanctuaries. Only when they would go back down the mountain after the mission is accomplished that the pilgrims savour the landscape, or stop by a stream to share a meal and exchange a few words or engage in banter. As their pilgrimage is culminated, they feel liberated, once again ready to face the heat of the plains, the mud of the paddy field, the dust of the roads. Some of them, those not pressed for time, would take some respite while in Rishikesh, acclaimed as the town of the wise men, dedicated to Vishnu and Krishna, and named after them. They spend several days in meditation with the ascetics, in one of the numerous ashrams that sanctify these locales. They visit the temples with azure blue or pale-green towers that flank the mountains and surrounded by forests swarmed with monkeys and wild animals, near the waters which have yet to reach the Ganges. Finally, going back by bus that descends these heights, they take a break at Haridwar, the 'Gate of the Lord', tucked away at the foot of the Shivalik mountains, where

the houses are lined up along the ghat, whose marble steps lead down to the Ganges. The city's real name is meant to be Haridwar, thus called by the followers of Vishnu. But pronounced as Hardwar by devotees of Shiva, and the Muslims call it Gangadwar. Among the seven sacred cities in India, as corroborated in the ancient text, *Skanda Purana*, "No other *tirtha* (holy place) is equal to Gangadwar; no other mountain equal to Kailasa; no god which matches the grandeur of Vasudeva (Vishnu); no other river is worth the Ganga. He who meditates on Shiva in this place, if only for a fortnight, would become one with Shiva. What more could be said?"

In Haridwar, the memory of numerous divine exploits and those of several wise men of the past is amazingly preserved. Vishnu's footprint can be seen on a stone in the wall of a ghat called *Har-ke-Charan*. Near this spot, stands a most important temple, and that too is called Gangadwar. It was here that Bhagiratha, a wise man of mythical times, wanted to save his ancestors, who had been burned alive by the evil spell of another wise man, Kapila. After a long and intense effort, Bhagiratha managed to call the Ganges down from the sky to sanctify the ashes of his forefathers. As per the *Mahabharata*, it was here only that one of the five Pandava brothers, Arjuna, met the nymph Ulupi, daughter of a Naga king. She begged Arjuna to marry her and he did. They had a son, Iravat. Another legend also has it that in this place, Sati, wife of Shiva, disturbed the great sage, Daksha, while he was making a sacrifice. His fury led to her misfortune as he began to ill-treat Sati and she sacrificed herself by fire. And a furious Shiva cut off Daksha's head, but brought him back to life paying heed to the prayers of other gods. As for Sati, she was reborn as daughter of the Himalayas. For sure, the philosopher Shankaracharya also spent some time in Haridwar, before settling higher in the mountains in Uttarkashi, known as the 'Varanasi of the North'.

Before reaching Ladakh, a region lost on top of the world, one must cross a part of Kashmir, which, by comparison, is sheer paradise. Ladakh is crossed by the upper paths of the Indus and the Sutlej rivers, which have dug deep gorges before reaching these heights. It was here that Buddhist spirituality took refuge at the time, when Hindu and Muslim India were no longer tolerant. Ladakh is strange but an incredible, magic universe of monasteries perched high atop peaks and Lamaist rituals. However, this 'Kashmir' is termed as the 'Switzerland of India', given its breathtaking landscapes, mountains and lakes, its pleasant and temperate climate. It is an enchanting region, and quite understandable as to why civil servants from Delhi come here to spend their vacations during the scorching summer.

But before untangling the mystique and magic of these high mountains, one ought to linger in the happy valley of Srinagar, the mountains' summer capital. In the winter, the civil servants settle a little further south, at the edge of the great plain of the Punjab, in Jammu, a small city set on the banks of the River Tawi, an affluent of the Chenab, itself a tributary of the Indus. Jammu draws attention essentially because of an enormous fortress that sits atop a rocky peak. This fortress belonged to the Dogras, a famous Rajput clan. And several Buddhist monasteries are scattered around the city, whose histories go back as far as the eighth century, one such example being Akhnur. There are also Hindu temples that date back to ancient times. The region around Jammu is not too extensive and its main city, Sialkot, is several kilometre away, in Pakistan territory. In former times, the city was home to several Hindu Maharajas, who erected palaces and forts before their territory was annexed by the Sikhs, in 1820. The holy Sikh city lies in Amritsar, a little to the south. The valley, irrigated by the Beas, stretches towards the southeast, all the way to the outskirts of Chandigarh, the new capital city

created in 1966, by architects Le Corbusier, Maxwell Fry, Jane Drew and Jeanneret, based on plans drawn by Albert Mayer and Matthew Novicky. Begun in 1953 and intended to be the common Capital for the twin states of Punjab and Haryana, finally, in 1975, it became the Capital of Punjab alone and gained the status of an autonomous territory in 1976. It is a dream constructed in concrete, but inspite of several concessions made to the Indian spirit, it could not procure popular approval.

Before going to Jammu and then on to Srinagar, one must take a little detour to the valley of Kangra, in Himachal Pradesh, so popular for its apple, apricot, and cherry trees, as well as its painting workshops, *pahari*, 'highlanders'. These workshops developed from around the year 1750, under the care and protection of the Maharajas, but the tremors of the terrible earthquake of 1905 ruined them forever. From this straggling village, located on the side of a slope at an altitude of only 760 metre, devout Buddhists climb up the wooded slopes to get to Dharamsala, a village whose two-storey houses are built in a row near immense cedar forests. In 1950, the Tibetan holy leader, Dalai Lama and his followers settled above this village at an altitude of 1700 metre, where he could recreate a sort of little Lhasa that included Tibetan monasteries and Buddhist libraries. These serene environs couldn't be more conducive to rest, introspection, and meditation, certainly for those lured by the Buddhist philosophy.

But Kashmir is above all, Srinagar, with its valley and its lakes, its network of streams that make it a kind of Venice of the mountains. It is the 'City of Lakshmi', goddess of beauty and companion of Vishnu. Most of the houses are built of wood, and the city itself resembles a mountain village in Europe. Parts of the city follow the meandering of the Jhelum River and the canals bordered with plantations of flowerbeds.

The Mughal emperors, though accustomed to this spate of droughts in Central Asia, they could hardly bear the excruciating heat of the Gangetic Valley. Naturally, Kashmir for them, became the epitome of paradise on earth. It is often quoted that Jehangir had thus muttered on his deathbed, as if in a reverie, "Kashmir, nothing else!" And this paradisiacal image so haunted the Mughal rulers that they tried to replicate its beauty in their regime, as widely seen in the poplar and willow trees planted along the roads and gardens extraordinaire built near the lakes. In 1817, the Irish poet Thomas Moore had one of the heroes in his play, *Lalla Rukh*, say: "Who doesn't know the Valley of Cachemire, with the most beautiful roses the earth has ever produced, with its temples, its grottos and fountains as clear as the eyes of lovers reflected in their ripples!" Moore, no doubt, was making allusion to the Shalimar Gardens that Jehangir had designed around Srinagar for his wife Nur Jahan. He went on to add further: "If a woman can make the most arid desert hospitable, just think to what paradise could Cachemire resemble!"

Fountains and pools reflecting black and white marble pavilions are fed by a sycamore-lined canal bringing water from Dal Lake and nearby springs. This renowned scenic spot is so awesome that *son et lumiere*, 'sound and light' shows are presented in the summer, retracing the life and loves of the Emperor. The audience can travel to that dreamland of opulence, love and romance back in time. Such was the splendour of the Great Mughals' court. In these magical moments of theatrical rendition, lights play on the streams and pools that are lined with cypress trees. In the psychedelic lights, as the costumes shimmer and transport the viewers to a world, almost beyond time — perhaps longing for times of the past — now lost forever.

And, of course, the most notable attraction of Srinagar is its lakes with such translucent waters that so clearly mirror the snow-clad and

perpetually misty peaks of the mountains of the north. They seem to form a kind of screen and beckon the traveller to stay put in the valley, also cautioning him not to access the domain of the gods. And yet, the inherent paradox of this place is that you are awestruck by the majesty of the mountains, which might appear thwarting but not in the least intimidating. Rightly so, as any endeavour to go beyond this silent and eternally forbidden zone would be far too hazardous. The road leading to the valleys across the summits, to Zangskar and to Ladakh, is as tough as the view is breathtaking.

So is Dal Lake, the cynosure of Srinagar. Fed by glaciers, its shallow waters are remarkably pure, though the transparency of the water is not easily seen from the banks, since it is blanketed with a layer of lentiscus that lends it a lovely emerald-green cover. But no way does it affect the regular crossing of the numerous boats that ply on the lake, or bother the gardeners, who have created veritable floating gardens, cultivating innumerable flowers, lotus and others that they transport to the market by boat. These flowers make for garlands to venerate the deities or welcome eminent guests.

Other traders supply various merchandise to the floating hotels or houseboats, occupied by those tourists or visitors who fail to find any lodging in town to stay. Some luxurious houseboats that match the five-star comforts are even rented out to tourists. And this tradition of floating houses dates back to the time when the British came to spend a vacation in Kashmir. Since they could not buy property legally, they got to improvise these houses on the lake, or houses moored to the banks of the Jhelum. These houseboats are fairly spacious often equipped with all modern facilities, offering running water and electricity. The occupants usually get around in shikaras, lighter boats that allow them to easily visit the shores of the lake, or simply to stay in a secluded spot and be gently rocked by the waves. A short distance to the west, nestling in the

mountains, is found Lake Wular, the largest lake in Kashmir, whose waters, like those of a little lake nearby, Lake Manasbal, reflect the azure skies and they are remarkably clear in springtime. Their banks are covered with iris, and in summer and autumn they are hidden by a rich carpet of lotus flowers. This is a spot of absolute solitude, far from the madding crowd of any town, populated only by the chirping birds. This happens to be the favourite haunt of the inhabitants of Srinagar, who come here to immerse themselves in nature that remains almost pristine, receptive though restrained.

On the contrary, the wrath and fury of the elements of nature don't make it so comfortable and easy for the wary though adventurous traveller, who wishes to traverse the east of the Himalayas. Like it is so difficult to access Zangskar, 'White Copper', a former small Tibetan state, situated in the valley of the river of the same name. One has to retrace the course of a stream, Suru, all the way to the foot of a Buddhist monastery, Rangdum Gompa, perched on these heights. Founded in 1781, this monastery is home to monks of a sect 'Yellow Bonnets' (Tibetan: dGe-lugs-pa) and can only be reached by a desert road, which is often inaccessible, given the landslides and falling rocks. Only trucks, jeeps and toughest of the tough mountaineers can dare to get through. The wild landscape has its own grandeur. On the right, one discovers the rocky peaks of Nun and Kun that boast of an altitude of over 7000 metre. Here, in the heart of the Himalayas, there is a sensation of invading an inhospitable, rugged rocky universe that belongs more to Tibet than to India. This is the final stop — the true Buddhist territory, as one begins to see chortens (Tibetan: mChod-rten), those characteristic Buddhist shrines, so typical of Lamaism, just about everywhere. One also encounters almost unapproachable monasteries, perched atop the rocky peaks.

And this ancient Kingdom of Zangskar, though stands isolated among the peaks, has a

long history. It remained a part of the western Tibet, at least since the seventh century, just as the neighbouring valley of Ladakh. As the historians have discovered, a certain King rNima-dgon, ruler of all western Tibet, nearing his death, in 930, divided his kingdom between his sons. One of them inherited Ladakh, the other, named lDe-tsu-dGon, inherited the valley of Zangskar, and granted it independence right away. This kingdom, administered by monk-kings, was at peace with its neighbours until about 1640, when the king of nearby Ladakh annexed it. Soon, Zangskar, in turn, tried to conquer Ladakh and at one time even governed a part of Guge, the western kingdom of Tibet. But no way are the people of the valley martial, jut simple peasants and miners. The former raising barley, mainly, and a little wheat in the lower valleys. They raise yaks and this domesticated animal provides them with wool and milk, so essential for their basic survival. The latter exploit copper, iron and gold mines that built the reputation of this valley and earned it its name. These villages are isolated by the snow for nine months of the year, totally paralysed by the cold that at times even descends to minus 40°C. These impoverished villages have grown only around the monasteries that the Tibetan monks chose to erect here, lured by the solitary feel of the summits. There are occasional celebrations that lead to the congregation of the villagers. And this is when their women don a splendid headdress, *perak*, cobra-hat, overstudded with jewels, turquoise and cornelian, sewn onto thick felt fabric or leather. These headgears are indicative of both their social standing and family wealth. The men take part in archery competitions and join the monks in ritual dances, masked dances (*cham*) that mark the end of the monsoon season.

This is one place where each valley and each rock has its own history, its places of prayer. The landscape is so mind-blowing, so isolated from the rest of the world that one only gets to hear the sounds of silence, sometimes even heightened by the whistling of the wind or the squeal of a bird, high in the sky, perhaps as it imagines itself to be a messenger of the sun. It would be impossible to visualise the majesty of these heights in your imagination, if one has never had the fortune of being there. For that matter, even the most poetic of words would fail to capture and depict any feeling of that unique experience when one faces a frozen solitude, all by oneself. It's a kind of spell cast by the serenity of the monks who live at these desolate heights, a different planet altogether, where the slightest blade of grass fascinates you enormously and where even one's breath becomes so tangible that you are only aware of one sensation — that of existence. . . .

As for the valley of Ladakh, though not a shade more cheerful, at least it seems more welcoming, given the fact that it is more densely populated with a larger number of monasteries. Among the more seasoned climbers, they reach this valley, following a narrow path that moves along the Zangskar River, starting at bZang-la, continuing through narrow and winding gorges, and finally leads on to the valley of the upper Indus. Others, who can't muster up much courage, go back to Kargil and follow the road leading to the Capital of Ladakh, Leh (Tibetan: gLeh). It is a small town of about 7000 inhabitants, nestling in a narrow valley where the Indus flows. It was once the Capital of a prosperous kingdom, when the royal residence shifted there from nearby Shey in the fourteenth century. And the most renowned ruler of this valley, Grrags-'bum-lDe, who reigned from 1410 to 1440, had got a red temple built, dedicating it to the cult of Maitreya, the Buddha to come. One of his successors, bKra'-shis rNam-rGyal (1500-1532), after having unified the valley, built an imposing fortress, 'Victory Peak'. From that time on, the city became an important centre for caravans. As merchandise from Central Asia,

Tibet, and China, arrived in the city, it was rerouted towards India. The wealthy King Seng-ge rNam-rGyal (1590-1642) was thus able to erect a sprawling royal palace for himself. Today, this regalia lies in ruins. For, the growing affluence of this state became the neighbour's envy, and Ladakh was attacked several times by the Mughals, the Tibetans, and also the Chinese, who wanted to control its trade and commerce. Finally, it was Ghulab Singh, a small Sikh Raja from Kashmir, also a vassal of Maharaja Ranjit Singh, who, in 1834, sent his General Zorawar Singh. This is when Ladakh and Zangskar were conquered and taken control of. As Ladakh became a part of British India, it retained a particular status, as vassal of both Kashmir and Tibet. After the Partition of India in 1947, Ladakh was deprived of the entire western part of the country. At the other end, the northern part of the plateau of Zhang-zhang, Aksai Chin, was completely annexed by China.

The Indian part of Ladakh, rich with the waters of the Indus and its agriculture (mainly barley, wheat and peas), still maintains innumerable vestiges of its past, like the abandoned fortresses and especially the magnificent Lamaist monasteries. With no more revenue being generated from trading, the natives today thrive on tourism that has lent them more comfortable lives. The large market at Leh, where the women come dressed in their most beautiful *perak*, offers travellers an infinite variety of local products, as well as manufactured goods from Tibet and China, which help to foster trade.

Away from the valleys, which are relatively green at the end of springtime, the general landscape of Ladakh is like that of the moon, mostly desert. It is a universe of never-ending rocks that freeze even in summer, when temperatures at times peak at 45°C in the sun; and they may be minus 10°C in the shade. In the winter, temperatures touch the nadir point at 40°C

below zero, as the region is shrouded in snow, and life reduced to its bare minimum. Even animals can barely be seen and the conditions being least conducive to vegetation, grass and shrubs are as rare. And yet, one can occasionally spot ibex, the wild sheep, besides herds of small wild horses, Kiang, who invariably fall prey to the wolves and snow panthers wandering in this desolation. Besides, a few nomad tribes live on these high plateaus and keep herds of yaks and several sheep. And one wonders and marvels at how these people really manage to survive in such hostile an environment, perhaps one of the most inhospitable on the planet.

Ladakh can certainly lay claims to its enormous attraction, owing to its Lamaist monasteries, each of them perched more than 3000 metre in altitude. Coming from Kargil, one can possibly access these monasteries only by going over several passes, which vary in altitude from 3700 metre to more than 4000 metre at Fotu-la. But one would not visit Ladakh just to savour its landscapes, which would become monotonous after a while, notwithstanding its exalted heights or how sublime they might seem in their sheer vacuity. To reiterate once more, its obvious charm lies in its monasteries and omnipresent chortens erected along the roads, on the edges of cliffs and rocky summits, standing alone or in clusters, some worn out, while others freshly repainted in white and red, acting as landmarks for travellers to keep a track. The most notable among them that warrants a 'must' visit, is Lamayuru, a huge monastic complex, believed to have been founded in the eleventh century, for the sect of 'Red Bonnets' (rNing-ma-pa) by Rin-chen bZang-po (956-1055), the great Tibetan Lama and translator of the Buddhist texts. Although, it looks somewhat rundown, which is attributed to an insurgency of the Dogra Sultans of Kashmir in the nineteenth century, but you still get to admire its splendid bas-reliefs and murals dedicated to the grand old masters of Lamaism, like Mar-pa and Mi-la-ras-pa.

The number of monasteries in Ladakh is so boggling that it would take an entire volume to put them on record, but two among them merit special attention, as they leave an indelible imprint on your memory — Lamaist art at its peak. The monastery of Alchi, built on the right bank of the Indus by Rin-chen bZang-po, encompasses the most admirable murals that can possibly be seen. Their reputed renown has been adding to the flow of art lovers who, despite the hazards of a journey to such tough terrains, come calling. As an ace expert Pratapaditya Pal puts it, "The unknown masters of Alchi know and express an electric civilization where elements from Tibet, Kashmir and cultures, such as Indo-European and Turk-Mughal, from Iran and even Byzantine are mixed." In fact, it simultaneously unfolds a summary of Tantric Buddhist art and a treasure of information on palace and monastic life of the eleventh, twelfth, and thirteenth centuries in the regions of western Tibet. The monastery of Hemis was founded later in the seventeenth century, at the bottom of a ravine for a branch of the 'Red Bonnets'. It draws special attention, not only for its stunning sculpted interiors, but as much for its annual festival of religious dances held at the end of June.

Though lost in the confines of Tibet, the palaces, fortresses, monasteries, chortens, and marketplaces, all liven up this valley and its imposing rocks. No wonder, the West is slowly discovering this region. The summits exude an ethereal aura given their altitude, their solitude, the primitive, arid nature and above all, because we are in awe of those holy men, who wanted to seek a domain here to confront eternity in eternal silence, despite such hostile climes.

But once you are back from the pilgrimage to these summits, the warmth and reassuring sights of green plains display the contrast at its best, though one can never let go the sheer thrill of these heights from your heart and mind. The imprint left on your soul is so strong that the desire to get back to those unimaginable heights overpowers you. And you want to immerse yourself all over again. For, up there on the summits, at the precarious edge of the roof of the world, you discover that it is only the spirit that lasts forever and enriches our lives. And for all you know, without even knowing it, you have been face to face with eternity.

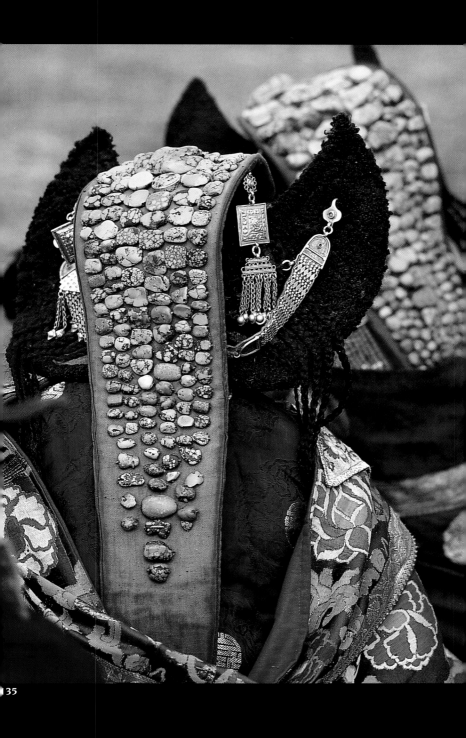

Women of Ladakh, a region of the Himalayas,
near the Tibetan border, sport 'cobra' headgear (perak).
These are generously decorated with turquoise, and believed to
constitute the women's fortunes. The number of stones
encrusted therein is indicative of
their status in society.

The inhabitants of Zangskar
are devout Buddhists,
followers of the Lama.
To pray on feast days,
women of the valley don
their headgear and dress in the
best of finery. The families
pay a visit to the closest
monastery during
important celebrations.
They walk under the
'horse of the wind'
(Tibetan: rLung-rta),
the coloured banners believed
to carry the prayers of the
faithful up to
the sky.

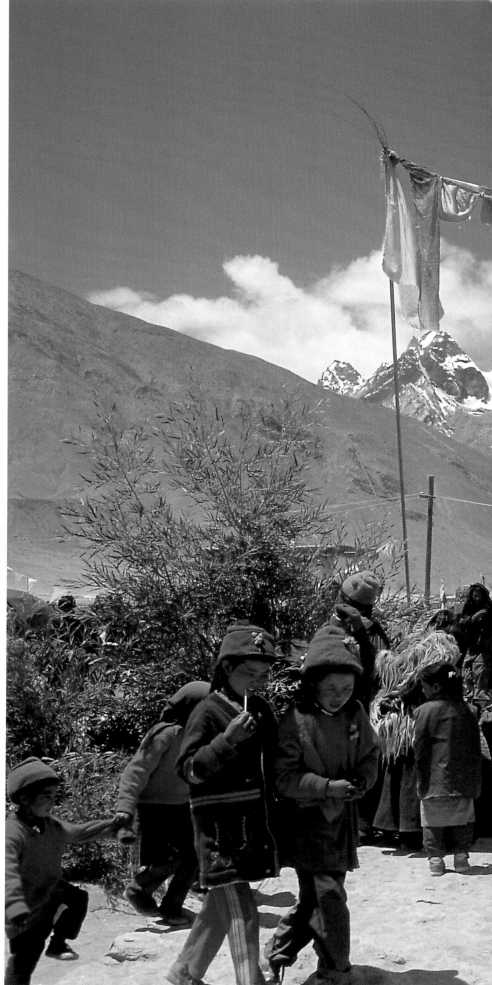

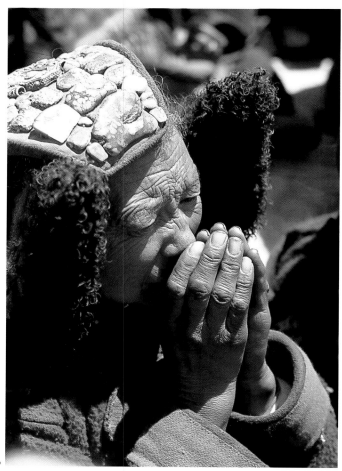

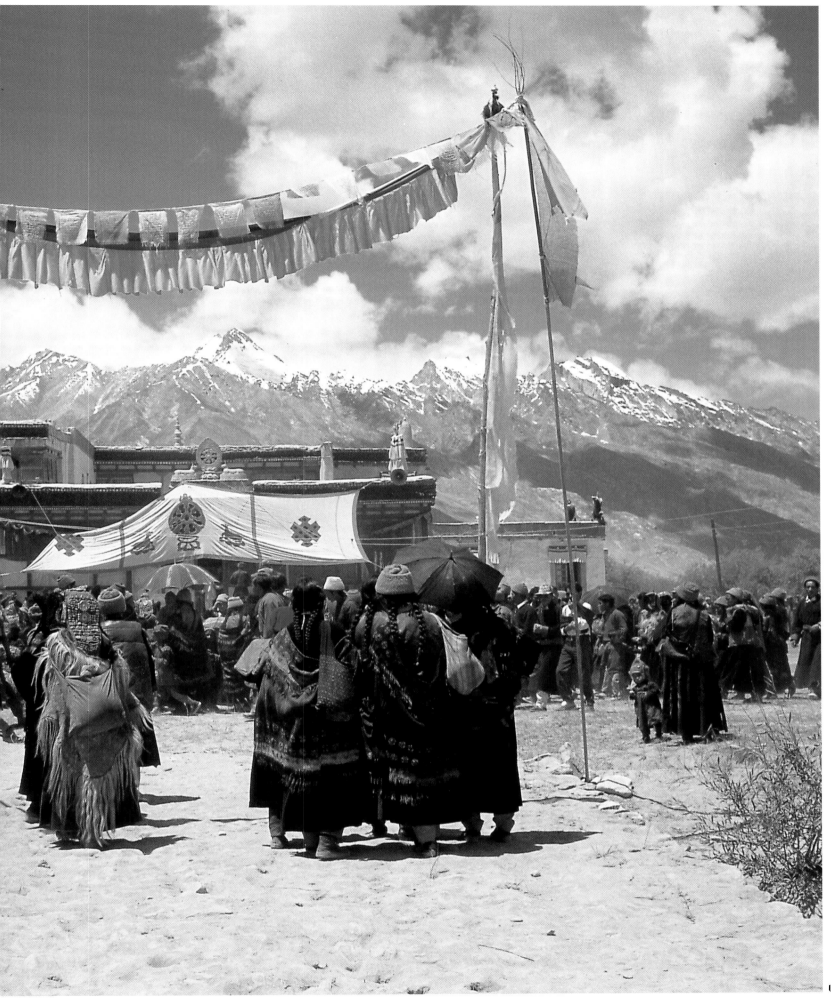

In the valley of Ladakh, at the foot of vertiginous Himalayan summits, followers of Buddha, in their piety, have erected numerous chortens (Tibetan: mChod-rten). These are stupas, symbolizing the Buddhist doctrine and serve as a reminder of the spiritual power of this doctrine.

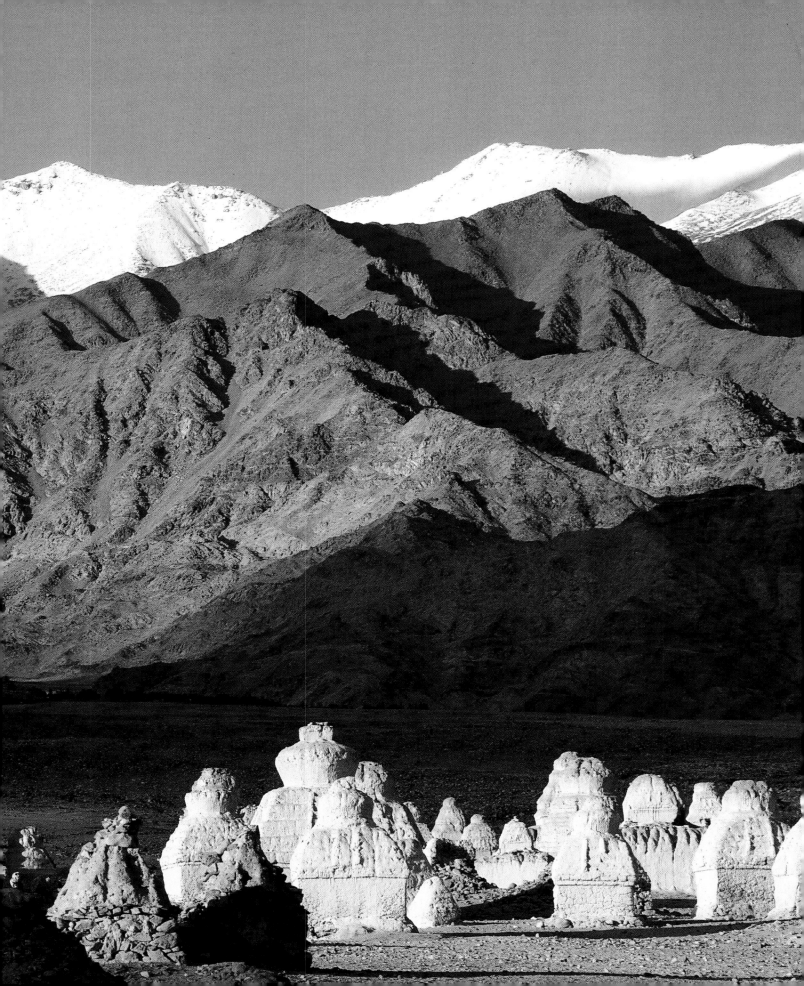

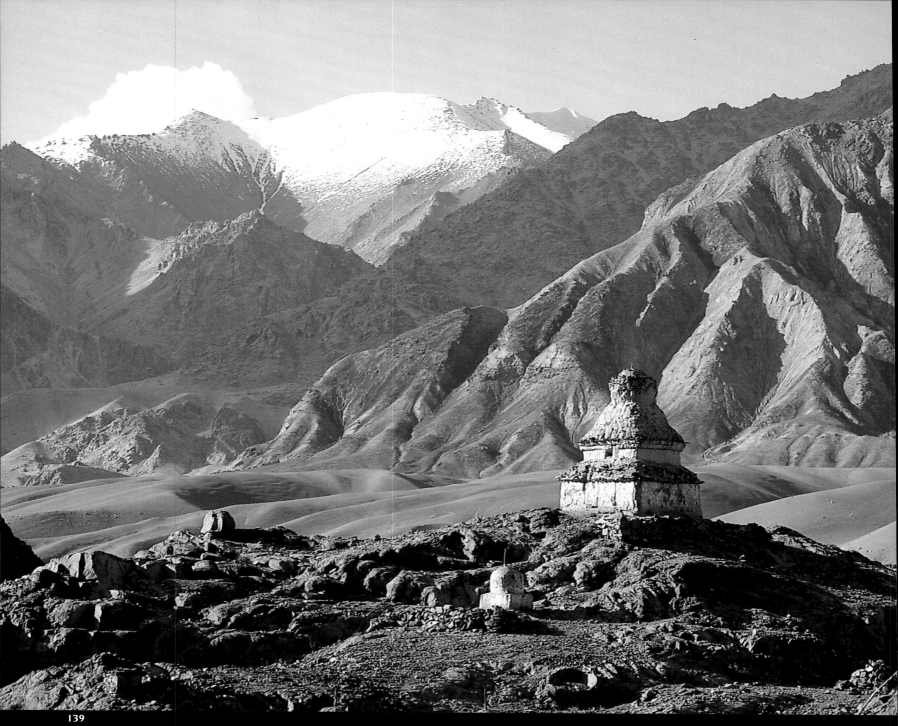

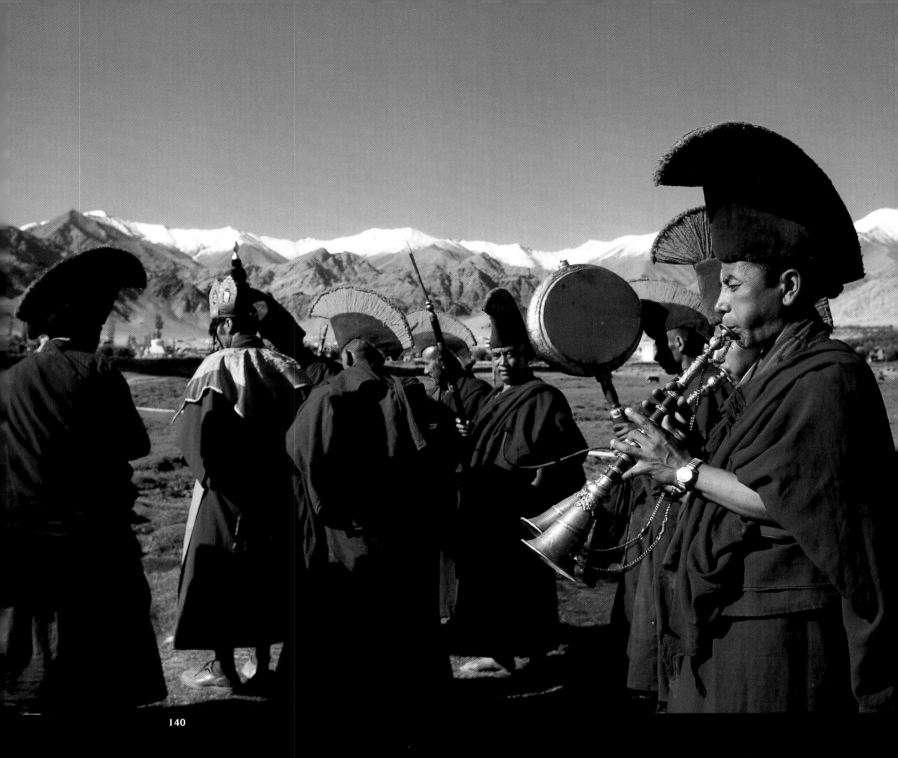

140

Monks from the sect of 'Red Bonnets' (or 'Old Ones', Tibetan: l rNing-ma-pa) proceed to the monastery of
Spituk in a procession. There, they would take part in composing a large mandala, a picture of the
Buddhist cosmos, which, once finished and consecrated, would then be destroyed
and thrown into the waters of the Indus, in order to be
reunited with nature and sanctify the waters.

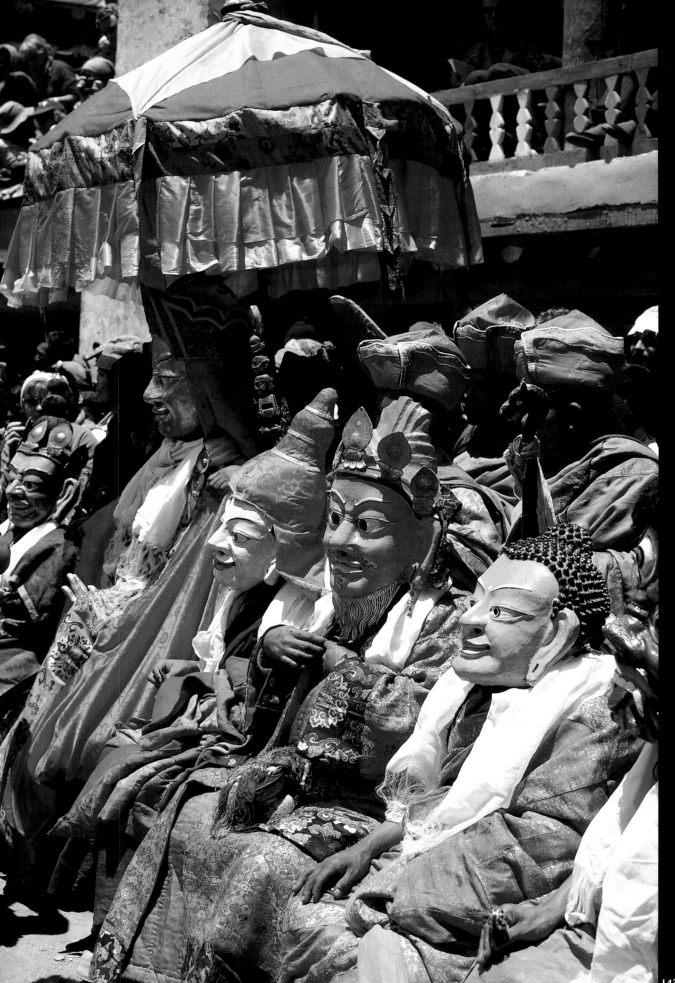

The monastery of Hemis, in Ladakh, founded in the seventeenth century by a Tibetan monk of the 'Red Bonnet' sect, is known not only for the paintings that decorate the walls of its rooms, but also for its grand festival of masked dances (Tibetan: 'cham). The festival that takes place by the end of June, attracts hundreds of pious or curious monks and villagers from the valley.

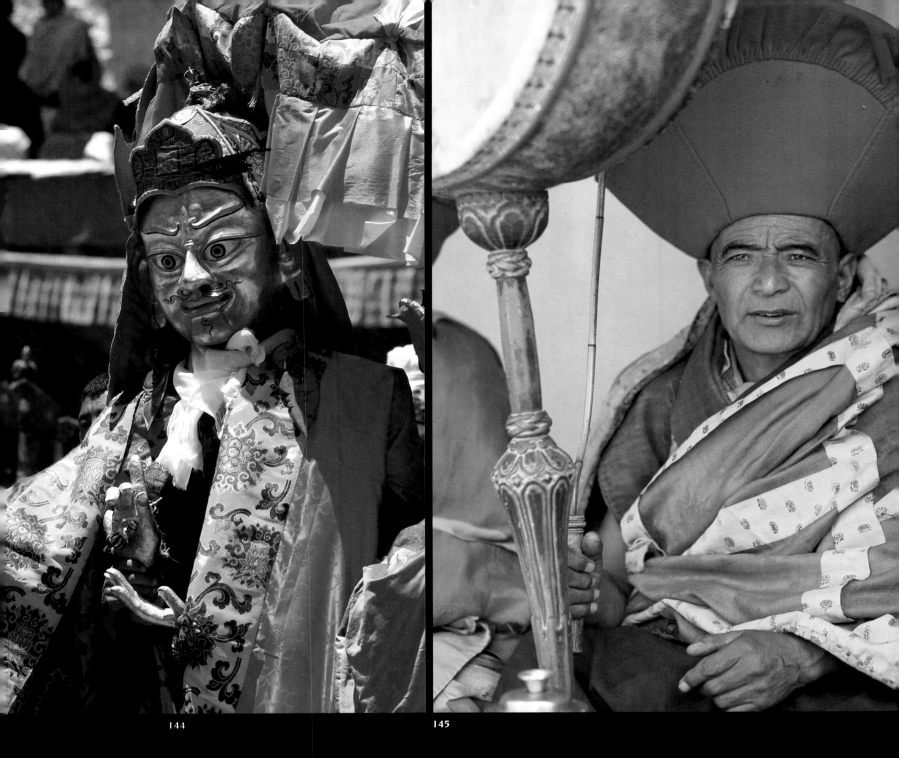

144

145

Numerous religious festivals in Ladakh mainly consist of
dances and pantos in which masked actors represent
divine and demonic forces.

The buildings of the great monastery of Thikse (Tibetan: Khrig-rtse),
founded in the beginning of the fifteenth century, cover the
summit of a rocky peak. The monastery constitutes a
veritable small city by itself (146).

146 ▶

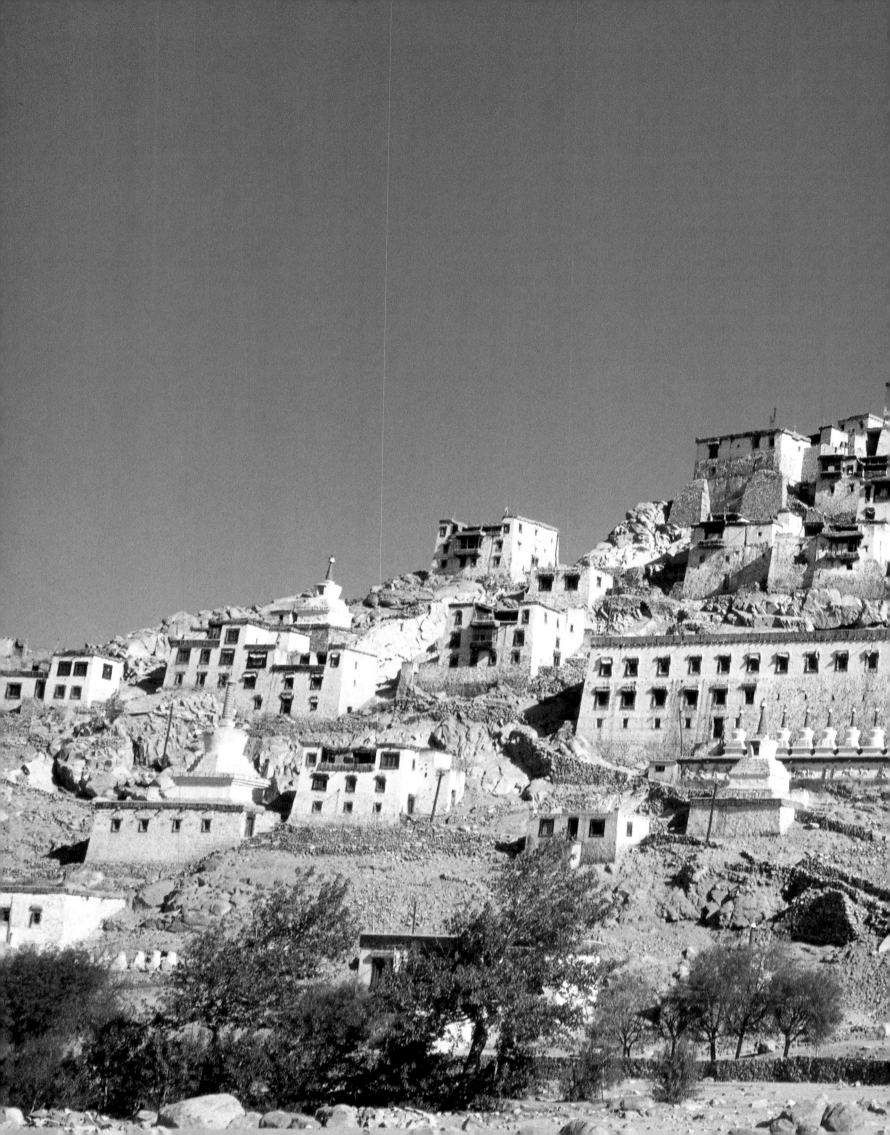

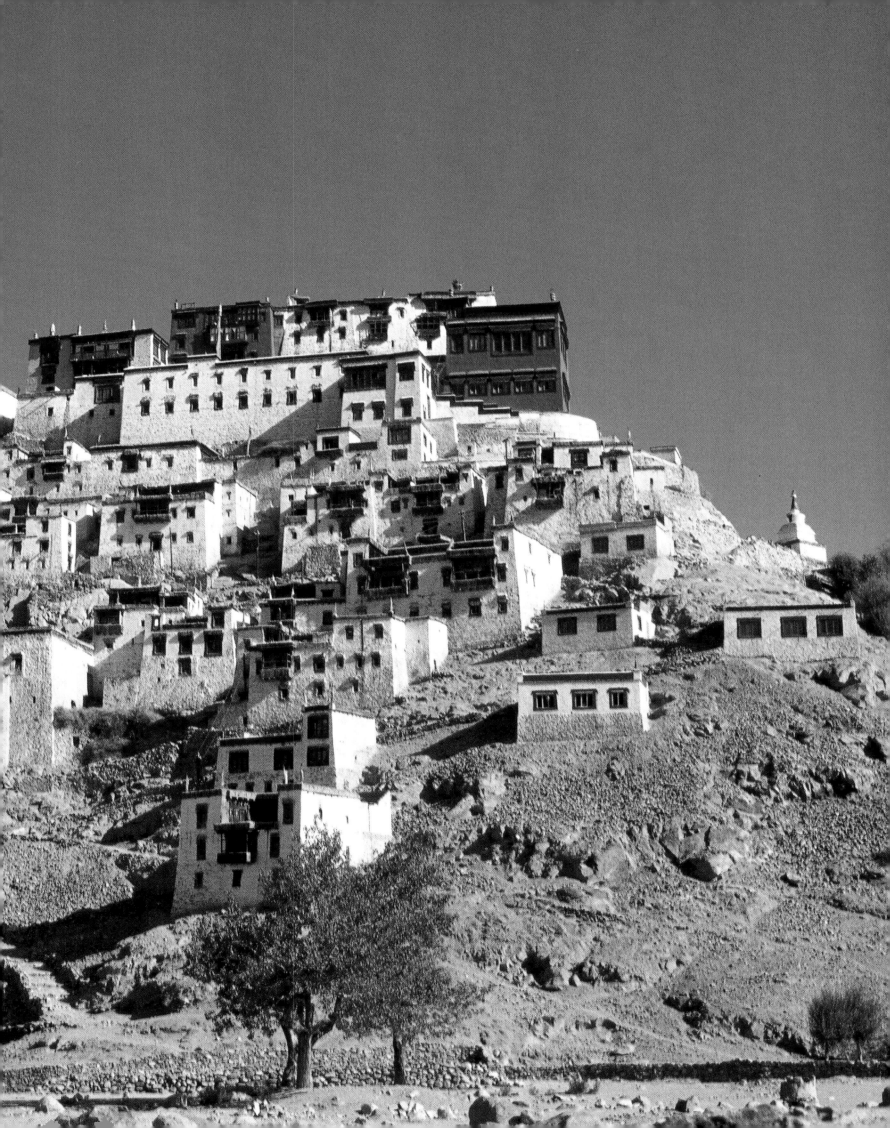

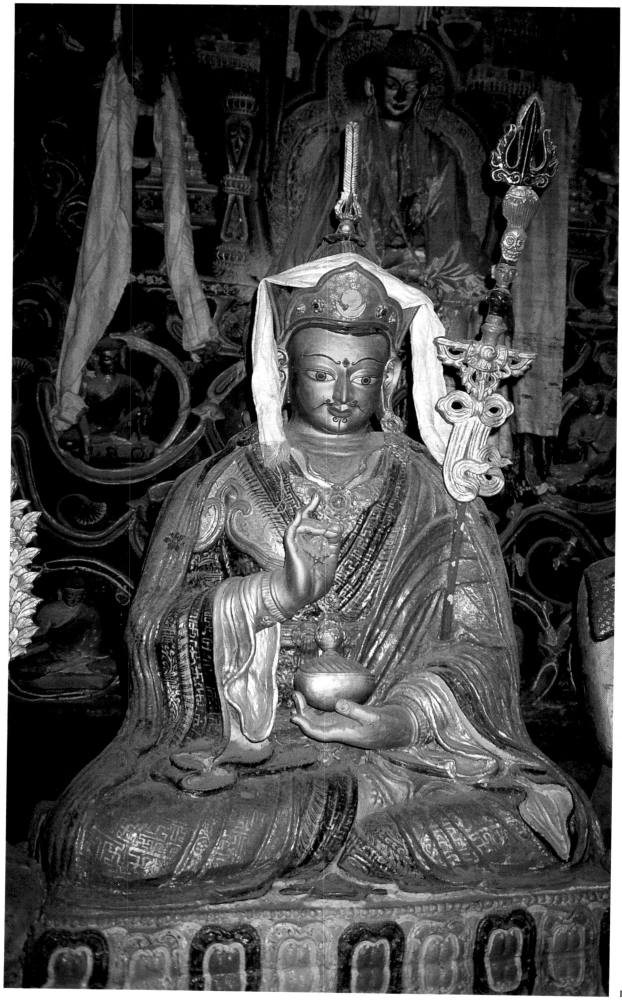

In the eighth century, Padmasambhava, an Indian monk from Kashmir, went to Tibet around 750 and introduced the Tantric doctrines that conceived Lamaism. Venerated by every sect and considered a deity, his statue, in one or another of its numerous forms, is given the place of honour in every monastery, as here in Lhalung, in the Spiti Valley.

Buddhist monasteries are not merely sanctuaries for prayer and meditation, but also great cultural centres where painting, sculpture, and literature are cultivated. Their libraries often contain ancient, very rare works, some of which have not been entirely understood or translated. Monks study them devoutly, in order to perfect their knowledge of Buddhist doctrine.

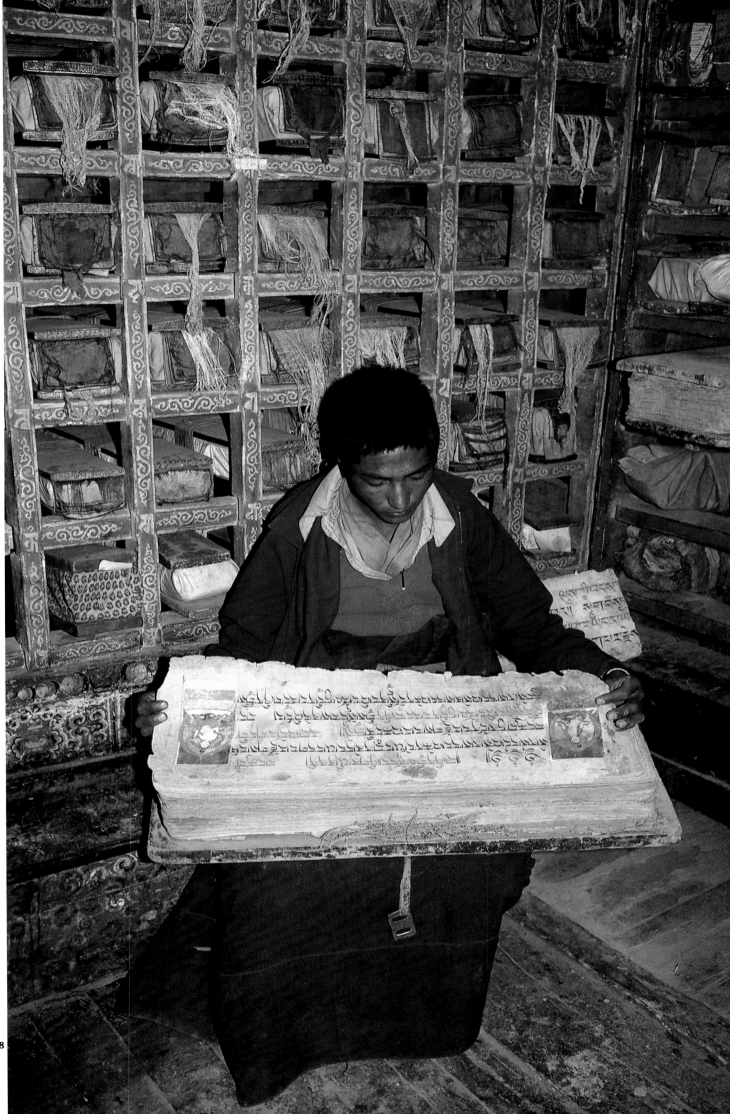

Not all Buddhist monks belong to the sect of the
'Red Bonnets', inspired by Padmasambhava,
and certain among them follow the 'reformed sect' (Tibetan: dGe-llugs-pa)
of Tsong-kha-pa (1357-1419). They are known as 'Yellow Bonnets', like this monk,
who belongs to a monastery of the Ladakh Valley.

Monasteries in Ladakh, like this one in Chendey that dates back to seventeenth century, possess land, which is cultivated for the monks by peasants in the surrounding areas. In the summer season, they harvest barley, which, once ground and mixed with tea, salt, and butter, becomes tsampa (Tibetan: rTsam-pa), the main source of nourishment for the monks, along with a few fresh vegetables.

150

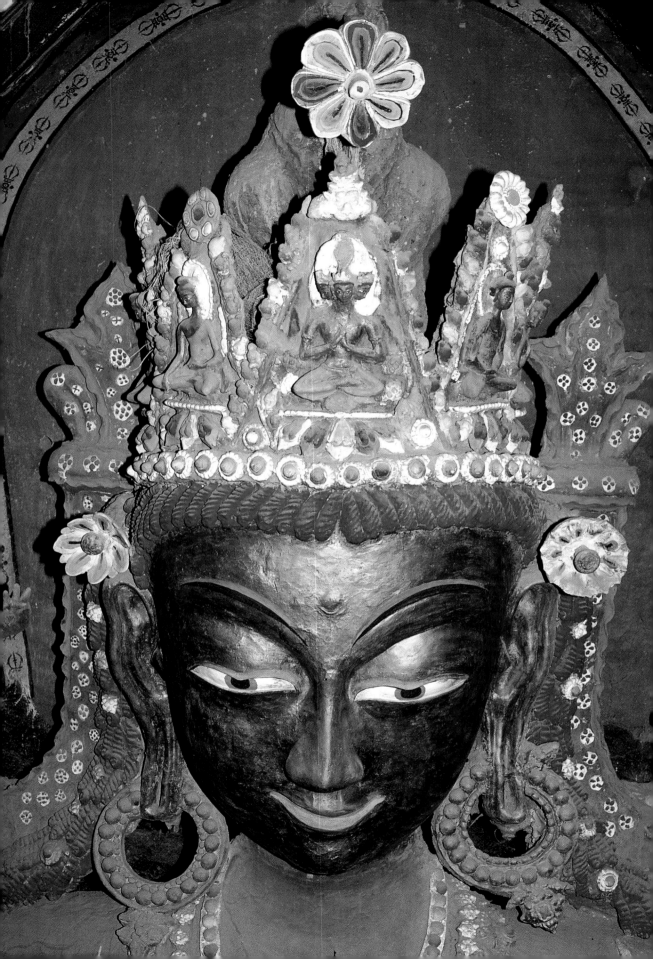

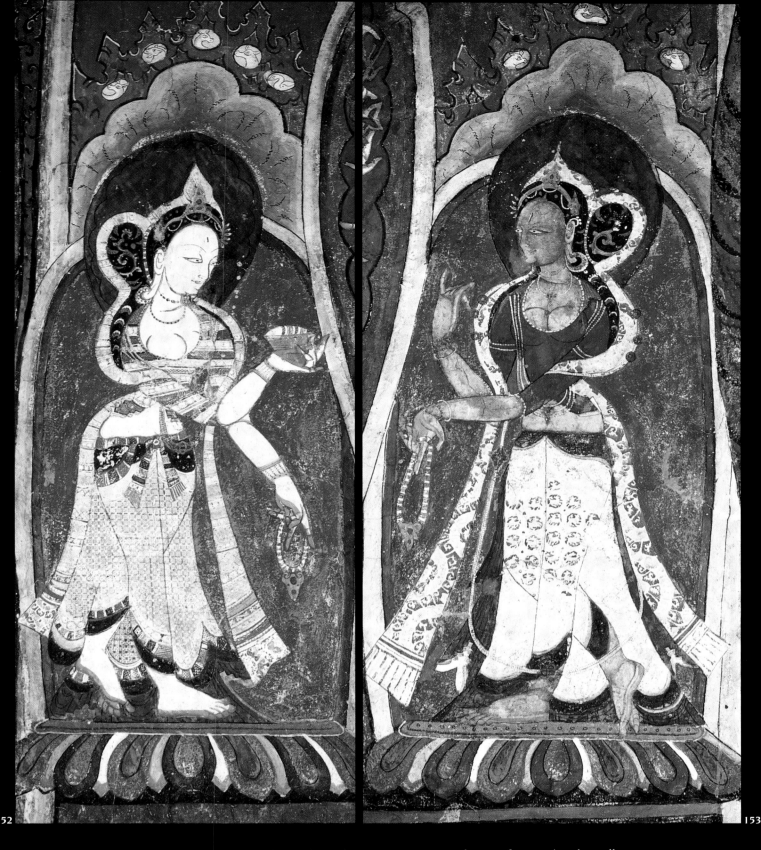

At Alchi, again, the murals of this eleventh-century monastery boast of exceptional excellence.
They not only represent deities, but also their Bodhisattva followers, donors
and praying figures, like these princesses paying homage
to Avalokiteshvara 'of a thousand arms', the great
Bodhisattva of compassion.

Women from the Zangskar Valley, wearing their turquoise
perak, gather for prayer during the great
festival of Kalachakra
in Padum (154).

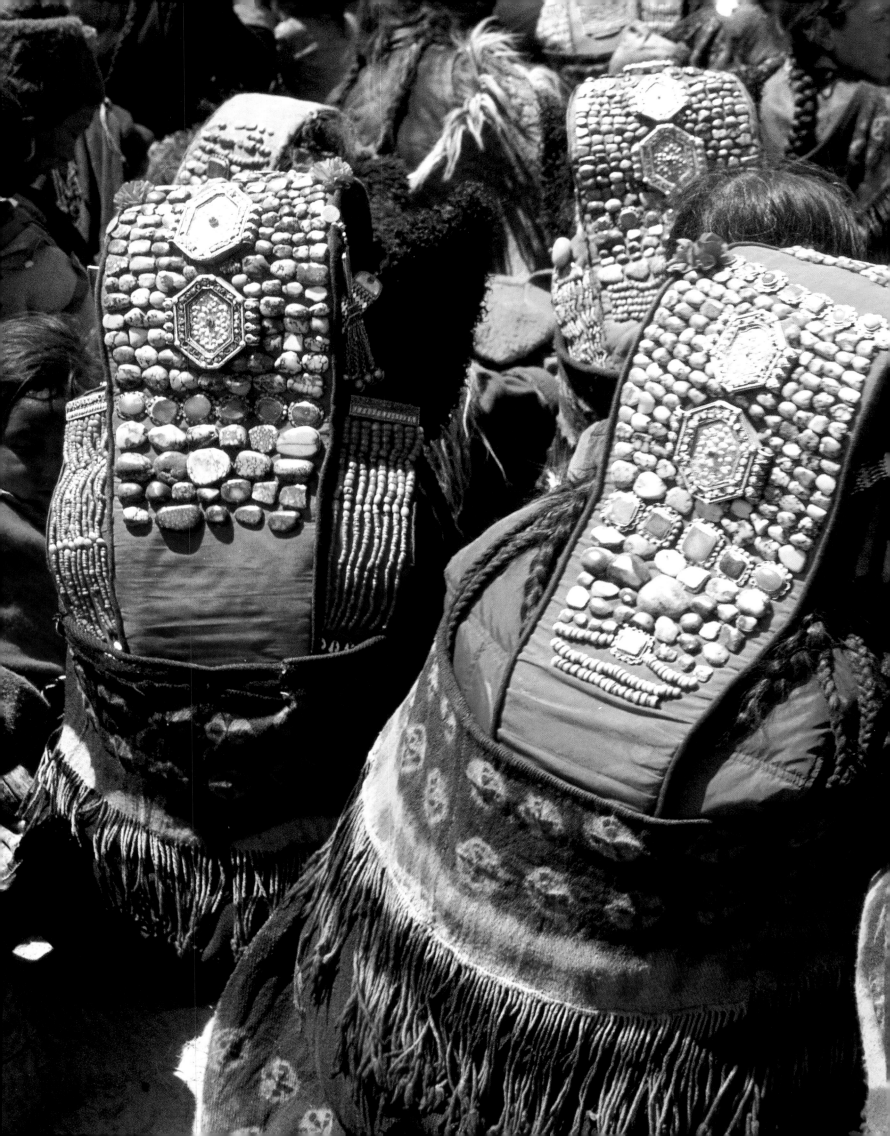

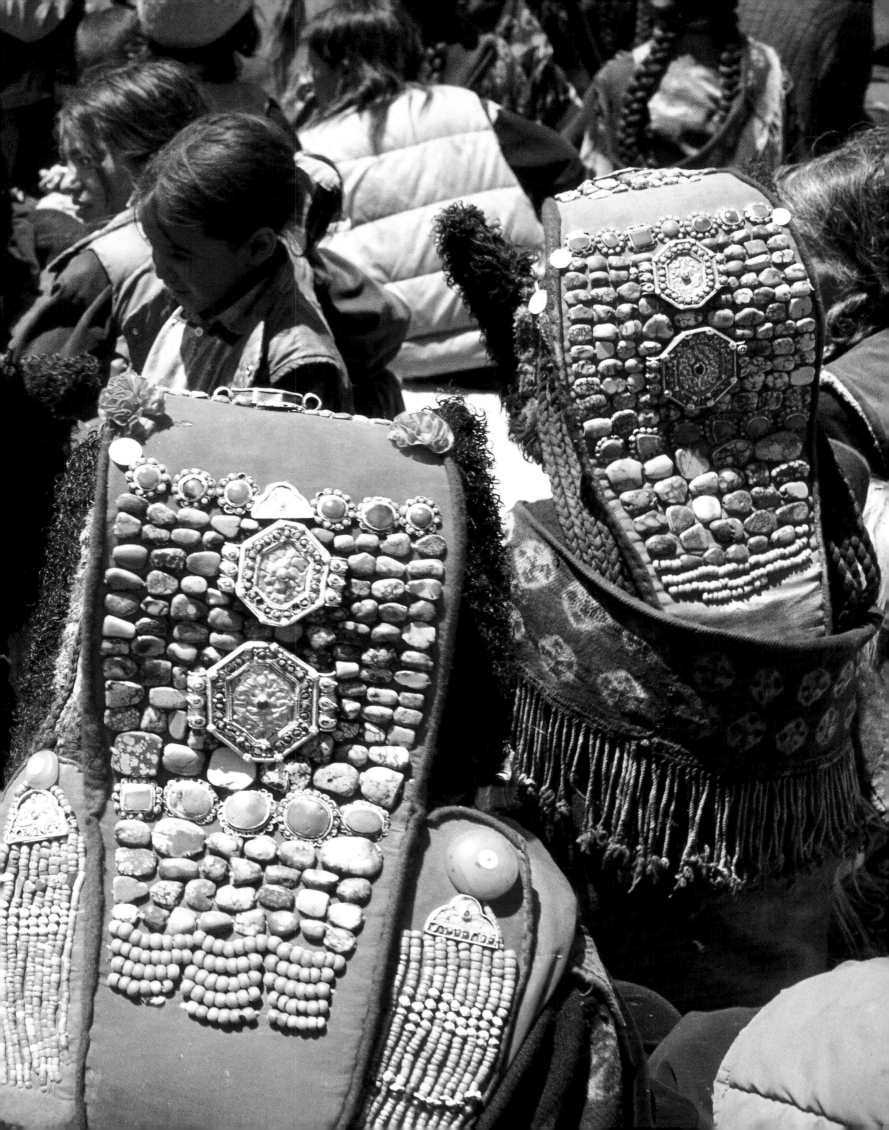

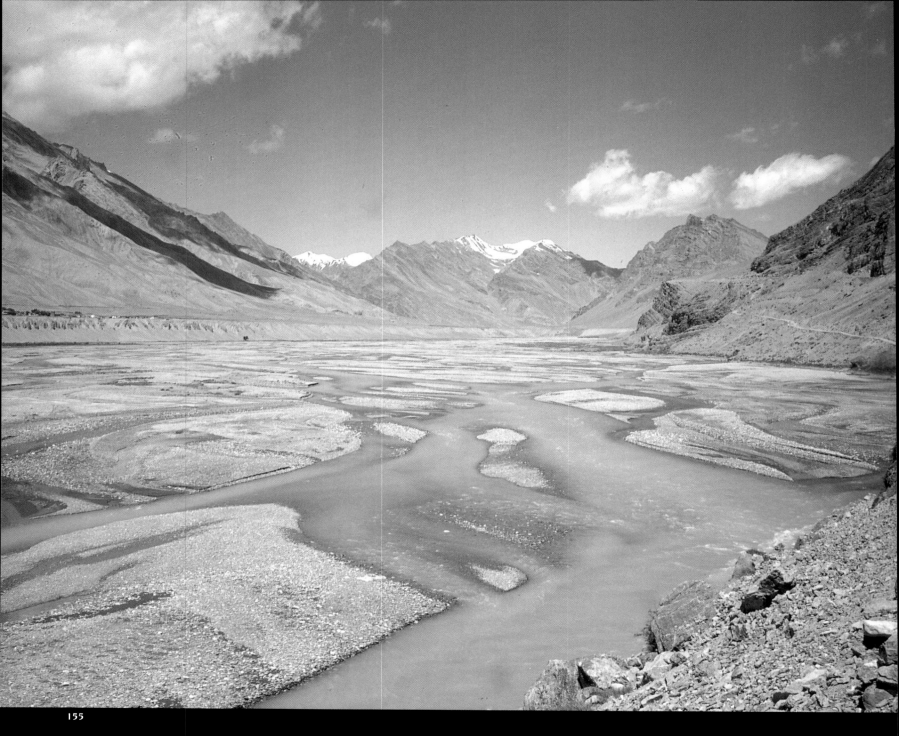

The large valley of the River Spiti with 'waters of turquoise', surrounded by
arid mountains, is situated at an altitude of about 4500 metre.
Notwithstanding its glacial climate, several
monasteries have been set

The monastery of Kye, founded in the fifteenth century, is perched on a rocky promontory, like a jewel embedded in the mountain. Some 230 monks live permanently in this monastery that also houses a precious collection of rare books, paintings and artifacts. Its school for monks (lama, Tibetan: bLa-ma) is fairly renowned, even in Tibet.

MAJOR MONUMENTS

*The diversity of India defies human imagination,
as much in its landscapes as in its splendid palaces, its exuberant people, and their
colourful customs. And since it is also a country of innumerable gods, the number of temples
exceed ten thousand, without even taking into account the village sanctuaries. Perhaps, this unique
amalgamation makes India the largest open-air museum in the world, with its treasure-trove
of vintage palatial structures, amazing fortresses, tombs, and gardens, some of which are
stunning beyond belief. In this endeavour to give a rounded vision of India, though an impossible
task to be accomplished in a single volume, here are a few black and white pictures of some
of the most renowned monuments that have become the crowning glory of Indian art on the
international horizon.*

The Golden Temple in Amritsar

This temple, the principal Gurudwara of the Sikhs, is also known as Har Mandir and Darbar Sahib. Created in the centre of a sacred lake, *Amritsagara*, 'Sea of Immortality' in 1574, it was destroyed in 1761, and rebuilt in 1764, blending quite a few styles. Its copper roof was covered with gold leaf in 1802, by Maharaja Ranjit Singh, leader of the Sikh nation. The narrow white marble bridge, the Saratpol that links the shore to the temple's only entrance is symbolic of the dangerous and narrow path the devout must follow to attain sainthood. This temple houses the Granth Sahib, the sacred book of the Sikhs that contains hymns and religious poems composed by the first gurus of the sect.

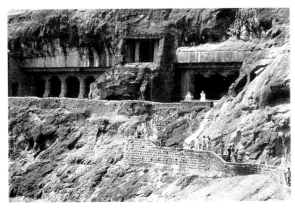

The Grottos of Ajanta

From the second century BC, religious Buddhists began excavating a series of grotto monasteries in the basaltic rock of the Western Ghats. It was between the fifth and seventh century that they decorated these grottos with such remarkable frescos, earning the distinction of being called the 'Sixtine Chapel of Buddhism'. This region has witnessed the prosperity to have supported hundreds of monks, who made a home there. The view of these 30 or more grottos, laid out in the form of a horse-shoe, leave you speechless, overlooking a ravine through which flows the Vaghora stream. These grottos became permanent monasteries from the third century, largely owing to the magnanimity of the powerful Vakataka and Chalukya rulers.

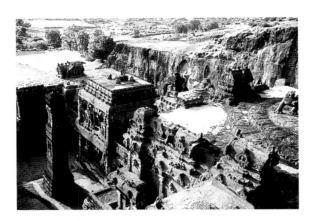

The Kailasa of Ellora

At some distance from Ajanta, the Buddhist, Brahman, and Jain grottos of Ellora were dug between the sixth and the thirteenth century. Unfortunately, with the ravages of time the paintings that embellished them have disappeared, but much to the delight of visitors, archaeologist's and historians alike, the majestic high-relief sculptures remain intact. The most surprising monument of this series, dedicated to Lord Shiva, was carved from solid rock between 725 and 755, in 'Dravidian' style. This temple, chiselled from a single block of stone, measures 54 x 36 metre with a height of 32 metre. Located in a cavity, it has been excavated from a rock, 92 x 51 metre, with a depth exceeding 30 metre. This temple with a pillared sanctuary has two enormous statues of elephants in front, two high square pillars, and a pavilion housing a statue of Nandi, Shiva's white bull. This gigantic stone jewel enjoys the unique status of being the largest monolithic monument in the world.

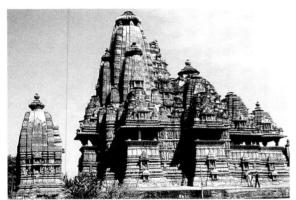

The Temple of Vishwanatha in Khajuraho

Located about 400 kilometre southeast of Agra, Khajuraho is now a small village in Madhya Pradesh. Once the religious Capital of the Chandela clan of Rajputs in the tenth and eleventh century, they erected more than 85 temples, 25 of which remain remarkably preserved today. These temples, dedicated to all the deities of the Hindu, Buddhist, and Jain pantheons, were cast from very finely grained ochre sandstone, that enabled the sculptors to demonstrate their talent at its best. All these temples are on high, decorated platforms that sometimes hold four smaller temples and pavilion housing a large statue of the bull Nandi, as here in the temple of Vishwanatha; or the avatar of Vishnu's wild boar, as in *Varaha*. Simply remarkable from an architectural standpoint, the inner and outer walls of these temples are so aesthetically decorated with sculptures of deities and women, often displaying erotic positions.

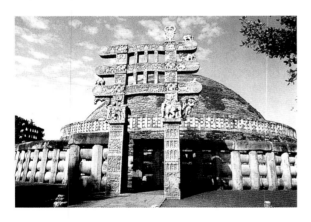

The Great Stupa of Sanchi

The site of Sanchi, near Bhilsa, right in the centre of Madhya Pradesh was rediscovered in 1818. A great repository of the Hinayana sect (small vehicle) of Buddhism since the time of King Ashoka (third century BC), numerous stupas were erected here, as well as on the surrounding hills. These monasteries were established to become the learning centres for Buddhist missionaries. And the most remarkable stupa in this locale measures about 40 metre in diameter. By the end of the first century AD, stone balustrades (*vedika*) were added on to the stupa, in a way, emulating a technique used by carpenters. This is how four high porticos were added, and decorated with bas-relief panels, depicting scenes from the life of Buddha besides the sculptures of wise men. Though nowhere is Buddha shown as a person, his persona is on display with suggestive symbols, like footprints, the empty seat of the throne, lotus flowers, etc.

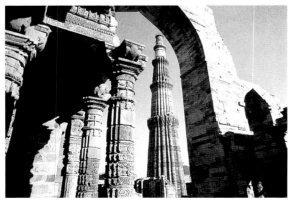

The Qutab Minar in Delhi

When the first Muslim rulers settled in Delhi by 1192, they lost no time erecting monuments to ascertain their power and might, while proclaiming their faith in no uncertain terms. Holding a testimony to that assertion is the huge mosque of Quwwat ul-Islam, built by Qutbuddin Aibak, between 1194-1199. And using debris from a Hindu temple, stands a titanic red sandstone, 80-metre high minaret in the courtyard of this mosque that has five storeys with balconies, the last of which is in white marble (probably an addition or a reparation made by Firoz Shah Tughlaq in 1370). The exterior of this minaret (minar) is decorated with friezes of Arabian characters and vertical stripes. And the interior spiral stairway has 379 steps. In 1312, another Sultan, Alauddin Khilji, attempted to build an even more ambitious minaret nearby, the Alai Minar, that was to reach a height of 170 metre, but the Sultan passed away in 1316. What we get to see today is only the base that is 29-metre high.

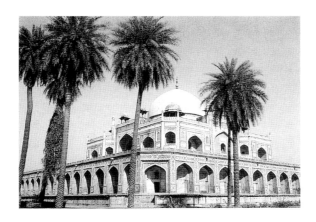

The Humayun Tomb in Delhi

The course of Mughal Emperor Humayun's fate was rather tragic. Even before he could succeed his father, Babur, he was driven out of India by a minor Afghan ruler, Sher Shah Suri. No sooner did he return to the throne in Delhi, that he met his end in 1556, falling from a staircase in his library. His widow, Hamida Banu Begum, with the aid of Humayun's capable son, Akbar, had a magnificent mausoleum built for him in Delhi. A Persian architect, Mirak Mirza Ghiyas completed the structure in 1565. Built in the style of the Timurides of Central Asia with Persian and Indian influences, the dimensions of this tomb are very impressive. Forty-two metre high, it stands in the centre of a high platform with red sandstone arches, topped with a large low dome of white marble, and surrounded with pavilions. Right in the middle of a large garden, this enormous tomb was the first true Mughal monument, built in a style totally new to India, serving as a model for most of the large imperial mausoleums of the Mughal period.

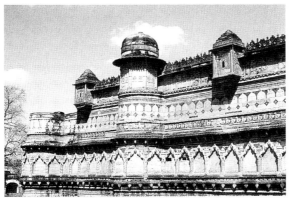

The Man Mandir in Gwalior

Perched on a rocky peak about 320 kilometre southeast of Delhi, the fortress of Gwalior was probably built in the sixth century by Rajput Rajas. Considering that it changed hands several times, it was endowed with various Hindu monuments at different periods. Its most distinguishing feature, especially because of its sheer size, is the sprawling palace that Raja Man Singh (1486-1517) had built for himself on the edge of a cliff. The colourful facade depicts pictures of various animals in blue, green, and yellow ceramics. This fortified palace has walls defended by elegant towers and the doors that are sculpted and decorated. The two storeys constitute a veritable maze of rooms and interior palaces, laid out around courtyards decorated with carved marble screens and enamelled ceramic mosaics, a style widely imitated during the Mughal period. Man Singh and subsequently his son, Vikramaditya were attacked by Ibrahim Lodi over the years, and the fortress finally fell into the Sultan's hands.

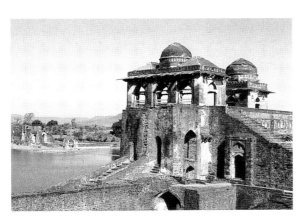

The Jahaz Mahal in Mandu

The ancient city of Malwa, Mandu, located about 90 kilometre southwest of Indore, in Madhya Pradesh, was fortified by Hoshang Shah (1405-1436). It stands on a hill surrounded by a red sandstone wall that is 40-kilometre long with six majestic gates, thus making it the vastest fortress in the world. But its impregnable reputation was shattered when Akbar managed to conquer it by sheer trickery in 1562. Thereafter, the city was abandoned and left to wild beasts for many a century. Being the domain of Ghori Sultans, they had beautified their city with magnificent monuments, mosques, and palaces, and among these structures standing intact is the extraordinary 100-metre long *Jahaz Mahal*, 'Boat Palace', commanding a view of two lakes. Built by Ghiyas ud-Din Khilji (1469-1500), for one of his favourite wives, this two-storeyed palace opens onto wide balconies, with the terraces adorned by pavilions.

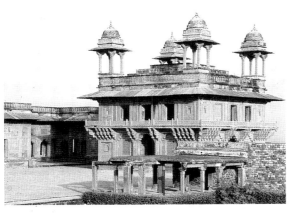

The Diwan-i-Khas in Fatehpur Sikri

When the Mughal Emperor Akbar visited a famous holy Sufi, Sheikh Salim Chishti, in 1568, in the village of Sikri, some 40 kilometre, south of his Capital in Agra, it was forecast that he would be blessed with three descendants. And he took a spot decision that he would build his new Capital on this very location. He summoned the best Hindu and Muslim artists and artisans to build red sandstone mosques, tombs, palaces, caravan serais, harems, swimming pools, towers, and various arsenals on the hill of Sikri. But the Emperor got to live very briefly in this magnificent city, as he left in 1572 to conquer Gujarat. On returning victorious, he got erected an enormous 40-metre high victory gate, the *Buland Darwaza*, at the entrance to the grand mosque. This is when he named it Fatehpur, 'City of Victory'. Its stupendous structures pioneered a new Indo-Muslim style. The *Diwan-i-Khas*, 'private audience room' housed the Emperor's throne, perched on an enormous central pillar, decorated by 32 intricately sculpted crows.

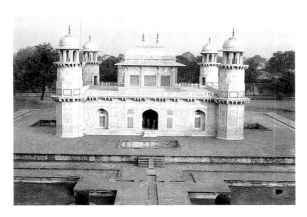

The Tomb of Itimad-ud Daula in Agra

When the Mughal Emperor Jehangir married Mihr-un-Nisa, in 1611, he named her Nur Mahal, 'Light of the Palace', then changed it to Nur Jahan, 'Light of the World'. This stunning beauty was the daughter of a minor Persian nobleman, Mirza Ghiyas Beg, who became a significant figure in his ruler's court and received the title of Itimad-ud Daula, 'Pillar of the State'. And when he died in 1762, his daughter erected a mausoleum for him in a beautiful garden on the banks of the Yamuna. Designed by Hindu and Persian architects, this tomb in white marble encrusted with semi-precious stones, stood on a 50-metre square terrace. A rectangular pavilion standing in the centre of the terrace, replacing the traditional dome, shows great innovation both from an architectural point of view and sterling quality of its decoration. And that makes it one of the most beautiful monuments of the Mughal period.

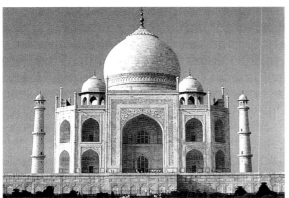

The Taj Mahal in Agra

Words fail to capture its magnificence. Indisputably considered the most delectable mausoleum of the Mughal epoch, the white marble architecture of the Taj Mahal rises on the banks of the Yamuna. Situated at the end of a majestic garden with canals, fountains, and colourful flowerbeds, the Emperor Shah Jahan got it built between 1632-652, to perpetuate the memory of his beloved wife, Arjumand Banu Begum, better known as Mumtaz-e-Mahal, 'Ornament of the Palace', who died in 1631, giving birth to their fourteenth child, a daughter who did not survive. A 20,000 workforce of architects, artisans, sculptors, and jewellers erected this gigantic cube of white marble, encrusted with semi-precious stones, on a large terrace with high minarets rising at each corner. Topped by a high onion dome, this splendid tomb ruined the royal treasury. Built in the Persian style, the central dome of the Taj stands over 62-metre high above the square block of the tomb itself measuring 62 metre on each side.

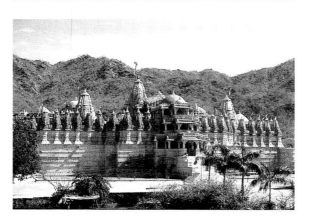

The Temple of Adinatha in Ranakpur

Situated about 90 kilometre north of Udaipur, Rankapur is a small city shrouded in greenery at the bottom of a small valley, when, from the thirteenth century, at least, Hindus and Jains built temples for their large communities living in the area. The city is especially renowned for its extraordinary Jain temple dedicated to the tirthankara Adinatha, also known as Yugadishvara, 'Ruler of the Epoch', and *Chaumukh*, 'Four Faces'. The quadruple picture of Adinatha found there earned it the sobriquet, *Chaumukh*. Built around 1434, the architecture of this temple is simply amazing, as it defies the conventional styles generally followed for temples in India. Made up of numerous rooms, it has 420 marble pillars topped with 80 domes. Laid out in such a form as to represent a 'cosmic diagram', it is decorated with thousands of extremely fine marble sculptures.

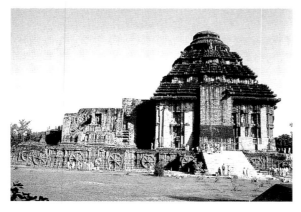

The Temple of the Sun in Konarak

Around 1241, King Narasimhadeva I (1238-1264) decided to consecrate a magnificent temple to *Surya*, the Sun God, paying obeisance to the deity for having cured him of leprosy he believed he was afflicted with. Built in the Orissa style, the temple's sanctuary tower (*deul*) rose to a height of 70 metre and the various rooms represented the sun's chariot, mounted on 24 gigantic wheels, drawn by eight horses. But in 1630, an earthquake toppled this splendid structure and nothing remains but the base of the *deul*, the offering room (*Jagmohan*), and the base of the dancing room (*Nat Mandir*). These parts of the temple resisted the tremors because their spangled sandstone blocks (chlorite) were welded together with iron spikes. The ruins of this gigantic temple exhibit a remarkable decoration of medals and panels illustrating dancers, couples and divine scenes executed in a remarkable style, displaying the scale of excellence of the art forms of Orissa.

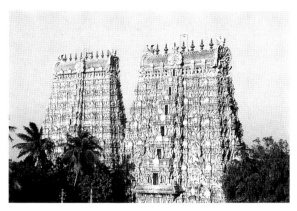

Gopuram of the Meenakshi Temple in Madurai

Around the first century AD, Madurai, situated on the Vaigai River in Tamil Nadu, about 400 kilometre southwest of Madras, became a centre for literary and academic pursuits and as much a flourishing Capital, given its prosperous trade with Rome. Marco Polo, who visited this city and lived there between 1288 and 1293, left avid descriptions of his impressions of the times. When the city was being ruled by the Nayaka, and in particular Vishwanatha Nayaka, around 1560, construction commenced on this grand temple dedicated to Shiva, in the form of Sundareshwara, the 'Handsome God' and his consort Meenakshi 'with eyes like fish'. This was also the period when the city began to regain its past splendour after having been partly destroyed by the Muslim raid of Malik Kafur in 1311. The great temple is, in fact, an entire city within its multiple concentric walls. The gate towers that rise above the walls make it highly visible from quite a distance and its southern tower reaches the height of 60 metre.

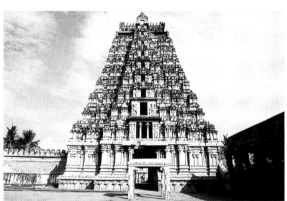

The Court of Horses in the Temple of Srirangam

One of the largest and most visited temples, Sri Ranganathaswami, in the south of India, stands on a small island in the Kaveri River in Tamil Nadu, linked to the river banks by a bridge with 32 arches that dates back to the eighteenth century. Built north of Tiruchirapalli between the fourteenth and eighteenth century, this temple is dedicated to Vishnu. With a surface area of nearly 630,000 square metre, it is surrounded by seven successive walls and guarded by 21 *gopurams*. With innumerable courtyards and rooms (*mandapa*), one of them has as many as 953 sculpted pillars. One side of one of these courtyards is distinguished by a row of sculpted pillars in the form of horses standing on their hind legs, and these horses date from the sixteenth century. An active centre for Vaishnav philosophy, the eminent philosophers who resided in these precincts were the Alvars, a group of religious poets, and the most renowned among all, Ramanuja (circa 1050-1137), was also known to have founded over 700 monasteries in Karnataka.

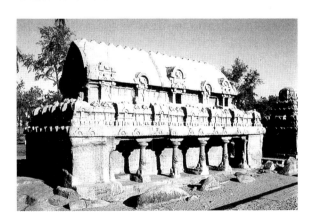

The Ratha of Mahabalipuram

On a sandy beach near the sea, about 60 kilometre south of Chennai, enormous granite rocks were sculpted into temples dedicated to Shiva, Vishnu, Krishna, and Durga, exhibiting such diverse styles of architecture. And one of them bears an inscription from King Pallava Narasimhavarman (circa 630-660). Though the exact purpose of these structures has remained unknown and certain never got completed, popular perception has lent them names corresponding to the five Pandava brothers from the period of the *Mahabharata*. Thus the group of 'five rocks of the south' was named *Ratha* (chariot of a procession), accompanied by the sculptures of a lion, a bull, and a life-size elephant, and magnificently decorated with bas-reliefs along with statues in the Pallava style. Other rocks were also carved into the form of sanctuaries (*mandapa*). One of these, known as 'Descent of the Ganges' is entirely sculpted in bas-relief, though the scenic depictions are unclear.

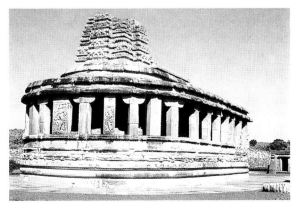

The Temple of Durga in Aiholi

It is in Karnataka that the first real attempt at architectural construction took place; perhaps that's why the little Sanchi temple number 17 seems to be an imitation of a simple Greek temple. This location, which still boasts about 70 monuments built between 450 and 700, witnessed the separation of the two major styles of Hindu architecture: 'Northern' (*Nagara*) and 'Dravidian'. One of the oldest and most curious temples, Durga, built around 550, is one such unique architectural endeavour, a stone imitation of a Buddhist sanctuary (*chaitya*); much like those found in the grottos of Ajanta and Ellora, the only exception being that it is consecrated to the Brahman deities, Shiva, Durga, and Vishnu. Raised on a high plinth, it is embellished with relatively primitive bas-reliefs. As the interior room is divided into three naves by two rows of heavy pillars, and a kind of small square tower, with curved edges, added to the roof (*shikhara*), it became a distinctive sign of *Nagara* style temples of later times.

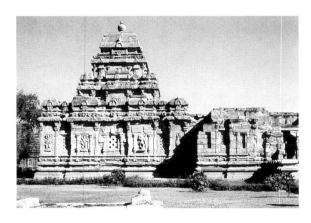

The Temple of Virupaksha in Pattadakal

Inhabited since the Iron Age, the region of Karnataka has witnessed the creation of many a capital. And among them, the Capital of Pattadakal was founded at the beginning of the eighth century by King Chalukya Vikramaditya II, and named Pattada Kisuvolal, 'City of the Coronation Rubies', several kilometre from the site of Badami. A multitude of temples were constructed by the very pious Chalukya rulers, later enlarged or renovated periodically by the Pallava rulers of Kanchipuram, who happened to be constantly at war with the Chalukyas. As terrific illustrations of the architectural developments of the *Nagara* and Dravidian styles, some of these temples exhibit the blending of both styles, defined as 'hybrids' (*Vesara*). Among them, one of the most remarkable, the temple of Virupaksha, dedicated to Shiva, was constructed by the wife of King Vikramaditya II around 744, to commemorate her husband's victory over the Pallavas. This temple shows a clear juxtaposition of both the Dravidian and 'hybrid' styles.

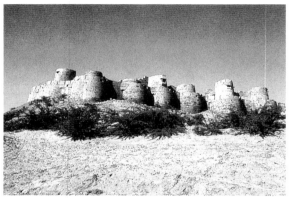

The Ramparts of Jaisalmer

The proud 'Pearl of the Thar Desert,' Jaisalmer is situated on the caravan route leading from the northwest to the ports on the western coast. Founded (or perhaps enlarged) by the Rajput Jaisal, in 1156, the city protected this trade route, since the region was infested with bandits and subject to intrusions from tribes of the Indus Valley, walls were erected around the city. But they proved inadequate and the city was plundered in the thirteenth century by the Sultan of Delhi, Alauddin (1242-1246). Again, in the following century, new walls in yellow-coloured sandstone were erected, though they were higher and defended by numerous towers. The walls, over five-kilometre long, encircle the hill on which the city was built. The Rajas (here addressed as Rawals) had not only huge palaces built for themselves but also got Hindu and Jain temples built. In the eighteenth century, rich merchants of the Baniya caste built themselves splendid houses (*haveli*), decorated with sculpted and painted balconies.

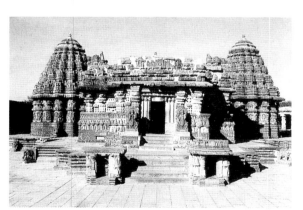

The Chenna Keshava of Somnathpur

Around 1268, a distance away from the city of Mysore in Karnataka, a minister of King Hoysala Narasimha III, had a temple constructed modelled after those of Belur and Halebid. With three sanctuaries laid out in the form of a sixteen-pointed star, this temple is dedicated to Vishnu and two of this deity's forms, Janardana and Gopala (Krishna). It indeed stays unique as the only temple of its style that has lasted over these centuries with its roof intact. The temple, raised on a plinth decorated with sculpted friezes, is located in the centre of a square courtyard surrounded by walls that have 64 chapels bordering their interior side. Lighted by windows of pierced stone, they are decorated with canopied niches that hold high-relief images of deities. The sheer beauty of these sculptures in such harmonious proportions, illustrate the stupendous skills of the Hoysala artists. All exterior surfaces with friezes depict episodes from the *Ramayana* and the *Mahabharata*.

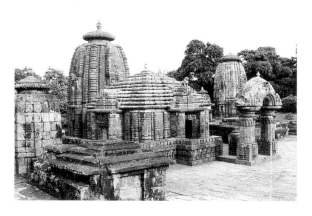

The Mukteshvara of Bhubaneswar

Not far from Konarak and the holy city of Puri, the site of Bhubaneswar, in Orissa, became a repository of the Shiva faith, around the sixth century. Believed to have been inhabited since the time of the Emperor Ashoka (third century BC), this region has numerous temples (an estimated 500) and most of them were built around the sacred Lake Bindusagara, where a particular style of temple was developed. Rather than being built above the temple itself, the *shikhara* (tower sanctuary, termed *deul* here), were built from the ground up. This style, particular to Orissa, finds culmination at its best in the large Temple of the Sun in Konarak. Though the Temple of Mukteshvara, built near the end of the tenth century, already exhibits all the intrinsic traits of this style in full evolution, it, however, remains one of the rare temples of the province to have decoration on the interiors and, equally rare, to have such an original kind of arch (*torana*) in the front.

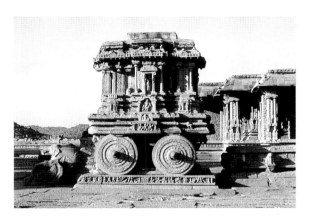

The Temple of Vitthala Swami in Hampi

The opulent city of Vijayanagara, lying in ruins today, was the Capital of the Hindu empire of the same name. Now better known as Hampi, it was completely destroyed in 1565, after the defeat of the empire at the hands of the Confederation of Muslim Kingdoms, at the battle of Talikota. In the fifteenth century, this city was surrounded by seven fortified walls, as its coffers were overflowing with wealth. Travellers estimated its population to be more than half a million. After the defeat of the Hindus, tribes from the mountains looted the remaining of its treasures. Dedicated to a form of Vishnu, Vitthala (or Vithoba), the construction of a temple with the same name was started by King Krishna Devaraya Tulva (1509-1529), later continued by his queens. Standing on the banks of the Tungabhadra, the temple still lends glimpses of its faded splendour. It has beautiful pillared rooms (*mandapa*) and an especially admirable little sanctuary in the form of a four-wheel *ratha* (procession cart) decorated with terrific high-relief sculptures.

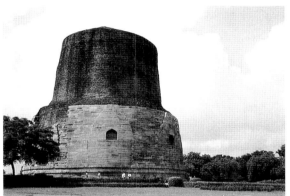

The Dhamek Stupa in Sarnath

It was in Sarnath that Buddha joined his former ascetic companions, after he received 'Enlightenment' at Bodh Gaya. Situated several kilometre north of Varanasi, the numerous ruins at Sarnath bear witness to the devotion of the followers who came here on pilgrimages. In particular, the remains of a large stupa, the Dharmarajika, with polished sandstone column inscribed with a saying of Ashoka, is topped by a magnificent sculpture of four lions, back to back, has found a pride of place as the national emblem of India. The Dhamek Stupa, is a large, solid cylindrical structure, 35-metre high, decorated by four niches, where pictures of Jina or hypostases of Buddha scan the horizons, as related by the cosmogony of Mahayana. Founded around the second or third century, it was enlarged several times. Made of stone, stabilised by iron spikes, the present structure with its high base decorated with geometric and floral friezes, dates back to the seventh century.

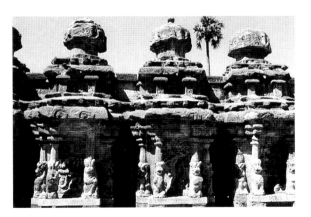

The Kailasanatha of Kanchipuram

Situated some 70 kilometre from Chennai, in Tamil Nadu, Kanchipuram was the Capital of the Pallava dynasty from the sixth to the ninth century. Known as the Golden City, it is also one of the seven sacred cities of India that experienced a great economic boom due to its maritime trade with China, the islands of Southeast Asia and the ports on its eastern coast. By the seventh century, the city had already earned great reputation as the learned centre for Brahman, Buddhist and Jain studies. No doubt, Hindu temples were constructed in such large number, the most outstanding example of unmitigated splendour being the Kailasanatha, dedicated to Lord Shiva by King Rajasimha, around 720. Heralding the true beginning of the 'Dravidian' style of architecture, built like a pyramid on a high square base, its 17-metre high tower (*vimana*), is formed of several storeys. The temple itself has a wall around it displaying 54 bas-relief decorated alcoves, opening into the interior by way of pillars sculpted in the form of standing lions.

CHRONOLOGICAL CATALOGUE

BC

Circa 1500	Indo-Iranian tribes arrive in the north-west of India.	V Century	Life of Buddha and Vardhamana.
Circa 1000/800	Indo-Iranians advance into the Gangetic Valley.	326	Alexander the Great reaches the Indus.
Circa 800	First attempts to conquer Deccan.	Circa 200	*Mahabharata* written. 'Aphorisms' by Patanjali.
Circa 800/600	Kingdoms of the Ganges and great battle recounted in the *Mahabharata*. Beginning of ancient books, Veda, Upanishad.	II Century	Conquest of western Deccan by people of the Ganges.
Circa 518/515	Conquest of the Indus basin by Darius I, King of Persia.	Circa 80	The Scythians invade the northwest of India.
		58/56	Beginning of the Vikrama era.

AC

I Century	Arrival of the Kushana in the northwest of India, at Gandhara.	712	Arab conquest of Sind.
78	Beginning of the Shaka era.	Circa 740	Driven from Persia, the Parsis settle in India.
Circa 200	Brahmanism extends towards South-east Asia. Writing of *Ramayana*, *Mahabharata*, and *Bhagavad Gita*.	Circa 750	Badami temples, grottos of Ellora and Elephanta.
End of the III Century	Beginning of Pallava control in southern India.	733-793	Rashtrakuta dynasty replaces the Chalukya dynasty in western Deccan.
Circa 320	Gupta Empire founded.	Circa 760-820	The philosopher Shankaracharya develops Vedanta philosophy.
Circa 375/400	Hephtalit Huns (Shetahuna) arrive in northwest India. Invention of the zero. Brilliance of the Ajanta grottos.	Circa 800	The cult of Shiva replaces Buddhism in Kashmir.
500/700	First temples built in Sanchi, Aihole, Pattadakal, Badami.	Circa 900	The Cholas replace the Pallavas in the south of India.
Circa 850	Wars between the Pallava and the Chalukya.	X Century	Separation of the great Rajput clans in the west of India.
600-660	The highly accomplished Pallava in southern India. Rocks sculpted at Mahabalipuram.	Circa 900	The city of Delhi founded.
		End of the X Century	Buddhism regresses. Temples of Khajuraho, temples of Orissa.
606-612	Reign of Harshavardhana in Kanauj.	1142	The Sena dynasty replaces the Pala dynasty in Bengal.
643	First Arabo-Syrian attacks in Sind.	1185	*Gita-Govinda* written in honour of Krishna.
685	Arabo-Syrians take control of Kabul.	1192	The Turks of Muhammad Ghori defeat Prithiviraja, the Hindu king of Delhi. Beginning of the Muslim conquest of the Gangetic Valley.
VIII Century	Beginning of the spread of the Krishna cult.		

1206	A Turk dynasty founded in Delhi.	1674	Pondicherry founded by the French. Shivaji establishes the Maratha Empire. The British settle in Bombay.
1231	Genghis Khan invades northwest India.		
1288-1293	Marco Polo visits India.	1680	Rebellion of the Rajput.
Middle of the XIII Century	Temple of Konarak.	1686-1690	Aurangzeb conquers the Muslim kingdoms of Deccan.
1327	A part of Delhi's population moved to Daulatabad.	1690	British merchants establish Calcutta.
1336	Hindu empire of Vijayanagara founded.	1710	First revolt of the Sikhs against the Mughals.
1339	Muslim kingdoms of Bengal become independent from Delhi.	1724	The Muslim kingdoms of Deccan and Oudh declare their independence.
1346	Muslim dynasties in Kashmir.		
1347	Bahamani sultanate founded in Bijapur.	1739	Nadir Shah of Persia raids Delhi.
1399	Tamberlaine seizes Delhi and plunders the city.	1740	Bengal declares its independence.
		1746	*Mahé de la Bourdonnais* takes control of Madras (which is later exchanged for a city in Louisiana in 1749).
1411	The city of Ahmedabad founded in Gujarat.		
1469-1539	The life of Nanak, founder of the Sikh religion.	1749-1754	Dupleix in southern India.
1498	Vasco da Gama arrives at Calicut.	1755-1756	The Afghans plunder Delhi.
1507-1510	Portuguese ships take control of Goa.	1757	British impose their domination, at the Battle of Plassey.
1526	The Mughal Babur defeats the Indian confederations at Panipat and establishes the Mughal empire.	1758-1763	Third Anglo-French war in southern India.
		1764	The Sikh establish a state.
1520-1530	Bahamani Muslim Empire breaks up into five sultanates.	1799	Tipu Sultan, a French ally, defeated and killed at Seringapatam.
1540	Babur's son, Humayun, is driven out of India by the Afghan, Sher Shah Suri, and takes refuge in Persia.	End of the XVIII Century	Struggles among the Rajput clans for supremacy.
		1803	The British take over Agra and Delhi.
1542	Francis Xavier in Goa. Beginning of the Inquisition.	1803-1818	Anglo-Maratha War. The Marathas are defeated at Pune.
1556-1605	Reign of Akbar at Agra and Fatehpur Sikri. Conquest of Gujarat and Bengal.	1818-1819	The Sikh conquer Kashmir.
		1822	First Indian newspapers.
1565	A Muslim coalition destroys the Hindu empire of Vijayanagara.	1823	The last Rajput rebels submit to the British.
1599	Ahmadnagar is annexed by the Mughal Empire.	1839-1842	First Anglo-Afghan war.
		1845-1849	The British fight two wars against the Sikhs.
1605-1627	Reign of Jehangir, son of Akbar.	1853	First railroads in India.
1611	The Dutch establish a colony in Masulipatam.	1857	Universities established in Calcutta, Madras, and Bombay.
1612	The British establish a colony in Surat.	1857-1858	Great revolt of the *Sipahi* (Sepoy) against the British.
1627-1658	Reign of Shah Jahan, son of Jehangir.	1858	India becomes British Crown Colony.
1640-1652	The British settle in Madras. The Taj Mahal constructed.	1861-1871	Several widespread famines in northern India and in Orissa.
1658-1707	Reign of Aurangzeb. Wars and conquest in the south	1876	Queen Victoria is proclaimed Empress of India. Famine in southern India.
1664	Establishment of *Compagnie Française des Indes*.	1878-1880	Anglo-Afghan war.
		1885	Establishment of the 'Indian National Congress' in Bombay.

1893	Vivekananda speaks at the Parliament of Religions in Chicago.	1972	Pakistan withdraws from the Commonwealth.
1896-1899	Famines and plague in northern India and Bombay.	1974	Pakistan recognises the Independence of Bangladesh.
1905	Lord Curzon divides Bengal, provoking serious unrest.	1977	Indira Gandhi loses the elections to the Janata Party (People's Party).
1906	The Muslim League is established in Dhaka.	1980	Indira Gandhi returns to power.
1911	Division of Bengal abandoned. Construction of New Delhi, which became the Capital of British India.	1984	Indira Gandhi assassinated by Sikh bodyguards. Her son Rajiv Gandhi assumes office.
1913	Rabindranath Tagore receives the Nobel Prize for Literature.	1991	Rajiv Gandhi assassinated by Tamil separatists. PV Narasimha Rao is elected Prime Minister and sets the pace for a liberal economy.
1914-1918	India takes part in World War I on the side of the Allies.	1996	The Congress Party is defeated at the hustings. Narasimha Rao resigns.
1919	India is admitted to the League of Nations.		Bhartiya Janata Party stakes claim to form the government. Atal Behari Vajpayee takes oath as Prime Minister,
1920	Mahatma Gandhi refuses to cooperate with the British.		but bows out of office before proving the majority on the floor of parliament.
1922	First trade unions in India.		A new government, led by HD Deve Gowda of the United Front,
1924	Creation of the Indian Communist Party.		assumes office.
1929	Afghan rebellions on the north-eastern border. Mohammed Ali Jinnah heads the Muslim League.	1997	Congress withdraws support from the United Front Government led by Gowda. And this time round, IK Gujral assumes office in this coalition of United Front. Congress again lends outside support.
1930	Mohandas Karamchand Gandhi launches the 'Civil Disobedience Movement'.		
1935	'Government of India Act', first Indian constitution.	1998	There is a mid-term election as Congress again pulls the carpet leading to the fall of the United Front Government. Since no national party wins single largest majority, a National Democratic Alliance is formed, led by Atal Behari Vajpayee, who assumes the office.
1936	Nehru becomes President of the Indian National Congress.		
1939-1945	India refuses to support the British war effort.		
1940	The Muslim League demands the creation of Independent Muslim Pakistan.	1999	In April this year, Vajpayee loses the no-confidence motion on the floor of the parliament. Subsequently, the Congress President, Sonia Gandhi, makes a claim to form a coalition but fails to muster the requisite numbers, leading to mid-term election in October. A stronger National Democratic Alliance Government, under Vajpayee, comes back to power.
1947	Lord Mountbatten, the Viceroy, decides to divide India and Pakistan. Mass exodus follows, resulting in millions of casualties.		
1948	Mahatma Gandhi assassinated by a Hindu extremist. Death of Mohammed Ali Jinnah.		
1950	Proclamation of the Republic of India.		
1951	Chandernagar returns to India.	2004	Bhartiya Janata Party loses out to the Congress and its political allies. Manmohan Singh, the former Finance Minister in Narasimha Rao's cabinet, assumes office, leading a coalition, termed as United Progressive Alliance.
1961	India reclaims all its foreign territories.		
1962	Brief Sino-Indian conflict in Ladakh.		
1964	Death of Jawaharlal Nehru.		
1966	Indira Gandhi, Nehru's daughter, is elected Prime Minister.		
1971	East Bengal separates from Pakistan and becomes Bangladesh.		

GLOSSARY

*Indian words are pronounced almost like Latin, the letter 'u' is always pronounced as 'ou',
the consonant 'g' is hard, as in 'god'. The 'c' sounds like 'tch'.*

Agni
God of sacrificial fire.

Ahimsa
'Nonviolence', the preoccupation not to mistreat or kill any living thing, even the smallest animal.

Alvar
Mystic poets, followers of Vishnu, who lived between the VII and X century in the south of India.

Asura
'Anti-gods' in the Brahman pantheon, endlessly at war with the Deva.

Avatar
'Descent', incarnation of a deity to save humanity from danger.

Baoli
Large decorated wells, common in the west of India.

Basti
Groups of Jain temples surrounded by high, blind walls. Also called *Tuk*.

Bhagavad Gita
'Song of the Lord', a highly philosophical chapter in Indian religious writing, included in the *Mahabharata.*

Bhakti
Pious philosophy.

Yellow Bonnets
Reformed sect (Tsong-kha-pa) of Tibetan Lamaism, dating from the XIV Century. The monks set themselves apart by wearing a yellow headdress.

Red Bonnets
Old sect of Tibetan Lamaism (founded by Padmasambhava), dating from the VII Century. The monks wear a red headdress to set themselves apart.

Brahma
First deity of the Brahman Trinity, theoretically assimilated with the Creator, but relatively venerated little. His mascot (*vahana*) is a swan, Hamsa.

Brahmans
The first caste in Brahman society, that of priests.

Chhattri
Pavilions with a cupola supported by small columns, generally housing a cenotaph.

Chorten
Tibetan name (mChod-rten) for stupa.

Sepoy see **Sipahi.**

Deul see **Shikhara.**

Deva
Ordinary gods of the Brahman pantheon, constantly fighting the Asura.

Devadasi
Sacred dancers who, in former times, performed in temples.

Dharma
Religious and individual 'duty', which every Hindu must scrupulously follow to live correctly, according to his caste or station in life.

Dhoti
Made of very light cotton fabric, typical attire for men in Bengal and the Gangetic Valley.

Dupatta
Long scarf traditionally worn by women of the Punjab and Kashmir.

Durga
Brahman goddess, consort (wife) of Shiva and aspect of Parvati. She is usually shown riding a tiger.

Fakir
Poor Muslim Saint.

Ganesha
Brahman deity of travellers, merchants, and thieves. He is the son of Shiva and Parvati and has the head of an elephant. His mascot (*vahana*) is a rat.

Garuda
A kind of vulture, mascot (*vahana*) of Vishnu.

Gauri
Brahman goddess, one of the forms of Parvati, consort of Shiva.

Gavial
A kind of crocodile with a long narrow mouth, which lives in the waters of the Ganges and the Yamuna. They live on garbage and small fish.

Ghee
Clarified butter used as much for cooking as for burning in sacrificial fires.

Gurudwara
Sikh temple where their sacred book, *Guru Granth Sahib*, is venerated.

Hanuman
In the epic, *Ramayana*, General of a tribe of monkeys, who helped Rama rescue his wife Sita, kidnapped by the Demon-King Ravana.

Haveli
Very ornate home(s) of rich merchants, found in the cities of Rajasthan.

Hinayana
'Small vehicle', pejorative term used by followers of Mahayana, when referring to primitive Buddhism, such as the 'Schools of the South' or Theravada, 'School of the Old Ones'.

Holi
Great festival of the spring equinox.

Indra
King of the gods (*deva*) believed to command 33 million gods living on the slopes of Mount Meru, the axis of the world, supposed to be located beyond the Himalayas.

Jagannatha
One of the aspects of Vishnu, especially venerated in Puri, in Orissa.

Jainism
Hindu religion characterized by the search for purity and the preoccupation with nonviolence (*ahimsa*) towards all beings. The Jain venerate the memory of 24 prophets (*Tirthankara*).

Jali
Screens of pierced marble decorating the windows and balconies of palaces.

Jauhar
Collective suicide practised by Rajput nobles in case of defeat, the men fighting to death, the women throwing themselves upon the burning pyre.

Kailasa
Mythical mountain, found in Tibet, paradisiacal home of Shiva.

Kali
One form of the goddess Parvati, consort of Shiva, especially venerated in Bengal.

Karma
In Indian philosophy, the whole of an individual's actions and thoughts influence his future rebirths.

Kashmir
Correct spelling of the region the West calls 'Cachemire'.

Kathakali
Pantomime dance, particularly performed in Karnataka and Kerala. It is usually presented at night by the light of torches and recounts episodes from the *Mahabharata* and the *Ramayana*.

Khalsa see **Sikh.**

Khumba Mela
Large gatherings of pilgrims, which generally take place every 12 years in a traditional, consecrated place.

Krishna
'The Black One', incarnation of Vishnu, intensely venerated.

Kshatriya
The second caste of Brahman society, the caste of warriors.

Kochi
Present name of the city of Cochin in Kerala.

Lakshmi
Brahman goddess of beauty and wealth, wife of Vishnu.

Lingam (Linga)
Symbol of Shiva, stylized stone phallus pushed into the yoni, stone basin symbolizing the feminine element.

Lungi
A kind of attire draped around the hips, typical dress of the inhabitants of southern India.

Mahabharata
Great epic poem recounting struggles between the Indo-Iranian clans in the Gangetic Valley and containing numerous legends about Brahman deities. Probably written around the I Century AD.

Maharaja
'Great King', title of numerous important Indian sovereigns.

Mahayana
'Large Vehicle', term indicating the theistic forms of Buddhism, still called 'Schools of the North'.

Makara
Mythical monster, both crocodile and dolphin, symbol of water, often seen in temple decorations.

Manu
Name given to the 'first new man', equivalent to Noah in the Bible. His Indian name is Manava.

Masjid
Mosque.

Meru see **Indra**

Naga
Chthonian genies haunting the earth and the waters, represented by cobras.

Nayanmar
Mystic poets, devotees of Shiva, who lived in the south of India between the VII and X Century.

Pariah
Caste of untouchables.

Parsis
Iranians of the Mazdeenne religion (followers of Zoroaster), who settled in the west of India after being driven out of Persia in the VIII Century. They worship light and fire.

Parvati
Brahman goddess of the mountains, consort of Shiva.

Perak
'Cobra' headdress of women in Ladakh, decorated with turquoise.

Puja
Ritual prayer, in the temple or at home.

Purana

'Ancient', sacred Brahman texts, recounting innumerable legends about the gods and sacred places (*tirtha*).

Raja

'King', title of numerous Indian sovereigns. See Maharaja.

Rajput

Ancient population which settled in the west of India. Divided into various clans, they are characterized by their courage and spirit of independence.

Rama

One of the *avatars* (incarnations) of Vishnu, King of Ayodhya, whose adventures are recounted in the *Ramayana*, a long epic poem written by Valmiki around the I Century AD.

Ramayana see **Rama**

Sadhu

Holy man, generally itinerant or a hermit.

Saraswati

Brahman goddess of music and the arts, a form of the consort of Brahma.
Name of mythical river which merges into the Ganges at Prayaga (Allahabad).

Sari

Typical dress for Indian women.

Shakti

Consort (or wife), active energy of a Brahman deity. The devotees of this deity are called *Shakta*.

Shikara

Small piers found on the lakes of Kashmir.

Shikhara

Sanctuary tower of a temple. Called *deul* in Orissa.

Sipahi

Indian name of the sipoy, indigenous soldiers recruited by the British. Origin of the word '*spahi*.'

Shiva

Hindu god of the creation and destruction of the world, third person in the Brahman Trinity. His mascot is the white bull, Nandi.

Shudra

The fourth caste in Brahman society, servants of the three other castes.

Sikh

Followers of Guru Nanak, a saint-philosopher of the XV-XVI Century. The Sikhs formed communities (Khalsa), mainly in Punjab, and refused to be included in Islam or Brahmanism. They are purely monotheistic.

Singh

'Lion', title used by all Sikhs.

Stupa

Monument in the form of a round tumulus, sometimes decorated, symbolic of Buddha's death and His teaching.

Sufi

Muslim philosophy which somewhat approaches the Hindu philosophy of Vedanta, very pious.

Surya

Brahman deity of the sun, possibly of Iranian origin. He crosses the sky in a chariot drawn by eight horses.

Thar

Vast desert located between Rajasthan and Pakistan. Also called 'Land of Death', *Marusthali*.

Tirtha

Sacred place, usually near a river or a source of water.

Tirthankara

Jain prophets, 24 in number.

Tuk see **Basti**

Upanishad

A number of Sanskrit theosophic or philosophical treatises.

Vahana

Mascots characterizing the great Brahman deities.

Vaishya

Third caste in Brahman society, that of farmers and artisans.

Varaha

Mythical wild boar, *avatar* of Vishnu.

Varanasi

Real name of the holy city of Benares.

Varuna

Old Vedic deity of the waters, equal to Poseidon for the Greeks.

Veda

'Knowledge', generic title of four 'books' containing the wisdon of the sages from the ancient times of Indian history. Considered 'inspired' texts.

Vedanta

'End of the Veda', very detailed Hindu philosophy, monotheistic, mainly brought to light in the VII Century by Shankaracharya.

Vimana

Sanctuary tower built in storeys on a platform, typical of the 'Dravidian' style of temples in the south of India.

Vishnu

Hindu deity of preservation, second person in the Brahman Trinity, especially venerated in his incarnations, Rama and Krishna. His mascot (*vahana*) is a vulture, Garuda.

Vyasa

Name of a mythical wise man who dictated the text of the *Mahabharata* to Ganesha.

Yamuna

Principal affluent of the Ganges, on the right bank.

Yoni see **Lingam**.

Yuga

Great period of the universe, according to Brahman cosmology, equivalent to 4,320,000 of our years.

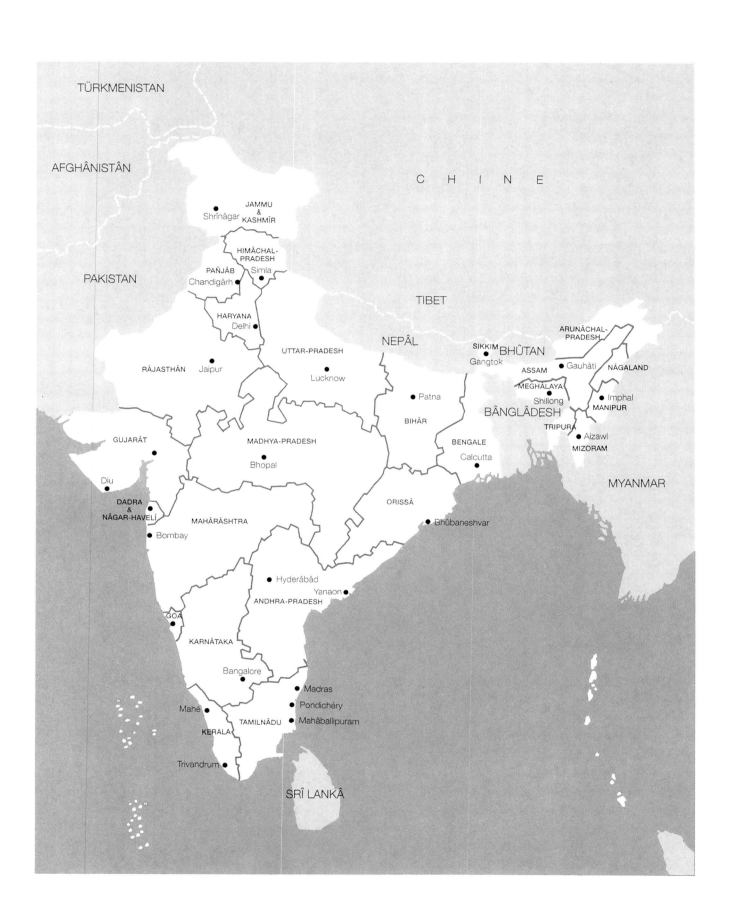

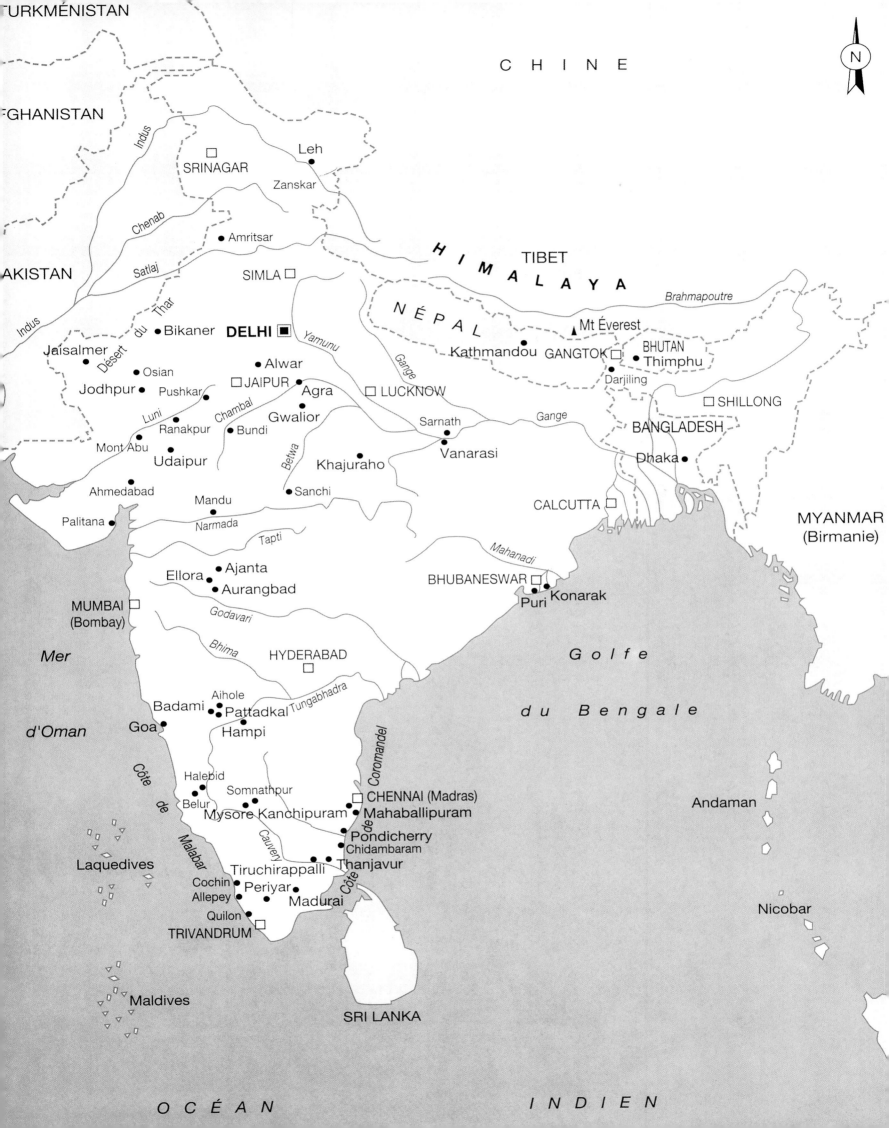

INDIA: SPLENDOUR AND COLOUR is published by Om Books International
(New Delhi, India)

Collection directed by Michel Laugel

Photographs: Suzanne Held

Text and Captions: Louis Frédéric

Translated from the French original: M.V. Tulli

Layout and Concept: Michel Labarthe

Composition of text in Garamond and Dutch801: Archetype

Chinese Gold East Glossy Art Paper 157 gsm

Photographic processing: SNO

Printing and technical advice: C & C, offset Printing Co. Ltd.

Bound by C & C

Published, 2005
By Om Books International (New Delhi, India)
© 1995 La Martiniere
© 2005 Om Books International
World English Rights, Om Books International
© Photographs Suzanne Held
&
Text Louis Frédéric
Printed in China
ISBN 81-87107-27-8